ART: As You See It

IONE BELL, M.F.A.
Austin Community College

KAREN MATISON HESS, PH.D.
Normandale Community College
Innovative Programming Systems, Inc.

JIM R. MATISON, M.A.
Minneapolis Public Schools
Instructional Media and Research, Inc.

John Wiley & Sons, Inc.
New York • Chichester • Brisbane • Toronto

Publisher: Judy Wilson
Production Manager: Ken Burke
Editorial Supervision: Judith Fillmore
Photo Research: Joyce Campbell
Makeup: Meredythe

Library of Congress Cataloging in Publication Data

Bell, Ione 1916–
 Art as you see it.

 (Wiley self-teaching guides)
 Includes indexes.
 1. Art appreciation. 2. Art criticism. I. Hess,
Karen M., 1939– joint author. II. Matison, Jim R.,
1944– joint author. III. Title.
N7477.B43 701'.1 79-12697
ISBN 0-471-03826-1

Printed in the United States of America

79 80 10 9 8 7 6 5 4 3 2 1

For Elly

Acknowledgments

We wish to acknowledge and give thanks for the contributions of many students; the support and help of colleagues, librarians, and secretaries of Austin Community College; and the assistance of Irene Brownstone, Gen Cotter, and Craig Dalager.

To the Reader

Works of art can offer everyone many hours of enjoyment. You need not "know anything about art" or about specific works of art to see and enjoy them, just as you need not know anything about tennis and baseball to enjoy watching them played. Most people would agree, however, that an awareness of the structure of each of these games—their limits, rules, variations, and strategies—helps the viewer evaluate the strength of the players, the play itself, and the general quality of the game. Knowing and understanding can heighten enjoyment, whether you are watching a game or looking at a work of art.

Every work of art is unique; it can never be repeated. By transforming materials, an artist offers the viewer the tangible, visual form of dreams, desires, play, fears, miseries, plans, laws, spiritual values, future visions, fetishes, things seen, and evidence of things unseen in unending variation. Works of art can provide freedom from personal containment to worlds beyond the immediate self.

This book is intended to help you understand the universal factors with which the artist works and some of the ways these factors interrelate, forming a unified work to communicate meaning. Focusing on two-dimensional art, mainly painting, the discussion cuts across historical developments and styles to describe the most basic problems and solutions of the visual artist. Once you have assimilated the information, you will probably feel that it is knowledge you have always possessed. This approach has given many people direction and confidence in relating to works of art, whether traditional or contemporary, as well as the desire to study further in this field. We hope that it will do the same for you.

Ione Bell
Karen M. Hess
Jim Matison

How to Use This Book

This book is carefully designed to provide experiences needed to see beyond your first impression of a work of art. Each chapter contains:

> Objectives, cast in the form of the question *can you . . . ?*
> Explanations of concepts or skills
> Boxed summary statements
> Examples of the concepts or skills
> Applications in which you use what you have learned
> Answers to the applications so you can evaluate your own performance
> A Self-Test, with answers for self-evaluation

Throughout the book you will be referring to illustrations of works of art. These are in the back of the book, perforated and numbered so you can remove them and arrange them in sequence. Each time a work of art is referred to, the corresponding number of the black-and-white print or color plate is given in brackets.

For easy reference, each chapter is presented in numbered sections called *frames*. Whenever questions are asked, possible answers are provided immediately, below a line of dashes. You will learn most effectively if you formulate your own answer before reading the answers suggested. If you have missed the point, you may wish to reread the material before continuing.

When you have finished a chapter, review the boxed concepts and then take the Self-Test, to see how well you have understood the material in the chapter. If your score is lower than the suggested score, you should probably review the chapter, concentrating on the concepts and skills that you were not able to apply in the Self-Test. The specific number of the frames you should review is given in parentheses following the answers to each item on the Self-Test. Because each chapter serves as the foundation for the next, the book will be most meaningful if you thoroughly understand the material in each chapter before going on.

To make the book more useful for study now and for reference later, some special features have been included. Chapter 10 is a review with applications bringing together all the major ideas that appeared throughout the book. A Glossary defines all the major terms introduced. A General Index allows you to find the discussion of each major concept, and an Artist Index allows you to locate quickly where each work of art is mentioned.

If you follow the recommended procedures throughout this book, your capacity for enjoying works of art—and your confidence in evaluating them—should be increased dramatically.

Contents

Introduction

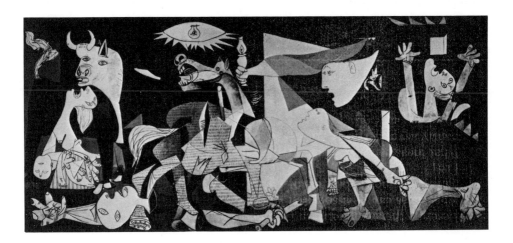

What is there to see in this work of art? Picasso's *Guernica* [50] is a famous work of art that has been the topic of discussion and study in religious groups and psychiatric sessions as well as classes in art. Countless words have been written about it. These are some of the questions raised:

Have you seen it before?
What is it about?
What do you see in it?
Is it organized or chaotic?
Is it meaningless or significant?
If it has a meaning, what is it?
How do you feel about it?
Do you know why you respond as you do?
How would your best friend probably respond to it? Why?
Why do so many people take time to look at it and talk about it?

These questions can be asked about any work of art. To be fair to yourself, the artist, and the work of art, time is needed to seek answers.

This book will guide you into experiencing some ways to view and discuss a work of art and some ways to find meaning—meaning that is your own because you have discovered it.

This book is intended as a *guide* to seeing two-dimensional works of art—that is, images on a flat surface or plane. A work of art is a system of

Pablo Picasso, *Guernica*. 1937. On extended loan to the Museum of Modern Art, New York, from the artist's estate.

relationships in which everything is involved in everything else. It is not possible to separate line from tone and color, to see space without motion, or to consider texture without shape. There is no right way to look at art and no correct sequence, but you need a starting point—you need specific things to consider if you are to really *see* art. So this approach to seeing art has, of necessity, been broken into key concepts, some greatly simplified to aid understanding of very complex ideas. As we proceed, we will consider how these concepts work together to form a total view of a work of art.

As your ability to *see* art grows, you will add to the material presented here because ideas about art can be packaged, but art itself cannot be.

CHAPTER ONE
Order and Balance

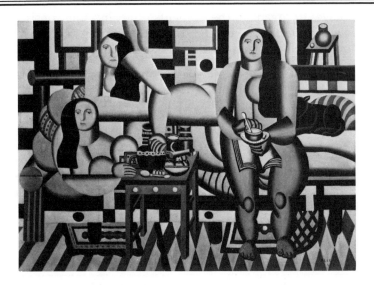

In a work of art, can you:

- determine whether the order system is primarily rigid or random?
- describe the shape of the field of action?
- locate and describe vertical center?
- recognize the use of symmetrical and asymmetrical balance?

In Chapter 1, we will concentrate on these skills. By the end of this chapter, you should be able to answer "yes" to each of these questions. Before beginning, however, gather the following materials, which you will need for the exercises in this chapter:

Graphite pencil	Writing paper
Marking pencil	Tracing paper
Ruler	

ORDER

We all need order—the feeling that we can keep some segment of our lives under control. Each of us tries to organize the chaos that surrounds us and

Fernand Leger, *Three Women (Le Grand Déjeuner)*. 1921. Collection, the Museum of Modern Art, New York. Mrs. Simon Suggenheim Fund.

constantly threatens to overwhelm us. Our activities, whatever form they take, reflect that order is necessary to life. Our minds equate order with sanity and meaning.

Not everyone manicures lawns or straightens magazines for company, but we all have some order patterns that help us survive. What is orderly and sensible to one may be neither orderly nor sensible to another.

Order refers to the sequence or arrangements of elements and is a primary concern of the artist. When we say "the artist composes," we mean that the artist arranges or organizes the elements of art in some consistent manner. Once we see and become interested in the finished work, our own work begins. We may not all become artists, but we can all become creative viewers.

Order Systems: Rigid and Random

1. All works of art contain an order system. The artist composes forms on a scale of order ranging from rigid to random. *Rigid order* is tightly controlled and deliberately planned; *random order* is planned, but it also allows for chance. Rigid order is like a time-blocked work week; random order is like a relaxed vacation. Rigid order is a sonnet; random order is free verse.

Rigidity and randomness are present everywhere. Neither guarantees that a work of art will result, but either can be the motivating force in creating a work of art. It is important to accept the artist's range of options because the order system of a work of art has an essential relationship to its meaning.

> *Order* ranges from geometrically *rigid* to haphazardly *random.*

Examples

Rigid	Random
Stripes of the same thickness	Color splashes on linoleum
Honeycombs	Cracks in a concrete wall
Pebbles placed in a circle	Pebbles on a beach
Trees planted along a city street	Trees in a forest
City streets	Forest footpaths
Flowers at equal intervals in a window box	Wild flowers along a roadside

Exercise

Think about each pair of items listed below and underline the one in each pair that is more rigid in appearance:

Tie-dyed shirt	Plaid shirt
Swarm of bees	V-shaped flight of wild geese
Whirlwind	Spinning airplane propeller

| Gurgle of a brook splashing over stones | Ticking of a clock |
| Paint colors poured onto raw canvas | Colors knit together with strands of fiber |

- - - - - - - - - - - - - - -

You probably underlined plaid shirt, V-shaped flight of geese, a spinning airplane propeller, the ticking of a clock, and colors knit together with strands of fiber. These are the more rigid in each pair.

Seeing the Order

2. Compare Pollock's *Autumn Rhythm* [58] with Warhol's *100 Cans* [86]. *Autumn Rhythm* is random order; *100 Cans* is rigid, geometric order.

Application

Place a check in front of the work of art in each pair which has the more rigid order:

_____ (a) Indiana—*The American Dream, I* [28] _____ Rauschenberg—*Buffalo II* [62]

_____ (b) Riley—*Current* [67] _____ Giotto—*The Lamentation* [26]

_____ (c) Albers—*Homage to the Square* [1] _____ Picasso—*Guernica* [50]

- - - - - - - - - - - - - - -

You probably selected all the works in the left column as being more rigid, because in each work the artist uses obviously geometric shapes. It might be difficult, however, to agree on whether Giotto is more or less rigid than Picasso.

If you look at two-dimensional works of art long enough, you will discover that each has a structurally important underlying geometric order that is dependent on the space in which the work takes place, its center, and related dynamics.

FIELD OF ACTION

3. Every work of art has bounds, a perimeter, an enclosure within which the artist performs. This is called the *field of action*. The field of action is the first and strongest ordering force, setting the work of art apart from the rest of the world. Its size, shape, and proportion are usually among the artist's first considerations and make an immediate first impression on the viewer.

The field of action is important because everything that happens within the enclosure of its perimeter has reference to its shape, proportion, and limiting outside edge.

Sometimes the field of action is predetermined for the artist by a patron who has commissioned the work and is paying the artist, or it is predetermined by a specific setting such as a wall or a ceiling. At other times the artist has complete freedom to choose exactly what the size, shape, and proportion of the field of action will be. The shape of a field of action might be

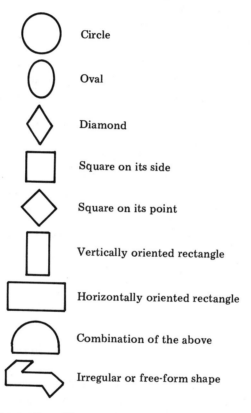

Circle

Oval

Diamond

Square on its side

Square on its point

Vertically oriented rectangle

Horizontally oriented rectangle

Combination of the above

Irregular or free-form shape

or it can be an entire wall, ceiling, a room or building, a park or an outdoor setting. Usually the field of action is decided in advance of the work, but sometimes it is determined as the work progresses. At other times the work may be done on a surface that is later cropped (trimmed) and the outer limit chosen to enclose only the portion of the work the artist wishes to retain.

> The size, shape, and proportion of the field of action are strong ordering forces.

Examples

We can compare the field of action of a work of art with a game field. A game usually takes place within specific limits such as a tennis court (a

rectangle), a baseball diamond, a checkerboard (square), or a golf course (which is the most open, the most free form). Games have set rules for playing, and these rules are often determined by the playing field (the "field of action"). In art, however, defiance of rules establishes new rules or even new games.

Exercise

Which of the following could be considered a field of action for an artist?

_____ (a) Canvas

_____ (b) Ceiling

_____ (c) Board

_____ (d) Dinner plate

_____ (e) Wall

— — — — — — — — — — — — — — — — —

You should have checked each of the possibilities since the field of action can be whatever the artist chooses from the many possibilities available. The size, shape, and proportion of each would influence what the artist composes. Because reproductions of works of art can be scaled smaller or larger than the original, we have to imagine the dimension or scale of the real work. One important reason for encountering the original directly is to experience the actual dimension of the work.

In much of the work of the past the artist was dictated to and closely supervised by a patron whose preferences determined the field of action as well as what was to be done on it. In much of contemporary art, however, the artist is free to establish the field of action and what it will contain.

In general, works of art adhere to a defined limit, but the story of the artist's attempt to escape this limit is a long one. In *Sketch Book*, Warja Honegger-Lavater examines the history of art in terms of the "disobedient" artist who rejects what has been accepted as "art," breaks with the past, and creates something new.* One such recent rebel, Jackson Pollock, has defied the edges of the field of action in paintings such as *Autumn Rhythm* [58] with forms that create energies pushing out of the picture plane to transcend the physical limits of the frame. With his challenge to the containment of a limited surface, painting became a new "game."

Seeing the Field of Action

4. Compare Picasso's *Guernica* [50] with Duchamp's *Nude Descending a Staircase* [19]. Notice that Picasso uses a horizontal rectangle; Duchamp uses a vertical rectangle. The field of action selected affects the overall impression

*Warja Honegger-Lavater, *Sketch Book* (Basel, Switzerland: Basilius Press, 1968).

of the work of art since it is the area the artist has chosen to activate and to control, and everything it contains relates to it.

Application

Look at the works of art listed below and describe or draw on a piece of paper the shape of the field of action used in each:

(a) Duccio—*Madonna Enthroned, with Angels* [18]
(b) Raphael—*The Dispute of the Sacrament* [59]
(c) Mondrian—*Broadway Boogie Woogie* [back cover]
(d) Vinci—*The Virgin of the Rocks* [83]
(e) Botticelli—*Madonna of the Magnificat* [5]
(f) Ma Yuan—*Bare Willows and Distant Mountains* [45]
(g) Michelangelo—*The Last Judgment* [48]
(h) Goya—*Execution of the Madrileños* [27]
(i) Durer—*The Knight, Death, and the Devil* [20]

—————————————————————

You should have found the following shapes to the field of action:

(a) Vertical rectangle with a pointed upper edge
(b) Semicircle
(c) Square
(d) Vertical rectangle with curved upper edge
(e) Circle
(f) Oval
(g) Sistine Chapel wall with two arches at upper edge
(h) Horizontal rectangle
(i) Vertical rectangle

Although you have seen many shapes, both regular and irregular, most paintings are done within rectangular shapes with the field of action framed by a horizontal-vertical relationship.

BALANCE

Balance refers to the equilibrium of various elements. Like order, balance is important to all of us. It relates to our need to stand on our two feet; it represents stability and continuity. It is fundamental in making visual judgments of any kind. Imbalance gives us feelings of askewness, crookedness, unfairness, discomfort of one kind or another. But imbalance in art can also create an exciting visual response.

We play games to prove our ability to maintain or regain balance. It is exciting to be momentarily off-balance, but important to reestablish balance for comfort and steadiness. Visual artists know and make use of our feelings about balance and imbalance. To convey serenity and stillness, artists use the kind of balance seen in Duccio's *Madonna Enthroned* [18] and Blake's *Book of Job: "When the Morning Stars Sang Together"* [3]. Many different

degrees of balancing action can be seen in works as varied as Rubens' *The Rape of the Daughters of Leucippos* [68], Renoir's *Le Moulin de la Galette* [64], Duchamp's *Nude Descending a Staircase* [19], and Kandinsky's *Improvisation 35* [33]. Imbalance can often convey feelings of excitement or discomfort as in Caravaggio's *The Conversion of St. Paul* [9] in the stricken figure of St. Paul; in El Greco's *The Resurrection* [21] with the apostles who fall back from the rising Christ; and in Chardin's *The Boy with a Top* [11] where we see the top just beginning to fall out of its balancing spin. But within each of these works the imbalance you see is counterbalanced. Every mark, every color, every shape in a work of art contributes to the totality of its balance system.

Vertical Center

5. The field of action with no mark on it is empty. Even with no image on its surface, however, a set of invisible forces operates within its perimeter. One of these forces is *vertical center.* Through a sense of our own balance and our own centered structure, we intuitively assign center to the working surface. And, since we are upright creatures, we think "vertically." We divide things into right and left sides.

The vertical center of an empty field of action is a vertical line dividing the field of action in half—a left side and a right side:

The field of action also has a *horizontal center*—that is, a horizontal line that divides it into a top half and a bottom half:

In addition, the field of action has a *center point* where the vertical center and the horizontal center meet:

You can illustrate the vertical center, horizontal center, and the center point by folding a square or rectangular piece of paper in half from left to right and then in half again from top to bottom.

In addition, invisible *diagonals* run from the lower-left corner to the upper-right corner and from the upper-left corner to the lower-right corner of a rectangle. You can locate them by folding from opposite corner to corner:

These diagonals intersect at the same point as vertical and horizontal center, reinforcing the center point:

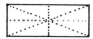

and together the four lines form an underlying skeletal frame that is an important invisible inner structure.

> *Vertical center* is a strong ordering force within the field of action.

Examples

Field of Action	*Vertical Center*
Football field	50-yard line
Oak leaf	Stem through middle
Light bulb	Filament
Clock (nondigital)	Clock hands at 6:00
Tennis court	Net

Exercise

(a) Draw on a piece of paper, using a ruler and/or compass, the shapes of three different fields of action.
(b) Indicate beneath each whether the major spatial orientation is horizontal, vertical, or both.
(c) Estimate where the center point is in each field and place a pencil point there.
(d) Draw freehand with a dotted pencil line vertical center and horizontal center.
(e) Measure and draw with a ruler and fine marking pencil the accurate vertical center and horizontal center.

— — — — — — — — — — — — — —

Your drawings might look something like the following: (see next page)

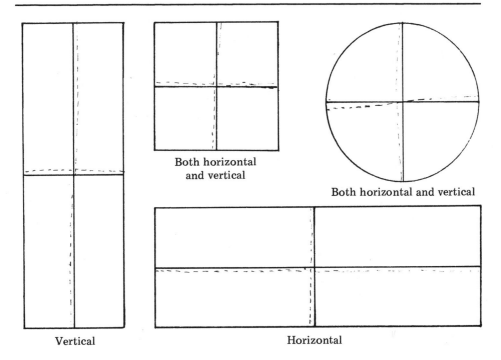

Both horizontal
and vertical

Both horizontal and vertical

Vertical

Horizontal

Seeing Vertical Center

6. Look at Leonardo da Vinci's *The Last Supper* [79]. Notice how vertical center cuts directly through the figure of Christ.

Application

Examine the following works of art, locate the vertical center of each, and describe in a word or phrase its location:

(a) Warhol—*100 Cans* [86]
(b) Indiana—*The American Dream, I* [28]
(c) Tintoretto—*The Last Supper* [74]

— — — — — — — — — — — — — — —

Your answers should be similar to the following:

(a) Vertical center runs between the fifth and sixth cans from top to bottom.
(b) Vertical center cuts between the circles with the numbers and the word *tilt* on the left; *take all* and *the American Dream* on the right.
(c) Vertical center falls along the jar in the foreground, through the animal form touching the corner of the small table and through the lighted head of Christ. (Notice the weighting of figures to the left balanced by the open space at the right.) Center is not as obvious in this work.

Symmetric Balance

7. The field of action has *symmetric balance* when parts on either side of a center line or a center point correspond in size, shape, and relative position. Symmetric balance is also called *formal balance*.

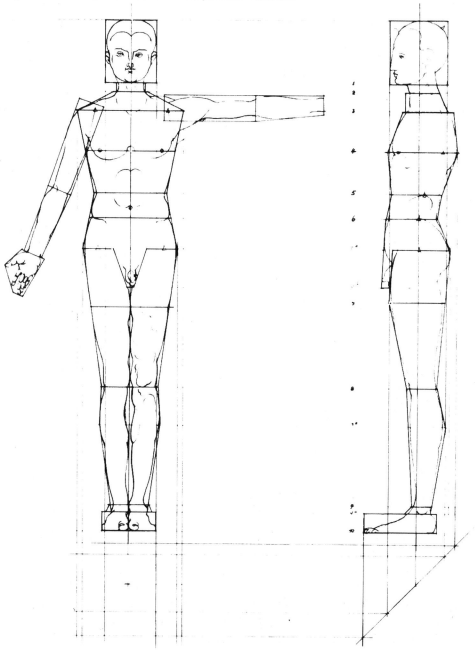

From Heimo Kuchling (ed.), *Oskar Schlemmer Man* (Cambridge, Mass.: M.I.T Press, 1971), p. 58.

When you stand facing a mirror with weight equally distributed on each foot, hands to sides and eyes straight ahead, your body is a symmetrical plan. You can relate symmetry in a work of art to your own body symmetry.

When each side of vertical center is a mirror image of the other, the result is *bisymmetry*, as found in an oak leaf, an acorn, or a bird's spread wings. When vertical center is very apparent with some variations in weighting to right or left, the result is *lateral symmetry*, as seen in the positions of two football teams effectively lined up or a neatly set table. When a construction spreads from a center point, the result is *radial symmetry*, as seen in a snow-flake or a sunburst.

Visual symmetry generally has the effect of stillness, rest, and tranquil-lity, and implies certainty, predictability, and stability.

Symmetric (formal) *balance* is created when parts on either side of a center line or a center point correspond in size, shape, and relative position. The effect is static, restful, or tranquil, implying certainty, predictability, and stability.

Examples

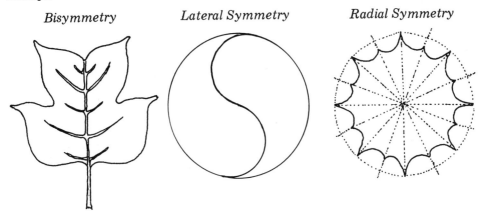

Bisymmetry *Lateral Symmetry* *Radial Symmetry*

Exercise

Circle those letters of the alphabet that have symmetric balance:

A B C D E F G H I J K L M N O P Q R S T U V W X Y Z

Can you identify which have bisymmetry, lateral symmetry, and radial symmetry?

— — — — — — — — — — — — — — — — —

You should have circled A H I M N O S T U V W X Y and Z. Bisymmetry occurs in A H I M O T U V W X and Y; lateral symmetry occurs in N S and Z; radial symmetry occurs in X, which can also be considered bisymmetry.

Seeing Symmetric Balance

8. Look at Albers' *Homage to the Square* [1]. This illustrates bisymmetry. Without Albers' skillful use of color, this surface does not hold attention for long. Now look at Anuszkiewicz's *Splendor of Red* [2]. This work uses radial symmetry. It, too, depends on color for continued interest. Finally, look at Vinci's *The Last Supper* [79]. It is not as obvious as the first two examples, but it is predominantly lateral symmetrical balance. The centered figure of Christ is accentuated by the opening behind him and the arch over it. On either side of Christ are two groups, each with three of the apostles. Behind them on each of the walls are four panels leading the eye to the back wall and its center opening with smaller, balancing side panels.

Application

After finding vertical center in the following works of art, check which are predominantly symmetrical in balance:

_____ (a) Duccio—*Madonna Enthroned, with Angels* [18]

_____ (b) Blake—*Book of Job: "When the Morning Stars Sang Together"* [3]

_____ (c) Chardin—*The Boy with a Top* [11]

— — — — — — — — — — — — — — — —

You should have checked (a) and (b).

Asymmetric Balance

9. Balance can also be achieved by *asymmetry*, which is a balance of unequal parts. When a plumb line is dropped through the profile view of the human body, anatomical parts are distributed unequally on either side of this center line, and your eye is drawn diagonally from one side to the other. (You may want to refer back to page 12 and look again at Schlemmer's body studies.) When the body swings into action, the emphasis on the diagonal in the displacement of anatomical parts is more exaggerated. We relate asymmetry in a work of art to our own asymmetry.

The emphasis in asymmetric balance is alignment with diagonals of the field of action. Equilibrium is established when larger or heavier weights on one side of center balance with weights that are smaller, lighter, and more in number on the opposite side. The variation in weighting creates visual tensions by attracting the eye from side to side, causing asymmetric balance to be more dynamic in contrast to the serenity of symmetric balance.

Balance and weight are closely tied together (see next page):

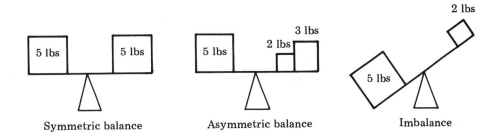

Symmetric balance Asymmetric balance Imbalance

Simplified sketches can indicate only a general difference between symmetry, asymmetry, and imbalance. The key to establishing balance is weight, but innumerable factors can visually communicate weight. Controlling the complexity of these weights is the real struggle in the artist's problems with balance. There are no laws or rules, and every work becomes a unique set of weight problems.

In general, weight appears heavier with greater size and amount; however, brighter, or lighter areas attract the eye and can appear larger than a darker area of the same size. So a light area can be smaller and balance a larger dark area. Some hues such as red may appear heavier than others, and the more demanding bright colors seem heavier than dull, dark colors. Usually a small amount of a bright color is enough to balance a large amount of a dull color.

Location is another important weight factor. Clustered forms can appear lighter and less important than an isolated form, even though the latter may be smaller in size. In general, forms with a vertical axis will seem more substantial in weight than those with a diagonal direction; forms that appear to have solid volume will seem heavier than flat, two-dimensional forms; and those that suggest nearness will probably seem heavier than those that seem far away.

Whether compactly geometric or irregular free-form shapes are heavier will depend on many variables including size, location, and color. If forms suggest recognizable objects, what we know about relative weights will enter our judgment. For instance, feathers will undoubtedly tend to appear lighter than metal coins.

It should become apparent that every addition or change of any part of the field of action changes the balance of the entire work. As Cezanne painted, he felt that it was necessary to advance together the entire surface of his canvas at every stage of construction.* In the final product, not one dot or shadow can be changed or omitted without changing the total effect, just as changing a note in a melody or changing a word in a poem makes a different song or a different verse.

*Erle Loran, *Cezanne's Composition* (Berkeley: Univ. of California Press, 1950), p. 15.

> *Asymmetric balance* establishes equilibrium by placing a few large, heavy weights on one side of vertical center and more, equalizing, smaller, lighter weights on the opposite side. (Weights can involve size, amount, location, direction of line, light/dark, color, form, texture.) The effect is action, motion, or tension.

Examples

Symmetrical Balance *Asymmetrical Balance*

A	a
O	Q
M	b

Exercise

Circle those letters of the lower-case alphabet that have asymmetric balance:

 a b c d e f g h i j k l m n o p q r s t u v w x y z
— — — — — — — — — — — — — —

You should have circled all *except* o, s, v, w, x, and z.

Seeing Asymmetric Balance

10. Look at Chardin's *The Boy with a Top* [11]. The field is a horizontal rectangle. Vertical center falls along the right side of a small light rectangle at the bottom edge, touches the center fingertip of the boy's left hand, touches the tip of the blue coat lining, and continues to the left of the fluff of hair just above the boy's right eye. In line with the lower-left to upper-right diagonal are the pivot of the spinning top, the boy's chin, the tip of his ear, and the hair ribbon. The boy's attention in watching the top is directed along this line. The edge of the table is almost parallel with the lower-right to upper-left diagonal, and the boy's coattail and elbow align with it. Notice the position of the hand, which has just spun the top, and its location in relation to center and to the two diagonals.

Application

Look at the following works of art and describe the asymmetry:

(a) Mondrian—*Broadway Boogie Woogie* [back cover]
(b) Manet—*At the Races* [41]
(c) Mathieu—*Painting 1952* [44]

— — — — — — — — — — — — — —

(a) A clue to vertical center is the red block flush with the bottom edge. Its right side falls on center and directs the eye along the vertical row of

small squares to the right. Searching from right to left, either spaces or colors vary.

(b) Three groups of horse and rider and a brief view of spectators are on the left of vertical center, with one horse and rider, a long view of spectators, and balancing unfilled space in the foreground to the right of vertical center.

(c) The snapping violent action on the right is balanced by fewer action lines and unfilled space on the left. Vertical center goes through the lower springlike curve and touches the ends of two curves as it probes on through tightly bent wirelike lines in the upper half. A delicate, slightly curved line almost at right angles to the lower off-center upward thrust starts on horizontal center.

Symmetry and Asymmetry Combined

11. In searching for specifically symmetric and asymmetric examples, we quickly discover that paintings may be predominantly one or the other, but that many painters use different kinds of balance within one work. For example, the figure groups of the apostles in Leonardo da Vinci's *The Last Supper* [79] are asymmetrically arranged within each group, giving an electric action charge to the predominantly static work. Likewise, the background stripes of Chardin's *The Boy with a Top* [11] are symmetrical, providing stability to the foreground asymmetry.

By combining symmetry and asymmetry, the ancient Egyptians improvised a formula for representing the human body which served them for centuries and which we accept without question when we look at Egyptian works. It consists of a profile asymmetric view of the head with a full front eye, a full front symmetric upper torso, and the hips, legs, and feet in profile; see (Egyptian)—*Fowling Scene, XII Dynasty* [88].

We always relate, consciously or subconsciously, to vertical center, horizontal center, and to the diagonal tensions of the field of action. We can make these invisible forces into a visible guide by using tracing paper to locate these lines in specific works. This allows us to see the balance system with greater clarity.

Application

Locate vertical center, horizontal center, and the diagonal tensions in Picasso's *Guernica* [50] by following these steps:

(a) Place tracing paper over the work and draw the outer limit of the field of action.

(b) Fold this shape right edge to left edge to locate vertical center.
Were there clues to find center before you began?
What, if anything, falls on center?

(c) Now fold the field of action you have marked on the tracing paper from top to bottom to find horizontal center.
Are there any alignments in the painting?

(d) Next draw diagonals from the upper-right corner to the lower-left corner and from the lower-right corner to the upper-left corner.
What, if anything, falls along these diagonals?
On what does center point fall?

— — — — — — — — — — — — — — — — —

Your answers should be similar to the following:

(b) *A clue for vertical center* is an unbroken vertical edge of the light panel (just off center) that is parallel and left of the kerosene lamp.
Falling on vertical center is the point of the horse's wedge-shaped breast, which directs the eye to the oval handle of the broken dagger.
Each side of center is divided into three loosely shifting vertical panels with broken edges.

(c) *Horizontal center alignment* is with the edge of dark into which the falling figure drops and the top of the horse's tail. (Each of the four rectangles made by vertical and horizontal center is the same proportion as that of the total rectangle, a significant aspect of the order system.)

(d) *Lower-left to upper-right diagonal* corner to corner aligns with the profile of the fallen warrior at left and the corner of the light window in the upper right.
Upper-left to lower-right corner to corner follows a dark ceiling diagonal, aligns with the bull's ear, through a white diagonal, touching the back of the horse, and through a point in the structure of the figure at lower right.
Center point or "dead center" falls near the top of the wedge-shaped (or heart-shaped) breast of the horse.

Although your first impression of *Guernica* may have suggested a random order or even chaos, you should have found a careful symmetric balance system within which asymmetric relationships take place. Whenever the forms of a work of art align with a geometric understructure, there is a psychological relationship between two communication systems. In some works such correspondences are very close; in others they are only hinted at.

In drawing a skeletal framework for any work of art, you create a guide to help you decide whether the work is predominantly symmetric or asymmetric. With the guide you can also discover whether the work is mainly rigid or random by determining whether it conforms to or defies the lines of inner structure.

This is a point for a very important discovery:

> **The structure and the meaning of a work of art are inseparable.**

We will talk about meaning in greater depth as the book progresses. To see the direct relationship between structure and meaning, however, look carefully at the works of art discussed in the following three paragraphs.

When the artist constructs with a predominantly *symmetric* balance plan, a generalized intention related to certainty becomes apparent:

— the *solemnity* of Masaccio's *Holy Trinity* [43]
— the *security* of Heaven and saintly patronage in Raphael's *The Dispute of the Sacrament* [59]
— the *permanence* of marriage in Van Eyck's *Jean Arnolfini and His Wife* [color plate 7]
— the *conviction* of Francesca's *The Resurrection* [57]
— the *inevitability* in Vinci's *The Last Supper* [79]

The basic structure of such works that align closely with a strong horizontal-vertical framework establishes in the viewer feelings of unalterable stability and timelessness.

In the choice of a predominantly *asymmetric* balance plan, the artist does not intend the impression of stability, but of action, dynamic tension, and uncertainty:

— the *transience* of the moment in Chardin's *The Boy with a Top* [11]
— the *immediacy* of action following decision in Rembrandt's *The Night Watch* [60]
— the desperate *struggle* for survival in Gericault's *The Raft of the Medusa* [24]
— the *violence* in Goya's *Execution of the Madrileños* [27]
— the lyrical *sensuousness* in Giorgione's *The Concert* [25]
— the *changing* aspect of nature in Kandinsky's *Improvisation 35* [33]
— the rapidly *shifting* conditions in Manet's *At the Races* [41]
— the *fleeting* gesture in Rauschenberg's *Buffalo II* [62]
— the *momentariness* in Lichtenstein's *Whaam!* [37]

In the basic structure of such works, important alignments will be with diagonals. The result is oscillating balance—disturbance of stability with complex tensions pulling from one side to the other, suggesting action, impermanence, change.

Endless possibilities of combining symmetry and asymmetry result in a dynamic symmetry that is some variant in a balancing out between stillness and action, between permanence and change, as observed in Vinci's *The Last Supper* [79] and Chardin's *The Boy with a Top* [11].

Variant systems of order and balance are endless, but all seem to depend on first locating center as a reference. You are always relating to your own center and your ability to maintain balance both physically and mentally. Balance and order are very complicated. We have explained them in very simple terms, but in reality they are probably our deepest, most complex common needs, stretching to cover all our other needs: physical, mental, social, and spiritual.

We strive for order and balance constantly, endlessly. The study of these fundamentals can be carried to much greater depth, but you have taken a first step in understanding the important part they play in visual art.

You should now be able to look at a work of art and describe its order, field of action, and balance. You may want to review the questions appearing at the beginning of this chapter and the material in this chapter before completing the following Self-Test.

SELF-TEST

This Self-Test will help you evaluate how much you have learned so far—how well you can answer the questions raised at the beginning of the chapter. Answer the questions as completely as you can (use a separate sheet of paper) and then check your answers against those that follow.

1. Place a check in front of the work of art in each pair which has the more rigid order:

 (a) _____ (Egyptian)—*Fowling _____ Renoir—*Le Moulin de la
 Scene, XII Dynasty* [88] Galette* [64]

 (b) _____ Mondrian—*Composition _____ Pollock—*Autumn
 No. 10, Plus and Minus* Rhythm* [58]
 [49]

 (c) _____ Vasarely—*Eridan II* [78] _____ Watteau—*The Embarka-
 tion for Cythera* [85]

2. Look at the art works listed below and describe or draw the shape of the field of action used in each:

 (a) Anuszkiewicz—*Splendor of Red* [2]
 (b) El Greco—*St. Martin and the Beggar* [22]
 (c) Poussin—*Shepherds of Arcadia* [color plate 6]
 (d) Botticelli—*Madonna of the Magnificat* [5]

3. Locate and describe the vertical center in Van Gogh's *The Starry Night* [color plate 8].

4. After finding vertical center in the following works, identify which is predominantly symmetrical in balance:

 _____ (a) Indiana—*The American Dream, I* [28]

 _____ (b) Tintoretto—*The Last Supper* [74]

5. Describe the asymmetry in El Greco's *St. Martin and the Beggar* [22].

6. What ideas can be associated with meaning in relation to the predominantly symmetric balance of Duccio's *Madonna Enthroned, with Angels* [18]?

7. What ideas can be associated with meaning in relation to the predominantly asymmetric balance of Mondrian's *Broadway Boogie Woogie* [back cover]?

8. Look at (a) Leger's *Three Women* [36] and (b) Seurat's *Models* [71].
 Answer the following questions for each:

 (1) Where does the work fall on a scale of order?
 (2) What is the shape of the field of action?
 (3) Where does vertical center fall?
 (4) What kind of balance predominates?

Answers to Self-Test

In parentheses following these answers are given the number of points each
question is worth, if you want to total your overall score, and the frame
references where the topic is discussed, if you wish to review.

1. You should have selected all the works in the left column as being more
 rigid. (frames 1–2; 3 points)
2. (a) square; (b) vertical rectangle; (c) horizontal rectangle; (d) circle.
 (frames 3–4; 4 points)
3. Vertical center cuts through the large swirl in the center of the picture
 slightly to the left of the steeple. (frames 5–6; 2 points)
4. (a) Indiana's *The American Dream, I* is predominantly symmetrical in
 balance. (frames 7–8; 1 point)
5. The nearest straight leg of the white horse is aligned with vertical center.
 Above and in line is the reining hand of St. Martin and above that the
 side of his head, which is turned away from us. On the left are the beg-
 gar and the action of St. Martin's sword cutting his cape. On the right
 are the front of the horse's body with the action-bent leg and the right
 background opening to a distant view. (frames 9–10; 3 points)
6. Authority, power, permanence. (frames 7–8, 11; 2 points)
7. Action, change, syncopated beat. (frames 9–11; 2 points)
8. (a) (1) Rigid order. (frames 1–2; 1 point)
 (2) Horizontal rectangle. (frames 3–4; 1 point)
 (3) Center follows the right front table leg through the highlight
 of the jar and along the edge of a vertical black rectangle
 (which has three small horizontal rectangles to the right).
 (frames 5–6; 1 point)
 (4) Asymmetric balance. Two partially indicated reclining figures
 weight the left side and one full-seated figure balances the
 right side. (frames 9–12; 2 points)
 (b) (1) Rigid, but not as rigid as Leger. (frames 1–2, 1 point)
 (2) Horizontal rectangle. (frames 3–4, 1 point)
 (3) Center is through the vertical center axis of the middle figure
 and along the line indicating the corner where two walls meet.
 (frames 5–6; 1 point)
 (4) Symmetric balance. The center figure is standing frontally
 balanced with a view of the seated model on either side. The
 dark picture panel behind the smaller figure at left balances

the larger light wall and larger figure at right. (frames 7–8,
11–12; 2 points)

Total possible points: 27. Your score: _____ . If you scored at least 21
points, you understood the main points of the chapter. If your score was
lower than this, you may want to review the appropriate frames before you
go on.

IMAGINATION STRETCHES

At the end of each chapter we will give you *imagination stretches*—mental
exercises to extend your imagination. To imagine is to take hold of sug-
gested possibilities in your mind, consider them, and think of further new
possibilities.

Every imagination stretch you try out enriches and extends your mental
range. This is a game with endless moves; when any of the combinations you
are testing in your mind harmonizes with actual experience, your sense of
reality becomes deepened and heightened.

Order

— Sort out in your mind order patterns essential to your life, order patterns
 you find so important that you cannot continue without them—a personal
 survival survey.
— Find a desk or kitchen-counter arrangement that is orderly for someone
 else, but not for you. Try a sketch of the arrangement of objects.
— Mentally plan a walk and imagine some chance system from the toss of dice
 that will direct where you go. For instance, walk the number of blocks that
 the dice total. When the total is odd, turn left; when the total is even, turn
 right. Picture in your mind where this will take you.

Field of Action

— You have decided to keep a daily sketchbook record. These are some of
 the available sizes: 4″ X 6″; 5½″ X 8½″; 8½″ X 11″. What size will you
 select?
— You want a portrait of someone very dear to you. What size and shape will
 you choose?
— Can you imagine creating or possessing a free-form painting? What might
 your reason be for such a preference?

Balance

— Think through subject matter for a roll of film in which all photographs
 have symmetrical balance and another roll in which all have asymmetrical
 balance. Does the composition deepen the meaning in your picture?
— Can you find examples of imbalance with your camera?

CHAPTER TWO
Line

▶ In a work of art, can you:

- identify the following kinds of line: straight, curved; horizontal, diagonal, vertical; continuous, broken; contour, edge; visible, invisible?
- describe the effect of different kinds of line?
- describe how an artist conveys volume using line?
- recognize calligraphic line?

By the end of this chapter, you should be able to do all of these things. For the exercises in this chapter, you will need:

Pencil or marking pencil, pen, brush, ink
Writing paper
Tracing paper
Apple or some other piece of fruit

Robert Rauschenberg, *Buffalo II.* 1964. Leo Castelli, New York. Collection: Mr. & Mrs. Robert Mayer. Photo Credit: Rudolph Burckhardi.

INTRODUCTION

Howard Nemerov's poem "Writing" presents connections between visual line, the written word, and meaning. Read the poem and think about how it applies to seeing line in works of art as well as in the world around us.

Writing*

The cursive crawl, the squared-off characters,
these by themselves delight, even without
a meaning, in a foreign language, in
Chinese, for instance, or when skaters curve
all day across the lake, scoring their white
records in ice. Being intelligible,
these winding ways with their audacities
and delicate hesitations, then become
miraculous, so intimately, out there
at the pen's point or brush's tip, do world
and spirit wed. The small bones of the wrist
balance against great skeletons of stars
exactly; the blind bat surveys his way
by echo alone. Still, the point of style
is character. The universe induces
a different tremor in every hand, from the
check-forger's to that of the Emperor
Hui Tsung, who called his own calligraphy
the "Slender Gold." A nervous man
writes nervously of a nervous world, and so on.

Miraculous. It is as though the world
were a great writing. Having said so much,
let us allow there is more to the world
than writing; continental faults are not
bare convoluted fissures in the brain.
Not only must the skaters soon go home;
also the hard inscription of their skates
is scored across the open water, which long
remembers nothing, neither wind nor wake.

The poem suggests that, in some ways, everything in the world is a form of record-keeping similar to writing and drawing.

We are all line makers. The scratching of prehistoric man, urban-world graffiti, desk-pad doodlings, all suggest an inborn marking instinct in each of us. Further, our lives are greatly influenced by line, especially the lines used in writing. Much of our education centers on arranging lines that can be read (writing) and on interpreting such lines (reading).

The artist organizes lines in a pattern to record or communicate a message. The viewer must learn to interpret what the artist has communicated

*Howard Nemerov, *New and Selected Poems* (Chicago: Univ. of Chicago Press, 1967), p. 75.

through the use of lines. The path left by a human foot, the veining of a leaf, the trailing of larvae in tree bark, the eroding of stone, and the rippling in water are stories told to us as surely as lines shaped into letters placed side by side to form words juxtaposed to become sentences.

A line, which always begins at a point and ends at a point, is a story of energy expended, tension released, the translation of a course followed by anything that has shifted from one place to another, whether a growing, a joining, or a separating.

A line can be straight, or it can circle around to meet itself to enclose a shape. It can be the edge of an overlapping form that ends where another begins, as where flesh becomes fingernail or water becomes land. It can be the rim, contour, or silhouette of a solid mass or a flat shape. It can be the meeting of two forms such as flush cupboard doors or clasped hands. Line may even be invisible, as when living beings look or gesture to each other.

Line can indicate objects and their relationships; it can show direction and imply movement in time and space. Line has the power to suggest mood: light-hearted, sad; funny, tragic. And line can reveal the individuality and uniqueness of an artist.

A line can be thin, fragile, and light; or it can be thick, strong, dark, and heavy. Length, width, and the way line meets or relates to other lines also affect the quality of line.

Lines can be made in many ways: incised (cut, scratched, worn) into the surface or imposed (imprinted, drawn, brushed, poured) onto the surface. Different tools and media may be used, such as pen, pencil, brush, lead, charcoal, ink, pastel, and paint.

Through consistently disciplined control of line, artists communicate the story they want to be seen, knowing as they work that line always contains its own story, with every aspect of their choices giving multiple meaning to their message.

The complexities of line are elusive. You may have responded strongly to a visual image without knowing just what caused your feeling of like or dislike. As a viewer, you will want to *see* the lines the artist has used, to consider the many possible qualities of the lines, and to determine what meaning is communicated to you by these lines as part of the total work of art.

BASIC KINDS OF LINE—STRAIGHT AND CURVED

1. Line can be straight, curved, or some combination or variation of straight or curved. A *straight line* is open-ended, going in opposite directions like a stretched wire or a string that has no directional deviation. A *curved line* bends or turns without angle.

Variations of these two basic lines include zigzag (angular bent lines), wavy (curve followed by reverse curve), or any combination of straight with straight, curved with curved, or straight with curved.

> Lines are either *straight* or *curved*. Many variations of these two basic kinds of line are found in works of art.

Examples

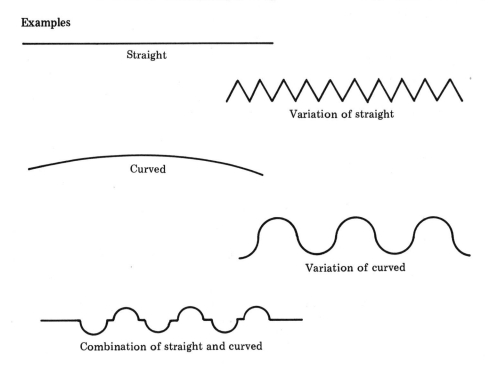

Straight

Variation of straight

Curved

Variation of curved

Combination of straight and curved

Exercise

Identify the basic kind(s) of line to be observed in the following:

(a) Rainbow
(b) Full moon
(c) Handsaw
(d) Telephone pole

(e) Rim of a cup
(f) Yardstick
(g) Telephone receiver

- - - - - - - - - - - - - - - -

(a) curved; (b) curved; (c) straight and zigzag; (d) straight; (e) curved; (f) straight (numbers would use a combination of straight and curved); (g) curved

Seeing Straight and Curved Lines

2. Compare Mondrian's *Broadway Boogie Woogie* [back cover] with Van Gogh's *The Starry Night* [color plate 8]. Mondrian uses mostly straight lines, Van Gogh mostly curved lines.

Application

Examine the following works of art and identify the *predominant* kind of line used in each:

(a) Vasarely—*Eridan II* [78]
(b) Blake—*Book of Job:* "*When the Morning Stars Sang Together*" [3]
(c) Courbet—*The Painter's Studio* [13]

— — — — — — — — — — — — — — —

(a) straight; (b) curved; (c) straight and curved

LINE DIRECTIONS: HORIZONTAL, VERTICAL, AND DIAGONAL

3. The most defined directions that lines can take are horizontal, vertical, and diagonal.

A *horizontal line* is parallel to the horizon (the apparent junction of earth and sky) and is related to the great stability of the earth. The force of gravity constantly pulls all forms downward. The horizontal is related to yourself in a reclining position and is associated with relaxation, serenity, and rest.

A *vertical line* is perpendicular (at right angles) to the horizon and is related to a dropped plumb line. It also relates to resistance against the force of gravity. It is always self-sufficient: balanced, poised, forceful, with either an upward or downward thrust. A vertical is related to the uprightness of trees, towers, and yourself in a standing position—still, but ready for action.

A *diagonal line* is oblique or slanted at some degree between vertical and horizontal. A diagonal is related to the ascending flight of a bird or to yourself running. It is associated with the greatest sense of action, with dynamic vitality, and also with imbalance.

Horizontal lines are associated with relaxation, serenity, rest.
Vertical lines are associated with still tension, readiness, strength, support.
Diagonal lines are associated with action, vitality, imbalance.

Examples

Exercise

Identify the basic line directions in the following:

(a) Telephone pole (e) Guy lines to steady a TV antenna
(b) Upright doorway (f) Skyscraper
(c) Edge of a tabletop (g) Ascent of an airplane
(d) Floor (h) Factory smokestack

— — — — — — — — — — — — — — — —

(a) vertical; (b) vertical; (c) horizontal; (d) horizontal; (e) diagonal; (f) vertical; (g) diagonal; (h) vertical

Seeing the Line Directions

4. Look at Friedrich's *Monk by the Seaside* [17]. The predominantly horizontal lines of the sea and land convey the image of an unbroken shoreline and the stability of the earth, except for the vertical figure of the monk who provides scale, suggesting the smallness and aloneness of man in the vastness of empty space.

Now look at Monet's *The Poplars* [51]. The foreground verticals running from the bottom almost to the top of the composition suggest tree trunks and their reflection in water. The upward thrust of the row of spindly trees represents a balanced poise of graceful dignity that is interrupted only by the horizontal of the earth and the diagonals of the foliage.

Application

Look at the following works of art; on a piece of paper describe the main line directions used and the effect they suggest to you:

(a) Braque—*The Musician's Table* [7]
(b) Anuszkiewicz—*Splendor of Red* [2]
(c) Warhol—*100 Cans* [86]

— — — — — — — — — — — — — — — —

(a) Placed within an oval (suggested by broken arcs), the diagonal lines (mainly of paper edges that are more defined toward the center) give the effect of projecting and revolving. These suggest the importance of the moment of chance and of spontaneous choice in a musician's (or any artist's) work.
(b) All diagonals that intermesh as they radiate from a center in a vibrant, spreading effect.
(c) Horizontals and verticals make an almost monotonous grid. Note the spaces between the cans, the curvature of the bottom and top of each can. Think of all the spinning action to open all those cans!

The more fully you can describe what the artist has done, the more aware and sensitive you become in what you see. Not only will you find

yourself experiencing each work of art in greater depth, but you will make the exciting discovery that you are learning linear clues for identifying the work of specific artists whenever you encounter any work they have done.

The remainder of this chapter describes some distinctive line-control methods that can lead to heightened visual experiences. Sometimes one system will be used exclusively in a work, but most often several ways of using line can be found within one work. Although these methods may at first appear to categorize the very free and flexible means of line, remember that every individual artist's way of controlling line is unique; it is this uniqueness as well as the controls for which you search.

CONTINUOUS AND BROKEN LINE

5. A line may be either continuous or broken. A *continuous line* remains uninterrupted for a long flow. Sometimes it returns to its starting point to meet itself in defining shape and enclosing the outer limit of a form. Sometimes it continues open-ended at length, providing an unbroken flow which the eye follows to its conclusion. Such lines may be firm and thick or wavering and thin, but whenever the line returns to meet itself it will convey an image that seems to be contained, clearly defined, and decisive.

A *broken line* is fragmented with starts and stops, leaving openings before the line starts again. When the artist uses a broken line you are encouraged to actively participate in the completion of form with your eye supplying what is left out and your mind connecting the breaks. With broken line, form seems to be open, free, flexible, and not fully defined.

A work of art may be constructed of predominantly continuous line or predominantly broken line. The artist very often uses both kinds of line in the same work.

> *Continuous line* around a form tends to clearly define, contain, and hold form captive. *Broken line* tends to allow open, free, and flexible form.

Examples

Continuous	*Broken*
Tire tracks in snow	Footprints in snow
Cursive writing	Printing
Cording around a pillow	Fringe

Exercises

It is important to try the following drawing exercises. The objective of the exercises is *not* to produce a work of art, but rather to see how form can be constructed with different kinds of line.

(a) On a blank sheet of paper, draw a *continuous line* around the hand opposite your writing hand. Repeat the exercise using a *broken line* (short dashes).

(b) Draw the shape of an apple with a smooth *continuous line*. Then draw the same shape with a *broken line*, using quick strokes in staccato rhythm.

(c) Begin a line at the edge of a sheet of paper and let it wander to the other edge without lifting your pencil—a continuous line. On the same sheet of paper, repeat short broken lines side by side:

These lines are called *hatching*. Then cross over these lines with another set of parallel lines in a different direction:

Broken lines used in this way are called *cross-hatching*.

Continuous Line

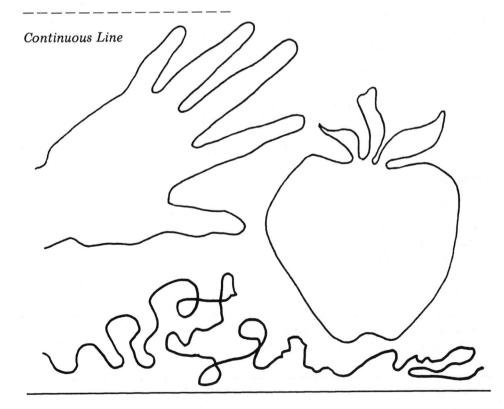

Broken Line

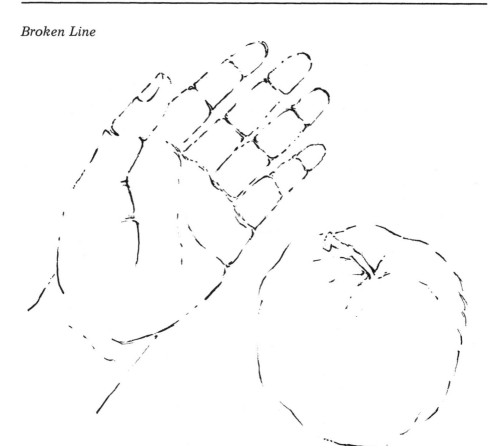

Seeing Continuous and Broken Lines and the Effect Created

6. Compare Stella's *Sinjerli Variation IV* [72] with Kandinsky's *Improvisation 35* [33]. Stella's lines clearly define and contain the form he is communicating. Kandinsky's swinging lines—many of which start and trail off without connecting—float and dance, thus communicating a more free and open form.

Application

Determine whether the lines in each of the following works are predominantly continuous or broken. Describe the effect created in each:

(a) (Celtic Manuscript)—*Lindisfarne Gospels: Initial Page* [87]
(b) de Kooning—*Woman I* [15]
(c) Picasso—*Girl Before a Mirror* [color plate 5]
(d) Mondrian—*Composition No. 10, Plus and Minus* [49]

(a) Continuous lines define and contain the spiraling, twisting, flowing form.
(b) Broken lines start and stop with energetic dashes, building a flexible form that has no precise definition.
(c) Continuous lines, some of which return to their starting point, define and enclose the forms.
(d) Broken lines—short horizontals and verticals—almost meet, shaping a maze that encourages the eye to wander within.

Notice the contrast between de Kooning and Picasso. De Kooning's free, slashing brush strokes lack final definition, allowing you to imaginatively link the forms. Picasso's forms are tightly enclosed and contained. The containment of form in (Celtic Manuscript)—*Lindisfarne Gospels: Initial Page* is similar to that of Stella's *Sinjerli Variation IV.* Kandinsky's use of broken line is more open, free, and varied than Mondrian's short horizontals and verticals.

CONTOUR AND EDGE LINE

7. A *contour line* suggests the three-dimensional substance of a form. It is sometimes a continuous line, but it is more often a broken line that moves along a form's outer edge, then leaves the outer containment and turns inside the form, describing the location along which one plane recedes and another advances. If you grasp something with your hand and draw the way the thumb projects and the other fingers curl around and under the object held, you have a contour line.

A contour line is never uniformly mechanical. It may be a wavering line with varying width, or it may seem uniform in width but through the accented, decisive touch of the artist may become darker, particularly where it is explaining the place where a form advances or falls back.

Giving instruction in how to do a contour drawing, Kimon Nicolaides tells the student to:

> Imagine that your pencil is touching the model instead of the paper. Without taking your eyes off the model, wait until you are convinced that the pencil is touching that point on the model upon which your eyes are fastened. Then move your eye slowly along the contour of the model and move your pencil slowly along the paper. . . . This means that you must draw without looking at the paper, continuously looking at the model Exactly coordinate the pencil with the eye. . . . Not all of the contours lie along the outer edge of the figure. . . . draw these inside contours exactly as you draw the outside ones. . . . This exercise should be done slowly, searchingly, sensitively. . . .*

Depending on their relationship with other lines in a work, continuous lines, broken lines, and contour lines may also become edge lines.

*Kimon Nicolaides, *The Natural Way to Draw* (Boston: Houghton Mifflin, 1941), pp. 9–13.

An *edge line* is the termination of a shape, implying a linear boundary where another shape begins. This can be a continuous, broken, or contour line. It can be a sharp definition where dark meets contrasting light or where color meets contrasting color. Or it can be a soft, unclear differentiation of close values or close colors that fuse with one another. It can communicate one plane overlapping another, two planes meeting on the same level, or a plane split in two, revealing a linear section of a plane beneath.

> A *contour line* suggests the three-dimensional substance of a form. An *edge line* delineates where one shape or color ends and another begins.

Examples

Contour line: Let your eye start at the middle thumb joint following along the outside edge to the upper joint along an inward curve as the skin breaks into a fold; then out and up to the round roll of the thumbnail, along the upward curve of the nail line, turning down and back to the flesh of the thumb. Your eye is following the form's contour, with the advancing and receding changes indicating its dimensional character.

Edge line: Let your eye follow the edge line formed between two cupboard doors that close to meet each other or the line formed between two hands in prayerful position.

Exercises

Remember that it is important to do the drawing exercises in order to see how forms can be constructed with different kinds of line.

(a) Follow the directions of Kimon Nicolaides (preceding page) and draw your hand with a *contour line.* Use a graphite pencil, marking pencil, ink and pen, or ink and brush.

(b) Then draw your hand using a contrasting area of color or dark around it to get an *edge line.*

(c) Draw an apple using *contour lines.*

(d) Draw an apple using areas of dark against light to indicate the shape.

Contour Line

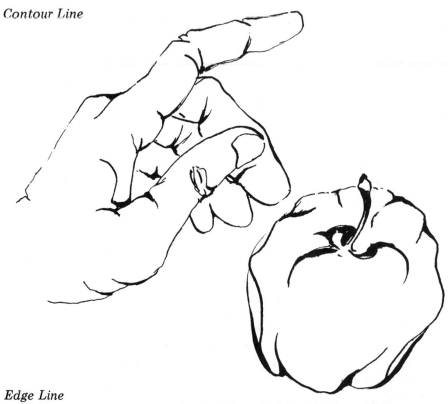

Edge Line

Seeing Contour and Edge Lines

8. *Contour:* Look at Manet's *Olympia* [40]. The starting and stopping line varies in thickness as the brush indicates the body marking the underside of the form to separate the white flesh from the off-white of the luxurious bedding. The line starts again from within the form to distinguish her arm as it joins the body. It breaks and starts inward again to indicate the lower arm following hand and fingers and around the outside of the arm to break at the shoulder. It starts slightly inward and turns farther inward to differentiate shoulder from neck. The line again begins following the subtle diagonal curve of her breast and around to describe the under curve. It continues over the curves of the abdomen and on to begin the hand. With starts and stops, thicker and thinner lines, the fingers are described continuing on to the thigh, getting darker and thicker below the knees where one leg overlaps the other.

 Edge Line: Look at Albers' *Homage to the Square* [1]. The shapes are indicated with lighter or darker areas that spread to a defined edge. In the original each area is also differentiated with a specific and carefully selected color meeting to form edges.

Application

Describe verbally or redraw (using tracing paper over the illustration) the artist's use of line in each of the following:

(a) Limbourg—*Book of Hours: Duc du Berri*—*Month of April* [38]
(b) Braque—*The Musician's Table* [7]
(c) Van Gogh—*The Yellow Chair* [77]

— — — — — — — — — — — — — — — —

(a) The garments of the foreground figures form edge lines that meet the background against which they are placed.
(b) Overlapping papers show as edge lines through light contrasting with dark. Broken lines suggest other objects.
(c) Broken contour lines describe the chair legs and seat, the onions and onion box.

VOLUME LINES

9. Infinite variations of line can be combined to optically communicate solid mass or volume, to give the impression of three dimensions rather than two.

 Contour lines can create the illusion of volume, as seen in our previous discussion. Contour maps rely on this type of line.

 Hatching placed closer or farther apart to form planes can also create volume. Through length of line and change of direction, these surfaces can indicate advancing or receding form.

 Cross-hatching can suggest flat planes or curved surfaces with straight lines intersecting straight lines, or curved against curved, or straight against

curved. The appearance of this linear web is similar to the vertical and horizontal threads of loose gauze as it wraps over and around a three-dimensional shape.

Edge lines that show an object in front of or behind another also create volume or dimension in a work of art.

Curved lines are particularly effective in suggesting volume. When lines curve as a shape curves, the implication is that the line continues on around the unseen far side of the form.

In addition, clear, sharply defined lines usually appear to project, to seem near. Unfocused, blurred, dimly seen lines usually appear to recede, to seem distant.

Line is also used to define space, as you will see in Chapter 5.

> *Volume* may be communicated by contour lines, hatching, cross-hatching, edge lines, and curved lines. Clear, sharp lines usually appear to project. Unfocused, blurred lines usually appear to recede.

Examples

The lines in tree bark take the eye around the cylindrical shape. The lines in a stone suggest visually whether the stone is round or flat. The curved lines of hair indicate the curvature of the body from which it grows. A curled leaf forms space by the curvature of the leaf's spine and ribs.

Exercise

Circle the object that implies volume in each pair:

(a) A human figure or a shadow
(b) A book viewed from the corner or a book viewed from directly above
(c) An airplane seen high in the air or an airplane seen on the ground

— — — — — — — — — — — — — — — —

(a) a human figure; (b) a book viewed from the corner; (c) an airplane seen on the ground

Seeing the Communication of Volume

10. Compare Albrecht Durer's *The Knight, Death, and the Devil* [20] with Bridget Riley's *Current* [67]. Both artists use curved parallel lines to suggest a change of surface. Durer uses clearly seen contour hatchings in the horse's neck and rear leg shank to describe the rippling surface of the horse's body. The curvature created by hatchings and cross-hatchings along the form's edges suggests the solidity of the forms throughout the work. Riley's parallel curved lines are more uniform, appearing to be mechanically drawn. They give the optical illusion of a rippled surface.

Application

Describe how the illusion of solid volume is created in each of the following:

(a) Rembrandt—*The Raising of Lazarus* [65]
(b) Poussin—*Shepherds of Arcadia* [color plate 6]

— — — — — — — — — — — — — — —

(a) The hatching and cross-hatching indicate changes of surface as in the
 foreground where the diagonal hatching indicates a rise in the ground.
 Just above it vertical hatching indicates the edge of the stone tomb slab.
 Dense cross-hatching behind the lighter figure of Christ indicates the
 solid stone of the cavelike setting.
(b) The way the drapery curves fall over the shapes of the four figures helps
 to indicate the solidity of their bodies. (Drapery has traditionally been
 used in painting to suggest volume. Examples of the use of the curved
 line of drapery to indicate volume are found in Grunewald's *The Resur-
 rection* [29] and Giotto's *The Lamentation* [26].)

<div align="center">VISIBLE AND INVISIBLE LINES</div>

11. So far the lines we have been talking about are visible—that is, you can
actually see them. More difficult to discern, but equally important to a work,
are the *invisible lines* within it.

 In Chapter 1 we discussed invisible lines within the field of action—the
invisible horizontals, verticals, and diagonals that form center of every shape.
These invisible lines are *axis lines*, which create an invisible scaffold for the
overall shape of the work and for each shape within it.

 Points of eye appeal also create invisible lines—that is, paths of interest
which the eye follows as it moves from object to object within a work. The
eye is led over the surface of the field of action, with what is important to
the viewer directing the flow of what is seen.

 The pattern of these invisible passage lines can change from one viewing
to another. The action of the eye tends to take in so much simultaneously
that it is difficult to decide a linear sequence in the forms of a pictorial com-
position. It requires looking slowly to decide on what path the forms lead
the eye. Usually, however, we are attracted visually to locations of brightness
of light or hue and to the action of diagonals, curves, and intersecting lines.

 Robert Henri has said, "Look for the way the pictures are laced and
bound together by their lines—how they flow in currents which control your
sight and your interest."*

 Paths of look and gesture are often found within a work of art as well
as between the work of art and the viewer. These invisible lines of connection
and communication may be looks exchanged between you and a figure within
a work or between two figures within the work. They may also result from

—————————

*Robert Henri, *The Art Spirit* (Philadelphia: Lippincott, 1960), p. 185.

directed pointing of hands or feet or the turning of the head or body to lead your eye from one form to another. As noted by Henri, "Your eye follows the spirit of life in the gesture and look."*

> *Invisible lines* include the inner structure of form, points of eye appeal, and paths of look and gesture.

Examples

Inner structure of form: You cannot see the framework of a house once it is completed. You know it is there, but it is not visible.

Points of eye appeal: Our eyes are drawn to bright colors or to points of action.

Paths of look and gesture: When someone points to an object, we usually know exactly where to look. The gaze of two lovers holding hands can link them.

Exercise

For each of the following, describe at least one example of invisible lines similar to those just given:

(a) Inner structure of form
(b) Points of eye appeal
(c) Paths of look
(d) Paths of gesture

— — — — — — — — — — — — — — —

Answers will vary considerably here. You might have mentioned some of the following:

(a) Your own skeleton; the framework of a car; the steel structure of a skyscraper.
(b) A pretty girl; a handsome boy; action; unusual shapes or colors.
(c) A cold stare; a quarterback's rapid scan of his receivers.
(d) Path from one person to others in a "come-here" gesture; a person pointing to herself; a call by a football referee.

Seeing Invisible Lines

12. Look at Leonardo da Vinci's *The Last Supper* [79]. The artist has chosen the moment of reaction to the famous words, "One of you shall betray me." In response, an invisible current of looks and gestures travels like an electric shock from either of the center outstretched hands through the flanking groups of apostles.

**Ibid.*, p. 112.

Application

Examine and identify the invisible lines used by the artists in the following:

(a) Vinci—*The Virgin of the Rocks* [83]
(b) Delacroix—*Liberty Leading the People* [14]

— — — — — — — — — — — — — — — —

As with any work of art, the points of eye interest will vary; they will not be the same for any two people nor the same for you on different viewings. The following are possible patterns:

(a) The angel at right looks out and downward toward us; with her pointing hand, accented by the Virgin's outward blessing gesture, she directs our path of vision to the infant (St. John). The Virgin's head also turns to direct us to the kneeling child in prayerful pose looking to the Christ Child who answers with a hand held upward, the traditional gesture of blessing. This invisible circuit of looks and gestures leads us back to the pointing hand and the outward gaze of the angel directly behind the Christ Child. The Virgin's body, outward held arms and hands, and her downward gaze contain the current of looks and gestures.

(b) One likely pattern starts with the figure of Liberty and the banner she holds aloft. It moves to the young boy beside her with a gun in each hand, to the tophatted gentleman and rifle at her other side, to the accompanying sword-wielding soldier of fortune, to the wounded, kneeling, piratelike figure at her feet, and then to the spread of the battle dead in the foreground over whom the army will stride.

CALLIGRAPHIC LINE

13. *Calligraphy* is the art of beautifully controlled handwriting that conforms to a systematic pattern. *Calligraphic line* gives the effect of alphabetic shapes or the written word. An artist can control the speed, length, width, and direction of lines, thus creating a pattern that is a distinctive, personal kind of writing. The artist's brush strokes can always be considered as a unique form of writing or even as a personal signature.

Alphabetic marks can combine to form actual words as they do in many works of art, or they can be used to *seem* wordlike even though we can't read a dictionary meaning. Like a shorthand notation, marks can be beautiful without conveying a literal meaning. A sensitive viewer "reads" the speed, the vigor or delicacy, the assurance or lack of assurance, the consistency or lack of consistency of patterns and the gesture combined with the energy that made the marks. All of these characterize the touch of the artist, revealing the mood of the moment and becoming part of the message of the work.

> *Calligraphic line* refers to alphabetic shapes or to lines that suggest the written word.

Examples

Fissures in tree bark, ripples in water, weather erosions left in stone—
"... tongues in trees, books in the running brooks, sermons in stone ..."*—
tracks of a bird in sand or snow, cross-sections of wood grain, marks of
skaters on ice, hieroglyphics ...

Exercise

Following is an abbreviated set of letters from the Modified Runic Alphabet
invented by J. R. R. Tolkien for *Lord of the Rings*.†

Try writing your name or a sentence in Modified Runic:

In the space below design a new shape of your own for each letter of the
alphabet:

A	B	C	D	E	F	G	H	I	J	K	L	M

N	O	P	Q	R	S	T	U	V	W	X	Y	Z

Now, write a word, your name, or a sentence in your new forms:

— — — — — — — — — — — — — —

*William Shakespeare, *As You Like It*, Act II, Scene i, lines 16–17.
†Kathryn Blackmun, "The Development of Runic and Fëanorian Alphabets for the Trans-
literation of English," *Tolkien Papers*, Vol. II, No. 1, February 1967, Mankato (Minn.)
State College, p. 82.

You may want to compare your creation with the following sentence written in an alphabet created by George Bernard Shaw:*

1 ℮ ˙ˢⁱᵈᵒᵒ⌐1/ᴐ1, ℮ ⨍/ˢᵧᵣ1ⁱ Jᴐ ⁱ1√ᵃᵈ ᵧᵣᵖᴐᴐ√1ⁱℓ

To the Secretary, the society for italic handwriting

<p align="center">Seeing Calligraphic Line</p>

14. Look carefully at Jackson Pollock's *Autumn Rhythm* [58]. The larger blots of paint have enough body to suggest alphabetic shapes of an angular, printed character. The gray, thick line has both curved and straight connections that suggest a private alphabet. The thin, trailing line curves in the manner of script writing. Each is fused together, forming a total surface difficult for the eye to unravel.

Application

Describe calligraphic line in the following:

(a) Mathieu—*Painting, 1952* [44]
(b) Soulages—*Painting, 1953* [73]

— — — — — — — — — — — — —

(a) There is a strong vertical and horizontal emphasis, yet an electric abandon with which this alphabetic scribbling has been done. The lines form the beginning of a grid structure that snaps and springs with diagonals and sudden, swinging curves.
(b) Verticals and horizontals swing from edge to edge, along with a few diagonals. The whole work suggests a large, single character of some ancient language.

<p align="center">APPLICATION</p>

15. Your trained eye searches much as a track follower or a sleuth, and you then piece together your discoveries into meaning based on your own past experience. Through careful seeing and considering of the motion with which the artist made the lines, you can transcend your own being and tune in on the same frequency as the artist, resonating physically and mentally not only your own personal responses but also to the original experience of the artist while the work was being produced.
 Examine the following works and describe the artist's use of line in each:

(a) Botticelli—*Madonna of the Magnificat* [5]

**The Journal of the Society for Italic Handwriting*, No. 34, Spring 1963, p. 22.

(b) El Greco—*The Resurrection* [21]
(c) Duchamp—*Nude Descending a Staircase* [19]
(d) Soulages—*Painting, 1953* [73]

————————————————————

(a) The eye is led by edges of sheer fabric in the Madonna's headpiece, along the twisting of the scarf that repeats the intertwine of her hair. As the eye moves along the edges of her outer robe, we follow a curvilinear rhythm that is tightened by the water pathway in the background. The rhythm of the graceful hands is like a dance, with gesture answering gesture throughout. The outer angels' heads and hands direct us to the magnificent crown over the Madonna's head. In a current of looks and gestures, the three angels at the left look to one another, to the Madonna, and to the hands holding ink, pen, and book. The Christ Child looks up to his mother, the mother down to her child. The curves of drapery lines seem to come from behind forms to suggest solid volumes. The curved lines throughout have a sinuous relationship to the containing edge of the circular field of action. (Mastery of line is one of the noteworthy accomplishments of Botticelli.)

(b) Strong, straight lines appear in the banner staff, the swords, and the lances. The only other crisp, sharply defined lines are in the edges of the banner held by Christ, the hand that holds it, and the other outstretched hand and arm. Most of the other lines are out-of-focus edges with the play of alternating lights and darks. The ascending Christ looks out to us, establishing a line of vision. The apostles fall back as if from an explosion while they look and reach upward toward him to direct invisible lines toward the miracle of ascension.

(c) Broken straight lines predominate with only a few curves in a large top-to-bottom zigzag locking into the field of action from upper left to lower right. Short, staccato, parallel lines within this large, light shape give the impression of shifting planes. (One attempt to diminish this work described it as "an explosion in a shingle factory.") Although the rounded forms of the human body have been flattened to planes that may appear shinglelike, the work does not express explosion so much as progression from up to down, closely related to the effect of repeated edges in a stroboscopic photograph of action. Through line Duchamp has indicated that the human form is not a static solidity; it shifts with motion.

(d) Straight lines push off the edges of the field of action on all four sides, denying its containing force. The form appears to have been constructed from a few wide brush strokes made with vigor and certainty, with the architectural precision of a calligrapher forming a single letter shape. The upper part appears more flat, the lower part as more dimensional, almost window- or boxlike because of the lower strong diagonal that connects with two verticals of different width.

SEEING THE UNITY

16. This and the remaining chapters of this book will conclude with a section called "Seeing the Unity," which will pull together all the aspects of art discussed so far. This special section will be indicated by the yin-yang symbol you see above, which is the Chinese symbol for unity.

Add what you now know about line to what you have learned in the last chapter about order and balance. Look at Rauschenberg's *Buffalo II* [62] and describe as completely as you can the artist's use of order, balance, and line.

—————————————————

Order: The field of action is a vertically oriented rectangle. There is a rigid understructure of verticals and horizontals, but with the appearance of a random order through the tilting diagonals, out-of-focus edges, and smears and splashes of paint.

Balance: The work is asymmetric, with the longer, less broken, darker panel containing the image of Kennedy pointing and the strongly contrasting air balloon a light against dark background. The light rim holding the faint image of an ancient god on the right side balances the lighter, more broken panels to the left side.

Line: Continuous line outlines the box at lower left. *Broken lines* from it point above and to lower right as well as from the eagle's beak and downward from the cafeteria sign. The printed word *cafeteria* and the familiar, scriptlike *Coca-Cola* are also broken lines. *Edge lines* indicate outside of rectangles. Some are straight, sharp, and defined; others are blurred and out of focus. All are held within the vertical rectangle of the field of action. Forms identifiable through edges are the photographic Kennedy figure and pointing hands, circular shapes, keys, eagle, whirlybird, and the mountain that appears to be sinking in a swirl at upper left. Out-of-focus, less-defined edges occur in the bird, the ship sails, and the Rubens' mirrored reclining nude turned on its side. *Invisible lines* occur in the underlying grid, the hand indicating a hand pointing out to the right, Kennedy who looks to the right of the spectator, the eagle who looks to the right. The keys point down and to the right; the bird's beak points to the downward pointing key; the arrow points diagonally up to the bird. *Volume line* occurs in the curves of collar and cuff in the Kennedy figure, suggesting a solid shape. The curves of the balloon at lower right indicate a round form. The box lines project a transparent draft of a six-sided form.

You should now be able to look at a work of art and describe some of the ways in which the artist has used line. You may want to review the questions appearing at the beginning of this chapter and the material in this chapter before completing the following Self-Test.

SELF-TEST

This Self-Test will help you evaluate how much you have learned so far—how well you can answer the questions raised at the beginning of the chapter. Answer the questions as completely as you can (use a separate sheet of paper) and then check your answers against those that follow.

1. Give at least one example of each of the following lines from Picasso's *Guernica* [50]:

(a)	Straight	(h)	Edge
(b)	Curved	(i)	Contour
(c)	Continuous	(j)	Visible
(d)	Broken	(k)	Invisible
(e)	Horizontal	(l)	Volume
(f)	Diagonal	(m)	Calligraphic
(g)	Vertical		

2. Examine the following works and identify the predominant kind of basic line (straight and/or curved) in each:

 (a) Albers—*Homage to the Square* [1]
 (b) Magritte—*The False Mirror* [39]
 (c) Vasarely—*Vega-Nor* [front cover]

3. Name the predominant line direction and use one word to describe the resulting effect created in:

 (a) Friedrich—*Monk by the Seaside* [17]
 (b) Gericault—*The Raft of the Medusa* [24]
 (c) Monet—*Rouen Cathedral* [color plate 3]

4. Look at Seurat's *A Sunday Afternoon on the Grande Jatte* [color plate 4] and describe the main directionals used and what effect they suggest to you.

5. Determine whether the lines in Warhol's *100 Cans* [86] are predominantly continuous, broken, or both. Describe the effect created.

6. Describe verbally or redraw (using tracing paper over the illustration) the artist's use of edge and contour line in the following:

 (a) Matisse—*Icarus, From Jazz* [47]
 (b) Mantegna—*The Dead Christ* [42]

7. Describe how line is used to create the illusion of solid volume in the following:

 (a) Vasarely—*Vega-Nor* [front cover]
 (b) Durer—*The Knight, Death, and the Devil* [20]

8. Identify five different kinds of invisible lines in the following:

 (a) Poussin—*Shepherds of Arcadia* [color plate 6]
 (b) Rubens—*Rubens and Isabella Brandt* [69]

9. Describe calligraphic line in Klee's *Park Near Lucerne* [35].
10. Look at Picasso's *Girl Before a Mirror* [color plate 5] and describe as completely as you can the artist's use of line.
11. Look at Klee's *Around the Fish* [34] and describe the artist's use of order, balance, and line.

Answers to Self-Test

In parentheses following these answers are given the number of points each question is worth, if you want to total your overall score, and the frame references where the topic is discussed, if you wish to review.

1. Your answers will be different from those that follow, but the *type* of line you have selected should be very similar to these answers.
 (a) Vertical edge of light panel at right of center. (frames 1–2; 1 point)
 (b) Noses and mouths of figure profiles; fingers and toes of figures. (frames 1–2; 1 point)
 (c) Outline around light bulb inside the sun-eye; the filament inside the light bulb. (frames 5–6; 1 point)
 (d) Short vertical dash lines over the horse's body. (frames 5–6; 1 point)
 (e) Ceiling line above the bull's head and behind the sun-eye; top and bottom of the window at the right. (frames 3–4; 1 point)
 (f) Line from gas lamp through the extended arm and down the invisible axis of the running figure to the dead weight of the distended knee. (frames 3–4; 1 point)
 (g) Axis of falling figure at the right. (frames 3–4; 1 point)
 (h) Shape of the bull's head; light against dark contrasts. (frames 7–8; 1 point)
 (i) The barely discernible flower coming from the hand clutching the broken dagger of the fallen warrior. (frames 7–8; 1 point)
 (j) Arrow- or daggerlike tongues of horse, bull, and screaming mother. Any line that is actually seen. (frames 11–12; 1 point)
 (k) Lance thrust into or through the horse's body and out again with arrow point penetrating, suggesting a broken lance; eyes of figures are out of balance and none look at or gesture toward one another. The bull looks out to the viewer. (frames 11–12; 1 point)
 (l) Curve of the horse's open mouth; curve of foreground rear hoof of the horse; diagonal indicating depth to the window at the right. (frames 9–10; 1 point)
 (m) The broken lines over the horse's body giving the effect of newsprint. (frames 13–14; 1 point)
2. (a) Straight (frames 1–2; 1 point)
 (b) Curved (frames 1–2; 1 point)
 (c) Straight and curved (frames 1–2; 1 point)

3. (a) Horizontal—serenity (frames 1–2; 1 point)
 (b) Diagonal—action (frames 3–4; 1 point)
 (c) Vertical—soaring (frames 3–4; 1 point)
4. Verticals in the figures and trees. Horizontal sky/earth division. Diagonals
 in the depth lines dividing earth and water and in the shadows. A serene
 moment in time. (frames 3–4; 3 points)
5. Both continuous and broken. The continuous lines contain form; the
 broken lines give slightly more freedom for the eye to hop. (frames
 5–6; 2 points)
6. (a) The Icarus figure is silhouetted with edge lines as are the star
 shapes, which are accented with a thin, continuous line around
 them. (frames 7–8; 1 point)
 (b) Contour lines used in the fabric reveal the shape of legs and body
 beneath. Edge line is used in the slab and pillow against which the
 figure rests. (frames 7–8; 1 point)
7. (a) Clearly defined curved lines contribute to the effect of projecting
 form. Not only are the most projecting lines given greater clarity,
 but also their curve, in contrast to the less clear vertical/horizontal
 straight lines, gives the appearance of a projecting surface bulge in
 the center. (frames 9–10; 1 point)
 (b) Through a system of hatching and cross-hatching carefully follow-
 ing the basic shapes of forms and accentuating their planes of pro-
 jection and recession, Durer has created the illusion of solid form
 in the figures of the foreground procession, the trees and roots of
 the midground, and the distant mountaintop castle. (frames 9–10;
 1 point)
8. (a) *Axis of picture plane:* The diagonals of the shepherds' staffs point
 to the vertical center of the picture plane. Horizontal center falls
 along a crack in the tombstone just above the inscription. *Axis of
 form:* Axis of standing figure to right falls from behind her ear to
 her wrist to her ankle. *Path of eye interest:* First focused on tomb
 inscription that the shepherds point to, then to the shepherds, to
 the right standing figure, back along the tomb to the trees and
 clouds, and then back to the inscription. *Look lines:* One shepherd
 looks at the tomb inscription; another looks at the right standing
 figure while she looks down at the ground. The leaning shepherd
 also looks down, following the diagonal of the staffs. *Gesture lines:*
 Two shepherds point to the tomb inscription. The shadow of the
 left one is also a pointing shape. The shepherds' staffs point diago-
 nally to the ground. The outside trees behind the tomb are parallel
 with the staffs of the two pointing shepherds. (frames 11–12;
 5 points)
 (b) The invisible inner structure or axis of forms is indicated in the
 following sketch along with the device of pointing figures to lead
 the eye. Use your tracing paper to copy the sketch. Place it over
 the Rubens illustration to see the invisible lines become visible.
 (frames 11–12; 3 points)

9. The branchlike forms are calligraphic, suggesting the hieroglyphs of a foreign language. (frames 13–14; 1 point)

10. Continuous outlines bound the shapes of color in a stained-glass window effect. Some are curved; some are straight; some are thick; some thin. Most are black, but some are blue and/or orange. The background is straight intersecting diagonals that form diamond shapes. (Chapter 2; 10 points)

11. *Order:* Rigid order system of concentric horizontal ovals. Nothing is haphazard or accidental. (Chapter 1; 5 points)

 Balance: Symmetrical with parts distributed carefully on either side of both vertical and horizontal center. (Chapter 1; 5 points)

 Line: The eye moves around the edge line of the platter oval with attention on the broken lines of the fish's scales. The only escape from the containing platter edge is along the diagonal shaft of light to the left. An exclamation point and an arrow tell us we are traveling in the right direction. The eye follows continuous and broken lines in the fish

scales, the shaft of light, the skeleton head, stems, flower centers, branch springs, and cross. Edge lines define an arrow, a flag, glass shapes, a cucumber cross section, a circle, and a crescent. As these objects are threaded by the movement of your eye, you create the strong, invisible path "around the fish." (Chapter 2; 10 points)

Total possible points: 67. Your score: _____ . If you scored at least 53 points, you understood the main points of the chapter. If your score was lower than this, you may want to review the appropriate frames before you go on.

IMAGINATION STRETCHES

— Compare the line of Frank Stella [72], who uses masking tape and ruling tools, with Willem de Kooning [15], who uses a spontaneous, swinging brush stroke. Imagine how the work of each would be changed if the way each uses line were switched.
— Read a map or make a map. This exercise uses lines as symbols to indicate roads, rivers, government boundaries, mountain ranges, and so on.
— Stand in front of an object (or a work of art) and stretch your arm toward it. With index finger pointing, follow the lines that your eye travels along. Feel for a body rhythm in relation to the work's rhythm.
— Observe the lines connecting with a row of telephone poles. Draw lines connecting this pattern. Also observe and draw sidewalk patterns that connect people or the electrical lines that connect us in one way or another.

CHAPTER THREE
Light and Dark

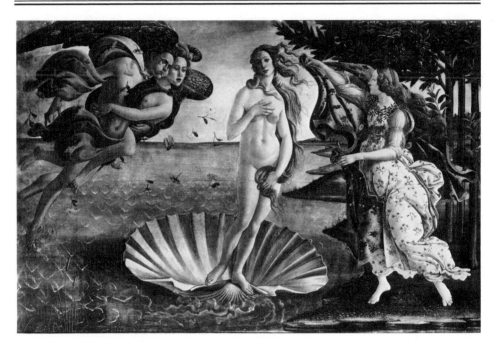

 In a work of art, can you:

- recognize tone, contrast of light and dark, and gradation of light and dark?
- describe the contrast and gradation of light and dark used to create the illusion of solid form?
- describe edge line and flat tone and the effect achieved?
- describe the relationship between light and the disintegration of form?
- recognize the relationship between the distribution of light and dark and the emotional response created?

In this chapter you will learn how to do all of these things. For the exercises in this chapter you will need:

Graphite pencil	A small box or a Ping-Pong ball
Paper punch	Spotlight, flashlight, or candle
Writing paper	Scissors
Ruler	Paper clips

Sandro Botticelli, *The Birth of Venus.* C.1480. Alinari/Editorial Archives.

INTRODUCTION

Our world turns on days and nights. During every rotation, light and dark alternate with gradual transitions of receding or lengthening shadows. Our most basic ideas about light and dark are obtained from day and night.

Color is inextricably a part of light, and yet we are so aware of the importance of tonal differences in light that we accept as "true to life" black-and-white photographs or television images that are truly unrealistic. It is difficult to set aside the demand made by color in relation to light until we realize how much we subconsciously respond to the *tone* of light—its relative lightness or darkness.

It is because of light that we can see, and it is through degrees of tone in light that we can make reference to space and the things outside our bodies—their distance, depth, relative size, shape, and movement. Our intuitive response to the tone of light allows the artist to sketch a black-and-white image that appears "realistic."

Factors Influencing Light and Dark

Each source of light—sun or star, reflected light of moon or metal—provides a different kind and degree of light, as does each source of artificial light—candle, gas, neon, sulfur, or electric. Examples of specific light sources as integral parts of a work of art can be seen in the following:

Candle: de la Tour's *The Adoration of the Shepherds* [color plate 1]
Lantern: Goya's *Execution of the Madrileños* [27]
Oil lamp: Tintoretto's *The Last Supper* [74]
Chariot of the sun: Limbourg's *Book of Hours: Duc du Berri—Month of April* [38]
Stars and crescent moon: Van Gogh's *The Starry Night* [color plate 8]
Kerosene lamp, flames, sun-eye, light bulb: Picasso's *Guernica* [50]

An ancient example of real light used by the artist is the control of fireworks, an art form in its own right. In the gallery of today the artist can install plug-in light paintings dependent on electricity for visual effects often similar to fireworks. In contemporary work, electric light as an art material has become an experimental medium, serving to break down the traditional division between painting and sculpture.

In addition to the source of light, the time of day, the season, and the particular setting influence the light we observe. The angle at which the light moves and how it is absorbed, deflected, or reflected from its path by objects receiving it also determine the quality of light.

Natural light is never uniform; it changes constantly with such infinite variables that no second is exactly the same, and observed forms change under its shifting spell. The artist cultivates powers of observation, examining closely and continuously the display of light to transfer some of its effects onto a surface for you to contemplate. The artist is aware of and makes use of our basic conscious and subconscious feelings about light and dark.

We usually respond to dark as opaque, as solid density or matter; dark is most likely to represent the unknown and fearful. We usually respond to light as empty space, transparent atmosphere, what we can see; light is most likely to represent the known and comfortable. These feelings are sometimes reversed, however, when bright light is blinding and frightening or when dim light is softly comforting. The artist knows that control of light and dark is an important way to communicate meaning.

TONE: CONTRAST AND GRADATION

1. When we look at the use of light and dark in a work of art, we describe it in terms of *tone*. Tone refers to relative lightness and darkness. Every mark on a field of action becomes a vibration between light and dark. A mark made with any kind of material or tool can become a means for building or constructing a light/dark system. Tone can be controlled to suggest the illusion of solid form, a flat plane, the disintegration of form, the sensation of light itself, or the illusion of space.

Tone may be handled in two general ways: through *contrast* of light and dark or through *gradation* of light and dark.

Contrast

You are in an electrically lit room at night; you switch off the light and find yourself in the dark. To find the way from where you are, you switch the light on again. This experience involves contrast of light and dark.

The strongest contrast an artist can make is the sharp, sudden difference between the extremes of white and black with no transition between them. The many ways of producing contrast all depend on making the most of the distinct difference between light and dark.

The result of sharp contrast is the tension of firmness, the fixedness of clear definition, the sureness of clear focus.

Gradation

The infinite transitions of light at dawn and dusk—from the light of day to the dark of night—provide the experience for the graduated steps from light to dark used by the artist. These steps consist of gradual intervals of gray between white and black and are referred to as a *tonal scale* or *value ladder*. The words *tone* and *value* may be used interchangeably when discussing light and dark.

The most convincing gradation the artist can make is a tonal scale with intervals of tone that are imperceptible because each step is blended into the next. Gradations of greatest effectiveness are made by the physical mixing of paint and depend on very gradual transitions from light to dark.

The result of gradation is haziness, softness, and indeterminacy with indistinct, out-of-focus forms. Even when images are indicated with a hard edge, the edge appears diffused if tones close in step are placed side by side. When two close tones are blended together through the sliding of paint, the surface seems even softer.

> *Tone* refers to relative lightness or darkness. *Contrast,* distinct differences between light and dark, results in firmness, fixedness, clear definition, and clear focus. *Gradation,* gradual steps of change from light to dark, results in haziness, softness, indeterminacy, and out-of-focus forms.

Examples

Contrast: Lighting a candle or flashlight in the dark
Alternating stripes on a zebra (black/white)
The low note at one end of a sound scale alternating with the high note at the other end of the sound scale (low/high)
A leap from top to bottom of steps or ladder (up/down)
Skip from the number 1 to the number 100 (few/many)
Other contrasts include hot/cold, filled/empty, young/old, soft/hard, wet/dry

Gradation: The gradual lengthening and darkening of shadows at evening (especially dramatic against the white of snow)
Each note of a piano keyboard sounded consecutively
Each step of a ladder or stairway taken in sequence
Counting one by one from the number 1 to the number 100

Exercises

(a) In the sketch that follows, fill in every other rectangle with as strong a dark as you can get with a graphite pencil to produce an example of contrast.

(b) In the sketch that follows, use a graphite pencil to produce an example of gradation. Leave the first square paper white; fill the second with a soft touch to get a light gray; fill the third square with a heavier touch to get a dark gray; fill the fourth square with a still heavier touch for the darkest tone you can get.

(a)

(b)

Seeing Light/Dark Contrast, Gradation, and the Resulting Effect

2. Picasso's *Guernica* [50] shows tone contrast. The artist has used areas of strong lights and darks placed side by side throughout the work. Gray areas are so sharply differentiated that they give added contrast rather than serving as soft transitions between the opposition of light and dark. The result is a flashing on/off effect similar to a strobe light. Do you see any forms with a softened look?

Contrast also results when black marks are spaced far apart, letting in the light of the paper. When the marks are placed closer together, they shut out more of the light, producing darker areas. When they touch, the result is a black mass. For instance:

This method does not rely on the physical mixture of paint, but on a visual mixture in which bits of black and white are mixed by the eye of the viewer to get intermediate tones. Edvard Munch's *The Cry* [52] is handled this way. Dense, black side boards of the bridge railing contrast with the light, white top boards. Delicate black lines in the lake make it slightly darker than the white railing; the sky is darker than the lake, and the earth forms are still darker as lines of black get heavier and closer together. Flat, black shapes suggest two men crossing the bridge. The contrasting light of face beside dark of the flamelike body in the foreground figure emphasizes a tragic sense of drama.

Now look at Botticelli's *The Birth of Venus* [4] to see how different the effect is when gradation is used. Subtle transitions of middle tones

between the lights and darks in the body forms give the appearance of soft, rounded flesh. The gradations from light to dark in the fabrics and landscape forms are also softly blended and easy on the eye, giving the effect of serenity and harmony. On what form is the light/dark contrast strongest?

Application

Most people can easily separate four tones: white, light gray, dark gray, and black. Some artists such as Kasimir Malevich have shown us a wide tonal range of difference within what we call white. Other artists such as Ad Reinhardt have shown us a wide tonal range within what we call black. Art students learn to control as many as thirty tonal steps from the whitest white to the blackest black.

In the preceding exercise you determined four tones. Now let's determine six. Copy the following sketch onto another piece of paper. Using graphite pencil and the same touch technique as in the preceding exercise, create a tonal scale having six steps. (Another way to make this value ladder is to find as many tones as you can in the advertising pages of discarded magazines. Clip and paste these tones into the spaces in a sequence of gradual steps from white to black.) The light end of the scale is described as *high key*, the dark end as *low key*.

Gradation

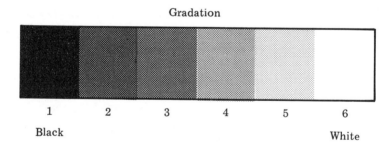

1 2 3 4 5 6

Black White

Use a paper punch to make an opening in the center of each step of your tonal scale. It should look like this:

Gradation with center circles of white

1 2 3 4 5 6

Black White

Use the tonal scale as a finder to determine the value range in Magritte's *The False Mirror* [39] and Raphael's *Madonna del Cardellino* [61]. Observe each work carefully and place an equivalent tone number in the place you

feel it belongs on the following line drafts of these two works. Before doing so, explain briefly what *tone* refers to:

Magritte—*The False Mirror* [39]

Raphael—*Madonna del Cardellino* [61]

_ _ _ _ _ _ _ _ _ _ _ _ _ _ _ _ _

Tone refers to the relative lightness and darkness. It occurs as contrast or gradation. (Your tone scale may differ slightly from ours.)

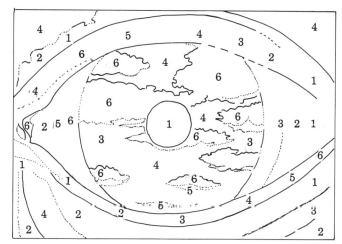

Magritte—*The False Mirror* [39]

Raphael—
Madonna del Cardellino
[61]

THE ILLUSION OF SOLID FORM (THREE-DIMENSIONAL)

3. To create the illusion of solid form, some artists emphatically prefer contrast, others gradation. Whichever tonal preference is displayed, the artist's intent in creating the illusion of solid form is to give the viewer a sense of form that has an inner core, to convey the idea of mass and weight, and to communicate that which is concrete and tangible.

When high *contrast* is used to suggest solid form, it appears as if a strong light is directed from one angle with an illuminated side of the form reflecting lightness, revealing a clearly defined shape while the other side absorbs light, losing its shape in deep shadow. With such a sudden contrast, the form appears to have planar sides that turn away from each other in opposite directions, resulting in *advancing* shape at the edge of greatest contrast. Form indicated in this manner gives the feel of very firm substance, of solid images that seem carved from block material. The emotional response tends to be related to the theatrically decisive and the impact of the unexpected.

When *gradation* is used to suggest solid form, the source of light is not apparent; it is spread more evenly, as in the light of a cloudy day. Forms reflect such light more evenly with transitions of tonal gradation between the lights and the shadow areas. The artist records this with tones of light sliding into darker values much as a sculptor models in clay.

This system of soft blending of light is often called *modeling* or *shading*. The effect is the illusion of a form that bends gently forward to project and curves softly inward to indicate a *receding* shape. Form has a diffused, out-of-focus appearance, allowing the spectator's imaginative associations. The emotional response tends to be related to easy, graceful, expected transitions. Leonardo da Vinci felt that every face acquires a charm in a moderate light where there is little difference between its lights and shadows.*

Often both contrast and gradation are used within the same work. Ingres has used both with masterful control in his portrait of *Madame Moitessier* [31]. The light of her face and arms contrasts sharply with the dark of the background and the deeper dark of her gown. To create the appearance of solid form, Ingres has modeled with subtle gradations of light in the light areas and with subtle gradations of dark in the dark areas.

> The illusion of solid form can be created either through contrast or gradation. Forms constructed with high contrasting light and dark will appear firmly defined, with the impact of surprise or shock. Those constructed with light/dark gradation will appear softly diffused, with the easy grace of expected transition.

*Edward MacCurdy, *Notebooks of Leonardo da Vinci* (New York: Reynal and Hitchcock, 1939), p. 900.

Examples

If the forms of a paper cup and a Ping-Pong ball are drawn with an outline around them or filled in solid, they appear *flat:*

But there is the illusion of *solids* even through the most simple modeling with lines or dots:

Exercise

Try making two models with which you can see and record the difference in contrast of tone and gradation of tone. First, cut two white paper strips 1″ X 6½″. Fold the first strip, in proportions like those shown below, to form a rectangle. Clip the ends together to secure them. Then direct a strong light toward one side to observe contrast of tone over the surfaces.

Fold		Fold	Fold		Fold

Bend the second strip so opposite ends meet; clip the ends together to hold them secure. Then place the model in an even light to observe gradation of tone over the surfaces.

Using a pencil and your tone scale from page 54, place the tones to indicate the effect of contrast and gradation on these drawings of the models:

Then, applying what you have learned, try to make these flat surfaces appear convincingly solid.

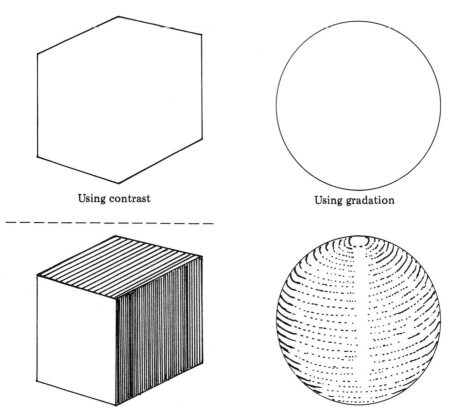

Using contrast Using gradation

Seeing Use of Light and Dark to Create the Illusion of Solid Form

4. Caravaggio used *high contrast* to indicate form in *The Conversion of St. Paul* [9]. He painted figures in a saturated dark background as if theatrically spotlighted from the upper right. The focus of the bright light throws into sharp relief the front of the attendant's face, the front flank of the horse, and the face, chest, and arms of the stricken St. Paul. Observe on each of these figures the location where the light turns to dark with firmly defined contrast. The suddenness of the light change gives emphasis to the abruptness of this high point of drama in the life of St. Paul. (You might like to find the Bible story [Acts 9:1–9] to recall how the ability to see, both physically and mentally, is involved in this episode.)

Leonardo da Vinci used *gradation* of tone in his portrait of *Mona Lisa* [82]. We cannot see a source for the even light that seems brightest from the left. The face and hands are modeled with subtle gradations to suggest the softness of flesh and the roundness of body forms. The famous smile is gently blended; the mouth is a hazy, almost cloudlike shape. The out-of-focus gradation around the eyes results in undefined forms that permit the changing

expression experienced by many people as they look at this painting. The more angular folds in her sleeves are in sharper contrast, relating to the lights and the forms of the mysterious background. The quiet, close harmony of the tonal gradations in the figure tied with the diffused atmospheric background give a dreamlike quality to the dignity and composure of *La Gioconda*, another name by which you might like to know the *Mona Lisa*.

Application

Describe the artist's use of light and dark to create solid form in the following:

(a) Vermeer—*The Artist in His Studio* [81]
(b) Giorgione—*The Concert* [25]

— — — — — — — — — — — — — — — —

(a) The setting is an indoor room with strong light channeled from a left opening, probably a window. Bright light floods the space between the back wall and a dark left foreground drapery swag and chair which catch only glints of the sharp light. The front of the model's face and body is brilliantly lit with the side toward the artist strongly dark. She holds an angular book that has a strongly defined light side and dark page edges. The wall area to the left of the map is a wedge of bright background. The tabletop reflects the bright light, yet its legs facing the spectator are dark. A downward light accents the strong contrast of the alternating light/dark floor pattern and gives shape to the artist's legs. The strong contrasts add to the intensity of concentration in the absorbed effort of the artist as an image emerges on his canvas.

(b) The setting is a meadow. The even light suggests lengthening shadows. Gradations of light to dark in the bodies of the nude women gently blend, so the forms are rounding like the delicate softness of real flesh. They are lighter in tone and larger in scale than the much darker, smaller figures of the clothed men. The languorous tenderness in the soft transitions of the rolling hills and foliage and in the quiet moment between notes of music or conversation give the effect of an idyllic summer dream.

SILHOUETTE FORM—EDGE LINE
AND FLAT TONE (TWO-DIMENSIONAL)

5. You experience one of the most mysterious effects of light when the source of a strong light is directly behind the form you are viewing. In this relationship, called *backlighting*, the form (no matter how massive) tends to appear flat with an even, overall tone of contrasting dark against light.

Rendering form as *flat* is one way of distinguishing shape. The most extreme application of this system is a contained shape with a contrasting background. An even tonality with no shading over the confined area gives the impression of a flat figure placed against a contrasting background. As a

technique in drawing and painting, this method is sometimes referred to as *edge line and flat tone*. The figure can be dark and the background light, or the figure can be light with the background dark. Either way, the figure looks flat. This can be observed in Velasquez's *The Ladies-in-Waiting* [80]. The figure in the doorway of the back wall is backlighted, giving the form a two-dimensional appearance.

The shadow of a form is another natural phenomenon related to back-lighting. If you place a piece of white paper so that the shadow of an object falls on the paper, you will find that what appears to be a sharp shadow edge is actually, at close range, a soft, unfocused edge with a halolike quality. You will also discover that in natural light the shape you want to record is constantly changing. If you capture the shadow area on the paper with a solid, even dark color, you will have a true *silhouette* drawing.

The flat shadow shape or silhouette is one way we see form; the edge-line, flat-tone technique is the artist's way of recording this kind of seeing. Sometimes artists paint the three-dimensional figure as flat and backlighted; sometimes they paint just the cast shadow as flat (Poussin's *Shepherds of Arcadia* [color plate 6]); and sometimes they paint both the forms that are normally three-dimensional and the cast shadows as flat (Gauguin's *The Market* [23]).

Edge line and flat tone rivets the eye of the viewer specifically into forms by holding shapes defined and captive within edges. It effectively expresses the importance of forms as distinct from background and from other forms.

The story is told that late in his life a French artist, Puvis de Chavannes, "amused himself as he had done as a child, by skipping stones in the Saône. [He felt that] mural painting is analogous to this pastime; in order not to break through the surface, one must not place weight on it."* With his flat areas suggesting people, trees, and hills through highly simplified shapes, along with limited modeling, Puvis provided inspiration for the flattened work of such artists as Gauguin and Matisse.

> Forms that are backlighted or presented in edge line and flat tone appear flat and two-dimensional.

Examples

Thousands of cubic feet of conical mountain can appear as flat as a paper cutout when the sun is directly behind them.

The human form, when it is backlighted (as when silhouettes of people are backlit by a campfire), appears as dimensionless as the ace of spades.

Art in America, May/June 1977, p. 95.

Exercise

Which of the following would appear as flat and two-dimensional?

_____ (a) Cement highway

_____ (b) Empty movie screen

_____ (c) Surface of a tennis court

_____ (d) Page of an open book

_____ (e) Drawn window shade

_____ (f) Surface of a canvas stretched over a frame

_____ (g) Road map

_____ (h) Mountain with the sun rising behind it

_____ (i) Mountain with the sun above it at noon

_____ (j) Human being on stage with a spotlight directly from behind

_____ (k) Human being on stage with a spotlight from side front

_____ (l) Tree shadow shapes against a cement walk

— — — — — — — — — — — — — — —

(a), (b), (c), (d), (e), (f), (g), (h), (j), and (l); only (i) and (k) are solid and three-dimensional

Seeing Edge Line and Flat Tone

6. Look again at Vermeer's *The Artist in His Studio* [81], particularly at the backlighted figure of the artist, to see how the modeling becomes minimal with darks against darks and the form flattens.

Edouard Manet is considered a bridge between traditional and modern art. One way in which Manet breaks with the past is in his abandonment of traditional modeling and the elimination of tone transitions between light and dark. The modeling in his work is so minimal with lights against lights and darks against darks that the forms lose three-dimensional solidity, becoming more two-dimensional. Look at Manet's *Olympia* [40]. Before *Olympia* the female nude form had been painted with soft gradations and subtle modeling. Manet's flattened forms and strong lights and darks suggest the unexpected boldness of a prostitute rather than the expected shy grace of a goddess, which may partly explain the shock experienced when this work was first seen. You might locate a reproduction of Manet's *Breakfast on the Grass* to compare with Giorgione's *The Concert* [25].

In *Eridan II* [78] Vasarely uses flat tone and high contrast of silhouette black against white and the reversal of white against black with the intent of creating an eye-wrenching optical experience.

Application

Discuss the artist's use of edge line and flat tone in the following:

(a) Matisse—*Icarus, From Jazz* [47]
(b) Nolde—*The Prophet* [53]
(c) (Egyptian)—*Fowling Scene, XII Dynasty* [88]
(d) Picasso—*The Three Dancers* [56]

—————————————————

(a) The helpless figure of Icarus is a flat cutout area of dark suspended against a lighter backdrop with no ground line. The star shapes are of middle tone with a thin outline halo. The open shape in the body is as light as the backdrop, suggesting an opening or a transparency through the body.
(b) This work shows strong contrast, with the areas defined by edges of light meeting edges of dark. The dark shapes suggest long, caplike hair; heavy, overhanging eyebrows; a defined nose bridge and nostrils; a mustache and beard. Beard and hair are slightly lightened in value by letting in thin streaks of light that merge with the dark background except for the upper-left corner of alternating darks and lights. The light reveals forehead, cheeks, lower lip, and chin, suggesting a face that emerges from the dark as if through a focused spotlight.
(c) The head, hips, and legs of the figures are seen as flat and in silhouette side view, with full-front upper torso. There are unmodulated areas filled with solid color. A suggestion of projection is made in the lines of the loin-cloth apparel. (Do you see the relationship of these figures with the unmodulated figures in Gauguin's *The Market* [23]?)
(d) The forms are filled with flat color and either outline or edge line with no tonal modeling. The shapes lock together and shake free of one another in a lively pattern, with some shapes appearing to be substance and some to be shadow.

DIRECT LIGHT AND DISINTEGRATION OF FORM

7. The relationship of light and form that reveals the solidity of form is the most common way of seeing objects. However, another relationship of light and form that is often experienced, yet infrequently acknowledged, is the *disintegration* of form through light.

An intense and direct light on a three-dimensional shape will so brighten the area that few or no surfaces of dark appear to recede. The result is a surface with no value differences and the appearance of a flat, two-dimensional plane or a dazzling breakup of the surface. In this way direct sunlight can seem to dissolve the solidity of objects, depriving them of both substance and weight.

> Intense light directed against an object can give the appearance of *disintegration of form*. The result is a flat, two-dimensional plane or a dazzling breakup of the surface.

Examples

In direct bright sunlight, a cement walk, tennis court, or highway can appear dazzling.

Direct sunlight on water reflects light to make solids appear to lose dimension.

Direct sunlight on a white sand beach tends to flatten solid projecting forms.

Exercises

(a) Drive west on a highway with the setting sun at eye level. Observe the way solid forms flatten or disintegrate.

(b) Use a bright theater spotlight to shine close in and directly onto a solid shape to see how it can be made to dissolve, flatten, or disintegrate. This can also happen in a darkened room using a flashlight or candle for backlighting or dissolve lighting of an object.

Seeing Disintegration of Form by Direct Light

8. Look at Monet's *Rouen Cathedral* [color plate 3]. The solidity of stone has been dematerialized, and the three-dimensional character becomes atmospheric and weightless through the way in which the cathedral is conditioned by light falling on it. Any defining boundary through line or strong value contrast has been eliminated; shape has been distinguished mainly through hue contrast.

Application

Look at the following works and discuss the artist's use of direct light to disintegrate form:

(a) Renoir—*Le Moulin de la Galette* [64]
(b) Turner—*Steamer in a Snow Storm* [75]
(c) Monet—*The Poplars* [51]

— — — — — — — — — — — — —

(a) Bright sunlight filters through the leaves overhead and projects patterns of light on the ground, on the clothing of the figures, faces, and hair. Patterns of light on the tabletop break up the continuity of a tone gradation that would suggest solidity. The result is a shifting surface appearance of a coming and going, a dissolving and reappearing of solid shapes.

(b) The intense flash of storm light reveals an atmospheric space of shifting water and surges of spray with only the linear mast of the ship to suggest any stable, earthly solid around which the storm swirls.

(c) Sunlight has dematerialized not only the tensile trees and their cloud-like foliage heads, but also the earth that merges with water and the reflections of trees. No edges or sharp lines give definition. The values are very close throughout, neither strong light nor contrasting dark, but delicate values on the light end of the tonal scale.

DISTRIBUTION OF LIGHT AND DARK AND EMOTIONAL RESPONSE

9. Artists can choose to emphasize dark, producing a low-key work; they can choose to emphasize light, producing a high-key work; or they can equally balance the light and dark areas. The distribution (the amount and location) of tonality over the field of action is a major factor in the emotional effect of the work. Amount, location, and degree of tone are important means for setting the *mood* of whatever state of mind the artist wants to communicate to the viewer.

Remembering that dark can sometimes be comforting and light can sometimes be fearful, we can say in general that a low-key, predominantly dark work tends to give us serious feelings that can be solemn, somber, or even grim, whereas a high-key, predominantly light work tends to give us a sense of uplift and feelings of contentment or even joy.

> Distribution (amount and location) as well as degree of light and dark affect mood and the emotional response to a work of art. A low-key, dark work generally results in a solemn, somber, even grim response; a high-key, light work generally results in a happy, contented, joyful response.

Examples

A bright, sunny day usually makes us feel cheerful.
A wedding dress is traditionally white.
A dark, cloudy day tends to make us feel depression and gloom.
Black is a traditional color for mourning.

Exercise

What is your emotional response to the following:

(a) Entering a darkened theater to find a seat
(b) Sitting around a campfire with friends
(c) Watching an on-off strobe light
(d) Dining by candlelight

(e) Driving west when the sun is shining at eye level
(f) Watching Christmas tree lights

— — — — — — — — — — — — — — —

(Your answers may vary from the suggested answers given below.)

(a) Bewilderment
(b) Comfort, warmth, security
(c) Excitement, verging on hysteria
(d) Romantic elegance
(e) Annoyance and a feeling of inadequacy
(e) Fun

Seeing Distribution and Degree of Light and Dark
and the Emotional Effect Created

10. In Pol de Limbourg's *Book of Hours: Duc du Berri—Month of April*
[38], the major tonal cast over the surface is light and bright. The sun shines
high above, and only a few darks appear in the apparel of the foreground fig-
ures. We respond as if to a warm spring day.

In contrast, Goya's *Execution of the Madrileños* [27] depicts night,
with the only light source the box lantern on the ground ahead of the row of
soldiers. The shirt of the victim catches the brightest light, with diagonals of
the focused light getting darker at the edges. Falling away from the triangular
shapes of light, darks take over the space and add to the horror of the bru-
tality.

Application

Examine the following works and discuss the artist's use of light and dark
and the effect created:

(a) Monet—*The Poplars* [51]
(b) Rembrandt—*Philosopher in Meditation* [63]

— — — — — — — — — — — — — — —

(a) There are no areas of deep dark. The impression of a shimmering, bright,
 summer day results from emphasis on an overall high-key light applied
 in small bits of paint that give a dazzling reflective surface. The suggested
 glow of warmth and summer remind us of boating, suntans, and good
 times.
(b) The sunset light gradually fuses into softened darks in subtle transitions
 on the wall opposite the window. We are aware that light is fading and
 dark is filling the room. The window, the book, and the forehead of the
 philosopher are the brightest lights. Varying degrees of shadow absorb
 most of the space, bringing serious thoughts about the passage of time.

APPLICATION

11. Examine the following works and discuss the artist's use of light and dark:

(a) Indiana—*The American Dream, I* [28]
(b) Gericault—*The Raft of the Medusa* [24]

——————————————————

(a) The values are defined by flat tone and held within sharp edges. High, bright lights and low, dense darks alternate with a range of intermediate tones in the geometric shapes that consist mainly of circles, stars, squares, numbers, and letters. Where the forms are related through strong contrast of light and dark, there is a projecting and vibrating effect; where they are close in tone, there is a receding and vanishing effect. With no softened transitions to slide along, the eye jumps from vanishing to vibrating forms. The result is a pulsating effect that is still more forcefully charged with energy in the original by the color choices.
(b) The upper sky area and center foreground are mainly light in tone. The center action area is an interlocking balance of lights and darks with the heaviest darks center left. The water, boards of the raft, and figure forms are painted with strong light/dark contrasts to convincingly provide the illusion of three-dimensional solid forms and depth into space.

 SEEING THE UNITY

12. Add light and dark to what you already know about the artist's use of order, balance, and line. Look at Botticelli's *The Birth of Venus* [4] and discuss his use of order, balance, line, and light and dark.

——————————————————

Order: The painting leans toward a rigid order system within a horizontal rectangle.

Balance: The balance is symmetric. The graceful centered Venus is placed on a shell altar with attendants on either side as if pivoting diagonally from her head. Repeated curved shapes within these larger forms are stabilized by the horizontal marking the separation of earth and sky, the vertical tree trunks at right, and the cattails at left foreground.

Line: Undulating curved lines are varied in the waves, the shell, the billowing fabric, the lyric rippling of hair strands, and the body shapes. Botticelli paints trailing lines (hair waves), edges (bodies, shell), and contour lines (bodies).

Light and Dark: The foreground is dark with water horizontals shifting to a lighter tone, then to a still lighter tone, and finally to a parallel thin band of dark where water meets the light sky area. Against this the figure forms, especially the bodies, are modeled with subtle gradations of light to dark

that suggest three-dimensional forms with an almost sculptural feeling for solidity. The trees and foliage are darker and closer to flat tone. The most contrasting use of light and dark is the alternation in the shell's pattern.

You should now be able to look at a work of art and discuss the artist's use of light and dark. You may want to review the questions at the beginning of this chapter and the material in this chapter before completing the following Self-Test.

SELF-TEST

This Self-Test will help you evaluate how much you have learned so far—how well you can answer the questions raised at the beginning of this chapter. Answer the questions as completely as you can (use a separate sheet of paper) and then check your answers against those that follow.

1. In a work of art, what does the word *tone* refer to?
2. Identify which of the following works emphasize *contrast* of tone and which emphasize *gradation* of tone:

 (a) Matisse—*Icarus, From Jazz* [47]
 (b) Vinci—*Mona Lisa* [82]
 (c) Picasso—*Guernica* [50]
 (d) Vasarely—*Eridan II* [78]
 (e) Giorgione—*The Concert* [25]
 (f) Botticelli—*The Birth of Venus* [4]

3. Compare the use of tone to create the illusion of solid form in Delacroix's *Liberty Leading the People* [14] with Raphael's *Madonna del Cardellino* [61].
4. Discuss the artist's use of edge line and flat tone in Toulouse-Lautrec's *La Divan Japonais* [76].
5. How does Manet's use of tone contribute to the disintegration of form in *At the Races* [41]?
6. Compare your feeling response to the amount and degree of light and dark in Monet's *Rouen Cathedral* [color plate 3] and Goya's *Execution of the Madrileños* [27].
7. Examine Magritte's *The False Mirror* [39], and describe the artist's use of light and dark.
8. Examine de Kooning's *Woman, I* [15], and describe the artist's use of order, balance, line, and tone (light/dark).

Answers to Self-Test

In parentheses following these answers are given the number of points each question is worth, if you want to total your overall score, and the frame references where the topic is discussed, if you wish to review.

1. Tone has to do with relative lightness and darkness—the contrast or gradation, the degree and amount. (frames 1–2; 3 points)

2. (a) contrast; (b) gradation; (c) contrast; (d) contrast; (e) gradation; (f) gradation. (frames 1–2; 6 points)

3. In Delacroix's *Liberty Leading the People* [14], a cloud wedge of even white in the upper portion contrasts with a dark lower earth wedge. Figures are set off against these background tones. A shaft of strong light from the upper left casts a high, bright light on the left sides of the figures; their right sides are dark. Through contrast of tone the figures appear convincingly solid with dramatic definition. In Raphael's *Madonna del Cardellino* [61], the overall light is even and generally diffused. A light rectangle with light gradations suggests distance and sky above a dark rectangle with dark gradations that suggest curving earth forms. Within the light shapes of the figure forms, subtle gradations of light suggest the softness and roundness of flesh. In the darkest area, the Madonna's gown, darker gradations give the illusion of fabric over her solid form. (frames 3–4; 6 points)

4. The foreground lady's elegant hat and gown and the man's tophat are dark silhouette shapes. His jacket is a lighter tone; musicians and musical instruments are a middle tone. Contrasting light distinguishes the chair, the lady's face, her hands, and the man's face, lace shirt, and cane. The stage proscenium and actress to the left repeat foreground lights while darks at the background left repeat foreground darks. Forms are carried out in edge line and flat tone with no modeling. Contour lines provide clues to shape details. (frames 5–6; 3 points)

5. A brilliant, overhead sunlight is suggested. The horses, riders, and spectators become blurs and blotches of shape with no defined line or edge to suggest more than an impression of forms. Irregular spots of dark distinguish the shapes and greater weight of the horses, while middle tones suggest riders, earth, and foliage. Dabs of light give the sparkle of dazzling sunlight. (frames 7–8; 3 points)

6. Monet's *Rouen Cathedral* [color plate 3] tends to give a positive, uplifted feeling, a satisfied contentment. It is predominantly light and bright in tone. Goya's *Execution of the Madrileños* [27] tends to give a feeling related to introspection, depression, or fear. It is a night scene, predominantly dark in tone. (frames 9–10; 4 points)

7. Light appears to come from behind the eye form as well as from in front of it. The black disk seems backlighted and flattened against sky and clouds, suggesting an eye pupil or a cosmic eclipse. From left to right the upper lid is a gradation of light to dark, the lower lid a gradation of dark to light. The right and left inner membranes are contrasting gradations. Outer corners are gradations except for the flat-tone, upper-right corner, which carries Magritte's signature. The unexpected use of contrast and gradation contributes to the double reading of iris-sky and pupil-eclipse. (Chapter 3; 10 points)

8. *Order:* Leans more toward random order within a vertical rectangle. (Chapter 1; 5 points)

Balance: Asymmetric. (Chapter 1; 5 points

Line: A head, arms, body, and legs are made with broken lines that swing and slash in a rapid staccato of intense energy, starting and trailing away, leaving vague connections. Figurative forms to right and left of the central image seem to hold the woman captive in spite of the freedom of the open lines. (Chapter 2; 10 points)

Tone: Tones build with the layering of linear brush strokes. Lights race through the work along the edgings of dark broken lines. The strongest darks are the flat tone of the eyes, giving the effect of a manic stare. Dark brush strokes at the side of the head, neck, and shoulders result in a locked-in tension. Other dark strokes call attention to the huge breasts, the centaurlike leg, and the bodyless figure at the right. (Chapter 3; 10 points)

Total possible points: 65. Your score: _____ . If you scored at least 52 points, you understood the main points of the chapter. If your score was lower than this, you may want to review the appropriate frames before you go on.

IMAGINATION STRETCHES

— Watch the sky change from light to dark and shift in pattern at sunset. Or get up early enough to watch the rays of light stretch over the horizon as the sun rises.
— Go from a brilliantly lit room to a very dark room. Notice and record how long it takes your eyes to adjust. (Check eye-adjustment time in looking at an Ad Reinhardt painting.)
— Ask a friend to pose outdoors on a bright, sunny day. Draw just the silhouette of the model as the shadow is cast on the ground.
— Project black-and-white slides on a screen. Observe the light and dark areas. Or project them on paper and shade in lights and darks yourself. This can be done with mater paintings.

CHAPTER FOUR
Color

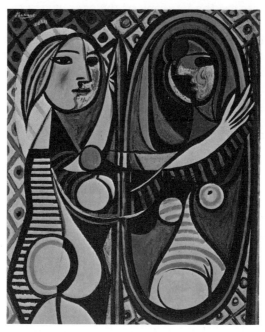

▶ In a work of art, can you:

- identify the hues the artist has selected?
- describe the tone (light and dark)?
- describe the color intensity?
- recognize choices of "warm" or "cool" colors?
- describe the amount and force of color?
- recognize the interaction of complementary colors?
- describe the artist's attempt to simulate additive colors?

These aspects of color are the topic of this chapter. Materials needed for exercises include:

Colored paper from magazines, seed catalogs, package wrapping, or
 other sources
Scissors and paste
Paint or ink: blue, red, green, white
Brush

Pablo Picasso, *Girl Before a Mirror*. 1932. Collection, the Museum of Modern Art, New York, New York. Gift of Mrs. Simon Guggenheim.

Although you are learning how to view works of art rather than how to create them, an understanding of how the artist controls color is basic to an understanding of what is created.

INTRODUCTION

Most students begin their looking with the expectation that the artist will match the local color of objects in the real world. It is important to become aware at once that local color matching—that is, making the colors in a work of art look like real life—is seldom the first concern to the artist and is often of no interest whatever. This chapter touches on some of the color problems that take precedence in the artist's involvement.

In Chapter 3 we noted that our power to see depends on light and that light and color are inextricably related. In reality, it is impossible to separate color from tone. The difficulty of sorting what we see becomes apparent with the realization that we almost never perceive what color actually is physically because of the transience of light along with other variables. For this reason, color will always be the most elusive of the artist's means.

Josef Albers has told us that "colors present themselves in a continuous flux, constantly related to changing neighbors and changing conditions."* He tells his students, "On the blackboard and in our notebooks we write: Color is the most relative medium in art."† For the artist it is this very aliveness and changing character that represents the great challenge of color.

Illumination and Color

Many variables influence seeing and naming colors. One variable is the illumination under which colors are seen. The same colors appear different in daylight, in tungsten light, and in fluorescent light. Tungsten light is somewhat closer to daylight, but marked color changes are perceived when the same colors are viewed under fluorescent light. Whether colors are viewed indoors or outdoors also influences the color perceived.

Many researchers and writers have contributed to our knowledge and understanding of color. Eugene Chevreul's book, *Principles of Harmony and Contrast of Colors and Their Application to the Arts* (1889), was one of the first about color contrasts. Among many other color theorists whose writings are available to the student are Johann von Goethe, Hermann von Helmholtz, Wilhelm Ostwald, and A. H. Munsell. Only recently have the records and color discoveries of the influential artist-teachers Vassily Kandinsky, Paul Klee, Johannes Itten, and Josef Albers become generally obtainable, providing a wealth of information.

*Josef Albers, *Interaction of Color* (New Haven, Conn.: Yale Univ. Press, 1971), p. 5.
†*Ibid.*, p. 8.

Since much of our response to color depends on psychic experience along with physical sensation, we cannot apply color principles with scientific precision when we look at works of art. Impression, memories, associations, knowledge, experience, and training as well as traditional beliefs influence the effect of a particular color on a viewer.

One place to begin a study of color is with the search for those distinguishing differences which the student can sort out and describe. The information presented here is based primarily on the ideas of Johannes Itten and Josef Albers.*

Basically, color has three dimensions: *hue, tone,* and *intensity.*

CONTRAST OF HUE

1. *Hue* refers to color name—for example, red or blue. When a ray of light is refracted by a prism, it is broken into the spectrum colors, and we see hues that have the following generally agreed-upon names: red, orange, yellow, green, blue, and violet.

For most of us, preschool word learning, both spoken and written, included the association of color names with color experiences. We all probably heard something like: "*Color* the apple *red.*" In spite of this, if ten people were asked to present a sample of the hue red, the result would be ten variations of red—with no two alike. There are many different systems of measure, but there is no conclusive agreement on what is "true" red or the reddest red. The same is true of any other hue.

Finding a distinct difference in hue is somewhat easier, however. The *greatest contrast* in hue can be seen in *red, yellow,* and *blue.* These are sometimes called the *primary colors.* They are strong, decisive, and clearly different from one another. The contrast among them is diminished when any one of them moves away from its most definite state toward either of the other hues.

The *next most contrasting* hues are *orange,* produced by mixing red and yellow pigment; *green,* produced by mixing blue and yellow pigment; and *violet,* theoretically produced by mixing red and blue pigment (actually difficult to produce this way). These hues, sometimes referred to as *secondary colors,* are less decisively contrasting, and it is more difficult to agree on their definitions.

Hues still *weaker* in contrast are *red-orange, yellow-orange, yellow-green, blue-green, blue-violet,* and *red-violet.* These hues, sometimes called *tertiary colors,* are still more difficult to differentiate and are least strongly contrasting.

*Johannes Itten, *The Art of Color* (New York: Reinhold, 1967); Josef Albers, *Interaction of Color* (New Haven, Conn.: Yale Univ. Press, 1971).

> Red, yellow, and blue are the most distinctly contrasting hues. Green, orange, and violet are less distinct in hue contrast. Red-orange, yellow-orange, yellow-green, blue-green, blue-violet, and red-violet are still less distinct in hue contrast.

(*Note:* Names for the spectrum colors are generally agreed upon, but specific colors given these names may vary.)

Examples

Red—ripe tomato, cranberry, catsup, blood
Yellow—ripe banana, ripe lemon, egg yolk, lemon pie filling
Blue—midday sky on a sunny day, Cookie Monster
Green—grass and leaves of trees in midsummer, Jolly Green Giant
Orange—the fruit, ripe tangerine, ladybug beetle, carrot
Violet—the flower, eggplant, purple cabbage

Exercise

Use magazine advertisements or colored paper to find what you consider to be:

(a) Red—the reddest red
(b) Yellow—the yellowest yellow
(c) Blue—the bluest blue
(d) Violet—a distinct violet that does not lean to blue or red
(e) Green—a distinct green that does not lean to blue or yellow
(f) Orange—a distinct orange that does not lean to yellow or red

Paste your color samples onto a card and use it as a hue chart to guide you in deciding hue in works of art.

Red		Yellow		Blue		Violet		Green		Orange

Seeing Hues in a Work of Art

2. Look at Mondrian's *Broadway Boogie Woogie* [back cover]. The hues are clearly red, yellow, blue, and white. Small squares consistent in size follow in sequence in a horizontal/vertical pattern with space intervals of each hue contributing to a rhythmic repeat plan. Accents of each color, like sound accents, are provided with larger rectangles. The interspaces are white. Let your eye move over the surface, picking up the rhythm of the red areas, space intervals, and size changes. Do this with yellow, then blue, then white.

Application

Factually identifying the hues within a specific painting can be a starting point for seeing what happens between colors. Look at Seurat's *A Sunday Afternoon on the Grande Jatte* [color plate 4]. Find the location of each of the most contrasting hues (red, blue, yellow) and each of the next most contrasting hues (green, orange, violet). Write your answers on your own paper.

— — — — — — — — — — — — — — —

It does not seem so on first looking, but this is basically a red, yellow, and blue painting. Seurat has used little points of paint side by side and in overlapping layers to build the hue structure. Areas that appear red are constructed of predominantly red points of paint with highlights of yellow to appear more orange and shadows of blue to appear more violet. Areas that appear violet are predominantly points of blue paint with carefully located red points so they mix in the viewing eye to appear violet. Areas that appear green are a mix of yellow and blue points of paint. Shapes that appear most sunlit are predominantly yellow, and shadowed shapes are predominantly blue.

CONTRAST OF TONE (LIGHT AND DARK)

3. Every hue has a *tone*—a value sequence that ranges from white to black in gradual steps. A light, white-tinged hue is called a *tint;* a dark, black-stained hue is called a *shade.* For example, pink is a tint (a light tone) of red; burgundy is a shade (a dark tone) of red. It is the nature of yellow to be inherently the lightest and the most light-giving of all the hues, whereas violet is inherently the darkest hue. Light tones are referred to as *high key;* dark tones are referred to as *low key.*

Tone also involves weight. Light values are, in general, light in weight; dark values are, in general, heavier in weight. In a painting the artist coordinates hues, controlling the intervals and amounts of hues that are light in value along with the intervals and amounts of hues that are dark in value in order to maintain balanced weighting of tones as well as hues.

Through the control of light and dark (tone), artists have great power in modifying the two dimensions of a flat surface. They can make the surface and shapes on it remain flat, or they can make the surface appear spatial and the shapes on it seem to project or recede, giving the illusion of three-dimensional form.

Some words often used to describe colors light in tone, or light value intervals, are *pale, pastel, light, tint, weak, white-stained.* Words describing colors dark in tone are *muted, dusky, dark, shaded, black-stained.*

Training the eye to see tone scales in visual art has parallels with training the ear to hear sound tone scales in music.

> Every hue has a tone sequence from its lightest tints to its darkest shades. Through light/dark contrast, color can be controlled to exaggerate form toward three-dimensional effect or to suppress form toward a flattened effect.

Examples

When your hair becomes bleached by summer sun or peroxide, it becomes lighter in value than before. When the bleach grows out, the hair becomes darker in value.

When you roast a marshmallow, it changes in value from white to a very light brown to a darker value of brown. If you are not careful at this point, it will turn black—a still darker value.

Exercise

Indicate the contrasting tones associated with each of the following:

(a) Coffee stain on a white shirt
(b) New blue denim patch on faded denim jeans
(c) Tree shadow on a yellow house
(d) Teeth brushed with "Sparkle-brite" showing through lips with red lipstick

— — — — — — — — — — — — — — — —

(a) Stain is darker in value than white fabric
(b) Patch is darker in value than the jeans
(c) Shadow area is darker in value than the yellow wall
(d) Teeth are lighter in value than lips

You may find it helpful to make a tonal scale of at least one hue. Using blue-colored ink or paint, place the undiluted blue in the center frame. Going to the right of center, add a little water or white paint to dilute the blue for each step of the frame, leaving white in the last frame. Going to the left, add a very little black for each step until you reach black for the last frame. You may even succeed in extending this value scale further than the steps in following the sketch. It is possible to make such a tonal scale for each hue.

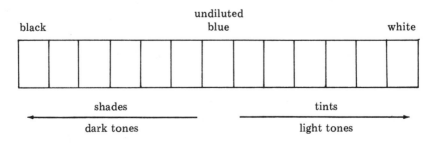

Seeing Contrast of Tone in a Work of Art

4. Look at Poussin's *Shepherds of Arcadia* [color plate 6]. The main hues are the three most contrasting—red, yellow, blue—brightest in the apparel of the three nearest figures. The farthest figure, leaning against the tombstone, wears a light value of red (pink) robe, and skin tones of the two left figures are a still lighter reddish color. The two figures to the right have whiter skin tones with their robes darker except for the very light yellow toga. The sky is a lighter value of blue than the peoples' robes, and the blue of the mountains becomes dark in value. The earth shadows are a very dark blue. The tombstone is a muted warm brown (very dulled red) with a play of value range from light to dark shadow areas. Light tones of dulled yellow, yellow-green, and green in the foreground earth shift to darks in the background. The foliage of the nearest trees is dark green, and that of the distant trees is a lighter yellow-green. The lightest tone in the work is in the soft-edge, off-white clouds.

Tone and hue are used effectively to model and to give the illusion of three-dimensional form.

Application

Look at Van Eyck's *Jean Arnolfini and His Wife* [color plate 7] to determine: hue contrast, tone range and contrast, and whether tone control expresses three-dimensional form or flat, two-dimensional form.

————————————————————

The most clearly identifiable hues are red, green, blue, white, and yellow. The lightest areas are the white headdress and gown trim of the wife, the flesh tones of hands and faces, the empty space of the window and lights that fall through it onto objects that suggest reflections, the metallic chandelier, the mirror, clogs, bed, and floor—all comparatively small areas. The largest areas are darker in tone, with Arnolfini's hat and undergarment the darkest. In general, lights and darks are juxtaposed to form definite sharp-edge contrasts, and within forms the gradations of tone express three-dimensional form and space.

CONTRAST OF INTENSITY

5. *Saturation* and *chroma* are words used interchangeably with *intensity*. Intensity refers to the degree of brightness or dullness of a hue. The brightest hue at full intensity (full chroma or full saturation) comes with no mixing from the tube or jar of pigment. (Sometimes adding a small amount of white will heighten brilliance, but too much white will weaken the brilliance.) Contrast of intensity is contrast between pure, radiant, bright hues and the same hues when dulled or muted. A hue can be progressively dulled or muted by gradually mixing its corresponding complement—red with green, blue with

orange, yellow with violet. With a carefully balanced mixing of two complementary colors, gray results.

Hues can also be dulled as well as darkened with gray or black. By adding white the artist can produce light tones of dulled hues.

Within a composition, an artist is using contrast of intensity when tones of pure red are combined with muted or dulled red, or when pure blue is related to a muted blue, or when pure, brilliant yellow is related to a dulled yellow. In order to control the totality of color, an understanding of intensity is necessary.

It is more difficult to agree on a differentiation between bright/dull of a hue (saturation) than to find the difference between light/dark of a hue (value). This requires continued study and work with color. For the beginning student, however, an awareness of this difference is important in seeing the refinements of color. Training the eye to intensity of color has parallels with training the ear to pitch of sound.

Every hue has an intensity scale running from dull light to bright to dull dark.

Examples

From the brightest red, the scale can go to a light dull red (grayed pinks) by mixing with small amounts of green and white. Or it can go in the opposite direction to a dark dull red (grayed maroon) by mixing with larger amounts of green. Theoretically, it can go on to a neutral gray with no hint of red or green.

A man's suit might be a muted, dark blue, and he might select an intensely bright blue necktie.

A room might be decorated with muted earth tones and only a few accents of red, orange, or yellow at full intensity.

Male birds generally have brighter feathers (tending to be lighter in value); female birds generally have duller plumage (tending to be darker in value).

Exercise

You may find it useful to make a saturation scale using the same hue as your value scale on page 77. Start with the hue as bright as possible, placing it in the center square. Blue will be dulled by orange. Or, if you would like to use red, place the brightest red in the center frame, then add a slight amount of green, placing it in the first step from center to the left. To this same mixture add a little white and place it in the first step to the right of center. Next add a little more green to red for the second step left from center. Add white to this for the second step right from center. For the third step left, add more green for a dark dull red, and for the third step right, add white to this mixture for a light dull red.

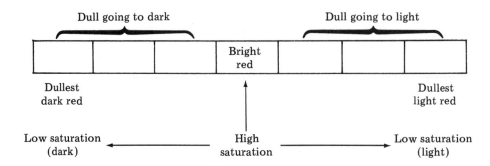

Underline the terms in the following list that you might use to describe highly saturated colors (high saturation is used in relation to bright hue; low saturation is used in relation to dull hue):

Bright	Vivid	Tawny	Intense
Dull	Darkened	Brilliant	Radiant
Swarthy	Gloomy	Strong	Murky
Low key	Pure	Obscure	Deadened

— — — — — — — — — — — — — —

You should have underlined: bright, vivid, pure, brilliant, strong, intense, and radiant.

Seeing the Contrast of Intensity in a Work of Art

6. Look at Georges de la Tour's *The Adoration of the Shepherds* [color plate 1]. This is an example of a painting that is predominantly one hue— red. Most of the work is dark in value, with only the figure of the Christ Child and the forms immediately around him light in value. The largest area of greatest saturation is the figure at the left. A few flashes of this degree of brightness also occur at the right near the candle source of light. The child is lightest in values of red and pinkish, as in the candle flame. The rest of the work consists of muted or dulled reds and browns suggesting shadow. The darkest area is the center figure farthest back and the foreground right corner with the hand of the right figure backlighted by the contrasting light of the candle flame, the small lightest area in the work.

Application

Look at Vasarely's *Vega-Nor* [front cover] and describe the intensity used.

— — — — — — — — — — — — — —

Vasarely has juxtaposed bright yellows and reds set against bright blues and greens, making a tremendous visual demand with high-intensity hues in the center of the composition. The outer edge of the circle appears to recede, and the color contributes to this illusion through the gradual muting of all the hues in all directions. The outer corners are dulled hues, but light in tone.

CONTRAST OF WARM AND COOL

7. Although experiments have been conducted to "prove" color temperature, this remains a subjective consideration, primarily related to our feeling responses to color. Generally, the colors described as *warm* are in the yellow, yellow-orange, orange, red-orange, red, red-violet range of the spectrum and are associated with the sun and flame. The colors described as *cool* are in the green, blue-green, blue, blue-violet, violet range and are associated with water, sky, and trees.

The warmest color is red-orange, which leans on either side of itself toward another warm color, either red or orange. The coolest color is blue-green, which leans on either side of itself toward another cool color, blue or green. Each of the other hues has a brief but exciting warm/cool gradation sequence. Cool blues lean to green, and warm blues lean to violet; cool reds lean to violet, and warm reds lean to orange; cool yellows lean to green, and warm yellows lean to red.

The so-called "neutral" colors—grays, whites, and blacks—almost always lean to either warm or cool. Among the demanding visual refinements of color are warm whites in relation to cool whites, warm blacks in relation to cool blacks, and warm grays in relation to cool grays. It is very difficult to locate a totally neutral gray, white, or black.

The three most contrasting colors (red, yellow, and blue), when added to one another, can produce a dull brown-yellow, a red-brown, or a cool blue-brown, depending on the relative amount used of each hue.

Outdoors we can see decisively that distant forms appear as a hazy blue or lavender. From this observation, we assume warm/cool contrast to also suggest near/far—with warm colors appearing to advance and cool colors appearing to recede.

Warm colors (in general, yellow, yellow-orange, orange, red-orange, red, red-violet) appear to advance; *cool* colors (in general, green, blue-green, blue, blue-violet, violet) appear to recede; white, gray, brown, and black lean toward warm or cool.

Examples

According to the "color" of the day, the sky can be seen as gray, many variations of blue, or filled with white, pink, or yellow clouds. The sun may be seen as white, red, yellow, orange, or yellow-orange. Water may be seen as blue, green, olive, brown, or reddish. And nearby trees may be seen as green, yellow-green, light-green, dark-green, blue-green, blue-violet, brownish, or reddish. Varying degrees of warm/cool will be associated with the color you see. For example, in the fall of the year after their leaves have turned, trees will usually appear "warmer" than the same trees in the spring or summer. Mountains from far away seem a cool blue or violet. Distance along the horizon seems a cool blue-green.

Exercise

Identify the following colors as primarily warm (W) or cool (C):

(a) Turquoise (a stone)
(b) Ruby (a stone)
(c) Emerald (a stone)
(d) Maroon
(e) Gold (metal)
(f) Ultramarine (related to water)
(g) Scarlet
(h) Amber (a stone)

(i) Burgundy (wine)
(j) Maize (corn)
(k) Chartreuse (liqueur)
(l) Moss (growing form)
(m) Coral (sea animal)
(n) Mulberry (fruit)
(o) Ivory (variation of bone)
(p) Cream (dairy food)

_ _ _ _ _ _ _ _ _ _ _ _ _ _

(a)	C	(e)	W	(i)	W	(m)	W
(b)	W	(f)	C	(j)	W	(n)	W
(c)	C	(g)	W	(k)	C	(o)	W
(d)	W	(h)	W	(l)	C	(p)	W

Seeing the Warm and Cool Colors in a Work of Art

8. Look at Van Gogh's *The Starry Night* [color plate 8]. The earth is mainly cool colors: blues and some touches of greens with the cypress tree mainly a dark green. The bigness of the sky is predominantly cool: blue with streaks of green but with some warm yellows. The warm hues are the yellows streaked through the sky, particularly along the horizon, and the concentration of warm white and yellow in the stars and especially in the bright yellow-orange crescent moon. Warm touches of yellow suggest lights in the buildings, and some of the houses have warm outlines of red. The cypress tree is outlined in dark, warm brown lines.

Application

Observe Poussin's *Shepherds of Arcadia* [color plate 6] and describe the use of warm/cool contrasts.

_ _ _ _ _ _ _ _ _ _ _ _ _ _

Cool hues occur in the blue of the sky and mountains and the greens of trees and earth, the blue of the kneeling shepherd's toga and the shirt of the shepherdess. Warm hues occur in the red of the pointing shepherd's toga and the pink toga of the shepherd farthest from us as well as in the pink headdress of the shepherdess. Warmth also occurs in the yellows of the distant trees, the foreground earth colors, the warm brown of the tombstone, and the warm whites of the clouds.

CONTRAST OF AMOUNT AND FORCE

9. A hue may predominate in a work of art because there is a large amount of it, because it is repeated often, or because of the attraction of its brilliance. It takes less of some hues and more of others to attract your eye. Goethe evolved the following numerical system* to indicate the force (the natural value at full saturation) of each hue:

9	8	7	6	5	4
Yellow	Orange	Red	Green	Blue	Violet

Notice that yellow, the lightest in value, has the strongest force and that violet, the darkest in value, has the weakest force. It takes a considerably greater area of violet to balance a much smaller area of yellow.

Other hues in the work may shift toward or away from the predominating hue, either blending or contrasting with it. Regardless of how other colors are treated, if a predominating hue exists, it will make itself felt; it will predominate through area (amount) or brilliance (force). In some paintings hues are so balanced or interspersed that it is difficult to see one hue definitely predominating.

> Hues may predominate through amount or force. The inherent force of each hue, going from strongest to weakest, is: yellow, orange, red, green, blue, violet (Goethe).

Example

In a summer landscape on a sunny day, the predominating hues are blue and green. Highly saturated, warm hues are limited and become accent contrasts. You realize this with the breathtaking brilliance of a cardinal flying through green trees or the flashing of the colors of wild flowers by the roadside.

Exercises

Using your own paper, complete each of the following:

(a) Have you ever thought that when we eat, we literally eat color? When we eat carrots, we eat orange; when we eat lettuce, we eat green. Plan a meal that is *un*appetizing in color.
(b) Imagine that you are going shopping for clothes. How will you best plan color choices?
(c) Imagine that you have the chance to redecorate a room in your home. How will you go about planning the color?
(d) Select one color reproduction. Examine the color balance by finding blocks or shapes of color in the approximate percentages of those in the

*Johannes Itten, *The Art of Color* (New York: Reinhold, 1967), p. 104.

print. Cut matching color into shapes to paste into proper placement, or mark color name into place for each area.

— — — — — — — — — — — — — — — —

Possible answers:

(a) You might have suggested an "all white" meal such as mashed potatoes with cream gravy, chopped egg whites, white bread, flounder or torsk, white corn, angel food cake, to be served on white plates set on a white tablecloth with white napkins. We crave color contrast in food just as much as we do flavor and texture. Amount and force of hue in food color is critical in relation to appetite appeal. (Just for fun, you might try a potluck meal where everyone brings food that has been modified to an unexpected color.)

(b) Examine fashion magazines to see how often a gown or suit is all one muted or quiet color with a very small amount of a bright hue in an accessory.

(c) Examine color solutions in interior-decorating magazines to see how much and how many times a single less visually demanding hue is used in large amounts with balancing accent notes of small amounts of bright color.

(d)
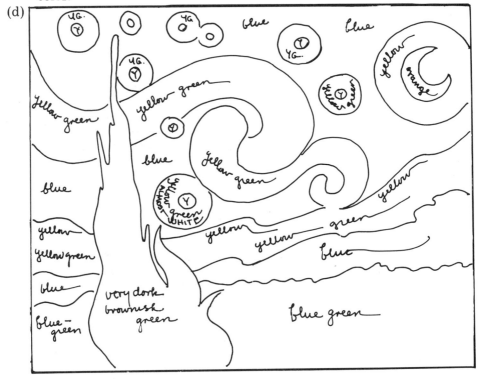

Seeing Contrast in Amount and Force of Hues

10. Look carefully at Matisse's *The Red Studio* [color plate 2]. The greatest amount of any one hue is the slightly dulled red of walls and floor, which makes the entire surface come forward. The thin yellow outlines of furniture, though less in amount, burn forcefully into the red with a lighter value. Small amounts of bright color and white in the studio paintings and furnishings (pink, blue, orange, green, violet) provide a jewellike effect. The tones of the foreground dark vase and yellow stem relate to the dark, horizontal, decorative band with its yellow line pattern above the chest of drawers.

Application

Look at Van Gogh's *The Starry Night* [color plate 8] for contrast of amount and force. Consider whether one hue predominates, whether small areas of bright occur in large areas of dark, which areas are brightest and darkest and the amount of each, and how the artist has balanced the hues through amount and force.

— — — — — — — — — — — — — — —

Blue predominates. Small areas of yellow and yellow-green, and smaller areas of red and white occur in the larger areas of dark. The brightest color is the crescent moon. Because of tone contrast, the most dazzling is the white and yellow star along the horizon. The streak of yellow-green along the horizon, bits of yellow in the house windows, a few lines of red in the rooftops, and the dull red-brown of the cypress tree provide additional notes of warm color.

CONTRAST OF COMPLEMENTS
AND SIMULTANEOUS CONTRAST

11. When the color spectrum is bent to form a wheel, colors that are side by side or neighboring are very similar and low in contrast. These closely related colors are called *analogous colors.* Those across from one another on the color wheel are in contrast and are called *complements*—for example, yellow/violet, blue/orange, red/green. (Color wheel on following page.)
 In a pair of complements, each of the three most contrasting colors is present: yellow-violet is yellow + red + blue; blue-orange is blue + red + yellow; red-green is red + blue + yellow. Complements in a sense "complete" each other. When admixed (mixed together), they mute each other, finally arriving theoretically at neutral gray where neither predominates.
 These complementary pairs are distinctive: yellow-violet is the extreme light/dark contrast; red-orange/blue-green is the extreme warm/cool contrast; red and green have the same brilliance at full intensity.
 When complements at full intensity are placed side by side, they have a vibrating effect because the two hues make an equal demand on the eye. The viewer cannot ignore either one. The eye jumps back and forth from one to the other.

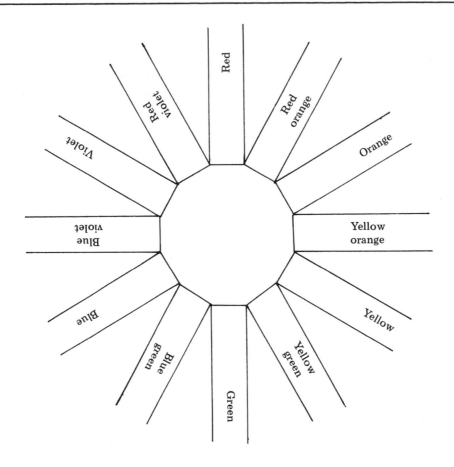

Simultaneous Contrast

Simultaneous contrast involving complements is the most dramatic of all color experiments: "Simultaneous contrast results from the fact that for any given color, the eye simultaneously requires the complementary color, and generates it spontaneously if it is not already present."* The effect of simultaneous contrast can be observed occurring dramatically in the *after-image* that results when one looks at a circle of red and then looks at a white surface—a greenish circle is seen on the white.

The principle of simultaneous contrast states that whenever colored surfaces are juxtaposed, each is altered as if it were mixed to a certain extent with the complementary hue of the other. It is particularly evident when a bright area of high intensity is juxtaposed with a medium gray or a weak tint of light tone and low intensity. The lighter, weaker area will take on the appearance of the complement of the bright hue.

The effect of simultaneous contrast occurs not only between a gray or

*Johannes Itten, *The Art of Color* (New York: Reinhold, 1967), p. 87.

weaker color and a strong, saturated color, but also between two hues that are *not* complements: "Each of the two will tend to shift the other toward its own complement and generally both will lose some of their intrinsic character and become tinged with new effects."*

Applied in painting, low-intensity areas can be raised in intensity by juxtaposing the complement, and high-intensity areas can become subdued by juxtaposing a dull, similar color or a light/dark contrast.

> *Analogous* colors are those that are side by side on a color wheel. *Complements* are opposite each other: yellow/violet, blue/orange, red/green. When two colored surfaces are juxtaposed, each is altered by the other (simultaneous contrast).

Example

Color contrasts in a garden can be planned for vibrating complementary contrast: violet petunias clustered next to yellow marigolds, blue delphiniums planted next to orange zinnias or nasturtiums, or red flowers with contrasting green leaves.

Here is a simple experiment in experiencing simultaneous contrast: Draw two circles the same size, one red, the other white, and place a small black dot in the center of each. Place each circle against a black ground. Then look fixedly at the red circle for a count of sixty. Quickly shift your eyes to the white circle, and you will discover that it is . . . greenish.

Exercises

(a) Name the complements for each of the following:

Red
Orange
Yellow

(b) Name the analogous colors for each of the following:

Green
Blue
Violet

(c) Make a surface of circles side by side and color them bright yellow. If you stare at them intensely, and then look onto a white surface, what will you see?

— — — — — — — — — — — — — — —

(a) Green, blue, violet
(b) Blue and yellow, green and violet, blue and red
(c) A field of violet diamonds (after-image)

Ibid.

Seeing Contrast of Complements and Simultaneous Contrast

12. Look at Jan Van Eyck's *Jean Arnolfini and His Wife* [color plate 7]. Vibrating contrast is seen in the rich green of Arnolfini's wife's gown with the equally rich red of the bed and its canopy to the right as well as the red pillow, fabric, and shoes at left directly under the clasped hands. The jewel-like pattern of the rug border leads the eye downward, balances the texture of the shirred green dress panel, and completes the effect of the figure against a red background. The back wall, left wall, floor, and ceiling are all browns and variants of muted red, giving visual relief from the contrasting brights of red and green. Arnolfini's rich outer garment is also a dulled red-brown. His hat, sleeves, and stockings are a dark blue-black contrast. The greater amount of dark and muted color on the left balances the weight of the bright and vibrating colors on the right.

Application

Observe the contrast of complements in Matisse's *The Red Studio* [color plate 2]. Ask yourself:

— What are the complementary hues?
— Are they light or dark in tone?
— Are they bright and vibrating with equal intensities, or are the intensities contrasting?

— — — — — — — — — — — — — — — —

Red occurs in the wall and floor. The complement of the red walls and floor can be seen in the dark green of the table vase and the bright, the intense green of the plant leaves coming from it, the light green in the panel at left, and the touches of green in the wall panels at right. Violet occurs in the panel at an angle on the floor and in the foreground plate and tools. Its complement, yellow, outlines the furniture. Light orange touches occur on the frames, and light blue touches occur in the flowers and panel details. Intense pink, violet, light orange, and blue occur in the panels.

CONTRAST OF ADDITIVE AND SUBTRACTIVE COLORS

13. Additive colors differ from subtractive colors both in medium and mixture. *Additive colors* are produced by mixing *light, subtractive colors* by mixing *paint*.

Additive mixing can be experienced with three or more flashlights with a different-colored film over the lens of each. Mixing is done by projecting the color from each flashlight so that each colored ray of light overlaps the others. When one colored ray is projected on top of another, the areas of overlap become *lighter* than either of the isolated projected colors. The basic additive colors are magenta (a red violet), green (blue and yellow), and cyan (a blue blue-green). When these projected colors are added to one another through overlapping, the result is white light.

Additive colors and knowledge of their interaction is especially impor-
tant in theater, television, and the relatively new area of electric art.

Subtractive mixing can be experienced when paint, dyes, or transparent
materials such as tissue paper or sheer fabric are combined. Such combina-
tions or mixtures of pigment will never result in white. In fact, they will
always be darker than the lightest of any of the component colors. This is the
opposite of additive mixing, where the mixed color is always lighter than the
lightest of the overlapping colors. The basic hues for subtractive mixing are
red, yellow, and blue.

The Impressionist artists painted with small bits of color intermingled,
resulting in an *optical mix*. Instead of mixing the paint on a palette, they
placed spots of carefully selected color in juxtaposition, so the colors placed
side by side would mix in the eye. The result was an optical mix that at-
tempted to achieve the effect of a mixture of light rays from different
sources—in other words, to achieve the effect of the additive principle.
Essentially, these artists were painting how the eye sees light. This technique,
called *partitive* or *divisionist*, is related to the technique and effect of mosaic.

> *Additive* mixtures of projected colored *light* increase in light
> toward white. Basic hues are magenta, green, and cyan. *Subtrac-
> tive* mixtures of reflected color from *pigment* reduce light and
> get darker toward gray approaching black. Basic mixing hues are
> red, yellow, and blue.

Examples

Additive color:	Seeing a rainbow
	Working with color film and theater lights
Subtractive color:	Mixing red and yellow dye
	Painting with oil paint

Exercise

Indicate which is involved in each of the following—additive or subtractive
color:

(a) Using wax crayons
(b) Seeing colors of a sunset
(c) Looking at a light ray through a prism
(d) Mixing house paint

_ _ _ _ _ _ _ _ _ _ _ _ _ _ _

(a) Subtractive
(b) Additive
(c) Additive
(d) Subtractive

Seeing Simulation of the Additive Principle in a Work of Art

14. Look at Monet's *Rouen Cathedral* [color plate 3]. The artist has recorded the appearance of colored light as it dazzles the eye through reflection rather than the substance of the stone cathedral. The dabbing of paint with the interspersing of warm and cool colors with large areas of very light tone creates the effect of the additive principle.

Application

Look at Seurat's *A Sunday Afternoon on the Grande Jatte* [color plate 4] and observe particularly the artist's attempt to simulate the additive principle. Ask yourself:

— What are the basic hues?
— Are there contrasts of warm/cool? Of amount? Of complements?
— How is the use of color related to the additive principle?

— — — — — — — — — — — — — — — — —

Seurat's basic hues are red, yellow, and blue. Intermixed points of yellow and blue paint give the appearance of a yellow-green to green midground that is light in tone as it appears to recede in sunshine. In the foreground shadow, the ground is green to blue-green and darker. The tree foliage is yellow-green to green; the water is light blue to dark blue. With the clothing warm tones are placed against the lighter background and cool colors against the shadowed foreground. Strokes of "solar orange" are overpainted through all the surfaces, giving the sense of sunlight. Green is the most predominating color with accents of red. Complements are used in the halos around the figures to set them apart from the background. The red-orange shirt of the man in the left foreground is edged with intense blue. Where the dark blue bodice of the foreground lady meets the jacket of her escort, there is a halo of orange, and where the chin of her light orange face meets the jacket, there is a halo of blue. The paint is applied in small points of paint color juxtaposed to mix in the eye, a specific technique called *pointillism*, developed by Seurat. (Optical mix as used by Seurat was based on the idea that the brilliance of nature's light resulted from the additive mixture of colored light. Seurat felt that he was simulating the vibrating effect of outdoor light by recording his observation of the additive principle.)

APPLICATION

15. This chapter has focused on the color action within a work of art. Rather than focusing on color systems, it presents useful aids in seeing and a direct means of expressing what you see.

Any color evaluation can only approximate the factual colors from those seen in a reproduction. Printing processes used in reproducing works of art, no matter how refined, cannot duplicate original color subtleties with

complete accuracy. The only way to actually see the color action of a work of art is to be in the presence of the original—another important reason for encountering the original work directly.

Using all that you have learned about color, examine Picasso's *Girl Before a Mirror* [color plate 5] and describe as fully as possible the artist's use of color.

— — — — — — — — — — — — — — — —

Hue: Picasso's hues are red, yellow, blue, green, and a touch of violet.

Tone: Black outlines are a strong tone contrast to the lightest areas of face, back, hips, and thigh at left, and breasts and abdomen at right.

Intensity: Red is full intensity in the wallpaper at left, in portions of the mirrored face, in the full-front face, in the lower mirror background, and in one set of armswing stripes. The alternating stripes and stripes of an outer form are dulled red, light in tone and dulled in arms, face, breasts, abdomen, and thigh of the girl. *Yellow* is full intensity on the wallpaper at left and in the full-front face. It is light in tone in the hair of the profile form and more dulled in the wallpaper at right. *Blue* is brightest around the reflected head, in the lower mirror background, and blue-violet in the mirror edging. *Green* is brightest in forms under the full-front head at left, the forehead, and the linear forms edging the reflected face at right. A clear, light tone of green falls over the back of the profile figure and the stripes over the abdomen of the reflected form as well as wallpaper stripes on the right side. *Violet* occurs in one clear triangular patch beneath the chin at upper right and in the lower face of the mirrored form. The *orange* edge of the mirror is bright, brightest at the top curve of the mirror accenting the huge orange tear from the eye of the mirrored face. *White* forms a partial halo for the figure at left and fills the breasts and abdomen of the reflected right image. *Black*, heavy outlines throughout hold the multicolored effect in enclosed patterns. This is a complex interplay, with contrasting bright hues predominating.

Warm/Cool: Cool hues are found in the greens in the lower sections and the blues contained within the shapes on the right. The warm hues are found in the yellow in the sunlike face, lighter in value in the hair, and muted in the wallpaper; red in the mirrored face, the stripes of the armswing, and the wallpaper, as well as in the lower body bands of the left figure. High-intensity juxtapositions in the wallpaper area of warm and cool colors—red beside green, red beside yellow, and yellow beside green, and on the mirror edge the orange band beside the blue—have vibrating effects.

Amount and Force: Small areas of light and bright color break the entire surface in a jigsaw-puzzle pattern. Bright pieces are held together by the black outline.

Complements: Red-green; yellow-violet; blue-orange.

Additive: Picasso is not concerned with the phenomenon of light rays, but instead with a patternlike stained glass or cloisonné effect.

SEEING THE UNITY

16. Keeping in mind that all components of a work of art interact, look at Mondrian's *Broadway Boogie Woogie* [back cover] and discuss the artist's use of: order, balance, line, light/dark, and color. (Use a separate sheet of paper.)

— — — — — — — — — — — — — — —

Order: Rigid order system.

Balance: Asymmetric. Small square blocks of red, yellow, blue, and white are placed side by side in a staccato beat, moving both horizontally and vertically. Strong accents related to the crashing, interrupting downbeats of boogie-woogie music are seen in the eight balancing, larger rectangles of red, blue, yellow with rectangles within them. The measured spacing leaves large rectangular spaces of white that hold and unify the active segments of dynamic rhythm.

Line: Paths of line that the eye hops along are made by the juxtaposed red, blue, yellow squares. These carry the eye over a maplike framework of horizontals and verticals that move out to the edge of the field on all four sides.

Light/Dark: The lightest areas are the spaces of white. The next lightest are yellow spaces, greater in number than the red and blue, which are darker accents.

Color: The bright, high-key, and very contrasting hues of red, blue, and yellow set off by white are painted in flat tone without any modeling.

You should now be able to look at a work of art and describe the artist's use of color. You may want to review the questions at the beginning of the chapter before completing the following Self-Test.

SELF-TEST

This Self-Test will help you evaluate how much you have learned so far—how well you can answer the questions raised at the beginning of the chapter. Answer the questions as completely as you can (use a separate sheet of paper) and then check your answers against those that follow.

1. Find the location of each of the most contrasting hues (red, blue, yellow) and each of the next most contrasting hues (green, orange, violet) in de la Tour's *The Adoration of the Shepherds* [color plate 1].

2. Look at Monet's *Rouen Cathedral* [color plate 3] to determine hue contrast, tone range and contrast, and whether tone control expresses three-dimensional form or flat, two-dimensional form.

3. Examine Poussin's *Shepherds of Arcadia* [color plate 6] and describe the artist's use of color intensity.

4. Examine Monet's *Rouen Cathedral* [color plate 3] and describe the artist's use of warm/cool contrast.
5. Examine Mondrian's *Broadway Boogie Woogie* [back cover] and describe the amount and force of color.
6. Examine Vasarely's *Vega-Nor* [front cover] for the use of contrast of complementary colors.
7. Examine Van Gogh's *The Starry Night* [color plate 8] and describe the artist's attempt to simulate additive colors (the effect of light).
8. Examine Van Eyck's *Jean Arnolfini and His Wife* [color plate 7] and describe the artist's use of order, balance, line, light/dark, and color.

Answers to Self-Test

In parentheses following these answers are given the number of points each question is worth, if you want to total your overall score, and the frame references where the topic is discussed, if you wish to review.

1. This painting is basically of one hue (red). Everything in this work is some variation of red. There are no contrasting or accompanying hues. (This is called a monochromatic painting.) (frames 1–2; 5 points)
2. The identifiable hues are yellow, white, blue, and red. This is a high-key painting with light areas predominating and darks in only a few shadow shapes and three figure forms at the lower left. Contrast becomes strong, but edges between light and dark are blurred resulting in a flattening of form indicating the projection and recession pattern of the facade of Rouen rather than its architectural bulk. (frames 3–4; 5 points)
3. The intense red of the toga of the shepherd pointing to the monument vibrates in juxtaposition with the bright yellow of the shepherdess. The red and yellow are highest in intensity. The brightest blue is the toga of the left, pointing shepherd with clear, bright, light blues in the sky. Duller blue is found in the skirt of the shepherdess and in the mountains. Pinks and flesh tones are light but more low key in intensity. The trees and earth are muted yellows and greens, and the monument is a low-key, dull red-brown. (frames 5–6, 5 points)
4. Monet's work is predominantly blue-green and orange. The cool hues are variations of blue and blue-green. The warm hues are mainly light values of yellows, pinks, oranges, and red-violet. Except for the distinction between the sky and the cathedral, the warms and cools are not separated; they interlock with soft edges and shapes that are difficult to define. The impression is of the dematerialization of stone by the effect of the sun, low in the west just before setting. The lower-right door becomes a brilliant, high-intensity reflection of the sun itself. (frames 7–8; 5 points)
5. The largest rectangles are white and fall back because of the intensity and demand of the red and blue. There is least of blue and its force is felt through brightness and darkness. The amount of red is next. It is bright and occurs in larger, more frequent areas than blue. Yellow is

greatest in amount and is bright, but because of its light tone, it ties
with the white, losing its greatest force except where it is juxtaposed in
contrast with the reds and blues. (frames 9–10; 5 points)

6. The most defining of the framework shapes are the illusion of outer red
and yellow and inner green and blue. On the right side, red edges are
placed beside green. On the left side, orange is placed beside blue, com-
plementary pairs. (frames 11–12; 5 points)

7. Van Gogh uses broken brush strokes in an attempt to indicate the atmo-
spheric light of a bright moonlit night. The light forms in the sky area
are like spotlights casting a hazy light on earth forms. The hills, trees,
bushes, and building forms appear to have caught the sky light on the
sides nearest us, and the edges are outlined with a dark that suggests a
shadow that creeps from the far side. The star and moon light sources,
along with the reflected light of earth forms, simulate the effect of
night light that is related to the additive character of real light rays. This
is Van Gogh's record of how earth forms seem transformed in both
shape and meaning in the more unified dark tonalities of night light.
(frames 13–14; 5 points)

8. *Order:* Leans to a rigid order within a vertical rectangle. (Chapter 1;
2 points)

Balance: Symmetrical. (Chapter 1; 2 points)

Line: The eye is caught into the work by the invisible vertical cen-
ter along which the chandelier, mirror, clasped hands, pillow, clogs, and
dog fall. Linear edges of form defined with clarity lead the eye around
contained forms and within forms along edges of fabric folds. (Chapter
2; 5 points)

Light/Dark: The window at the left is the major source of light.
The lightest areas are the clasped hands, Mrs. Arnolfini's headdress,
sleeves of fur, and gown edging. Darkest are Arnolfini's huge hat, his
sleeves, and his leg covering. His overgarment is a little lighter in tone
than the rest of his clothes. Modeling of light/dark within forms gives
the appearance of solid volume. (Chapter 3; 5 points)

Color: The Arnolfini side is almost monochromatic with red the
one color. The floor, window wall, and ceiling are browns, as is Arnol-
fini's warm-brown outer robe. The fruit are spots of bright red. There is
by comparison a sharp contrast of color on the right side with the
bright green of Mrs. Arnolfini's gown against the bright red of the bed.
The back wall is a cool gray uniting the two sides. (Chapter 4; 10
points)

Total possible points: 59. Your score: _____ . If you scored at least 47
points, you understood the main points of the chapter. If your score was
lower than this, you may want to review the appropriate frames before you
go on.

IMAGINATION STRETCHES

— Observe the change in colors on a rainy day. Everything is in a different key.
— Try using the liquid from natural materials such as tree bark, leaves, nuts, or flowers to do a painting on paper.
— Observe the jewellike colors of city lights at night. The flashing on/off gives motion to color.
— Watch for the next sunset spectacular. Every one is different, each more beautiful.
— Select a limited area outdoors and observe the colors in the morning. Watch to see how different the colors appear at different times of the day: noon, evening, night. (Monet did this and painted haystacks as well as Rouen Cathedral at different times of day.)
— Walk through a parking lot or used-car lot and, with some color medium, record the colors of cars you see.

CHAPTER FIVE
Space

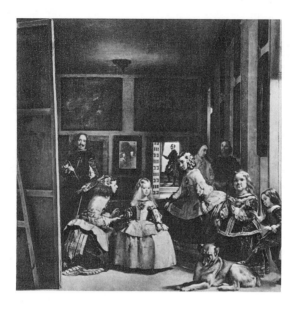

▶ In a work of art, can you:

- recognize differences in flat space, shallow space, deep space, and extension forward from the picture plane?
- describe the use of the basic conventions for creating depth: line, clear/blurred form, overlapping, size, figure position, gesture, light/dark, and color?
- recognize the basic characteristics of the following spatial systems: linear parallel perspective, linear angular perspective, horizontal banding, planar space, isometric perspective, plane and elevation on the same surface, reverse perspective, and simultaneous perspective?

There's a lot more to the study of space than you may think at first. When you have finished this chapter, you will probably view space, not only in works of art but also in your daily life, in quite a different way. You will need pencil and paper for the exercises in this chapter.

Diego Velasquez, *The Ladies-in-Waiting (Las Maniñas)*. 1956. Alinari/Editorial Photocolor Archives. Museo Del Pardo, Madrid.

INTRODUCTION

The kinds of space that interest artists are the same as those that provide you with memorable experiences:

> Inside your home—a particular corner, an important wall, a special room
> Where you have fun—park, lake, circus, dance hall, theater
> Where you think seriously—church, work, school, a desk
> Where you suffer or mourn—hospital, church, cemetery
> Where you are frightened or lost—unfamiliar spaces, dark spaces
> Where you dream—looking into clouds, the sky at sunset or sunrise

Every painting is a challenge to your mind to "enter" some kind of space. What you see is based on your past experiences in space. When the artist's representation of form in space follows your expectations, you are comfortable; you feel secure because you sense spatially where you belong in relation to what you see. When no familiar landmarks or spatial clues are provided, however, you tend to feel lost, left out; you feel insecure because you find no location for yourself in relation to what you see.

Every painting is a different kind of space requiring a different approach, a different kind of attention, and a different orientation to the world. Exercise your capacity to experience space. Make opportunities for seeing new spaces and for seeing familiar spaces in new ways.

Look through the entire set of art works represented in this book to place each into one of two categories: (a) those you feel comfortable with spatially—you know where you are in relation to what you see; and (2) those you cannot relate to spatially—you cannot determine space within the work or you don't know where you are in relation to what you see.

KINDS OF SPACE

1. Four kinds of space are: flat, shallow, deep, and extension forward from the picture plane.

Two-dimensional art occurs on a flat surface that has height and width (two dimensions), so it can always be considered in terms of its essential *planar* or *flat* character. Some artists emphasize this flatness by creating paper-flat shapes that lie on a level with the surface. In such works the action of color may be the main illusion of depth into space other than the thickness of the paint film or whatever medium the artist has used.

Other artists create an illusion of space by making the flat surface appear to have a floor, side enclosures, and a backdrop, giving a suggestion of the relatively *shallow* space of a contained, three-dimensional stage or room.

Still other artists transform the flat surface into the appearance of the indefinite depth into space of landscape, sky, and earth. This *deep* space also appears to be three-dimensional.

Another way the surface is considered in some contemporary work is in terms of the space that extends *ahead* of the picture plane. Artists of today

have defied the enclosure of the four edges of the picture plane and have also *extended the field of action forward* from the flat, planar surface. The result for the spectator is involvement with the area in front of the two-dimensional surface similar to the experience of relief sculpture or environmental sculpture that invites the viewer into the work. Such "walk-in" paintings are one more of today's contributions to the breakdown of the traditional categories for painting, sculpture, and architecture.

> **Space can be conveyed as a flat pattern, as having the illusion of some degree of depth, from shallow to deep, or as an extension forward from a surface.**

Examples

Flat space: a wall, a stretched canvas surface, a piece of paper
Shallow space: a box, a stage, the corner or side of a room
Deep space: a long passageway or hallway, a road or highway, a landscape vista or seascape
Forward extension: a door from which someone walks forward or a map with topological projections

Exercise

Identify the type of space (flat, shallow, deep, or forward extension) illustrated by each of the following:

(a) Paper doll
(b) Puppet theater
(c) The length of a hospital corridor
(d) A playing card
(e) Stage depth for legitimate theater
(f) Fields of growing corn
(g) A road map
(h) Wall shelves
(i) Someone leaning out of a window

— — — — — — — — — — — — — — — —

(a) flat; (b) shallow; (c) deep; (d) flat; (e) shallow; (f) deep; (g) flat; (h) shallow and forward extension; (i) forward extension

Seeing Kinds of Space

2. *Flat Space:* Look at Matisse's *Icarus, From Jazz* [47]. In the dark, flat, cutout shape of Icarus, the arms appear winglike, and the irregularity of the footless legs have a billowing effect. With no modeling to suggest solidity, the Icarus form and the star shapes appear suspended against a sky space. Icarus appears as the helpless victim of his fate.

Shallow Space: Look at Manet's *Olympia* [40]. The forms are pattern-like and close to the surface of the picture plane. Manet uses contour line and a minimum of modeling (shading) in the figures to suggest the substance of the bodies. He uses strong contrasts with few half-tones, so Olympia is strongly light and outlined against a dark background on one side of her body. The other side is white against white. The dark background suggests an enclosed room with only one small opening (the window) to light it. The strong vertical to the left of the background, the horizontal of the bed, and the diagonals of pillow and bedding are space clues indicating the shallow, contained, dark space. This space, the sharp light/dark contrasts, and the bold stare of Olympia become part of the painting's message.

Deep Space: Look at Giorgione's *The Concert* [25]. The illusion of a deep space is created with foreground forms modeled in subtle gradations of light and dark to give the suggestion of solid volumes. A lighter midground suggests a distant pasture with shepherd and flock. A still more distant body of water carries the eye from buildings along its shore to even more distant buildings on the far side. Sky and clouds seem to roll even beyond this. The indication of music and an aura of dream add other kinds of implied and intangible space.

Extension Forward from the Picture Plane: Look at Jasper Johns' *Target with Four Faces* [32]. The faces are not two-dimensional painting; they are three-dimensional reliefs of cast plaster set into a wooden frame. The noses project from the canvas. Johns tried to "influence the observer's physical position in relation to the painted surface. And he did this by providing a temptation, a source of curiosity, a reason to move closer and then step back."*

An earlier example of the artist's urge to break ahead of the canvas surface can be seen in Rembrandt's *The Night Watch* [60]. The projecting hand of Banning Cocq appears to extend into our space, and its shadow falls parallel with the picture plane and within the picture space. Mirror paintings such as Van Eyck's *Jean Arnolfini and His Wife* [color plate 7] and Velasquez's *The Ladies-in-Waiting* [80] also use devices to indicate something happening in the space where the spectator stands.

Application

Examine the following works and determine which type of space the artist used primarily—flat space, the illusion of shallow space or deep space, or extension forward from the picture plane:

(a) Vinci—*The Virgin of the Rocks* [83]
(b) Johns—*Target with Four Faces* [32]
(c) Chardin—*The Boy with a Top* [11]
(d) Indiana—*The American Dream, I* [28]

*Michael Crichton, *Jasper Johns* (New York: Abrams, 1977), p. 30.

(e) Raphael—*Madonna del Cardellino* [61]
(f) Albers—*Homage to the Square* [1]

————————————————

(a) illusion of deep space
(b) flat space and extension forward from the picture plane
(c) illusion of solid form in shallow space
(d) flat space
(e) illusion of deep space
(f) flat space (in the original, color makes space appear to advance or recede)

Note: Many works of art fit primarily into one of these categories. In many works, however, the space is too ambiguous to fit neatly into any one category. For instance, in Giotto's *The Lamentation* [26], the action occurs on a very shallow, stagelike foreground, but a faint hint of distant mountains is suggested as if on a stage backdrop. Seurat's *Models* [71] is placed in a shallow space—a room corner—but a painting within the painting on the left wall suggests deep space. Vermeer's *The Artist in His Studio* [81] is a shallow space with a map on the back wall suggesting the space of lands beyond the room activity. Courbet's *The Painter's Studio* [13] is a shallow, contained room, but a painting within a painting suggests a distant landscape, and a stage-set back wall suggests an outdoor scene.

Particular problems in defining space depth emerge in works such as Gauguin's *The Market* [23], where the forms are flattened with a minimum of modeling, but there is an indication of a distant landscape, and in Chagall's *I and the Village* [12], which is flat and "up-front," but also suggests distance through diminished size.

BASIC SPATIAL CONVENTIONS

Specific visual conventions or devices have developed through general agreement and usage. Artists can select conventions to portray the kind of space they want to share through their work.

When you look at a work of art in terms of space, observe not only whether the space is flat, shallow, or deep, but also if it is specifically within walls, outdoors, both, or unclear. Also observe your position in relation to the setting and forms. Has the artist made it clear that you are close to the subject as in Renoir's *Le Moulin de la Galette* [64]? Is it clear that you are removed and far away from the subject as in Friedrich's *Monk by the Seaside* [17]? Or is it less easy to decide whether the artist has considered a certain spectator position as in Kandinsky's *Improvisation 35* [33]?

Some space conventions generally accepted and understood by the Western world involve particular ways of controlling:

— line (horizontal/diagonal; clear/blurred)
— size and overlapping
— figure position and gesture
— light/dark and color

Each of these separately or in combination can provide clues to the kind of space artists communicate. Artists are not restricted to one set of conventions; they can and do choose from among them. These conventions should *not* be mistaken for rules; you will find that artists freely use or defy them.

Line Clues

3. Artists may use line to indicate depth. Use of horizontal and diagonal lines as well as clear or blurred lines are clues to the artist's illusion of depth.

A *horizontal line* across the picture plane (surface) can locate a separation of earth and sky if outdoors or a floor line if indoors. Because of our experience with the force of gravity, we see vertical forms as anchored to such a line. Horizontal lines can become a base related to earth/floor, the horizon. If there is no ground line or floor line, forms seem less anchored and may appear to float.

A *diagonal line* leads the eye inward and implies depth or distance into space. Outdoors, paths, hills, trees, or buildings placed on diagonals and counterdiagonals lead the eye into deep space. Indoors, a left or right diagonal floor or table line contributes toward constructing the illusion of room space.

Clear lines are often used to portray forms that are nearer, more detailed, more discernible as to specific shape. *Blurred lines* are frequently used to portray forms that are farther away, less distinct, less detailed, less evident as to specific shape, with a hazy lack of definition.

> Horizontal lines provide a base related to earth and the horizon. Diagonal lines imply depth into space. Clear lines suggest nearness. Blurred lines suggest distance.

Examples

A *horizontal line* (straight or irregular) can imply separation between earth and sky. When a horizontal line is low on the surface, it implies less of earth and more of sky. When it is high, the earth goes back into the distance, and we see less of sky:

A *diagonal line* (straight, curved, or irregular) can imply depth *into* space:

Clear/blurred lines can also imply nearness/farness. The road signs on a highway are a blur when they are far off. As you get near, they are clear and readable:

In summer a distant tree is a huge green mass. When you get close, you see the leaves and branches as clear, separate forms.

Exercise

Look at the use of spatial conventions in the following works of art. Identify the works where a horizontal defines earth or floor, works where diagonals function to carry the eye into depth, and works where clear/blurred forms have been used to suggest space. (More than one convention may be used in a given work.)

(a) Botticelli—*The Birth of Venus* [4]
(b) Caravaggio—*The Conversion of St. Paul* [9]
(c) Campin—*The Merode Altarpiece* [8]
(d) Chardin—*The Boy with a Top* [11]
(e) de la Tour—*The Adoration of the Shepherds* [color plate 1]
(f) Matisse—*The Red Studio* [color plate 2]
(g) Renoir—*Le Moulin de la Galatte* [64]

(a) horizontal, diagonal line
(b) diagonal line
(c) diagonal line
(d) horizontal, diagonal line

(e) diagonal, clear/blurred line
(f) diagonal line
(g) diagonal, clear/blurred line

Seeing Use of Horizontal, Diagonal, and Clear/Blurred Line to Create the Illusion of Space

4. *Horizontal:* Look at Friedrich's *Monk by the Seaside* [17]. A horizontal separates sky from earth. Diagonals from each side meet where the monk stands, suggesting a projection of earth into the sea. Look at Picasso's *The Three Dancers* [56]. A horizontal indicates where the floor meets the wall of the room in which the action occurs. Now, look at Pollock's *Autumn Rhythm* [58]. No ground or floor line is indicated. Without such a horizontal indicator, forms make a web over the surface out to the edges of the canvas, and we see a complex network, like a magnified detail of a textured surface.

 Diagonal: Look at Giorgione's *The Concert* [25]. The interlocking and opposing curved diagonals of the foreground hills, midground hill behind the tree at left, and background hill at right lead the eye back to the horizon where sky meets water. Look at Vermeer's *The Artist in His Studio* [81]. The diagonal seat of a chair placed at an angle to the picture plane leads the eye inward. Inward diagonals are accented in the tile floor pattern and also by the table edge between the artist and his model. (Behind the model is a map, a suggested extension of space beyond the room.) Finally, look at Manet's *At the Races* [41]. Steep diagonals at right and left telescope into the picture plane, suggesting fences on either side of a long track. The opposing diagonals forming the axis of each of the three nearest horses add to the convincing action in the foreground.

 Clear/Blurred: Look at Braque's *The Musician's Table* [7]. The clear, centered forms seem nearest to the spectator. The softened edges and blurred forms at the top and sides of the oval make them seem to drop away. Now look at Raphael's *Madonna del Cardellino* [61]. The clearly defined foreground shapes of the Madonna, Christ Child, and infant St. John seem very near. The hazy, unclear forms along the horizon add to the impression that they are distant.

Application

Examine the following works and describe the use of horizontal/diagonal and clear/blurred lines to indicate space:

(a) El Greco—*St. Martin and the Beggar* [22]
(b) Goya—*Execution of the Madrileños* [27]

— — — — — — — — — — — — — —

(a) An irregular horizontal appears low on the vertical rectangle where sky meets earth. Forms suggesting building and trees are blurred and hazy, implying great distance. St. Martin, the white horse, and the beggar are

placed diagonal to the picture plane on a hillock that seems very near. The horse appears to be moving from the background on a left-to-right diagonal. As St. Martin turns to share his cape with the beggar, the action between them is a right-to-left, downward-outward diagonal. The sword and rein of the horse are diagonals that lead the eye inward.

(b) A diagonal wedge of dark shadow appears at right; another of lighter value following forward from the lantern corner provides a ground surface for the soldiers; and a third, still lighter wedge moves away from the opposite corner of the lantern, giving an illuminated ground space for the heaped-up dead and dying. A diagonal lineup of the massed people about to be shot parallels the more rigid diagonal of the soldiers. The hill at left forms a diagonal in opposition to that of the hats of the soldiers. Diagonals leading the eye inward are stopped by the building in the background and the implied horizon. Figure forms farther back and the building are less clearly defined than foreground forms, adding to the illusion of depth.

Overlapping and Size Clues

5. A form that is close to you is completely seen and *overlaps* (cancels from view) the forms that are behind. From everyday experience with this phenomenon, you recognize that forms fully seen are nearer to you and those hidden from view by other forms are more distant. Most works of art have some degree of overlapping to indicate near/far.

Forms that are larger in size may appear closer than forms that are smaller. According to this convention, artists construct overlapped, distant forms smaller in scale than those that are near. A gradual decrease in size from large to small reinforces the spatial illusion of depth, especially when smaller, more distant forms are overlapped.

> When a form overlaps other forms, the completely seen form appears nearest. When images diminish in size, the smaller form appears farther away than the larger form (unless the smaller form overlaps the larger form).

Examples

Exercise

Place your hands in front of you so you see each one separately. Now place the left hand over the right hand. A covered portion of the right hand is blocked from view. You *know* the right hand is still all there and that it is behind the left hand. Even though you see only a portion of a form blocked from total view, you assume its entirety and you understand that the form you see entirely is nearest to you.

Hold your hand up in front of your eyes to observe what it blocks from view. Compare scale—the size of your hand and the size of what it blocks from view. What do you notice?

———————————————————

A much smaller object (your hand) very near to you can block from view distant forms that are actually much larger, but with distance appear smaller.

**Seeing Use of Overlapping and Diminishing Size
to Create the Illusion of Space**

6. *Overlapping:* Look at Picasso's *The Three Dancers* [56]. We see the entire central figure balancing on her forward leg, which overlaps the bent leg. With upraised arms she touches hands with the other two dancers, whose clasped hands (arm) are overlapped by her body. The group is dancing in a room in front of an open window that has a balcony railing outside it. (Note the diagonal of the right pane in the window.) A suggestion of shallow space is indicated through flat, overlapping forms. The central dancer seems nearest us; the other two dancers are farther back. Behind the group is the wall with an open window suggesting space outside the room.

Diminishing Size: Look at Giorgione's *The Concert* [25]. The two semi-nude female figures are larger in scale and seem nearest the spectator. The two clothed men are smaller and farther away. In the midground is a shepherd,

much smaller in scale, who seems far away. Beyond the trees are buildings still smaller in scale and seeming even more distant.

Application

Examine the following works and describe the artist's use of overlapping and/ or diminishing size to create space:

(a) Delacroix—*Liberty Leading the People* [14]
(b) Seurat—*A Sunday Afternoon on the Grande Jatte* [color plate 4]
(c) Cezanne—*Mont Sainte-Victoire* [10]

— — — — — — — — — — — — — — — —

(a) In the foreground—lowest, largest in scale, and appearing closest to us— are the victims of battle, the dead and wounded. These forms overlap midground figures who stride forward over the rubble: the gentleman soldier, the woman who represents Liberty holding her flag high, and the young boy, a gun in each hand. The gentleman with top hat and rifle overlaps a saber-bearing soldier of fortune to the left. Between the well-dressed gentleman and Liberty are blurred figures, smaller in scale and more distant, who seem to repeat the two midground soldiers at left in reverse position, with the sword-bearing figure ahead and the rifle-bearing figure with top hat behind. Urban buildings along an atmospheric skyline are relatively still smaller in scale, suggesting great distance.

(b) A horizon where earth and sky meet is located high on the picture plane. A diagonal moves from left foreground to right background, suggesting the inward projection of a lakeshore. The foreground lady on the right overlaps her escort, and the reclining man at left overlaps the other two figures of that group. The figure standing center, full-front midground and the child in white beside her are seen with no overlap. Figures get smaller in scale and less distinct in definition as the forms are placed higher on the picture plane on the right. Tree trunks overlap foliage. The boats are small to suggest distance. These devices contribute to the illusion of deep space extending as far back as the eye can see.

(c) The foreground tree is larger in scale than the buildings, which are smaller and seem more distant, and it overlaps other forms to give us the feeling that we are at the same level, high up in the trees.

Figure Position and Gesture Clues

7. The position of images in a work of art can be important space indicators. Viewers generally tend to raise their eyes to look into the distance and to lower their eyes to see that which is near. Artists conventionally place near forms at the bottom of the picture plane and distant forms higher on the surface or at the top of the picture plane.

Another image-position indicator of space is the relationship of human figure to human figure within the work. A figure can function to stop space

much as a wall does. Figures placed at angles to one another can be a means of constructing space.

 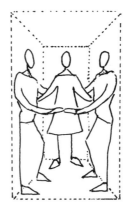

Gesture, too, contributes to definition of space and direction. A human form in a work of art can pull the spectator into the work through eye contact and can further construct space through the angle, bend, or twist of the body, head, arms, or hands.

> Images placed at the bottom of a picture plane usually appear near; those placed higher on the picture plane usually appear distant. Figure in relation to figure contributes to spatial construction. By forming connections through empty space, gestures such as signals from one person to another provide additional space clues.

Examples

Observe:

— your own head action in taking note of that which is near and far. Your head and eyes are lower when you look at what is near; you raise your head to see what is far.
— people relationships and the kind of space shaped by people in procession, people dancing, people clustered together talking, people eating, people in a theater, space shifts in a football game, choreography for dance.
— gestures that can direct and construct space by forming connections through empty space—the wave of a hand from someone you know, arms outstretched, a clenched fist held high, mime.

Exercise

Look at the following works and determine whether the artist has indicated space by figure position (high or low), position in relation to figure, or gesture:

(a) Campin—*The Merode Altarpiece* [8]
(b) Vinci—*The Virgin of the Rocks* [83]
(c) Goya—*Execution of the Madrileños* [27]

— — — — — — — — — — — — — — — — —

(a) Figure position and relation. At left the lower figures are also larger and seem near. Note the higher position, smaller scale, and distance of the figure near the open door. Beyond the door are a horse and rider (clearly seen in the original) that are higher, smaller, and more distant. At right St. Joseph seated at his carpentry is placed low, is larger in scale, and seems near. Through the open window we see grouped people placed higher, smaller, and farther away.

(b) Figure position, relation, and gesture. The placement of the four figures forms a mysterious empty space between them with the Virgin's body a canopylike container holding together the right angel who looks out and down to us and points to the infant John on the left kneeling by an angel and looking across to the Christ Child whose body repeats the angel's position, but with a hand raised in blessing.

(c) Figure position, relation, and gesture. The soldiers form a solid diagonal wall; the victims on the left form a parallel, more loosely constructed diagonal wall; and the guns span the space between. As the victims come forward, they turn at an angle to the "walls" to begin a closure along the inner edge of the ray of light. The lantern is placed at a turned angle within the empty space formed by the columns of figures.

Seeing Figure Position and Gesture Clues

8. Look at Gauguin's *The Market* [23]. The figure standing near us low on the field of action is large. A row of seated women, higher and smaller, appears farther away. Two fish-bearing figures, still higher and smaller, seem much farther from us.

Look at Velasquez's *The Ladies-in-Waiting* [80]. The little princess, her ladies-in-waiting, the court dwarfs, and their pet dog are placed across the lower edge of the painting. The painter himself at left and two attendants at right are deeper into the room space. These figures are placed higher, thus diminishing in scale. A figure considerably smaller is set higher in a doorway in the back wall against the open door, seeming very distant.

Look at El Greco's *The Resurrection* [21]. The figures fall away from the ascending figure of Christ to form an almost funnellike space from which he rises.

Finally, look at Rubens' *Rubens and Isabella Brandt* [69]. The frontal body of Rubens forms a back wall; his legs and outer arm form a left enclosure. The body of Isabella is placed at an angle to form a side wall at right. Rubens' pointing finger and Isabella's hat brim point to their clasped hands centered within the space constructed by their bodies. They both look out to us. As we look we are supplying an enclosing surface.

Application

Examine the following works and determine the artist's use of figure position, figure to figure relationship, and gesture to contruct space:

(a) Munch—*The Cry* [52]
(b) Francesca—*The Flagellation* [55]

\- \- \- \- \- \- \- \- \- \- \- \- \- \- \- \-

(a) The swaying foreground figure, larger in scale, is so close to us that we do not see legs or feet. It is as if we are also on the bridge, watching or ignoring the helplessness of a fellow human in a manner similar to the unaware men placed higher (and smaller) and distant at the far end of the telescoping bridge rail. Notice the use of line to "echo" the cry.

(b) The figures as well as the architectural forms construct space. In the group to the right, the center frontal figure forms a back wall; the two flanking figures form side walls with an empty space carved out between the three figures. Figures deep into space are placed as if to form four walls with Christ captive within the enclosed space. (This is a time-space painting. The figures at the right existed in the *now* of the artists' lifetime; however, the event deep in space at the left is from the distant past. On the same field of action, the artist is telling the stories of parallel events separated by time and space.)

Light/Dark and Color Clues

9. Light is usually related to clarity and appears to project. Dark is usually related to obscurity and appears to move back. As we have seen, the artist conventionally uses light values to suggest projecting forms and dark values to suggest receding forms. This value system can be totally reversed, however, so that areas with dark tones appear near and those with light tones appear more distant, as in Seurat's *A Sunday Afternoon on the Grande Jatte* [color plate 4].

Atmospheric perspective is a control of light and dark based on two observations: (1) Air is not completely transparent. A thin layer, increasing in density with distance, becomes an obscuring atmosphere that gradually inserts itself between distant objects and the viewer. (2) As objects go into the distance and become smaller, the eye gradually fails to perceive individual forms. Defined edges of forms blend and cancel out, leaving a prevailing softened lack of definition along with an obscuring middle tone of light suggesting the more dense atmosphere. Contrasts of light and dark diminish as objects recede into distance. Color contrasts also diminish gradually, assuming the bluish color of air. The work of J. M. W. Turner is a good example of this.

Color, too, is a means for producing spatial effects. Warm hues (red) and bright, high intensities appear to project. Cool hues (blue) and dull, low intensities appear to recede. The artist controls the appearance of color

projection/recession through selection of hue, value, intensity, amount, and juxtaposition with other colors.

> **Usually light, warm, and bright colors appear to project (seem nearer). Usually dark, cold, and dull colors appear to recede (seem farther away).**

Examples

To observe the actual phenomenon of light and color that inspired the artist to invent atmospheric perspective, you need to see a distant vista of sky and horizon. The bluish, blurred forms that you perceive along the horizon are similar to the effect Leonardo da Vinci has recorded with color in the background of his *Mona Lisa* [82] and are related to the way distance has been suggested by Raphael in his *Madonna del Cardellino* [61].

Observe color spots made by people filling an auditorium. Reds stand out; greens, blue-greens, and dull blues fall back. Also observe how red and yellow flowers in a garden stand out, seeming to come forward, and how in autumn, the red of sumac, oak, and hard maple leaves project dramatically, claiming attention.

Exercise

Look at the following works and describe how light and dark are used to construct space:

(a) Vermeer—*The Artist in His Studio* [81]
(b) Botticelli—*The Birth of Venus* [4]
(c) Courbet—*The Painter's Studio* [13]

Now look at the following works and identify the warm colors that contribute spatially by appearing to project:

(d) Poussin—*Shepherds of Arcadia* [color plate 6]
(e) Van Gogh—*The Starry Night* [color plate 8]

— — — — — — — — — — — — — — — —

(a) A very dark foreground chair is placed at an angle beneath a heavy drapery swag. From the left a contrasting light distinguishes a back wall on which a map hangs. The space between the chair and the back wall is defined by alternating light/dark floor tiles. The light-reflecting chandelier adds to the space illusion because it seems to hang from the ceiling center with space behind and ahead of it.
(b) The foreground water band is dark. Behind the shell is a light band, and a thin, dark strip along the horizon contrasting with a light sky area suggests far distant space.
(c) The right wall is dark with an outside light coming through a drapery-hung doorway. A back wall opens space with vertical panels of a stage-like landscape The floor is illuminated by light from the right opening.

The studio space is further defined by figure placement and by the easel painting on which the artist is working.

(d) The yellow and red garments of the right figures add to the illusion that these figures are closest to us.

(e) The crescent moon at right and the stars along with the village lights of warm yellows seem to glow and vibrate forward.

Seeing the Use of Light/Dark and Color to Create Space

10. Look at Caravaggio's *The Conversion of St. Paul* [9]. Alternating lights and darks move across the forms, arms, and horse's body, looking from left to right and also from the head of St. Paul inward along his body and around the horse's underside to the top side, to convincingly indicate space.

Now look at Vasarely's *Vega-Nor* [front cover]. Warm colors appear to project and cool colors to fall back, adding to the convincing look of a balloonlike, forward bulge.

Application

Examine the following works and describe the artist's use of light/dark and color to create space:

(a) Turner—*Steamer in a Snow Storm* [75]
(b) Monet—*Rouen Cathedral* [color plate 3]

— — — — — — — — — — — — — — — — —

(a) The absence of a ground line thrusts us into the storm at sea. The swirling pattern of alternating light/dark carries the eye around the boat tossed by the winds. The boat forms are a blur, the only definition being a mast and flag. (In the original the paint is applied in transparent layers, so we are seeing light/dark layered into depth as well as the more obvious surface swirling pattern.)

(b) Monet has used blue for the sky, which lays back to allow the warm, light tones of the cathedral to project. The patterns indicating undercuts and recessions in the facade are generally greens and blues. The entire face of the cathedral is placed at an angle to the picture plane and to the sunlight, so in the main portal a very light, warm area is caught by light with the other side in cooler, darker shadow. The right portal reflects the burning red sun with a deep blue shadow on the right.

• • •

Since this is a long chapter, you may want to take a break before going on to spatial systems.

SPATIAL SYSTEMS

Whatever the painted form or from whatever the limitless impressions and constantly changing conditions of life, the artist has selected something in particular, has caught and held it for us, the viewers. Essentially what the artist does is to choose images from the passage of time and give them form through line, tone, and color, constructing a space in which the life of the forms begins or continues.

The kind of space constructed depends on the artist's point of view, personal temperament, geographic location, cultural background, and specific historical time of life.

A *perspective* is a point of view with respect to the relative position and distance (importance) of objects and forms. Several perspective systems have evolved through the years. At different times and places, different systems have been preferred because they best expressed the values and understandings of the time. Within a particular space system, the artist may use the conventions of space in varied but similar ways. The artist of today (as well as the spectator) has available all the systems of the past from any place in the world; therefore, the possible variations of representing space seem endless.

The following space systems are now traditional and widely used, but other ways exist. No perspective system is better or more valid than any other. Each involves a different orientation to the world; each communicates a different kind of information to the viewer; and each has special advantages and disadvantages.

Artists have tried many ways to create the convincing illusion of three-dimensional depth in the space of a two-dimensional picture plane. Many variations construct the appearance of a boxlike, roomlike, or stagelike enclosure to contain and integrate figures. Two related systems, traditionally widely accepted in art of the Western world, are linear parallel perspective and linear angular perspective.

In the following discussions of visual perspective systems, we will vary our format slightly. Instead of everyday visual examples, we will give you a simplified diagram of a particular reproduction that illustrates each type of spatial perspective. In each case, as you read about the spatial system, look at your reproduction and compare it carefully with the simplified diagram.

Linear Parallel Perspective

11. For our discussion of *linear parallel perspective*, refer to Masaccio's *Holy Trinity* [43]. Also called *parallel one-point perspective*, this spatial system was known to the ancient Greeks and was rediscovered by Renaissance artists.

This system requires the viewer to see the work from a single fixed point of view—that is, the viewer's eyes are riveted to one position in space.

Linear parallel perspective uses an optical phenomenon—the *vanishing point*—an illusory point where two or more parallel lines appear to converge,

Eye level

usually at a point on or beyond the horizon. If you stand between railroad tracks and look between them into the distance, there is a point at which the two tracks will seem to converge and disappear where earth and sky appear to meet. The line where earth and sky appear to meet is called the *horizon line,* and the point where the railroad tracks seem to come together and disappear is the *vanishing point.*

When the artist establishes a horizon line on a two-dimensional surface, your eye level is also established. Somewhere on that line the vanishing point is located. Everything in the work is then related to these references.

In *Holy Trinity* [43], Masaccio has located eye level and the vanishing point of the painted architecture at the level corresponding to 5'9'' from the floor, the height of an average viewer standing in front of the painting. You, the spectator, are very carefully considered in this system. Space is painted using the documented observation that the illusionary convergence (at an infinite point on the horizon) of edges of objects that are parallel to the ground plane in nature always occur at a point level with the viewer's eyes.

Linear perspective uses spatial "props" such as tiled walkways, walls, buildings, or architectural detail, equidistant arches, plantings, fence posts, or telephone poles.

Within this space system the artist uses a calculated set of distortions from the actual measure of forms, a technique or effect called *foreshortening*. When the artist foreshortens a form, the proportions appear to diminish as the eye sees the form three-dimensionally and existing in depth. Foreshortening is seen in *Holy Trinity* where the tomb is narrower at the "far" edge than the wider "near" edge. In actuality we *know* the length of these two edges of the tomb must be structurally equal. So the artist is not drawing the known proportional truth with both sides in equal measure, but he is presenting the distortion of measure as the eye sees.

Another example of foreshortening in this same work is in the architecture of the ceiling vault. The "farthest" arch is smaller, the "nearest" one is larger. The sections in the coffered vault get smaller and closer together with apparent distance. In actuality, we *know* that structurally both arches would have to be the same dimensions and that each of the sections in the vault must be identical in measure. This foreshortening—distortion from actual measure—creates the illusion of depth, of three-dimensional space.

Spatial Conventions

A variety of spatial conventions may be used in linear parallel perspective:

— A horizontal line theoretically corresponds to the eye level of the viewer and to the horizon where you would see the curve of the earth actually obscure whatever is beyond.
— Diagonals, indicating depth into space, converge at a single point centrally located on the horizon line (creating a vanishing point).
— Objects diminish in scale as they become more distant. They approach the vanishing point compressed in scale vertically and horizontally, merging and disappearing at the vanishing point.
— Horizontal lines parallel with the top and bottom of the picture plane indicate receding spaces. Although actually evenly spaced, they appear closer together as they approach the vanishing point. (Hence the need for measured spacing, as in tile floors, coffered ceilings, arcades, or tree plantings.)
— If a particular image is placed above eye level, the "nearer" parts of it are larger and higher on the surface. The "farther" parts are smaller and lower. (See the crucifixion ceiling vault of *Holy Trinity* [43].)

— If a particular image is placed below eye level, the "nearer" parts of it are larger and lower on the surface while the "farther" parts are smaller and higher. (See the tomb altar of *Holy Trinity*.)

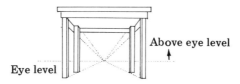

Above eye level

Eye level

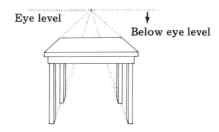

Eye level

Below eye level

— Light/dark is used to model the illusion of solid figurative forms. If the setting is outdoors, alternation of light and dark with the soft-edge patterning of aerial perspective represents a convincing atmospheric setting.
— Fully seen forms indicate "near" and overlapped, partially seen forms seen behind are convincingly "farther" into space.

> *Linear parallel perspective* **uses a single vanishing point, foreshortening, horizontal and diagonal lines, size, overlapping, and tone to create a three-dimensional effect.**

Example

Look again at Masaccio's *Holy Trinity* [43]. Through the use of linear parallel (one-point) perspective, he has convincingly painted the tomb and skeleton as if below your eye level. The kneeling donors to right and left of the niche are represented as if just slightly above the viewer, and within the niche Mary, the crucified Christ, St. John, and God are above eye level. Because of the mathematically correct perspective of the coffered barrel vaulting in the ceiling of the niche, the figures appear to be located deeper into space in relation to it. But notice where the head of each figure has been placed in relation to the ceiling pattern and the way in which the God-Father image seems to project ahead and extend out over the other figures.

Application

Look at Leonardo da Vinci's *The Last Supper* [79] and describe the conventions used to create linear parallel perspective.

– – – – – – – – – – – – – – – – – –

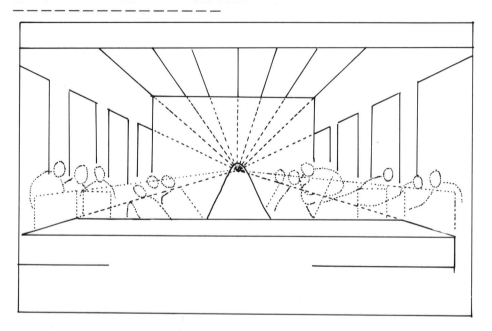

In Leonardo da Vinci's version of this event, a horizon line falls along the earth line of the landscape seen through the open windows, and the vanishing point is located at or behind Christ's head. Diagonals that recede to converge at this point are the lines separating ceiling and walls, the breaks in the coffered ceiling, the top edges of the wall panels, and the ends of the table. The length of the table, the back wall and windows, and the transverse lines of the coffered ceiling are parallel to the picture plane. Spatially, the figures are placed so that the two at each table end are parallel with the diagonal of the table ends. The next figure from either end is parallel to the length of the table. And on each side of center are groups of three, each forming a solid mass that makes a diagonal "wall," which turns outward from the triangular shape of Christ's body and gesture. Overlapping of forms is used, and we see diminution of width in the coffered ceiling with wider bands closer and narrower bands farther away.

The basic spatial conventions used are horizon line, diagonal depth lines, overlapping, size (larger "near" and smaller "far"), and use of light/dark to suggest depth. The conventions that are specifically linear parallel perspective include the definite location of eye level, a single vanishing point, placement of major forms parallel to the picture plane, and controlled use of foreshortening.

(This painting is a mural in the dining room of a monastery in Milan. The shape in the lower foreground was not part of the original composition—

it is a door that was cut into the wall of this room when the monks wanted access from their refectory to their kitchen.)

You may want to look at the following works to see other artists' use of linear parallel perspective:

Raphael—*The Dispute of the Sacrament* [59]
Francesca—*The Flagellation* [55]

Linear Angular Perspective

12. For our discussion of linear angular perspective, refer to Rembrandt's *The Night Watch* [60].

In linear angular perspective, the artist portrays space as if we were looking at or into a corner. As with parallel perspective, this is an optically satisfying way of representing space. It is a system that necessitates *two* vanishing points on the horizon line. If you stand at the corner of a building or a box like a refrigerator and point one arm along one side wall and point the other arm along the adjacent wall, you are pointing at the two vanishing points. Your eye level is the horizon line.

Figures and other forms follow the angular cues of the projective corner and receding sides, producing a dynamic central outward thrust and inward push back on the two sides. Or the artist can reverse this with a central inner thrust and the two walls thrust outward so it seems that we are looking into a corner as in Seurat's *Models* [71]. It is not difficult to imagine one's self moving back and forth within this space instead of simply standing in front of it looking in.

Spatial Conventions

Spatial conventions used in linear angular perspective may include:

— A single horizon line corresponds to the eye level of the viewer.
— At least two vanishing points occur on the horizon line—one to the left, the other to the right. Diagonal lines indicating spatial depth recede to one or the other of the two vanishing points.
— Objects diminish in scale as they become more distant, with verticals diminishing between the diagonals moving toward the vanishing points.
— Objects closer to the viewer are placed lower on the picture plane and overlap more distant forms in the same path of vision.
— Light/dark is used to model the illusion of solid figurative forms. Atmospheric perspective or a strongly contrasting spotlight effect may be used.

Linear angular perspective is more dynamic with its two directions than one-point perspective. It often uses asymmetric balance and inspires the complexities involved in action.

> *Linear angular perspective* uses two vanishing points, a horizon line, diagonal lines, size, overlapping, and light/dark to create a three-dimensional effect.

Example

Look again at Rembrandt's *The Night Watch* [60]. Originally *The Night Watch* hung fairly high above a wooden wainscoting rather than at the spectator eye level as at present in the Rijksmuseum in Amsterdam. Rembrandt's commission was to paint the men of Captain Banning Cocq and members of his company as they formed marching orders. Figures are placed in reference to diagonals that recede toward a left vanishing point and those on the right side toward a right vanishing point, resulting in a projecting "corner" at the points of the forward step and the leading hand of Banning Cocq. (His sash of bright red against the black costume he wears is also a projecting force.) The two figures closest to us are walking forward toward us and have been made largest and placed lowest, while those that follow are smaller in scale and placed higher. The forward figures of Cocq and his lieutenant have caught the most light and are painted with the greatest clarity.

The word *chiaroscuro* is often used to describe Rembrandt's mastery over light and dark with most of the work dark, low in color saturation, and with soft edges. Only the faces, necks, hands, and a few other forms have caught the theatrical spotlighting and have been given clearly defined form. The inside corner of the mass of figures recedes into a dense dark of the great hall from which the figures emerge.

Application

Look at Caravaggio's *The Conversion of St. Paul* [9] and describe the space conventions used to create linear angular perspective.

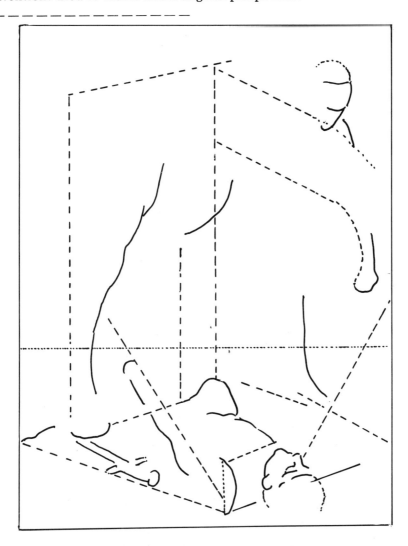

The horizon line is low in this composition. The forms fall on diagonals with St. Paul's arms and head forming a projecting corner. His body leads the eye inward on one diagonal, and the standing horse carries the eye inward the

opposite way on a counterdiagonal. Caravaggio has used light ingeniously; the front section of the horse is in much stronger light than the rear, so the horse's body appears to turn and form an inward corner. The step forward of the man behind the horse closes off the angular "box" space. St. Paul has been struck with such a strong bolt of light that he has fallen from his horse. Caravaggio captures the arrested moment of Paul's blindness through sharp contrasts, giving a brilliant cutting light effect similar to an intense spotlight.

You may want to look at the following works to see other artists' use of linear angular perspective:

Gericault—*The Raft of the Medusa* [24]
Goya—*Execution of the Madrileños* [27]
Seurat—*Models* [71]

Horizontal Banding

13. For our discussion of horizontal banding, refer to Blake's *Book of Job: "When the Morning Stars Sang Together"* [3].

Horizontal banding uses tiered horizontals in which space is indicated by placing stratalike levels of action one above another on the picture plane. Each horizontal indicates a different location in space. The total effect can suggest a lateral view of space with forms stacked like sandwich layers, or it can suggest a multiple perspective of above eye level (bird's-eye view) and lateral view simultaneously.

Spatial Conventions

The basic spatial conventions used in horizontal banding may include:

— Horizontals indicate ground lines or other demarcation of spatial location.
— Vertically oriented figurative forms are placed at right angles to horizontals.
— Overlapping may indicate some degree of depth, although forms often are isolated from one another.
— Smaller forms may be in the top level of banding. Sometimes, however, figures are the same scale on each tier of the bands. At other times hierarchic scale (the most important figures being largest) is used.
— Edge line and flat tone or a minimum of light/dark modeling may occur. Sometimes modeling is sculptural, as in Michelangelo's Sistine Chapel *The Last Judgment* [48].
— The floor plan and elevation may be on the same surface with floor or ground presented as if seen from above and vertical forms as if seen laterally.

Horizontal banding is an effective space system to communicate symbol meanings. It often conveys relative importance, authority, power, belief, or faith. Although limited in visual realism, horizontal banding can effectively communicate what is held in greatest esteem.

> *Horizontal banding* uses tiered horizontals, verticals, overlapping, and light/dark.

Example

In Blake's *Book of Job: "When the Morning Stars Sang Together"* [3], a defined center panel is divided into three levels. The first level suggests earth with kneeling figures. The middle level is a cloudlike ledge supporting a Sun-God-Father with outstretched arms embracing the chariots of the sun and the moon. The third level contains angels of the stars standing with upstretched arms. Framing the center panel is a border containing thin, lightweight line drawings illustrating and explaining the Biblical narrative. These match from side to side as if they might exist in layers behind the action of the center panel. There are few diagonals; the strongest are the axis of the sun and moon chariots poised to push into their respective journeys around the world beyond the immediate area, and the crossed, upstretched arms of the angels of the stars.

Application

Look at Friedrich's *Monk by the Seaside* [17] and describe the space conventions used to create horizontal banding.

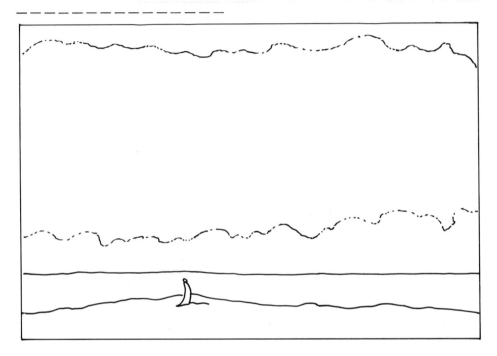

Horizontal bands stretch from left to right. The lower curved band with its irregular edge suggests earth; the next dark band with firm horizontal edge and horizontal flashes of light suggests water; a third band that is further broken into three suggests sky—loosely a very soft edge near the water band, a white cloud area higher, and a band of darker sky above. The only vertical figure is placed at the high point of the earth band connecting the levels of earth and water. No form stops space. The implication is that but for the limit of the edge of the picture plane, it could continue to spread infinitely in all four directions. The scale, the isolation, and the indefiniteness of the figure suggest the powerlessness of mankind, in contrast to the impartial dominion and vastness of space.

You may want to look at the following works to see other artists' use of horizontal banding:

(Egyptian)—*Fowling Scene, XII Dynasty* [88]
Michelangelo—*The Last Judgment* [48]

Planar Space

14. For our discussion of planar space, refer to Matisse's *Icarus, From Jazz* [47].

Planar space is the most two-dimensional, flat type of space, respecting the essential flatness of the picture plane with the least possible interest in three-dimensional depth. At its extreme, planar space is achieved with a film of paint over the field of action, no overlapping of form, and no modeling to indicate near/far. Color may be the most important means of suggesting space, as in Albers' *Homage to the Square* [1]. From the totally flat plane or the flat edge-line form, varying degrees of slight or greater projection of forms do involve figure overlapping ground or figure overlapping figure or a minimum of modeling.

Planar space is very open and free with the least possible containment. It does not represent a focused portion of the world, but rather it implies a

continuous, infinite spread with only the field-of-action edges to arbitrarily stop the spatial extension.

Spatial Conventions

The basic spatial conventions used in planar space may include the following:

— The physical paint itself is applied in flat-layered thickness.
— Sometimes figure overlaps ground; sometimes figure overlaps figure.
— Edge line and flat tone are used with little or no modeling in light/dark.
— Color may become an important space definer.

> *Planar space* uses flat-layered thickness of paint, some overlapping, edge line and flat tone with little or no modeling, and color to indicate space, creating the effect of two-dimensional or flat space.

Example

Look again at Matisse's *Icarus, From Jazz* [47]. There is no ground line. The edge-line, flat-tone figure forms are like paper cutouts that overlap the lighter background. They seem to float in a space that would continue indefinitely except for the terminating edge of the field of action.

Application

Look at Albers' *Homage to the Square* [1] and describe the space conventions used to create planar space.

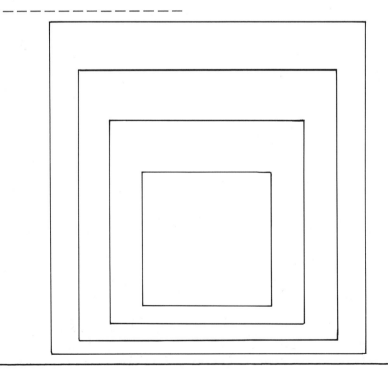

This work has no spatial certainty. It consists of flat-tone, unmodulated planes with a central square plane overlapping another square, overlapping another square, overlapping another square. But, because of the particular values and hues that Albers has carefully selected and placed, it can be viewed as the center square recessed with the middle and outside squares overlapping and projecting, or with the center square projecting and the middle and outside squares falling back, or as any two of the squares blending to fall back with the contrasting space projecting, or the reverse. (Albers has repeated the basic structure many times with the same proportions, but every version is totally different spatially because of the hue and value placement.)

You may want to look at the following works to see other artists' use of planar space:

Vasarely—*Eridan II* [78]
Warhol—*100 Cans* [86]
Anuszkiewicz—*Splendor of Red* [2]
Nolde—*The Prophet* [53]
Mondrian—*Broadway Boogie Woogie* [back cover]
Mondrian—*Composition No. 10, Plus and Minus* [49]

Isometric Perspective

15. For our discussion of isometric perspective, refer to (Chinese)—*Wen-Chi's Captivity* [89].

Isometric perspective does not present a full frontal view; rather it seems to turn away from the spectator. The effect is a slanted or angular view into the picture plane and a diagonally upward-inclined ground plane with the illusion of a very high eye level as if the artist and spectator were on a hilltop (or a theater catwalk) looking down on the scene below or as if we were looking up along an incline above us.

Diagonal lines pitch upward (inward) as if on the picture plane to join verticals that define floor and walls.

When the diagonals tilt inward from left and from right to meet a vertical, three planar surfaces are indicated, forming a diagram of an interior corner. In an architectural isometric perspective draft, the angle pitch is established and does not vary. In painting sometimes all diagonals remain absolutely parallel, and sometimes they incline or deflect slightly from a parallel relationship.

There is *no* horizon line, and depth lines do not converge at a vanishing point, but remain parallel or nearly parallel. More distant forms often do *not* diminish in scale since isometric perspective is a combination of observed fact and what we know to be true. For instance, someone moving away from us appears to get smaller, but we know this to be a temporary optical illusion.

Isometric perspective, a traditional preference of the Orient, deemphasizes temporary visual shifts of appearance and emphasizes the meaning inherent in unchanging, stable proportion. As Arthur Pope notes: "In Chinese and Japanese painting, and in Medieval and much other painting of the West, there is often no pretense of rendering the superficial appearance of things to the eye; nevertheless there may be a perfectly clear expression of the essential character of things."*

Oriental writing is read from top to bottom in vertical columns and from right to left. This totally different orientation to the written word may well relate to the Oriental preference of space and figure placement.

Spatial Conventions

Basic conventions often used in isometric perspective include the following:

— Diagonal lines that remain parallel without converging to a vanishing point indicate depth.
— More distant forms are placed higher, overlapped by forms lower on the picture plane.
— More distant forms are made smaller than foreground forms; sometimes, however, they are the same scale as foreground forms.

> *Isometric perspective* produces a slanted or angular view into the picture plane; forms tend to stay in the same scale.

Example

Look again at *Wen-Chi's Captivity* [89]. The scene turns away from the spectator with an angular, upward view. It is as if we were above looking down or below looking up. The frontal planes of buildings are parallel to the picture plane; horizontals record floor, door, and window structure. The uprights are verticals. Depth into space is indicated with diagonals that are all pitched at

*Arthur Pope, *Introduction to the Language of Drawing and Painting* (Cambridge, Mass.: Harvard Univ. Press, 1939), p. 5.

about a 40-degree angle. These diagonals run parallel and do not tilt toward converging. There is no horizon line. This placement leaves large open spaces for the figurative narrative to occur. Figure forms do not get smaller in the distance, but they are placed high on the surface.

Application

Look at Vincent Van Gogh's *The Yellow Chair* [77] and describe how the conventions of isometric perspective are used to create space.

The view is a room corner with an angular upward tilt. No planes parallel the picture plane. The angle of the floor is pitched at about a 30-degree angle, and the diagonal floor tiles are parallel without converging. The chair is turned at an opposing angle, and its diagonals are at about an 80-degree pitch. (Van Gogh was influenced by Oriental space in this painting as well as in many other of his works.)

You may want to look at the following works to see other artists' use of isometric perspective:

Cezanne—*Mont Sainte-Victoire* [10]
Leger—*Three Women* [36]

Plane and Elevation on the Same Surface

16. For our discussion of plane and elevation on the same surface, refer to (Egyptian)—*Fowling Scene, XII Dynasty* [88].

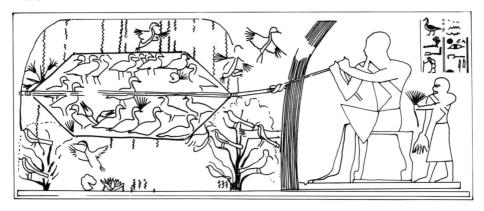

The largest figure is seated behind a screen of bending reeds, watching through the reeds as birds flutter above a net that we see from the bird's-eye view, as if from directly above. A rope that loops through the net and is held by the seated figure will be pulled up to tighten the net and capture the birds. The birds, trees, and human forms are seen from the side (lateral elevation). The net and the zigzag lines indicating the water on which the net floats are seen from directly above (plane). Each view requires a different position in space for the spectator to see in these ways, yet in this work both views are on the same field of action. This spatial system allows the artist to give us more information than if everything were presented from one view or the other.

Among many twentieth-century artists who have used this kind of space are Matisse, Braque, Klee, and Picasso.

Spatial Conventions

The ground, floor, table top, or other shapes that are extensions into space are presented flat and maplike, as if seen directly from above or at an angle from above. Upright forms—such as trees, buildings, animals, people—retain their verticality and are seen laterally. The appearance is of two views you would see from two different locations combined on the same surface.

> *Plane and elevation on the same surface perspective* combines two views—one from above, one from the side—on the same surface.

Application

Look at Limbourg's *Book of Hours: Duc du Berri—Month of April* [38] and describe how the conventions of plane and elevation express space.

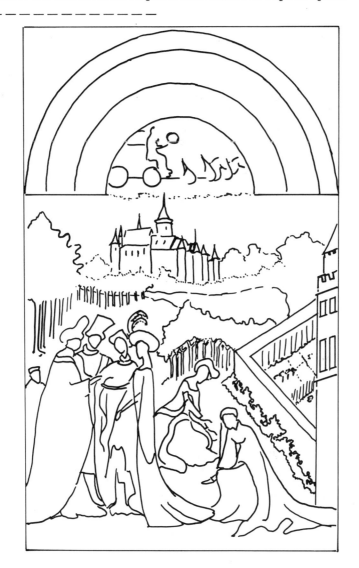

The foreground figures are seen standing or kneeling in profile. It is as if we are on the same level with them, looking into space laterally. The garden and wall of the chateau at right and the lake beyond are seen as if we are above eye level and looking down from above. We see down onto the ledge of the garden wall and onto the plantings of the garden.

You may want to look at the following works to see other artists' use of plane and elevation on the same surface:

Klee—*Around the Fish* [34]
Klee—*Park Near Lucerne* [35]
Campin—*The Merode Altarpiece* [8]

Reverse Perspective

17. For our discussion of reverse perspective, refer to Mantegna's *The Dead Christ* [42].

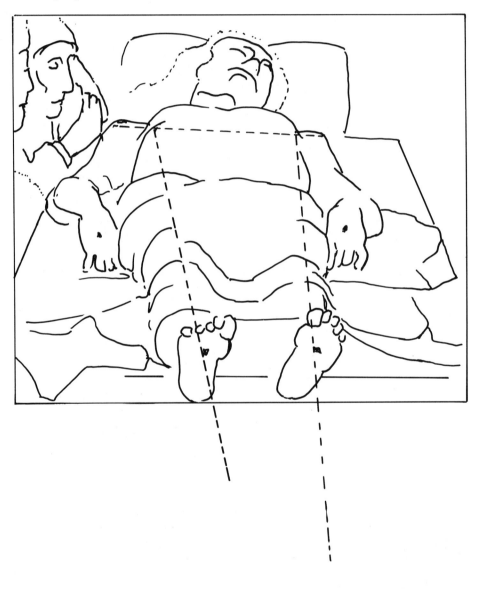

This kind of space system is sometimes called *inverted* or *divergent perspective*.

Many variations of the mourning over the dead Christ exist (note Giotto's *The Lamentation* [26]), but Mantegna's version is a unique representation of this theme. Christ has been laid on a slab with feet first and the torn hands held forth. The intention of the artist was to shock the spectator into feeling the pain. He intensifies the shock with an unexpected perspective reversal. Normally a figure in this position is foreshortened by mathematical rule (which Mantegna knew)—that is, he would have larger feet and a smaller head. However, here the head and chest are increased in size, the feet reduced in size, and the body follows diagonals that converge outside and well ahead of the picture surface so that we are at the vanishing point.

Spatial Conventions

Depth diagonals diverge instead of converge, with the widest spans between them nearer the top of the picture plane and the point of convergence nearer the bottom or in front of the surface. The top face, front face, and sometimes both side faces of cube forms are shown simultaneously, with the result being divergent perspective depth lines spreading apart from each other as they suggest distance rather than converging toward one another to suggest distance as in linear parallel perspective. The sense of movement is toward the viewer.

> *Reverse perspective* uses depth diagonals that diverge with the widest span toward the top; the point of convergence is near the bottom or in front of the surface, producing the effect of movement toward the viewer.

Application

Look at Duccio's *Madonna Enthroned, with Angels* [18] and describe how the spatial conventions of reverse perspective are used to express space.

— — — — — — — — — — — — — —

(Go on to art on following page.)

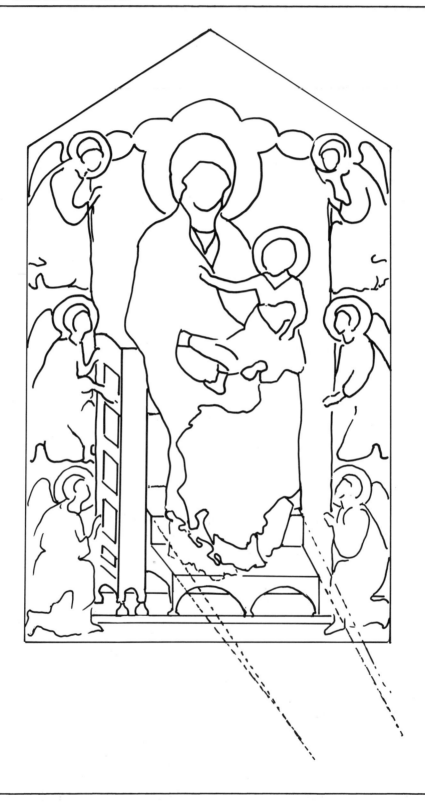

The diagonals of the two throne steps are farthest apart, higher, and "farther away." They are closer together lower and "nearer" to us, so the point where they would converge is out in the space where we stand.

Simultaneous Perspective

18. For our discussion of simultaneity, refer to Braque's *The Musician's Table* [7].

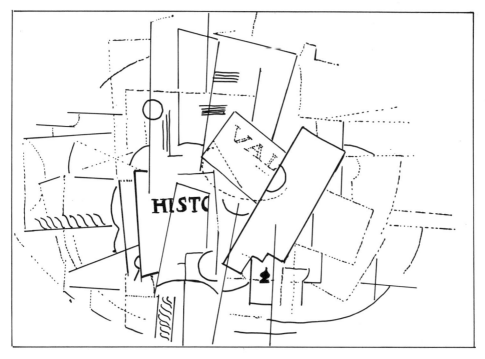

Simultaneity is a general way of describing *cubist* space, which in any of its variations is some combination of multiple perspectives. Cubism is a twentieth-century development in painting with the artist simplifying form so that natural imagery is generalized in the direction of geometric planes or solids. Through reassembling the simplified shapes, the viewer is given fragmented views of a subject seen from many different locations simultaneously.

With simultaneity, forms may be seen inside, outside, top, bottom, back, front, any angle, near, far—multiple viewpoints all at once on the same surface. (This system can draw on x-ray, microscopic, and telephoto viewing.) Since nowadays almost everyone has experienced multicamera imagery on the TV screen, it is easier to understand simultaneity in painting than when first seen early in the twentieth century.

In Braque's *The Musician's Table* [7], you are looking straight down from above onto an oval table. You are given enough clues to be aware of its symmetrical shape. You glimpse the grain of the wood to the left, the right,

and the front right. You look directly down on the circular mouth of a decanter at the left and the top of a stemmed goblet in the center. Simultaneously you see the sides of the decanter and the goblet, and you see through them to paper edges on their far sides. The various overlapping papers are presented from many angles. The letters HISTO and VAL hint at completed words (such as history, histology, valor, valid, valuable) that verbally imply the space of imagined ideas. Braque has used plane and elevation on the same surface in this work, but he has added many other angles of view.

Spatial Conventions

Forms tend to be flat and fragmented. Plane and elevation can be used and added to with many more viewpoints.

Simultaneous perspective presents fragmented views of a subject seen from many different locations at the same time.

Application

Look at Duchamp's *Nude Descending a Staircase* [19] and describe the artist's use of the conventions of simultaneity as a space system.

— — — — — — — — — — — — — — —

(See art on opposite page.)

Anyone looking for a single body in a fixed position will be disappointed. The human form has been simplified to flat planes. The form repeatedly merges with itself as changes in shape and position shift from the upper-left corner, which seems farther away, to the lower-right corner, which seems closer to us. The motion seems to be downward and forward, with forms painted as overlaps and transparencies.

You may want to look at other works in which simultaneity has been used as a spatial system:

Picasso— *Girl Before a Mirror* [color plate 5]
　　　　The Three Dancers [56]
　　　　Les Demoiselles d'Avignon [54]
　　　　Guernica [50]

APPLICATION

19. This has been a long chapter. We have looked into many of the ways in which artists deal with space. Before completing this final application, return to the first page of this chapter and review the chapter objectives. Then examine the two works listed below and describe as completely as you can the artist's use of space in each.

(a) Picasso—*Guernica* [50]
(b) Campin—*The Merode Altarpiece* [8] (each of the three panels)

(a) *Simultaneous perspective:* Picasso's *Guernica* takes place in a boxlike space that is indicated by ceiling-wall diagonals at upper right and left corners, and by floor lines suggesting a squared or tiled floor that tilts steeply into the picture plane. A back-wall window at right with the bright light of the pointed flame shapes implies fire on the other side of the wall as the figure at right seems to fall through space. Panels that swing unanchored may be shafts of light or falling walls. Figures that seem nearest to us are placed lowest and delineated with outlines, edge lines, and flashing alternations of flat-tone light and dark. Picasso has used the fragmented forms of simultaneity with interlocking, overlapping, and transparencies. The boxlike space seems more shallow because of the flat, two-dimensional figures.

(b) *Plane and elevation on the same surface:* The three panels can be looked at separately or together. When viewed together, the total surface is an interesting comparison with the composition of Picasso's *Guernica.* The left panel is outdoors, with large-scale figures of the man (who commissioned this work) and his wife kneeling at the foot of the steps in a courtyard (defined by wall and doorway). They are looking through an open door into the space of the center panel. A man is standing in midground, and we can see a horse and rider and buildings beyond through an open door in the back wall. The center panel is a room interior defined by a steeply inclined floor, by ceiling, side walls, and back wall with open windows through which we see key and clouds. In this space are two figures (the angel Gabriel and Mary) on either side of the tilted table. Both are large in scale in relation to the room. The long bench at the right sweeps the eye into space toward the back wall. Barely visible is a tiny angel carrying a cross gliding into the room space on a shaft of light from a circular window on the left wall. The right panel is the carpentry shop of Joseph. We see a room space with floor, right-wall ceiling, and back wall with open windows. Joseph, busy with his tools, is seated at his work bench, which tilts toward us. Space and the activity of village life can be seen through the openings in the back walls of the left and right panels.

 SEEING THE UNITY

20. As you have seen throughout this chapter, space is directly related to line, light/dark, and color. It also interrelates with order and balance. Examine the following works and describe as completely as you can the use of order, balance, line, light/dark, and space in each:

(a) Chagall—*I and the Village* [12]
(b) Velasquez—*The Ladies-in-Waiting* [80]

— — — — — — — — — — — — — — — —

(a) *Order:* Leans to rigid order (a vertically oriented rectangle).

 Balance: Radial balance.

Line: Mainly edge line, with some passages of continuous line. Contour line in the hand.

Light/Dark: Alternating areas of light/dark. The figures are not modeled in the traditional sense, nor are they flat tone. They are hazy and blot-like, coming and going with a cloudy quality both inside and outside defined edges.

Space: Near forms are large, so near that what we don't see is cropped from view; far forms are very small. A curved line suggests earth, but figures are not anchored and seem to float, defying gravity. A large face appears in one of the distant buildings, and the small animal and figure within the large animal head give an inconsistent scale. The ambiguous space and inconsistent scale suggest a dream or memory in which relative importance establishes priority in size and location.

(b) *Order:* Seems casual, but it is a rigid order system (a vertical rectangle).

Balance: Asymmetric.

Line: A strong, narrow-line pattern of light appears in the apparel of the two right figures. The linear ribbon pattern is picked up in variation as part of the skirt of the kneeling figure at the left. A long, narrow strip of light edges the floor-to-ceiling canvas, and another vertical of light is repeated at the right in the back of the room along the window recession.

Light/Dark: The darks are gray and shadowy, and the gloomy, high-ceilinged space contrasts with light flooding from the open door in the back wall and with the light from the window at right, which falls on the group around the central Infanta Margarita.

Space: The boxlike space of a room with a back wall, right wall, ceiling, and floor is defined by linear parallel perspective. A recessed window at the right lights the foreground figures; two less clearly defined attendants converse in a shadowed midground. A silhouetted figure, diminished in scale, is ascending steps leading out of the room through a brightly lit doorway in the back wall. We also see the reflections of two figures in a mirror against the back wall to the left of the doorway. A drapery swag implies space and action in the space where we stand ahead of the foreground figures. (Note the similarity of the mirror as a space device in Van Eyck's *Jean Arnolfini and His Wife* [color plate 7].)

The illusion of spatial depth is strengthened by two ceiling fixtures, the paintings on the walls (copies of works by Rubens and Jordaens), and the huge foreground panel on which the artist is working. At the left, Velasquez, with his palette and brush, has stepped back from his painting to the edge of the darkened midground. The children ahead of him are positioned to form a triangular floor plan, an inward wedge, and the elevation of this group is also a triangle with the apex the tallest standing lady. Through lighting, position, and gestures, the beautiful little Infanta is the center of attention.

(*The Ladies-in-Waiting [Las Meniñas]* was painted in 1656 for Philip IV of Spain. He and Mariana of Austria, parents of the five-year-old Infanta Margarita, are the two we see reflected in the mirror. The kneeling lady-in-waiting to the left of the Infanta is Doña Maria Augustina Sarmiento. To the right the other lady is Doña Isabel de Velasco. Farther to the right are two dwarfs who were part of the Spanish court, Maribarbola and Nicolasito. The man in the doorway is thought to be a relative of the painter.* It is not known who is posing for the large painting on which Velasquez is working. Some feel it is a portrait of the king and queen; others think it is a family portrait including the Infanta.)

You should now be able to look at a work of art and describe the artist's use of space. You may want to review the objectives at the beginning of this chapter and the material in this chapter before completing the following Self-Test.

SELF-TEST

This Self-Test will help you evaluate how much you have learned so far—how well you can answer the questions raised at the beginning of the chapter. Answer the questions as completely as you can (use a separate sheet of paper) and then check your answers against those that follow.

1. Examine the following works and identify whether the artist has used predominantly flat space, shallow space, deep space, or extension forward from the picture plane:

 (a) Klee—*Park Near Lucerne* [35]
 (b) Harnett—*Old Models* [30]
 (c) Francesca—*The Resurrection* [57]
 (d) Johns—*Target with Four Faces* [32]
 (e) Braque—*The Musician's Table* [7]

2. Examine the following works and identify works in which a horizontal defines earth or floor, works in which diagonals function to carry the eye into depth, and works in which clear/blurred forms suggest space:

 (a) Poussin—*Shepherds of Arcadia* [color plate 6]
 (b) Rembrandt—*The Night Watch* [60]
 (c) (Chinese)—*Wen-Chi's Captivity* [89]
 (d) Munch—*The Cry* [52]

3. Describe how overlapping and control of size of objects add to the illusion of space in Durer's *The Knight, Death, and the Devil* [20].

4. How does figure position on the picture plane contribute to the illusion of space in Rembrandt's *Rembrandt and Saskia* [66]?

*Kenneth Clark, *Looking at Pictures* (New York: Holt, Rinehart and Winston, 1960), p. 40.

5. How does gesture between figures help to create space in Poussin's *Shepherds of Arcadia* [color plate 6]?
6. How are light and dark used to construct space in Rembrandt's *Philosopher in Meditation* [63]?
7. How does color contribute to the illusion of space in Vasarely's *Vega-Nor* [front cover]?
8. Match the spatial perspective used (from the column on the right) with the artist and his work (from the column on the left). More than one perspective may be used in a single work.

(a) ____ Raphael—*The Dispute of the Sacrament* [59]	(1)	Horizontal banding
	(2)	Isometric
(b) ____ Seurat—*Models* [71]	(3)	Linear angular (two-point)
(c) ____ Michelangelo—*The Last Judgment* [48]	(4)	Linear parallel (one-point)
(d) ____ Warhol—*100 Cans* [86]	(5)	Planar space
	(6)	Plane and elevation on the same surface
(e) ____ (Chinese)—*Wen-Chi's Captivity* [89]	(7)	Reverse
(f) ____ Klee—*Around the Fish* [34]	(8)	Simultaneous
(g) ____ Picasso—*The Three Dancers* [56]		
(h) ____ Mantegna—*The Dead Christ* [42]		
(i) ____ Mondrian—*Broadway Boogie Woogie* [back cover]		
(j) ____ Francesca—*The Flagellation* [55]		

9. Examine Lichtenstein's *Whaam!* [37] and describe the artist's use of space.
10. Examine Delacroix's *Liberty Leading the People* [14] and describe the artist's use of order, balance, line, tone, and space.

Answers to Self-Test

In parentheses following these answers are given the number of points each question is worth, if you want to total your overall score, and the frame references where the topic is discussed, if you wish to review.

1. (a) flat; (b) shallow; (c) deep; (d) extension ahead of picture plane; (e) flat. (frames 1–2; 5 points)
2. (a) horizontal, diagonal, and clear/blurred; (b) diagonal and clear/blurred; (c) diagonal; (d) horizontal and diagonal. (frames 3–4; 8 points)
3. Foreground form of the knight and horse overlap both death and the devil, making the latter two seem deeper into space. The group of three overlap two dark hills, which seem farther away. The hills overlap a

group of buildings. The castle buildings are high and so small in scale that they appear very distant. (frames 5-6; 4 points)

4. The figures are at angles to each other and to the picture plane. Both figures turn to look out, drawing the spectator into the space between. The gesture of the upraised arm includes the spectator, bringing us into the celebration. (frames 7-8; 3 points)

5. Gestures of pointing hands (to tomb inscription) and pointing shadow. Two shepherds look downward following the line of the staffs. One shepherd looks to the pointing hands and tomb inscription; another shepherd looks outward toward the shepherd standing in the foreground. These looks and gestures occur ahead of the tomb. (frames 7-8; 4 points)

6. A right wall of dark penetrated by glowing light through a window to the outside. The illusion of other walls, vaulted ceiling, surfaces of floor and steps created by tonalities not as strong in contrast, but which alternate as shadow, reflected light, shadow. (frames 9-10; 3 points)

7. Warm and bright colors advance and seem to project. Cool and duller colors recede and appear farther back, adding to space illusion. (frames 9-10; 2 points)

8. (a) 4 (frame 11; 1 point) (f) 6 (frame 16; 1 point)
 (b) 3 (frame 12; 1 point) (g) 8 (frame 18; 1 point)
 (c) 1 (frame 13; 1 point) (h) 7 (frame 17; 1 point)
 (d) 5 (frame 14; 1 point) (i) 5 (frame 14; 1 point)
 (e) 2 (frame 15; 1 point) (j) 4 (frame 11; 1 point)

9. There is no ground line, but a sky path of clouds indicates the airplane's course from left to right frame. The diagonal axis of the airplane and repeated diagonals indicate speed. The explosion of another airplane takes place in the right frame with an outward radial pattern around the disjointed airplane parts. The forms are defined by a firm dark outline. The shapes are painted flat, using dots placed near or far from one another, yet the forms give the impression of deep sky space. The words are important to the time-lapse aspect of the two frames and to the narrative. (Chapter 5; 10 points)

10. *Order:* Appears chaotic, but has a rigid order understructure within a horizontally oriented rectangle. (Chapter 1; 2 points)

 Balance: Asymmetric. (Chapter 1; 2 points)

 Line: Forms are defined mainly with edge line. (Chapter 2; 5 points)

 Light/dark: Enough modeling to give the illusion of solid forms; much use of strong value contrast. (Chapter 3; 5 points

 Space: The figures are larger in the foreground and smaller in the distance. The forms are defined with greater clarity in the foreground and are soft and blurred to suggest distance. The gestures of the symbolic Liberty striding forward over the dead and wounded with her tri-colored flag held aloft opens the space ahead of her. This outward force is intensified by the man with the top hat carrying a rifle and the boy with guns, who contribute also to an upward motion in forming a

triangle that has its apex on the center axis. The bodies in the fore-ground form the base of this triangle. This work suggests deep space with a distant city behind. (Chapter 5; 10 points)

Total possible points: 73. Your score: _____. If you scored at least 58 points, you understood the main points of the chapter. If your score was lower than this, you may want to review the appropriate frames before you go on.

IMAGINATION STRETCHES

— Photograph empty buildings, streets, and areas emphasizing largeness, vast-ness, stillness, and emptiness.
— Ponder the idea that each spatial distance is infinite in itself.
— At night look at the universe and its infinite space, which is all focused on one finite dot on your eye, which is then pictured in your brain, which is approximately $6'' \times 6''$.
— Lie on your back and look up into the sky on a cloudy but warm day. The areas between the clouds develop into a good space study.
— Observe the space relations of parked cars, furniture in a room, dishes on a table, store items.
— Explore how stacked things make walls: oil cans, groceries, dishes, chairs, stones, logs, and so on.
— Go into the country and look at a long stretch of telephone poles. Stand to one side and look down the line. Pick out one in the distance and move toward it, keeping your eye on the pole you've picked out. Notice how the space and perspective change.
— Notice how space changes around you in a classroom, office, or auditorium through the differences in where people sit.

CHAPTER SIX
Shape and Proportion

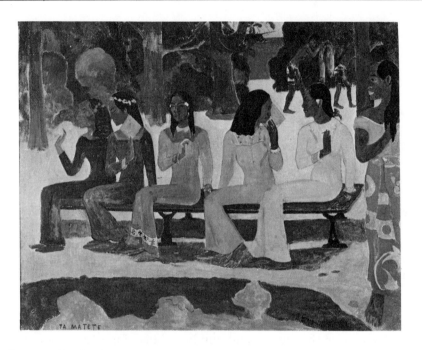

TA MATETE

In a work of art, can you:

- identify and compare geometric and organic shape?
- describe similar or "family" shape preferences in a given artist's work?
- recognize and compare figure and ground shapes?
- describe the scale (size, amount, degree) and its contribution to meaning?
- identify and distinguish between ideal, natural, hierarchic, and distorted proportion?

Now that you understand some ways in which an artist uses line, light/dark, and color, you are ready to look at how the artist controls these factors to create desired shapes and proportions. For the exercises in this chapter you will need (see next page):

Paul Gauguin, *The Market*. 1892. The Kunstmuseum, Basel.

Writing paper
Tracing paper
Pencil

INTRODUCTION TO SHAPE

Our response to shape or form is another influence on how we see works of art. We associate shape with our personal experiences, impressions, and feelings. An old, twisted, weather-beaten building may cause feelings of depression, loneliness, or nostalgia, while the silhouette of a castle high on a hill may evoke feelings related to majesty or fear of Count Dracula. We may associate the earth shapes of a desert with hopelessness and the shape of a steep cliff with fright. We may associate gently rolling hills with peace or comfort.

Keenly aware of our shape associations, advertisers may use bold shapes to suggest strength or assurance and dainty shapes to suggest delicacy or fragility.

"Wie gehts, heute?" If unfamiliar, this juxtaposition of letters and words may evoke feelings of confusion or irritation. When translated from German into "How are you today?," the familiar words are likely to bring a friendly response. Our emotions are affected by both the familiar and the unfamiliar.

Artists of the past tended to use shape to describe a generally agreed-upon reality, but today's artists often use shape to project personal inner worlds unknown to the viewer. We assume that the artist has derived shapes from some kind of life experience. But how do you react when shapes in some works are so foreign that you cannot make any association with life as you know it? This can be very frustrating, and your first response to the logical question, "What is it?" may be derisive or defensive: "My little brother could do that"; "The artist must be insane"; or "I just don't get it."

When the shapes are familiar and combine to present well-known ideas, understanding is easier. We can say that Durer's knight (in *The Knight, Death, and the Devil* [20]) is young and healthy because the shape and lines have a full, rounded character with an upward, forward determination we associate with youthful vigor. The figure of death and his tired old horse, on the other hand, have a downward sag that we associate with fatigue and age. The devil has a piglike shape that probably arouses feelings of repulsion in most viewers. We can, in general, agree that the meaning of this work deals with the relationships between life and death, good and evil.

When the shapes are not familiar or are arranged in an unfamiliar way, interpretation is more difficult. Paul Klee's *Around the Fish* [34] presents recognizable shapes and an order that we can agree upon, but since the sequence is like a series of foreign words, the meaning is probably different for every person seeing it. When seeing Kandinsky's *Improvisation 35* [33], you may not be able to associate shapes in the work with any life forms you have known. Look at it to enjoy the colors, lines, and shapes as you would enjoy watching tropical fish in an aquarium. Thoughts that might drift with

the shifting patterns and colors include sunlight through breaking bubbles, a carnival festival, or a floating garden. Or compare the pleasure of looking at Kandinsky's work to the pleasure of listening to symphonic music.

Familiar shapes and ideas give us the added richness of seeing not only the surface level of subject matter and story, but also different possibilities of interpretation based on our own experiences. Unfamiliar shapes and ideas can provide fresh adventures in seeing through the eyes and mind of another person who brings us provocative new visions and ideas about previously unknown worlds.

Whether representing recognizable objects or nonrepresentational configurations, shape, in itself, has expressive character.

GEOMETRIC AND ORGANIC SHAPE

1. Whether two-dimensional or three-dimensional, a shape* is a figuration that fits within a bounded area. (Recall our discussion of field of action in Chapter 1.) Two major kinds of shape are geometric and organic.

In general, *geometric shape* is a conceptual way of considering the world and forms around you. Basic geometric shapes have been given names: circle, rectangle, triangle, square. Each geometric shape contains its own dynamic. A circle pushes from its center, tending to be expansive. It also inclines to turn and may seem to revolve. A rectangle has a directional quality with either a horizontal orientation with a left-to-right tension or a vertical orientation with an up-down tension. A triangle, no matter what type, is always directional with a pointing character determined by its apex. (An equilateral triangle is the most stable of all triangles, and possibly of all shapes.) A square is a nondirectional shape, but it has an activating force: the diagonals from corner to corner.

Geometric shape is systematic, measured, conceptual; it involves the intellect and conscious decisions. The process of abstracting involves eliminating details from an image and reducing it to its essence, which often becomes a geometric form.

Organic shape is characterized by its resemblance to things that grow and change. Organic shapes are natural configurations, with differentiation rather than uniformity, randomness and chance rather than rigidity and predictability predominating. According to the Romantic poet, Samuel Taylor Coleridge, organic form manifests the process of growth by which it arose; it proclaims itself as the end result of a progressive sequence of development.†

*Sometimes the word *shape* is thought of as indicating only length and width (two-dimensional) and the word *form* as indicating length, width, and depth (three-dimensional). In dictionaries the two words are often used to define each other. In this chapter *shape* and *form* are used interchangeably and may refer to either two-dimensional or three-dimensional configurations.

†Philip C. Ritterbush, *The Art of Organic Forms* (Washington, D.C.: Smithsonian Institution Press, 1968), pp. 20–21.

Organic shapes contain the dynamic tensions of growth that we associate with chance, intuition, emotions, and unconscious choice making.

Although we usually associate geometric shape with man-made objects and organic shapes with objects found in nature, many geometric shapes exist in nature (snowflakes), and many organic shapes are man-made (free-form sculpture). Although artists usually lean more strongly to one kind of shape or the other, both geometric and organic shapes are involved in almost every work of art. The artist often attempts to balance the intellectual, calculated, and measured with the emotional, spontaneous, and intuitive.

> Shape expresses feelings to which we respond. *Geometric* shape is systematic and measured; it is related to the calculated and intellectual. *Organic* shape is irregular and flowing, containing the dynamic tensions of growth; it is related to the spontaneous and intuitive.

Examples

Geometric	Organic	Combination
Tin Woodman of Oz	Man	Men marching in military parade
Silver dollar	Full moon	Sunflower
Egyptian pyramid	Mountain	Pyramid of acrobats

Exercise

Identify each of the following as predominantly geometric, organic, or a definite combination of both:

(a) Skyline of Chicago
(b) Honeycomb
(c) Bird

(d) Aquarium filled with fish
(e) Planted cornfield
(f) Sidewalks

— — — — — — — — — — — — — —

(a) geometric; (b) combination (although literally an organic entity, the shape is very geometric); (c) organic; (d) combination (the aquarium itself is a geometric, man-made shape that contains the organic shapes of fish and plants); (e) combination (the corn is organic shape; the rows are geometric shape); (f) geometric.

Our environment combines hundreds of organic and geometric shapes. Passing a chain-link fence and looking through the mesh into a school yard in the summer, you would notice the geometric forms of the school building and playground equipment. Passing the same fence in fall when school is in session, you may see through the geometric mesh the organic forms of children playing at recess (random, natural growth) amidst the geometric shapes of the playground equipment. The second view probably is "warmer" than the strictly geometric view.

Perhaps you've noticed the cold, uncomfortable feeling of some shopping-center courtyards. This often results from lack of organic shapes. If you've ever canoed on a wilderness river, you may have been awed and mystified—partly a result of the lack of geometric shapes that provide some of the sense of order that we humans need. (Recall our discussion of order in Chapter 1.)

Seeing Geometric and Organic Shapes

2. Compare Leger's *Three Women* [36] with Giorgione's *The Concert* [25]. Leger emphasizes geometric shapes, which he has abstracted from familiar forms. The women are a geometric representation of organic form. Giorgione, on the other hand, uses predominantly organic shapes, retaining a semblance of familiar, real-life forms. *The Concert*, however, has a geometric under-structure.

Application

Examine the following works and identify each as predominantly geometric, organic, or a balanced combination of each:

(a) Braque—*The Musician's Table* [7]
(b) Gauguin—*The Market* [23]
(c) Kandinsky—*Improvisation 35* [33]
(d) Mondrian—*Broadway Boogie Woogie* [back cover]

— — — — — — — — — — — — — — — —

(a) The shapes are predominantly *geometric:* rectangles suggesting paper and playing cards, triangular glass goblet, oval tabletop. (However, organic form is suggested by the wood-grain texture.)
(b) The shapes suggest *organic* forms of human bodies, trees, earth, and water. But these are balanced by a geometric abstraction in all the forms. (Gauguin's abstraction of the human body is similar to that used in ancient Egypt.)
(c) The predominantly *organic* shapes, which are soft edge and atmospheric, could relate to earth and air shapes seen from an airplane. (A geometric structure underlines the total work.)
(d) The shapes are strictly *geometric* and placed within a related geometric space. This could be an air view of an urban center.

SIMILARITY OF SHAPE

3. We learn to recognize objects by their shapes; for example, we can usually tell a cat from a dog by shape alone. Knowing the many different kinds of cats or dogs requires a refinement of the ability to distinguish shape. *Similarity of shape* within an artist's work can be compared with shape similarities in family resemblances. With this parallel in mind, we can speak of a visual "family" of shapes within an artist's work.

A partiality for certain shapes may be found not only within a single work of an artist, but through an entire body of the artist's works. Or certain shapes may be preferred at particular stages in an artist's development, as in the case of Picasso. The human figures of an artist may literally have a close "family likeness" that is particularly evident in portraits. Although people of different ages, sexes, occupations, and stations in life may pose for the artist, the finished portraits are likely to appear as if the models were related to each other.

> Similarity of shape can help you recognize the work of specific artists.

Example

Sometimes members of a family look alike because they have similarly shaped head, nose, or eyes. Often we can match child with parent and sister with sister or brother.

Exercise

Check those items below that can be placed within a family of shapes:

(a) _____ Automobile

(b) _____ Roman capital letter

(c) _____ Rose

(d) _____ Robin

(e) _____ Townhouse

(f) _____ Gothic cathedral

_ _ _ _ _ _ _ _ _ _ _ _ _ _ _

You should have checked all the items. Each can be placed within a family of shapes. It's hard to think of any visual image that cannot be placed in some shape family.

Seeing Similar Shapes

4. Similar (family) shapes throughout an artist's works help us to recognize the artist. With practice, you will be able to identify a work by El Greco, Van Gogh, or another artist, with the artist's preferred shapes often providing a major clue. With further practice, shape can be a deciding factor in determining where and when a work was done.

Look at the works by Picasso from the set of reproductions: *Girl Before a Mirror* [color plate 5], *Les Demoiselles d'Avignon* [54], *The Three Dancers* [56], and *Guernica* [50]. In each work Picasso has transformed organic shape

in a way that indicates his intellectual, careful, conscious decision making. Little is left to chance or whim. His shapes tend to be sharply defined and contained by outline or edge line. Any of the tightly curved shapes seem held in place by predominating angularities with lines coming to points, forming zigzags, pyramids, or prisms.

Application

Observe the following works and identify any shape preferences that occur:

(a) Duccio—*Madonna Enthroned, with Angels* [18] and *Christ at Gethsemane* [16]

(b) Mondrian—*Broadway Boogie Woogie* [back cover] and *Composition No. 10, Plus and Minus* [49]

— — — — — — — — — — — — — —

(a) Preference for circular shapes. Notice the perfect halo circle behind each head in *Madonna Enthroned*. Further segments of circles characterize the entire work. A pervasive roundness carried throughout is a distortion from reality—for example, the abstracted eyes, the rounded nose tip, circular nostrils, round chins and cheeks, and almost cue-ball heads. *Christ at Gethsemane* manifests this same preoccupation with circular shapes: the outside shape of the apostles at left, their heads and halos; the large shape of the center group and their relation to Christ make a larger circle. There are also circles within circles: the shadow shape at right holds the body of Christ into a circular form. Note also the tree shapes and the arcs of the edge of Christ's robes.

(b) The emphasis is on a rigid vertical and horizontal with undeniable strength. In *Broadway Boogie Woogie* these meet to form small squares with rapid, sharp color changes, giving a staccato rhythm. In *Composition No. 10, Plus and Minus*, the shapes are more open with line not meeting to form areas, but always leading the eye to actual or implied right-angle relationships.

FIGURE AND GROUND

5. The word *shape* most commonly refers to a *figure*—a positive, space-filling or solid form. However, another vitally important aspect of shape is the configuration of the empty space surrounding the positive, filled shapes. This shape is called *ground*, negative space, unfilled space, or void. The term *negative* does *not* imply that ground shape is less important than figure shape. One depends on the other for its existence; positive shape cannot exist without negative shape. The terms figure/ground, positive/negative, filled/unfilled, solid/void are used synonymously to refer to this essential duality of shape.

The beginning viewer tends to ignore ground shapes—that is, the unfilled spaces. Concentration is often limited to the demand of the figure shapes, the filled spaces. The educated viewer notes both and their interaction.

Sometimes, however, it is difficult to determine which is figure and which ground. In much art of the Western world, figure and ground seem separately defined, but this is not as true of art of the Eastern world, where it has long been acknowledged that figure cannot exist without ground. The Oriental yin-yang symbol, which has a circle as the field of action, clearly expresses this duality, with one side determining the other and neither more or less important than the other:

When it is unclear which shape is figure and which ground, *ambiguity* results. Ambiguous shape has become a predominating interest of many contemporary artists.

> Every visual experience depends on both *figure* (positive, filled) shape and *ground* (negative, unfilled) shape. *Ambiguity* results when it is unclear which is figure and which is ground.

Example

Thirty spokes share the wheel's hub;
It is the center hole that makes it useful.
Shape clay into a vessel;
It is the space within that makes it useful.
Cut doors and windows for a room;
It is the holes which make it useful.
Therefore profit comes from what is there;
Usefulness from what is not there.*

Exercise

(a) Select a wall that has at least three objects on or against it. Focus your eyes on the outside edges of the objects. Eliminate from your vision all detail until each object becomes as nearly as possible a geometric shape. Now draw on paper the outside shape of the wall (field of action). Within its containing edge place each shape you have defined geometrically. Fill these enclosed shapes with a texture or a solid color.

*Lao Tsu, *Tao Te Ching* (translated by Feng and English). Reprinted by permission of Alfred Knopf, Inc.

(b) Using a copy of the first drawing, reverse the location of texture or color by filling the background and leaving paper color the object shapes.

(c) Look at the wall and the three objects again for a few of the most defining details in each object. Use a copy of the first or second drawing and draw inside the object shapes the most definitional forms that you see within their containing edges—for instance, the panels and door knob of a door. Basic figure shapes can become ground for additional figure patterning.

Here are examples of the three drawings:

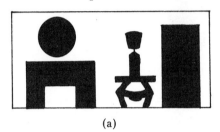

(a)

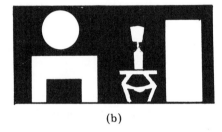

(b)

(c)

Seeing Ground and Figure Shapes

6. Look at Sung K'o—*Cursive Script Poem* [84]. Observe the superb control of filled and empty shapes. Notice the assured, spontaneous control of the forms themselves and the elegant balance of the spaces left behind.

Application

Compare the artists' use of shape in each of the following works with Sung K'o—*Cursive Script Poem* [84] and describe differences or similarities in each:

(a) Klee—*Park Near Lucerne* [35]
(b) Soulages—*Painting, 1953* [73]
(c) Mathieu—*Painting, 1952* [44]

Compare the following pairs of works and describe the artists' use of shape in each:

(d) Van Eyck—*Jean Arnolfini and His Wife* [color plate 7]; Rubens—*Rubens and Isabella Brandt* [69]

(e) Ingres—*Madame Moitessier* [31]; de Kooning—*Woman, I* [15]

(f) Stella—*Sinjerli Variation IV* [72]; Pollock—*Autumn Rhythm* [58]

_ _ _ _ _ _ _ _ _ _ _ _ _ _ _ _ _

(a) The forms are free from overlapping and are more uniform and rigid than the Oriental work. There is a conscious awareness of how each form approaches the others and of the ground as shape. Of the four tonalities, the ground tone is next to the lightest, and the shapes connected through this tonality are as varied and as interesting as the dark, branchlike figure shapes.

(b) It is as if one character of Sung K'o had been magnified, filling the space toward the edges of the surface. The positive shape is the darkest tone, is strongly vertical/horizontal, and its form is like the rune of an ancient Teutonic alphabet. The negative shapes are the lightest areas and the middle-tone areas, which are equal in importance to the positive dark shapes.

(c) Calligraphic lines are more consistent in width than in Sung K'o. It appears to have been done at greater speed, but with similar assurance and spontaneity. The thin line pattern springs against much more empty space. These dark, empty spaces provide other shapes and channels to follow.

(d) The Van Eyck human, animal, fruit forms are organic; the setting is geometric, man-made. Van Eyck's human shapes are thin, elongated, fragile, and delicate. They are large, filling the space of the compressed room. An open window wall and back mirror wall are background for Arnolfini; the mirror wall and bed wall are background for his wife. Rubens' humans are heavier, rounder, more buxom and robust. They are closer to the viewer, filling the surface from edge to edge, falling within a vertical oval shape. Forms in the four corners hint at a garden setting and a background of leaves and flowers.

(e) Organic curvilinear edges and shapes are consistent throughout Ingres' work. Rounded shapes remain a constant in the large shapes as well as in the details: the circle of head and hair accented by the rose circlet, the curve of the shoulders, the double reverse curve of the neckline, the circularity of hands, and the jewels. (Rounded shapes are consistent throughout all Ingres' portraits, each of which carries a very strong "family" resemblance.) The de Kooning forms seem almost like the channels of growing roots or furrows of earth. Distortion in shape is apparent in the large breasts, the seemingly crippled arms and legs, the spread feet, the huge, demanding eyes, and the exposed teeth. Broken line and veils of paint cancel other lines and areas, resulting in a brutal graffiti that meshes figure and ground. The lack of finality in resolving

the form implies the pain that accompanies growth and change, yet the work retains the freedom of the potential for further change.

(f) Stella's work is rigidly geometric, based on protractor curves with careful, measured control, whereas Pollock's forms are organic, based on chance and intuition. Stella's forms are so tightly interlocked that it is difficult to find a figure separate from ground. It is as if the arcs are wedged side by side and at some points woven under or over to tighten the interlock of shapes. In contrast, Pollock's lines, blots, and masses of color become a meshlike web against a lighter ground.

You may want to observe the following works for ambiguous positive/negative relationships:

Riley—*Current* [67]
Vasarely—*Eridan II* [78]
Kandinsky—*Improvisation 35* [33]
Turner—*Steamer in a Snow Storm* [75]

INTRODUCTION TO PROPORTION

You undoubtedly have heard (or used) the expression: "That's out of proportion." By *proportion* we mean the relation of the parts of a form to each other and to the whole. An established standard is implied, and everything is measured or compared with this standard.

Paul Klee believed that ". . . hidden numbers govern endlessly complicated forms of nature."* Many artists, past and present, have been concerned with numerical relationships; for them this is where beauty lies. Number and measure become a major motivation of their work, as in the late work of Mondrian and in many paintings of Jasper Johns where number is actually the subject.

In 1876 Gustav Flechner made thousands of ratio measurements of commonly seen rectangles: playing cards, envelopes, writing paper, books, windows, doors. He found the average close to the proportions of a *golden rectangle.* His and subsequent inquiries point to a popular preference for a rectangle approximating this proportion, undoubtedly an intuitive choice.

The ratio of the golden rectangle fascinated the ancient Greeks. Many of their buildings, including the famous Parthenon in Athens, were based on its ratio. It has been called the *divine proportion.*

Construction of the golden rectangle is accomplished in this manner:†

(a) Segment the side AB of a square ABCD at point E, midway between A and B.
(b) Draw a line from E to C.
(c) With E as center point and EC as radius, draw an arc connecting with C and producing F.

*Werner Haftman, *The Mind and Work of Paul Klee* (New York: Praeger, 1967), p. 37.
†H. E. Huntley, *The Divine Proportion* (New York: Dover, 1970), pp. 60–61.

(d) Locate F by extending AB to intersect the arc line.

(e) Extend DC to G and connect it with F.

AFGD is the golden rectangle. Eliminating a square from a golden rectangle leaves a proportionate shape that is another golden rectangle. This can be repeated indefinitely.

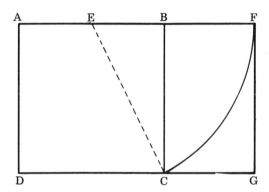

The proportion of the golden rectangle is a classic standard and can be a basis for comparing the proportion of any other rectangle. The measured proportion system of the Roman alphabet on the Trojan column is another example of a classic standard with which all of our letter shapes can be compared.

SCALE AND MEASURE

7. Proportion in visual art deals with comparative dimension, scale, or ratio. In spite of standards for measure such as inches, feet, yards, or metric units, the most basic, ever-present standard for comparison is our own body. Each of us is very aware of the space we displace and the relation of our own size to things and beings in the rest of the world. The focus in examining proportion is on the relationships of size, amount, and degree.

Size generally refers to "larger" or "smaller." Specifically it is expressed in relation to a standard:

YOURSELF	gnome	giant
MISS AMERICA 1979	Tinkerbell	circus fat lady
TYPING PAPER	notepaper	drawing pad
($8\frac{1}{2}'' \times 11''$)	($2'' \times 4''$)	($18'' \times 24''$)

Amount generally refers to "how much." Specifically it is expressed by numbers:

2 people	199 cats	100,000 apples
1 pint	2 quarts	10 gallons
3 lots	10 blocks	5 acres

Degree generally refers to a step in any sequence or gradient. Specifically it is a division of space or a point on a scale:

light · · · dark	bright · · · dull	hot · · · cold
near · · · far	high · · · low	up · · · down

Every artist has general scale preferences, beginning with the size of the field of action, which then becomes a major factor in controlling the scale of whatever happens within the boundary of its edges.

When works are big, more space is needed, not just to display the work but also to allow the viewer to step back far enough to take in its entirety. Small works tend to be closer; sometimes we can hold them in the palm of our hand. We tend to feel more familiar, intimate, near to that which is small. Conversely, we tend to be awed, overwhelmed, absorbed by immensity. Bigness implies greater weight and smallness implies lighter weight; both are balance factors.

Another consideration is the psychological inclination to attach greater importance to bigness and lesser importance to smallness.

> *Proportion* (scale) is based on relationships of size, amount, and degree. Juxtaposition is used for comparison. Scale influences balance and our emotional response.

Examples

Large, high, imposing buildings may fill us with awe, simultaneously making us aware of our own smallness. Smaller buildings may not impress us as much, but they may make us feel more comfortable. An area that is too small, however, makes us feel cramped and crowded.

Furniture that is too big may make us feel small and insignificant. Furniture that is too small may make us feel awkward and clumsily big. (Remember *Goldilocks and the Three Bears?*) Changes in body scale were an important part of Alice's adventures in *Alice in Wonderland.*

Exercise

Matters of proportion—size, amount, degree—are critical concerns in everyday choice making. Read the following and circle the responses that are closest to your choice in each instance:

(a) You are going to cut a door in a wall. How big an opening should you

make? $5'' \times 12''$ $3' \times 6\frac{1}{2}'$ $10' \times 25\frac{1}{2}'$

(b) You are planning to do a painting. How big will the field of action be?

$10'' \times 12''$ $2\frac{1}{2}' \times 4'$ $10' \times 20'$ other _____

(c) You must purchase paint for your canvas. How many and which colors will you choose? white gray black red orange yellow green blue violet other _____

(d) You are painting a self-portrait. Will you include your entire figure set in space as if far from us, or will you include only your head and shoulders as if near to us?

(e) You have been asked to season a salad dressing. Which and how much of the following condiments will you add? salt pepper thyme oregano garlic onion dill celery seed mustard other _____

(f) You are choosing a place to live. What must it be near to? a highway a bar a shopping center a library trees and water people like yourself people different from yourself other _____

- - - - - - - - - - - - - - - -

(a) $3' \times 6\frac{1}{2}'$ unless for a gnome or a giant.

(b) Your choice—a most important decision.

(c) Some limit themselves to two or three colors; others want many more. Where, how often, how much, and in what variation each color appears is as important as how many and which colors are used.

(d) This will depend on what you would like to tell about yourself.

(e) A matter of taste, usually four or five. Some like more, some less. How much is as important as the number selected.

(f) Closeness to (or distance away from) is based on your own preferences and priorities.

When you are looking at works of art secondhand, as in reproductions or slides, scale can be very deceiving. Wherever necessary in this book, the size of works is indicated. But it is hard to realize from the reproductions that Jackson Pollock's *Autumn Rhythm* [58] is large enough to cover a wall end to end, floor to ceiling ($8\frac{3}{4}' \times 17\frac{1}{4}'$). On the other hand, in Jan Van Eyck's *Arnolfini* [color plate 7] portrait ($33'' \times 22\frac{1}{2}''$), the figures are much smaller than life size. Whatever scale or measure system an artist uses affects our response.

Seeing Scale and Its Effect on Response

8. Look at Rene Magritte's *The False Mirror* [39] to see how proportion juxtapositions communicate scale. Considering the scale of an actual human eye (about $1'' \times 2''$), the single eye is greatly magnified in relation to the clouds and the vastness of the sky. Magritte's eye fits into a space of $24\frac{1}{4}'' \times 37\frac{7}{8}''$. In other works Magritte also uses amazing proportions: an apple that fills a room, a comb larger than a bed, a leaf as large as a house. In Magritte's

defiance of commonsense proportions, the ordinary world disappears and is replaced by the strange, yet familiar. Enchantment and anxiety come together as his realism combines with fantasy.

Application

Examine the following works to describe the scale of the proportion juxtapositions and how meaning is affected in each work:

(a) Duccio—*Madonna Enthroned, with Angels* [18]
(b) Francesca—*The Flagellation* [55]

—————————————————————

(a) We know the Madonna and Child are of greatest importance because they are so much larger than the angels.
(b) In this space-time work of art, large figures indicate the near and the now; the small figures indicate the distant and the past.

PROPORTION SYSTEMS

9. A history of art reveals changes in established and preferred porportions for the human body which become standards reflecting both time and place. The proportions of a Rubens figure (seventeenth-century Flanders) would scarcely be considered as qualifying for today's fashion model. Not only do proportion systems vary from time to time and country to country, they also vary from one individual artist to another. A great range of difference in the body proportions can be seen in Botticelli's *The Birth of Venus* [4], Giorgione's *The Concert* [25], Seurat's *Models* [71], Leger's *Three Women* [36], and Picasso's *The Three Dancers* [56]. Proportion is an essential distinction in every artist's work.

Difference in body scale can also be observed in the popular art of the newspaper comics by comparing the consistently recognizable proportions of Blondie with those of Orphan Annie or Peanuts with Dennis the Menace. A proportionately believable world is constructed as a setting for each of these comic-strip characters.

Individual proportion systems can be examined by comparing the work of each artist with the characteristics of four general categories: (1) idealized form, (2) natural form, (3) hierarchic form, and (4) distorted form.

Idealized Form

In ancient Greece (fifth century B.C.) the human body stood for ethical and spiritual values. It was believed that the perfect body might contain the perfect mind. The canon (rule) for ideal body proportions was defined by the most skillful sculptor of the times. These body proportions (as those of Greek architecture) were based on mathematical relationships with all parts determined by a fixed ratio, the unit of measure being a detail such as a finger or

a hand. Imperfections were entirely eliminated, and the canon became a standard for what we now call "classic" beauty. One such widely known and still respected classic standard for body proportions is the Venus de Milo.

Idealized proportion reappears at intervals through the history of art and always represents a striving for perfection.

Natural Form

Not all artists have been interested in ideal form. Some, being more responsive to nature—its accidents and imperfections—base their proportions on studio life studies. Natural form is more "real" than "ideal," more representative of humanity than of abstracted perfection. Natural form includes rather than eliminates observed flaws such as wrinkles or warts; it attempts to communicate photographically realistic proportions of the human body.

Hierarchic Form

The artist may also use scale to indicate a hierarchy of relative importance, making the most important objects largest, the least important objects smallest.

Distorted Form

Distorted form exaggerates proportions in some way, often creating a grotesque effect. This distortion communicates a special kind of information about the subject or provides the viewer with heightened expressiveness. Distorted form, frequently seen in primitive and folk art, is also characteristic of much twentieth-century art.

> *Idealized* proportion seeks mathematically perfect, flawless beauty. *Natural* proportion, based on life study, includes real, accidental flaws. *Hierarchic* proportion expresses the most important as largest, *Distorted* proportion exaggerates to inform or to intensify expressiveness, often creating a grotesque effect.

Examples

Idealized proportion: A Christmas tree on a greeting card, with the tree perfectly symmetrical, an ornament hanging from each branch.

Natural proportion: A painting of a Christmas tree that looks like a specific kind of pine, including a few bare spots and drooping branches.

Hierarchic proportion: A child's drawing of a little Christmas tree with the presents and the child bigger than the tree.

Distorted proportion: A "Charlie Brown" Christmas tree, without needles—
pathetic, grotesque.

Exercise

What proportion system would probably be intended in each of the follow-
ing:

(a) An advertisement with Miss America riding in a Cadillac.
(b) A political caricature.
(c) A photo on the sports page of a batter connecting with a pitch.
(d) An advertisement for a corporation in which the founders are photo-
 graphed nearest and large in scale and the working staff in the back-
 ground and small in scale.
(e) Find other examples of proportion systems in advertising.

———————————————————

(a) ideal; (b) distorted; (c) natural; (d) hierarchic;
(e) Answers will vary. You might have found: (1) Cosmetic ads or cover-
 girl photos where portrait photography is retouched to present *idealized*
 form. (2) The comic page on which almost every strip uses a different
 proportion system of *distortion.* (A few are idealized form—Steve Can-
 yon, Mary Worth.) Or the distortions of *Mad* magazine. (3) Candid-
 camera shots of people who are not posing self-consciously, or a news
 story with accompanying *naturalistic* photos. (4) Advertising photog-
 raphy where the product being promoted is gigantic and everything
 (everybody) else is smaller and less important—*hierarchic.*

The most important thing about an artist's proportion system is neither
degree of idealism nor distortion, but adherence to the standard set—that is,
consistency in using the proportion system. For instance, in any work of
Ingres the idealized proportions for the human form are always recognizable
to us and are an integrated part of the unity and meaning. In the work of
de Kooning the distortion of proportion that he feels impelled to paint and
by which we always know a de Kooning painting are equally an integral part
of the unity, the expressiveness, and the meaning.

Seeing the Proportion System

10. Ideal proportion, based on the search for flawless beauty, is seen in
Raphael's *Madonna del Cardellino* [61]. Natural proportion of figures based
on life study is found in Courbet's *The Painter's Studio* [13]. Hierarchic
proportion with the most important shapes largest is seen in Duccio's
Madonna Enthroned, with Angels [18]. And distorted proportion with exag-
geration to intensify expressiveness is found in Picasso's *Girl Before a Mirror*
[color plate 5].

Application

Identify the proportion system used (ideal, natural, hierarchic, distorted) in each of the following works:

(a) Vinci—*The Virgin of the Rocks* [83]
(b) de Kooning—*Woman, I* [15]
(c) Caravaggio—*The Conversion of St. Paul* [9]
(d) (Egyptian)—*Fowling Scene, XII Dynasty* [88]
(e) Botticelli—*The Birth of Venus* [4]

_ _ _ _ _ _ _ _ _ _ _ _ _ _ _ _

(a) ideal; (b) distorted; (c) natural; (d) hierarchic; (e) ideal

APPLICATION

11. Examine the (Egyptian)—*Fowling Scene, XII Dynasty* [88] and describe as fully as you can the artist's use of shape and proportion.

_ _ _ _ _ _ _ _ _ _ _ _ _ _ _ _

This work has a balance of organic form and geometric form (perfected in the art of ancient Egypt). Similar shapes are found in the alphabetic glyphs and in the variations of silhouette figure forms. The decorative bird shapes are recognizable species of fowl. Figure and ground are sharply differentiated, with contrast provided by edge line, outline, and flat tone. Hierarchic proportion presents the important figure, the Pharaoh-God-Man, largest and his attendants smaller. Body pose is distorted for maximum expressiveness. (This distortion uses an accepted Egyptian convention—presenting feet, legs, and head in profile; chest and eye in full front.)

 ### SEE THE UNITY

12. Combining what you have learned thus far, examine Gauguin's *The Market* [23] and discuss the artist's use of order, balance, line, light/dark, space, shape, and proportion.

_ _ _ _ _ _ _ _ _ _ _ _ _ _ _

Order: Rigid. A horizontal rectangle.

Balance: Asymmetric.

Line: Thin, dark, or light outline describe some forms; others are defined by edge line with color contrast. Directional emphasis is on verticals and horizontals.

Light/Dark: A minimum of modulation in the forms that appear more flat than three-dimensional. A mid-area band provides a light ground for the darker, major figure forms.

Space: Horizontal banding, with the conventions of forms overlapped and more distant forms made smaller and higher on the picture plane.

Shape and Proportion: Similar shapes are found in the hair, bodies, and foliage forms. Human forms are recognizably organic, but geometrically abstracted and distorted similar to the forms of ancient Egypt. The seated figures have profile heads (except one), full-front upper torso, profile hips and feet. Foliage forms are abstracted to large, flat shapes, suggesting the generalized shapes of plant growth.

You should now be able to look at a work of art and discuss the artist's use of shape and proportion. You may want to review the questions at the beginning of this chapter before completing the following Self-Test.

SELF-TEST

This Self-Test will help you evaluate how much you have learned so far—how well you can answer the questions raised at the beginning of the chapter. Answer the questions as completely as you can (use a separate sheet of paper) and then check your answers against those that follow.

1. Identify and compare the basic kinds of shape in:

 (a) Vasarely—*Eridan II* [78] and (b) Van Gogh—*The Starry Night* [color plate 8]
 (c) Leger—*Three Women* [36] and (d) Giorgione—*The Concert* [25]

2. Identify any similar shapes that occur in the following works:

 (a) El Greco—*St. Martin and the Beggar* [22] and *The Resurrection* [21]
 (b) Klee—*Around the Fish* [34] and *Park Near Lucerne* [35]

3. Compare the difference in the way figure/ground shapes have been delineated in:

 (a) Botticelli—*The Birth of Venus* [4] and
 (b) Duchamp—*Nude Descending a Staircase* [19]

4. Discuss the figure/ground relationships in Turner's *Steamer in a Snow Storm* [75].
5. Describe the scale within each of the following works and its contribution to meaning:

 (a) Chagall—*I and the Village* [12]
 (b) Friedrich—*Monk by the Seaside* [17]

6. Identify the proportion system (ideal, natural, hierarchic, distortion) in each of the following:

 (a) Courbet—*The Painter's Studio* [13]
 (b) Raphael—*Madonna del Cardellino* [61]

(c) Duchamp—*Nude Descending a Staircase* [19]
(d) Chardin—*The Boy with a Top* [11]
(e) Chagall—*I and the Village* [12]

7. Look at El Greco's *St. Martin and the Beggar* [22] and describe the artist's use of shape and proportion.

8. Look at Picasso's *Les Demoiselles d'Avignon* [54] and describe the artist's use of order, balance, line, tone, space, shape, and proportion.

Answers to Self-Test

In parentheses following these answers are given the number of points each question is worth, if you want to total your overall score, and the frame reference where the topic is discussed, if you wish to review.

1. (a) Geometric shape: squares, rigid edge definition of shape, sharply defined shape through strong contrast of tone. (frames 1–2; 2 points)

(b) Organic shape: softer edge curved and flowing shape. Broken lines as a unit of construction; less contrast in tonal relationship resulting in less sharply defined shapes. (frames 1–2; 2 points)

(c) Geometric shape. (frames 1–2; 2 points)

(d) Organic shape. (frames 1–2; 2 points)

2. (a) The shapes have a shifting quality due to the background shadows that "eat" into the forms. The shapes appear to cave in or depress in the shadow and to project in the light areas. This is always done in an angular emphasis with the forms being a series of interlocking triangles. The shapes never have straight edges, but are always flickering and flamelike. (Note the refinement of this in faces and hands.) (frames 3–4; 2 points)

(b) The shapes of Klee are indicated with trailing lines that most often curve slightly and terminate without completely defining or containing shapes. In *Around the Fish* the plate and fish are contained shapes, but the eye is led out of this central area by a light diagonal at left and continues "around the fish" on linear trailings. *Park Near Lucerne* suggests not only growing forms with these linear trailings, but also alphabetic, calligraphic shapes. (frames 3–4; 2 points)

3. (a) There is a definite figure differentiation between the forms of Venus, the "Winds," the clothed attendant, and the background against which they are seen. Figures are separated from ground through differences in tone, texture, and line direction. (frames 5–6; 2 points)

(b) Figure and ground are not definitively differentiated. Forms seem attached to one another and to the background. The intermeshing of figure/figure and figure/ground is accomplished through broken line and through closely related colors and tones. (frames 5–6; 2 points)

4. It is difficult to decide what is figure and what is ground. There seem to
 be no solid forms; only a few fragile lines suggest the shape of a ship.
 The ambiguous effect gives the impression of shifting atmosphere.
 (frames 5–6; 2 points)

5. (a) A small woman and goat are inside the larger goat's head. A small
 man and an upside-down woman are juxtaposed with the very large
 head at the right. Contrast of large/near and small/far with no
 transition suggests dream or memory relationships. (frames 7–8;
 2 points)
 (b) The smallness of the monk in comparison to the vastness of space
 implies the helplessness of a single human in the infinity of space.
 (frames 7–8; 2 points)

6. (a) natural; (b) ideal; (c) distorted; (d) natural; (e) hierarchic. (frames
 9–10; 5 points)

7. Shapes are nature-oriented and organic. Similar shapes are large, triangu-
 lar, wedgelike forms that are further broken into by smaller wedges
 through edges of form "eaten" into by background darks. Figure and
 ground are locked together by this light/dark interplay. The scale of the
 large figures contrasts with the very small forms of the landscape. This
 is a matter of relative importance as much as an indication of near/far.
 El Greco's figure forms lean toward distortion with exaggerated thinness
 and elongation. The tall, emaciated bodies contain a uniquely spiritual,
 expressive quality. (Chapter 6; 10 points)

8. *Order:* Rigid. (Chapter 1; 2 points)
 Balance: Symmetric. (Chapter 1; 2 points)
 Line: Thin light or dark broken outlines start and stop to describe
 shapes. Edge lines describe through color and tone contrast. The axis
 lines of the forms are vertical, but almost all outlines and edge lines fall
 along curved or straight diagonals. (Chapter 2; 5 points)
 Tone: A minimum of modeling suggests volumes. Hatching and
 stipple are used in faces and bodies of the two right figures. The bodies
 of all the figures are light in tone, but the faces of three are much darker.
 A narrow panel in the background at left is balanced by a wide, lighter
 panel of white and blue behind the figures. (Chapter 3; 5 points)
 Space: The forms all appear flat: figure shapes, still life, and back-
 ground. Overlapping occurs, but both figure and ground forms interlock,
 appearing as if broken into fragments, looking like shattered glass.
 (Chapter 5; 5 points)
 Shape and proportion: The sources for shape are recognized as
 organic, but there is a decided leaning to geometric transformation. A
 dissonant pattern of similar triangular shapes and clean, sharp lines or
 edges coming to points and abruptly changing direction continues
 throughout the work. The natural and comfortable transition of ana-
 tomical parts within the figure forms is destroyed by unexpectedly
 shattered form or by contorted poses. Figure and ground merge where
 line breaks or where hues and tonalities are close. In other parts of the
 work, figure and ground are distinctly separated by edge line, outline,

or clear, sharp contrast of hue or tone. The scale of the figures is large in relation to the field of action and the still life in the foreground. Picasso's figure forms are distorted from comfortably natural forms, and his expressive anatomical distortions are inconsistencies that become consistent. (Chapter 6; 10 points)

Total possible points: 66. Your score: _____. If you scored at least 53 points, you understood the main points of the chapter. If your score was lower than this, you may want to review the appropriate frames before you go on.

IMAGINATION STRETCHES

— Observe how snow changes, softens, and abstracts all shapes that it covers— like a white blanket over everything. Where a wind gets a whirling sweep, notice how mountainlike the drifts become.
— Ride in an airplane and look at the shapes of cities and the countryside from high above.
— Notice how the shadows of dusk change forms. Continue to watch shapes change with growing dark. They become more and more abstract, reduced in detail, and finally lost entirely.
— Look at and try to record the shapes between tree branches.
— Do you think your preference for a human figure proportion tells another person something about you? Karen Machover* does; she has developed a Draw a Person Test that, monitored in controlled conditions, is used as a psychological test.
— Give each person in a group a sheet of paper of exactly the same size (about 3″ X 6″). Ask each to draw the human form. Pin the results side by side to see how different each set of proportions is.

*Karen Machover, *Personality Projection in the Drawing of the Human Figure (A Method of Personality Investigation)* (Springfield, Ill.: Thomas, 1949).

CHAPTER SEVEN
Texture

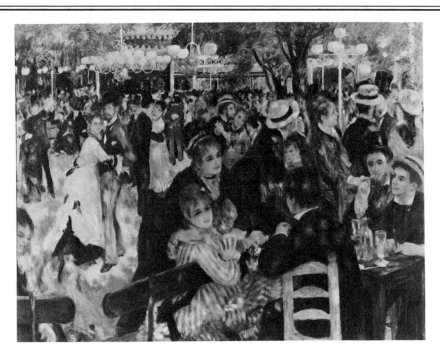

 In a work of art, can you:

- identify and describe the difference between actual texture and implied texture? Imitative and stylized texture?
- identify and describe how actual and implied texture were achieved?
- identify and describe textural variety, textural focus, and textural uniformity?

These are the skills on which we'll concentrate in this chapter. You will need the following materials for the exercises:

Paste
Some objects of varying texture
Pencil or pen
Wax or lithograph crayon
Paper
Photographs of yourself

Auguste Renoir, *Le Moulin de la Galette*. 1876. Des Musees Nationaux, Paris. Collections du Musee du Louvre.

INTRODUCTION

Texture refers to the tactile quality of an object—what it feels like to the touch. Texture also refers to the appearance of a surface in tactile terms—what we *think* it would feel like to the touch.

Every surface has a texture—smooth, rough, fine, coarse, soft, hard, loose, tight, slick, grainy, wet, dry—depending on its substance and structure. Since texture is ever present, it is easy to overlook its importance. For the artist, however, texture is a major consideration involving line, light/dark, and color with the following avenues of experience and control:

Actual texture—related to the direct touch sensation (independent of vision).
Materials used—which have their own distinct textures.
Implied texture—related to visual associations with actual texture.
Functions served by actual and implied texture.

ACTUAL TEXTURE AND MATERIALS USED

1. The first, most direct, way of experiencing texture is through physical touching. The sensation of touch does *not* depend on vision; it is the real experience of physical contact—*actual texture.*

Life begins with response to touch, the feel of things outside self. These sensations become part of learning about the world. Touching remains important throughout life for learning, experiencing, and growing. When we touch, we "feel," and we respond according to our needs and whether the experience is fulfilling or disappointing, pleasant or unpleasant.

The compulsion to touch is so strong in each of us that DO NOT TOUCH signs are commonly placed where it is understood that the temptation for direct contact is particularly great. The actual touching of paintings, drawings, and most two-dimensional art is generally discouraged or forbidden because of the possibility of damaging, wearing away, or soiling fragile surfaces.

Materials

Any material with which an artist paints or draws is called a *medium*. Media (plural) are the substances through which the work is accomplished. The media with which the artist works and the surfaces on which the work is performed are important contributing elements in the texture and the character of any work. Each medium and each working surface is a physical, textural substance requiring from the artist a special sensitivity to what each will and will not allow.

Working Surface

Various surfaces are available to an artist. The most commonly used surfaces include: paper, fabric (such as canvas), wood, masonite, and gesso (which is basically a mixture of refined plaster, glue, and water used to seal canvas, wood, and masonite).

Media

The media are also extremely varied. The artist can choose from among the following, and more:

— *Casein:* The pigment binder is lactic from milk or cheese. Casein is an opaque paint with a muted quality lacking transparency or high brilliance. It is soluble in water until it sets. The usual working surfaces are paper or wood.

— *Charcoal:* Wood such as willow or bass sticks are heated until everything but the carbon has evaporated. The process is controlled to produce soft, medium, and hard sticks of varying thickness. The carbon is also pulverized and compressed into sticks or made into pencils. The surface for charcoal is usually paper. Paper made especially for charcoal has a decided "tooth" that holds the powdery charcoal. Tortillons (tightly rolled paper sticks), chamois, and kneaded erasers are used to blend or lift the charcoal for gradations of light.

— *Conté:* Square sticks of crayonlike chalk are available in three degrees of hardness—soft, medium, and hard—and in white, black, and red earth colors. They have a waxy quality that adheres to the paper more than pastel. They blend, but not as readily as pastel.

— *Dye:* Chemical-action dyes and light-sensitive dyes used commercially are now available to the artist. Color fast and brilliant, they can be used to color fibers, paper, or leather. Less reliable, but often more subtle in color, are natural dyes brewed from flowers, nuts, tree back, leaves, lichens, and berries.

— *Encaustic:* Hot beeswax, glue, and turpentine or oil are mixed with a pigment. When the paint surface has been applied and cooled, it is sometimes burnished (rubbed with gentle, even pressure) to give added luster. The working surface is usually canvas, but it can also be paper.

— *Fresco:* The pigment is applied to the last refined coat of damp plaster coated onto a wall or panel. As the lime in the plaster interacts with the pigment, the paint bonds to the wall surface. Only as much of this last coat of plaster is prepared as can be painted on in one day. A true fresco has joins made in the work from day to day which become a part of the design.

— *Gouache:* Pigment is bonded with a mixture of water, gum, and honey. The effect is a mat (dull), opaque (completely conceals anything underneath) quality. The solvent is water; the working surface is usually paper.

— *Ink:* Although usually thought of as a fluid, ink can be in stick or paste form. Stick ink—usually Oriental (sumi)—is ground together with water in a slate tray as the ink is needed. Paste ink is used mainly in print making.

Fluid ink is made from lampblack or various dyes. Ink is generally controlled with a pen or brush. Pens are quill, reed, or steel, all of which continue in use today. Brushes in a variety of sizes and shapes are made from animal hair such as sable, ox, goat, rabbit, or, more recently, from plastic bristle. They are held in either a flat or round ferrule (a metal tube that joins the handle). Many other tools are also used in applying ink and paint: sticks, knives, spray guns, stamps of various designs, and cotton swabs, to name only a few. Papers used for inks range from newsprint to absorbent Oriental rice paper or slick, hard-press paper. Skin, scraped and stretched, is also used. Calfskin is known as vellum; sheepskin as parchment.

— *Lithograph:* A black chalk is compressed with grease into square sticks of varying degrees of hard to soft. Litho is very responsive to the pressure of touch, and it smears, but it does not erase easily.

— *Oil paint:* Pigment is bound with oil, usually linseed, and then thinned with turpentine, linseed oil, varnish, or some other solvent. Oil paint is flexible and can be used thinly and transparently (glaze) or thickly and opaquely (impasto) to stand out from the ground. Because of the oil base, the paint slides and is slow in drying, so it can be blended with great subtlety. One of its chief disadvantages is the cracking that occurs with drying at different stages in overpaintings. The working surface usually is canvas, wood panels, or masonite sealed with gesso. Many contemporary artists prefer unsealed or unsized canvas so the paint soaks into the threads.

— *Pastel:* Finely ground chalk is mixed with color and an aqueous binder, then compressed into round or square sticks. Available in a wide range of colors, pastels are dry, powdery, and easily blended. The working surface is usually paper.

— *Pencil:* The common "lead" pencil is actually graphite, which comes in several degrees of hardness. H pencils are hard and give light tones and a firm, fine line. B pencils are soft and give a dark tone and a spread line as the graphite gets softer.

— *Synthetic (acrylic) or plastic paint:* This paint, composed of pigment with liquid plastic as the binder, is soluble in water until it sets. It dries rapidly and is permanent both in color and texture. It does not crack or split. It is excellent for a smooth, brushless texture. It can be used as a thin transparency similar to water color or as an impasto by adding emulsion of marble dust, chalk, or sand to give added body. Synthetic paint does not have the luminosity nor the plasticity of oil paint. The working surface can be paper, wood, canvas, glass, or metal.

— *Tempera paint:* Traditionally the pigment was bound in egg yolk or egg white, and the working surface was a wooden panel surfaced with sanded layers of gesso. Tempera painted on gesso has a durable, jewellike brilliance. True egg tempera is not used much today, having been replaced by commercially prepared tempera paint.

— *Watercolor:* Pigment is bonded with thinned glue in dry cakes or in paste in tubes. This softens when water is added. Except for white, the colors are transparent. The working surface is usually paper. A rag paper is desirable because of its absorbency, toughness, and responsiveness to touch.

— *Wax crayon:* The wax crayon is well known and widely used by children. Pigment is bonded in wax that does not blend easily, but colors are sometimes layered and scratched back with a sharp tool to undercoats of color. With heat (electric light bulb or iron), they melt and spread. The surface is usually paper, but wax crayons have been used on other surfaces such as cotton fabric.

Some Techniques

Techniques in using these materials include painting, drawing, and print making. Since painting and drawing are probably already somewhat familiar to you, we will look briefly only at print making and some other techniques that may be new to you.

Print Making

Print making generally depends on a surface that has some raised and some lowered areas. Several materials may be used, including linoleum, wood, plaster, copper, and lithograph stone. Some of the better-known types of print making are described below.

— *Intaglio printing:* The depressed, grooved, or lowered surface holds the ink; the raised surfaces are wiped clean. Under intense pressure, the ink is squeezed out of the cut, bitten, or scratched hollows and onto dampened paper.
— *Planographic printing:* This method depends on the principle that oil and water don't mix. The area of the design to be printed is drawn with a grease crayon and chemically treated so it will hold and transfer ink. The rest of the surface is wetted to reject the ink. (Monoprint and lithograph.)
— *Relief printing:* The raised surface is inked. Under pressure the raised surface releases the inked design onto paper.
— *Stencil printing:* Areas that are *not* to receive ink are coated or masked off with film to hold back the ink, which is applied through the openings remaining. Silk-screen printing (called *serigraphy*) is a more sophisticated form of stencil printing.

The artist usually produces several of each print, but each one is given special care and is considered an original. Each is signed and numbered with a fraction, the first number indicating the position in the printing sequence, the second number indicating the total number printed. For example, the fifth print made in a series of twenty-five prints would be indicated as 5/25. If a print is not signed and numbered, its authenticity as an original is questionable.

Other Techniques and Materials Used

The techniques and materials available to present-day artists are greatly varied. Among them are the following:

— *Appliqué:* Areas of fabric or other surface material are laid over another fabric surface and glued or stitched into place.

— *Collage:* A collection of "found" objects,* which may be two-dimensional or three-dimensional (projecting in relief), are glued or stitched onto a surface (usually canvas or wood) and often combined with paint. They are sometimes called *combines* or *recycled art.*

— *Enamel:* Powdered colored glass is melted onto copper (sometimes brass) by means of controlled heat in an enameling kiln.

— *Mosaic:* Colored bits of glazed tile (called tesserae), natural-colored stone (sometimes semiprecious), and glass are bonded into place to form an abstract pattern or a pictorial image. Remarkable variation of surface can be achieved.

— *Needlework:* Stitchery with fiber or other stringy material is designed into a fabric or other surface such as felt or suede.

— *Rubbing:* Paper is placed over a textured surface. Wax crayon, lithograph, or pencil is lightly rubbed over the paper. High surfaces pick up the medium; low surfaces remain paper white.

— *Stained glass:* Segments of colored glass are held into place by I-shaped channeling of soft lead that bends to fit the irregularities of the glass shapes. The leading forms a consistent outline to the whole pattern. The surface is strengthened and the design affected by intervals of heavy metal rod that run horizontally from side to side of the framing edge.

— *Trapunto:* Fabric is stuffed and stitched to give it a dimensional projection from the flat surface. *Quilting* is a restrained variety of trapunto.

— *Weaving:* Stringy fiber or other material is intertwined. Weaving can be two- or three-dimensional. When a pictorial image is constructed into the threads, weaving is called *tapestry.* Basically warp threads lay on one plane and weft threads twine under-over-under-over with every other weft thread alternating the sequence. This is called a *tabby weave.* The variations of thread intertwine patterns in weaving are endless.

In contemporary art the artists' materials are mixed and combined in many new ways. The emphasis on experimentation and inventive new uses of both tools and materials gives results very different from traditional usage.

> *Actual texture*, that which can be physically felt, results from the materials and tools used in a work of art.

Examples

In the world-famous Brooklyn Botanical Garden the blind can experience growing things through touch. A circular garden has borders that are waist high so participants have only to lean over, reach out, and touch the plants whose leaves, stems, and blossoms have textures ranging from sharp, thorny, and bristly to smooth, soft, and velvety.

*See Glossary.

Aware that food provides a tactile experience, Oriental cuisine emphasizes foods that combine creamy and smooth, crisp and crunchy, and stringy and sinuous.

Exercise

Attach a textural word to each of the following:

(a) Mirror
(b) Oak bark
(c) Baby's skin

(d) Cement
(e) Thistle stem
(f) Ice cube

– – – – – – – – – – – – – – – –

(a) Smooth, hard; (b) rough, hard, coarse; (c) soft, smooth; (d) rough, hard; (e) prickly, sharp; (f) hard, smooth, wet.

To further experiment with actual texture, make a grid like that which follows. Find and mount side by side in the spaces samples of two-dimensional surfaces, each having a different feel—for example, tin, cotton, fur, coarse and fine sandpaper, satin, velvet, wool, felt, leather, suede, burlap, or lace.

Seeing Actual Texture

2. Look at Schwitters' *Revolving, 1919* [70], a collage built of actual found objects attached to the surface and painted on. The materials include real screen mesh, rope, wood, nail heads, and metal. The texture and color of the paint is worked into these objects, unifying their disparity through textural transitions and color keying. If you could touch Schwitters' collage, you would experience firsthand the actual objects and their textures. For the artist, constructing a collage is a different textural experience than painting the appearance of texture. Likewise, for the viewer, seeing the original is a very different visual experience.

Some artists make their textural surfaces physically rough by using very thick paint or by scraping paint off and adding this to freshly mixed paint and reapplying it, or by adding sand, plaster, or ground stone to the paint. Other artists paint very smoothly. Many, for example, add linseed oil to oil-base paint to make it spread more easily, giving soft, subtle blendings. Some use acrylic paint that does not blend as easily, but which gives a very flat, smooth, brushless surface.

Van Gogh's rough, broken brush strokes in *The Starry Night* [color plate 8] have been compared with skeins of stitchery. Seurat's points of paint in his *Models* [71] result in a consistent surface texture comparable to the uniformity of needlepoint. Stella's *Sinjerli Variation IV* [72] has a smooth, brushless surface that seems to have been stamped into place by machine rather than meticulously painted by hand.

Application

Although you are dealing with reproductions and it is very difficult to decide secondhand how texture feels from how it looks, try to imagine what the surface of the originals would feel like (rough or smooth?) in the following works:

(a) Magritte—*The False Mirror* [39]
(b) de Kooning—*Woman, I* [15]
(c) Indiana—*The American Dream, I* [28]
(d) Johns—*Target with Four Faces* [32]
(e) Turner—*Steamer in a Snow Storm* [75]

— — — — — — — — — — — — — — —

(a) Appears smooth with subtle value blendings and transitions.
(b) Rough with a smeared look of swift action and the total assurance of full arm motion in applying thick paint.
(c) Smooth and brushless areas of flat color.
(d) Rough from the mixture of oil paint and wax (encaustic). Also Johns has built a wood framing for the actually dimensional, masklike lower faces across the top of the painting. (Such works are impossible to categorize as clearly painting or relief sculpture.)
(e) Rough, as if paint were applied, scraped, and reapplied.

IMPLIED TEXTURE

3. We can see a surface and respond to its texture *without* actually touching it. We associate the appearance of an object with the actual feel of a surface. From this association we come to know by sight how a surface feels, without needing the direct touch experience. Through the control of a material such as paint, the artist creates *implied texture*—that is, visual effects that we can relate to actual contact. It may be imitative or stylized.

In the *imitation* of an actual texture, the artist simulates the way light is held or reflected by the surface of objects. The artist observes with care and then, through controlling line, contrast of light/dark, and a "matching" of object coloring, imitates on the field of action what the eye sees. When the result is so realistic that the implied texture seems literally to "be there," the effect is called *trompe l'oeil,* a reference to eye deception or the illusion of real objects. Some virtuoso painters in the past have used the trompe l'oeil effect, and currently there is a neorealist trend with some artists recording lifelike textures that appear photographically real.

Another kind of implied texture is *stylized texture*—that is, texture that is more generally patternlike. Stylized texture may describe to some degree actual materials; however, rather than indicate specific textures in detail, it is a more broad abstraction toward abbreviated or condensed design.

> *Implied texture,* the visual appearance of texture, may be imitative or stylized.

Examples

Photography has produced implied texture that *imitates* the real thing with great success. Food photographs in color can seem almost edible. Fabrics, flesh, metals seem literally before you.

Marks made by the artist such as the cross-hatch, stipple, and scribble seen in Rembrandt's *The Raising of Lazarus* [65] are examples of implied textures that are *stylized,* more abstract in a general description of earth, growing foliage, fabric, and flesh.

Exercises

(a) Find and mount side by side samples of implied texture from photography illustrations to be found in magazine advertisements. (Or better still, do your own texture photography, drawing, or rubbings.) Compare these samples with the samples of actual texture you selected on page 170.

(b) Rubbings give a wide range of implied texture surfaces. Try a rubbing by taping a piece of light yet tough white paper over a textured surface such as a grill, mesh screen, wood grain, or coarse fabric. Rub wax or lithograph crayon over the paper lightly, gradually increasing the buildup of the crayon. The crayon will fill over the surfaces that are high and projecting with dark values and will skip over the low areas, leaving all depressions in the actual textured surface paper white. The result is an implied texture taken directly from the original source.

Seeing Implied Texture

4. Look at Harnett's *Old Models* [30], an example of implied texture that *imitates* actual textures, giving a trompe l'oeil effect. The background looks like real wood that has split, in contrast to the cared-for wood of the violin. The metal of the horn is a different quality than the metal of the hinge and the key plate. The pottery jug, the leather books, the papers with music, and the ripped program fool the eye, making us think of them as the actual objects before us.

Now look at Braque's *The Musician's Table* [7], an example of *stylized* texture. The suggestion of wood grain is a more abstracted, generalized descriptive pattern than it is the simulation of real wood. The glass objects have a see-through transparency, but these shapes are abstracted to the degree that the texture, too, becomes pattern. The music or writing on the paper has been reduced to horizontal lines except for the letters of partial words, which the viewer must complete. The variations of stipple texture help to unify the work.

Application

Examine the following works and identify which artists have painted imitative texture and which have painted more generalized, stylized texture:

(a) Van Eyck—*Jean Arnolfini and His Wife* [color plate 7]
(b) Giorgione—*The Concert* [25]
(c) Anuszkiewicz—*Splendor of Red* [2]
(d) Ingres—*Madame Moitessier* [31]
(e) Lichtenstein—*Whaam!* [37]

— — — — — — — — — — — — — — — —

(a) imitative; (b) imitative; (c) stylized; (d) imitative; (e) stylized

When carefully controlled by the artist, texture can be an important factor in the overall design of a work of art and can function in one or more ways. Important among the features of texture are its variety, focus, and uniformity.

TEXTURAL VARIETY

5. Texture may provide *variety* by creating areas of surface interest by combining some degree of roughness with another degree of roughness or by combining a slick, smooth texture contrasted with a coarse, rough texture.

Textural variety occurs in the contrast of a rough/smooth relationship, or through two different degrees of rough or smooth texture.

Examples

If you look in your closet and drawers for textural variety, you will probably find a wide range of fabric, leather, and metallic textures.

Daily we encounter paper of different quality used for innumerable purposes. Although most paper consists of either wood pulp or rag, the texture variations include different degrees of thickness, smoothness or roughness, absorbency or resistance, and stiffness or softness.

Variety of food texture is one of the joys of preparing and consuming food: thin, crisp lettuce; stiff, fibrous celery; firm, solid root vegetables; flaky pastries and breads; and juicy fruit.

Texture even differs underfoot as you walk over a grass lawn, a cement walk, a gravel road, a plowed field, a marble floor, a path in snow, or a velvety carpet.

Every day can be an adventure in textural variety.

Exercise

Keep a list of the textural variety you encounter in getting to school or work. Compare this list with a list of textural variety you encounter during your leisure time.

— — — — — — — — — — — — — —

Your list might start something like the following: fabric of coat or sweater, metal of key and car, steering wheel, cement of highway, blacktop of parking lot, books and papers, formica floor, brick walls. If you ate breakfast: food textures, dishes and glass, silverware, chair, tabletop, etc.

Seeing Textural Variety

6. Look at Matisse's *The Red Studio* [color plate 2], which illustrates smooth, flat texture areas in contrast to small, vibrating texture areas. The tonal character of the smooth, flat, red walls and floor is given a rhythmic liveliness by the bits of decorative-object texture. Look at the objects in the room as texture rather than as objects and the work takes on an eye syncopation that can be compared with music.

Next look at Blake's *Book of Job:* "*When the Morning Stars Sang Together*" [3], an example of juxtaposed textures of different degrees of

softness. The open, stylized texture of drawing and letters on the border adds variety to the heavier, shaded textures of the figures, clouds, flesh, hair, and clothes, strengthening the convincing quality of volume in the forms at the center of the work.

Application

Examine the following works and describe the artists' use of textural variety:

(a) Picasso—*The Three Dancers* [56]
(b) Sung K'o—*Cursive Script Poem* [84]
(c) Botticelli—*The Birth of Venus* [4]
(d) Ingres—*Madame Moitessier* [31]
(e) Vermeer—*The Artist in His Studio* [81]

— — — — — — — — — — — — — —

(a) Smooth texture and contrast of stylized texture. The lively texture of the background wallpaper, the balcony railing and wainscoting, and the stripe in the left figure contrast with the plain, flat color areas of figurative forms.
(b) Smooth background texture and contrast of stylized brush textures. The rougher texture of calligraphic shapes alternates with the smooth texture of undisturbed background shapes.
(c) Texture beside texture: the texture of flesh in relation to the richness of the decorated fabric. The nervous curves suggest the motion texture of water in relation to the firm texture of the shell. Flying hair is seen in relation to the foliage.
(d) Juxtaposed textural opulence. The background textures of wallpaper and wooden wainscoting indicate a palatial setting. Madame Moitessier's flesh appears soft and young. Her gloves, shawl, and gown with lace sleeves are rich textures. The roses and jewelry also suggest the textural elegance of quality.
(e) Textural excitement is conveyed in the varied juxtapositions of brass chandelier, map, drapery swag, leather chair, tiled floor, fabric of artist's clothing, model, and still-life objects.

TEXTURAL FOCUS

7. In addition to providing variety, texture can also serve to *focus* the viewer's attention. Texture can give the illusion of space—with softer, less defined textures suggesting distance and bolder, more defined textures suggesting nearness. Texture may call attention to a point of interest or, in some works, may become a major, overall consideration of the entire work.

> *Textural focus* may give the illusion of space, may call attention to a point of interest, or may become the subject of the work.

Examples

A flower in the hair; pearls against black velvet.

Exercise

Make a jigsaw puzzle from a pictorial advertisement. Piecing it back together you will find yourself focusing on texture clues. You will be searching as much for interlocking texture patterns as for shape or color.

Seeing Textural Focus

8. Look first at Renoir's *Le Moulin de la Galette* [64], an example of textural focus that contributes to the illusion of space. The more distant forms are softer, more blurred, and less defined texturally. The closer forms are more defined; we see them as hats with ribbon, glasses and decanter, even the pattern and character of the fabric of the foreground lady's gown.

Now look at Chagall's *I and the Village* [12], an example of textural focus that calls attention to a major point of interest in the work. The varied sizes and shapes of light ovals, dots, and spots within the lower foreground wedge create a distinctive sparkle, a texture that calls attention to the branch, giving it special significance.

Finally, look at El Greco's *The Resurrection* [21]. Here texture is a dominating focus and a major consideration in the total work. The consistent texture with soft edges of dark shadow penetrating light forms over the entire surface gives the effect of flickering flame as much as it suggests people.

Application

Examine the following works and describe each artist's use of textural focus: does it provide the illusion of space, call attention to a point of interest, or act as a major focus of the entire work?

(a) Manet—*At the Races* [41]
(b) Goya—*Execution of the Madrileños* [27]
(c) Klee—*Around the Fish* [34]
(d) Pollock—*Autumn Rhythm* [58]
(e) Rembrandt—*Rembrandt and Saskia* [66]
(f) Ma Yuan—*Bare Willows and Distant Mountains* [45]
(g) Picasso—*Guernica* [50]

— — — — — — — — — — — — — — — —

(a) Illusion of space. The blur of textures suggests trees, bushes, and people behind the fences on either side of the race track. The three foreground horses and riders are slightly more defined; the texture around their legs suggests dust they have raised.
(b) Major point of interest. Does Death have a texture? Goya has implied its essence at lower left. Its disorganized chaos contrasts with the firm, metallic textures of the firing squad.

(c) Major point of interest. The implied texture suggesting the scales of the fish is the most heavily textured surface, making this area seem closer and most important.

(d) Overall consideration. The texture of stringy, splashed paint is a major focus of the entire work.

(e) Illusion of space. The defined textures of metal sword, feathered hat, rich fabrics of clothing, and handsome glass of beer all suggest nearness.

(f) Illusion of space. The softer mountain forms near the base suggest distance. The sharply defined trees suggest nearness.

(g) Major point of interest. Attention is focused on the horse by its newsprintlike texture, the only figure in the composition with this degree of texture.

TEXTURAL UNIFORMITY

9. Although texture may provide variety or focus the viewer's attention, it may also provide *uniformity* to a work. Textural uniformity may be accomplished through a consistent technique, through the medium itself, or through the repeated units of a textural pattern producing some quality of overall sameness. (Note that because of the uniformity of the ink, paper, and printing process, the reproductions you are studying have a deceiving textural uniformity that is *not* true of the original works of art.)

> *Textural uniformity* may be achieved through some general quality of textural sameness: a technique, the medium, or repeated units of textural pattern.

Examples

Socks and sweater of the same weave or knit.
Matching purse and shoes (not simply color, but material).

Exercise

Find three or more photographs of yourself that are different in size. They can be at the same or different ages, about your interests or your activities. Work out some *uniform* textural plan for bringing them together on the same surface. Textural transition possibilities include: torn edges, split or burned edges, scratched edges, cross-hatch or stipple from the surface toward or into the photo to fade out edges, ink edges with an irregular blur to soften edges, paint brushed in from the surface onto the photos, or paint dripped or dragged from picture to picture.

Note the effects Rauschenberg has used in *Buffalo II* [62].

Seeing Textural Uniformity

10. Look at Monet's *Rouen Cathedral* [color plate 3] as an example of uniform textural quality. The blurred, rough quality over the entire surface gives an even, controlled look of light playing over the faceted facade with its countless projections and recessions, making it look less like stone than like lace—or like the texture of the paint itself.

Another example of textural uniformity is Seurat's *Models* [71], which illustrates the technique of *pointillism*—that is, applying very small points of paint to give a uniform texture that results in a vibrating sparkle.

Application

Examine the following works and describe the textural uniformity:

(a) Mondrian—*Composition No. 10, Plus and Minus* [49]
(b) Nolde—*The Prophet* [53]
(c) Warhol—*100 Cans* [86]
(d) Riley—*Current* [67]

———————————————

(a) A repeated pattern gives a uniform textural surface (which was invented by Mondrian after observing a quiet body of water. Compare this with the invented coding for water texture in Botticelli's *The Birth of Venus* [4] and that of Turner's *Steamer in a Snow Storm* [75].)
(b) Textural uniformity results from the wood grain which has been left to print along with Nolde's cuts into the wood surface from which this print is pulled.
(c) Repeated units over the entire surface produce a machinelike textural uniformity.
(d) Repeats of a pattern unit result in a mechanically uniform texture suggesting rippling or flowing surface change.

APPLICATION

11. Look at Munch's *The Cry* [52] and describe fully the artist's use of texture.

———————————————

The actual texture of the original is the ink and paper surface of the lithographic process and the line technique used by Munch. The implied textures of layered clouds in the sky, earth forms, still water, bridge, and figure forms are achieved through line direction and spacing. Textural focus is on the foreground figure which is stronger in light/dark contrast with a line pattern suggesting a flowing, weightless form with more varied curves and a closer tie with organic form. (Compare this with Riley's *Current* [67].) Overall textural uniformity is achieved through the consistent line pattern.

SEEING THE UNITY

12. Combine what you have learned about texture with all that you have learned to this point. Look at Renoir's *Le Moulin de la Galette* [64] and describe the artist's use of order, balance, line, light/dark, shape and proportion, space, and texture.

_ _ _ _ _ _ _ _ _ _ _ _ _ _ _

Order: Seemingly random; like snapshot photography, but has an underlying rigid structure within a horizontal rectangle.

Balance: Asymmetric.

Line: The invisible linear axis of forms and the line directionals of look and gesture fall within pyramidal shapes. The edges are soft with few defining lines; most obvious as line are the stripes of the foreground lady's gown, her friend's neckband and bonnet edging, and the hatbands of the men.

Light/Dark: All contrasts of dark with light are softened by filtering light patterns that flicker through the foliage of the trees and from the chandeliers. There is a lively "hide-and-seek" interplay of light and darks. Values are modulated enough to suggest solid volumes.

Space: Planes are overlapped; near forms are larger, lower, and more defined; far forms are smaller, higher, and more blurred. The table is at angles to the picture plane and the center bench, both providing diagonal depth lines. Figure placement—on three sides of the table pairs of figures help to define the foreground space while the openness and crowding of the dancers adds to the illusion of depth. Cutoff forms on all four sides of the canvas and the momentariness of the poses give the appearance of a candid-camera casualness.

Shape and Proportion: The round, robust body forms communicate youth and glowing health. (Rounded forms and soft edges are shape preferences of Renoir.) Body proportion is naturalistic rather than idealistic or distorted.

Texture: The materials used by the artist create the *actual* texture (oil paint applied with a wispy, feathery brush stroke). The implied textures of fabric, skin, hair, glasses, decanter, and foliage convincingly imitate the softness and shimmer of these objects in real light conditions. The compositional and textural focus is on the lovely faces of the centered foreground girls.

You should now be able to look at a work of art and comment on the artist's use of texture. You may want to review the questions presented at the beginning of this chapter before completing the following Self-Test.

SELF-TEST

This Self-Test will help you evaluate how much you have learned so far—how well you can answer the questions raised at the beginning of the chapter. Answer the questions as completely as you can (use a separate sheet of paper) and then check your answers against those that follow.

1. Describe the textural difference between:

 (a) Schwitters—*Revolving, 1919* [70] and
 (b) Harnett—*Old Models* [30]

2. How is actual texture (the medium) used in the following works?

 (a) de Kooning—*Woman, I* [15]
 (b) Mathieu—*Painting, 1952* [44]
 (c) Johns—*Target with Four Faces* [32]
 (d) Manet—*At the Races* [41]
 (e) Indiana—*The American Dream, I* [28]
 (f) Nolde—*The Prophet* [53]

3. How is implied texture expressed in the following works—is it imitative or stylized?

 (a) Vermeer—*The Artist in His Studio* [81]
 (b) Picasso—*Girl Before a Mirror* [color plate 5]
 (c) Turner—*Steamer in a Snow Storm* [75]
 (d) Poussin—*Shepherds of Arcadia* [color plate 6]
 (e) Botticelli—*The Birth of Venus* [4]

4. Describe textural variety in:

 (a) Van Eyck—*Jean Arnolfini and His Wife* [color plate 7]
 (b) Rauschenberg—*Buffalo II* [62]
 (c) Rembrandt—*The Raising of Lazarus* [65]

5. Describe textural focus in:

 (a) Ingres—*Madame Moitessier* [31]
 (b) Magritte—*The False Mirror* [39]
 (c) Rubens—*The Rape of the Daughters of Leucippos* [68]

6. Describe textural uniformity in:

 (a) Renoir—*Le Moulin de la Galette* [64]
 (b) Albers—*Homage to the Square* [1]
 (c) Van Gogh—*The Starry Night* [color plate 8]

7. Look at Grunewald's *The Resurrection* [29] and describe the artist's use of texture.

8. Look at Seurat's *A Sunday Afternoon on the Grande Jatte* [color plate 4] and describe the artist's use of order, balance, line, tone, color, shape and proportion, space, and texture.

Answers to Self-Test

In parentheses following these answers are given the number of points each question is worth, if you want to total your overall score, and the frame references where the topic is discussed, if you wish to review.

1. (a) Actual texture, a collage of real attached textures, including paint. (frames 1-2; 2 points)

 (b) Implied texture with a realistic effect—trompe l'oeil painting. (frames 1-2; 2 points)

2. (a) The oil paint is rough, smeared, stringy. (frames 1-2; 1 point)

 (b) The paint has been snapped onto the surface to look like the texture of attached string. (frames 1-2; 1 point)

 (c) Encaustic paint-layered and rough with the actual texture of plaster-cast faces in relief set into actual wood frames. (frames 1-2; 1 point)

 (d) The appearance of blotted or smudged paint. (frames 1-2; 1 point)

 (e) Smooth, brushless surface. (frames 1-2; 1 point)

 (f) The grain and the splintery character of wood is seen through the inking and the angularity of the cutting. (frames 1-2; 1 point)

3. (a) Imitative—the appearance of real fabric, brass of chandelier, leather of chair. (frames 3-4; 1 point)

 (b) Stylized wallpaper pattern, clothing texture, and hair. (frames 3-4; 1 point)

 (c) Imitation of texture of water and wind. (frames 3-4; 1 point)

 (d) Imitation of texture of fabric, flesh, stone, leaves, clouds. (frames 3-4; 1 point)

 (e) Stylized texture in leaves, shell, water, hair. Appearance of somewhat more real texture in flesh and fabric. (frames 3-4; 1 point)

4. (a) Variety through appearance of real metal, fur, velvet, wood, hair, and glass. (frames 5-6; 1 point)

 (b) Variety of implied texture in sponge swish, scraping, blotting, dripping, torn edges; implied real texture in the balloon, eagle, metal key, and Kennedy photos. (frames 5-6; 1 point)

 (c) Variety of stylized texture in different degrees of cross-hatching, hatching, and in the open, unfilled spaces. (frames 5-6; 1 point)

5. (a) Textural focus on flesh (through contrast of light), on the roses, the necklace, and the jeweled hands. (frames 7-8; 1 point)

 (b) The flat, smooth disk and the firm smoothness of the eye forms give focus to the soft texture of the clouds. (frames 7-8; 1 point)

 (c) The foreground position and contrast of light against dark focuses on the flesh texture of the bodies of the two women. (frames 7-8; 1 point)

6. (a) A soft, feathery brush stroke is a consistently uniform texture over the entire work. (frames 9-10; 1 point)

 (b) A smooth, brushless look of paint scraped onto the surface with a palette knife. (frames 9-10; 1 point)

(c) Short, decisive strokes of staccato, nervous energy fill every form over the entire work. (frames 9–10; 1 point)

7. Actual texture is uniformly blended oil paint. Implied texture consists of the appearance of metal armor and swords, the stone of the tomb and the large stone in the background, fabric, and the atmospheric figure of the risen Christ. Variety of texture occurs in the firmness of metal, stone, stiff fabrics, and solid bodies in contrast to the textural focus on the soft, flowing fabric and the translucent, weightless body of Christ, which seems to be dissolving into a glowing atmosphere. (Chapter 7; 10 points)

8. *Order:* Rigid plan locking into an underlying grid; horizontal rectangle. (Chapter 1; 2 points)

Balance: Asymmetric. (Chapter 1; 2 points)

Line: Axis of forms provide a strong internal linear structure. The horizontal and diagonal lines of shorelines are also structural line. The edges of forms are made distinct through tone or color contrast. (Chapter 2; 5 points)

Tone: Light/dark alternation on the ground is a shadow, light, shadow, light sequence. A minimum of modeling suggests solidity of form. (Chapter 3; 5 points)

Color: Optical mix is used through the pointillist technique of applying little points of color. The hues, basically green, red, blue, and yellow, are applied to mix in the viewer's eye. The forms have halo edges of contrasting hue. (Chapter 4; 5 points)

Space: Deep space is suggested by the strong diagonal running left to right and the high, distinct horizontals indicating the water's edge. Planes overlap with figures near represented larger and lower and those far represented as smaller and higher. Alternating light/dark helps the eye to read back into space. (Chapter 5; 5 points)

Shape and proportion: The shapes are abstracted to almost geometric form with the human figures placed in profile and full front, both seated and standing holding umbrellas repeating these shapes in variation. The proportions are idealized abstractions. (Chapter 6; 5 points)

Texture: The actual texture is an overall stipple effect with the technique of pointillism resulting in a surface that vibrates with a uniform design pattern similar to needlepoint stitchery. This technique unifies the work, giving the whole a stylized textural quality. (Chapter 7; 10 points)

Total possible points: 73. Your score: _____ . If you scored at least 58 points, you understood the main points of the chapter. If your score was lower than this, you may want to review the appropriate frames before you go on.

IMAGINATION STRETCHES

— Arrange a walk through a "Texture Experience Exhibit" in which people are encouraged to touch.
— Arrange a still life that has smooth surfaces in relation to rough surfaces.
— Make a monoprint by smearing or dabbing (or any ingenious application) oil paint or synthetic paint onto a glass surface. Lay a piece of paper onto the paint, apply hand pressure, and pull the print. Each print can have a different textural effect.
— Rauschenberg invented a texture effect by softening a photo or ad image with cigarette lighter fluid (or other solvent). Try it—it's like magic. If you place white paper onto the image and rub the surface with a spoon, the image will transfer in reverse onto the paper. (Be careful of fire though.)
— Make a collage from scraps of different kinds of paper, fabric, and string that are all one color. Paste them onto a grid as in the exercises on pages 170 and 172.
— Paul Klee was a great experimenter with texture of materials. You might try some of the following, which are a few of the combinations listed for works he did:*

 Watercolor and oil on gauze prepared with plaster
 Pastel with paste
 Oil with wax on coated newsprint on burlap
 Paste and pigment on wrapping paper
 Scratched on plaster, tinted with tempera
 Watercolor and wax pigment on cotton on wood
 Airbrush, pen and ink, and colored crayon
 Waxed watercolor on plaster-grounded cardboard
 Watercolor and egg emulsion on oil-grounded canvas
 Pencil and red crayon

*Paul Klee, *Notebooks of Paul Klee: The Thinking Eye,* ed. by Jürg Spiller (New York: Wittenborn, 1961), pp. 525–530.

CHAPTER EIGHT
Motion

 In a work of art, can you:

- recognize visual rhythms: rhythms of conformity, sequence, and contrast?
- explain the actual motion in seeing a work of art once and in seeing it many more times?
- describe implied motion through examples of representational and nonrepresentational imagery?
- identify possible effects of movies and photography on an artist's communication of motion?

Though it may appear incongruous, the seemingly static, inert field of action of a work of art not only contains but also evokes action or motion. The actual and implied motion of works of art is the focus of this chapter. You will need only paper and a pencil for the exercises in the chapter.

Frank Stella, *Sinjerli Variation IV.* 1968. From the collection of Mr. & Mrs. Burton Tremaine, Meriden, Connecticut.

INTRODUCTION—RHYTHM AS MOTION

When the word *rhythm* is used, you may think first of music and sound, or of movement and dance. You are not as likely to think of rhythm in a visual sense. How can you *see* rhythm? You know that the beat of rock music and the stomp of the highland fling are rhythms. You know that rhythm is a regular pulsation related to your heartbeat. Rhythm comes from motion.

From the time when the first human drew in the sand with a stick, there has been a fascination with the action of hand-stick-sand and with the resulting record of motion. When you look at the marks made by the artist's tool, you are seeing the motion path of the hand, which is controlled by the artist's mind, heart, and breathing. By controlling a tool moving over a surface, you, too, can make rhythms that can be seen. These rhythms can be conforming, sequential, or contrasting.

RHYTHMS OF CONFORMITY, SEQUENCE, AND CONTRAST

1. In *conforming rhythm*, lines like this create a line rhythm seen as an even, steady, repetitious rhythm.

Conforming rhythm is created by similarities rather than by decisive change. Lines take the same direction, are the same length and width. Tones are similar—either all lights, darks, or middle tones. Hues are close neighbors—analogous colors such as yellow, yellow-orange, orange. Intensities are in the same range whether high or low key on the intensity scale. Shape is similar in form and size. Texture is uniform.

In *sequence rhythm*, lines like this create a sequence, a series of steps, a scale, gradation, or progression of form advancing from one position to another.

In sequence rhythm, lines gradually follow our expectations—for instance, shifting slowly from horizontal to vertical or from thick to thin. We have discussed gradation in tone and hue. Shapes also change form and size without abruptness, and texture shifts with gradual transitions to a different touch association.

In *contrasting rhythm*, lines like this create a line rhythm seen as a rhythm of opposites, differences of direction, and of thick and thin strokes

produced by alternating light pressure and heavy pressure, resulting in contrast of weight and tone.

Rhythm of contrast has sudden and definite differences. Lines might shift to opposite directions or from thick to thin. Tone is sharply contrasting dark and light. Hues are complements; intensities are high-key brights and low-key dulls. Shape may shift in form quickly, drastically, and surprisingly—sometimes even shockingly. Texture differences also occur suddenly and sharply.

If the lines of conforming rhythm are repeated:

and if these are combined with lines of contrasting rhythm:

the result is the combined two linear rhythms forming a third rhythm with new shapes into which rhythms of color and texture can be built. From this example, you can see how rapidly multiple rhythms and different levels of rhythm can emerge.

Artists combine line, tone, and color rhythms making spaces, shapes, and textures visually communicate personal ideas, dreams, and illusions. They create a new reality—a pictorial image that lives in the viewer's mind as surely as any human being. A Vermeer organizes the rhythms of his studio so that it exists as if waiting for us to enter; a Van Gogh puts an order of rhythms together to make a starry night that can change everyone's moonlit nights; a Kandinsky combines the rhythms of drifting debris and creates a dreamlike flotsam and jetsam to delight the eye; a de Kooning paints the rhythms of an unforgettable woman presence.

> The basic principle of rhythm is motion. Rhythm can be conforming, sequential, contrasting, or a combination of these to form complex multirhythm patterns.

Examples

Conforming rhythm:
> Heads of spectators watching a good tennis volley.
> The repeated motions of knitting a consistent pattern.
> A column of marching ants.
> The even pattern of sand-dune waves made by a steady wind.

Sequential rhythm:
> The roots of a tree gradually spreading underground in search of food
> and water.
> A fern moving upward from the earth and with a stately rhythm slowly
> uncurling to become a tapered frond.
> Fingers moving along a piano keyboard sounding a music scale.
> The rainbow spectrum creating a progression of hues.

Contrasting rhythm:
> A basketball player dribbling the ball on the run and then holding a
> position to pass the ball.
> Merry-go-round horses going up and down as well as around.
> Jumping rope—an up/down rhythm within the motion of the rope.
> Rubbing your stomach and patting your head.

Exercises

We can often see the results of actual rhythmic motion from activities such as those in the preceding example. According to Paul Klee, "Simple crafts such as plaiting, weaving, sowing, masonry show the original roads to form."* On a separate sheet of paper, complete the following exercise:

(a) Try to draw the motion of plaiting (braiding).
(b) Try to record the visual rhythm of weaving.
(c) Try a drawing of the basic rhythm plan for sowing seeds.
(d) Try a drawing of the basic rhythm of masonry.
(e) Write your signature—a highly personal rhythm pattern.

— — — — — — — — — — — — — — — —

Your exercise might look something like those shown at the top of the following page.

*Paul Klee, *Notebooks of Paul Klee: The Thinking Eye*, ed. by Jürg Spiller (New York: Wittenborn, 1961), p. 35.

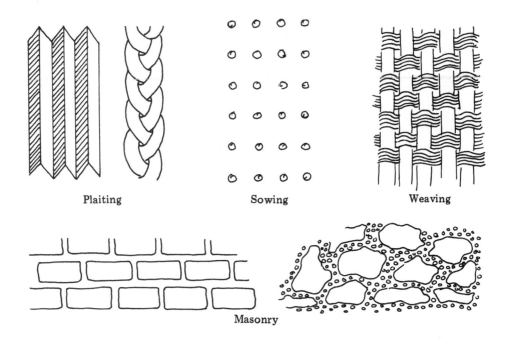

Plaiting Sowing Weaving

Masonry

Seeing Rhythms of Conformity, Sequence, and Contrast

2. Look at Mondrian's *Composition No. 10, Plus and Minus* [49]. The lines have *conforming* harmonies in their uniform width, similar lengths, and distance of spacing. *Contrasting rhythms* occur in the vertical/horizontal directions of the short lines, in the negative spaces left by the line pattern, and in the large oval in its relation to the straight sides and right angles of the picture surface. In the original, closely keyed tones of one hue (muted yellow-brown) provide a softening *sequence.*

Look at Picasso's *Guernica* [50]. *Contrasting rhythm* can be seen in the sudden opposing shifts in line direction, in the sharp contrast of tone, and in the unexpected distortions of shape. A few small areas of *conforming rhythm* are seen in the uniform texture pattern of the printlike surface on the horse's body. The original is closely coordinated in colors of black, white, and bluish grays.

Next look at Anuszkiewicz's *Splendor of Red* [2]. *Sequence rhythm* can be seen in the series of squares within squares with the two center ones turned to form diamonds on points within a third square on its side. Lines radiating from the center create a darker tone along the edge of the lightest diamond, and as the tips spread, they gradually let in more light. Additional lines make another darkened edge along the second diamond with the slight spread outward allowing a little more light. The direction of the line changes gradually from vertical to horizontal and back, pivoting around the center. The under color is one even tonality of red, and the lines are a uniform thickness and weight. *Contrasting rhythm* is seen in the length of the lines and in the dark of the fine lines against the light tone of the red background.

Finally, look at Watteau's *The Embarkation for Cythera* [85]. Rhythms of *sequence* are seen in the gentle, harmonious progressions throughout this work. The sequence of action follows a slow, graceful curve of the hill, which dips and curves upward along the lines of the barge at the right. Vaguely seen angels hover over the barge and, twisting on an "S" curve, gradually dissolve into space, which becomes subtle gradations of tone suggesting misty water, trees, mountains, and an undefined distance where earth and sky merge. Each of the foreground couples is a pair in the sequence of rising from a seated position to the couple who look back as they walk down the hill. The apparel of these figures is bright red and soft pink shaded with green, which in the lovers at the foot of the hill becomes muted, almost a vaporous blend with the angles, the atmosphere, and the barge. *Contrasting rhythm* can be seen in the complementary hues—red and green—which are skillfully brought together, and in the scale of the sheltering tree and the columnar idol at the right.

Application

Examine the following works and describe the artist's use of rhythms of conformity, sequence, and contrast:

(a) Warhol—*100 Cans* [86]
(b) Duchamp—*Nude Descending a Staircase* [19]
(c) Rubens—*The Rape of the Daughters of Leucippos* [68]

— — — — — — — — — — — — — — — —

(a) The rectangular shape of the soup can is repeated 100 times in horizontal and vertical rows. This repetition along with the repeated label gives a monotonous uniformity—conforming rhythm. Contrast is seen in the spacing between the cans. (In the original a stronger note of contrast is seen in the red, white, and black color relationship accenting the contrast of tone.)

(b) Progressive steps of action are compressed and overlapped. Lines are mainly variations of a diagonal direction, some with slight curves as they shift in a sequence from the upper-left corner to the lower right. Tones shift gradually along with the lines from stronger darks to lights moving from upper left to lower right. Outer corners suggesting steps are the darkest areas, but overall the tonalities are very closely keyed.

(c) Rhythms of contrast are seen in the nude women, the clothed or semi-clothed men, the light tone of the women, the rearing horse, the dark tone of the men and the other horse; in color—the warm body tones against the cool sky background; and in the contrasting directions of edges and axis of lines of arms, legs, and bodies. Sequential rhythms occur in the modeling of flesh and fabric.

Paul Klee has said that we perceive rhythm with three senses at once: that we see it, hear it, feel it in our muscles, and this is what gives it such power over us.* With this in mind, look . . . listen . . . feel:

Mondrian—*Broadway Boogie Woogie* [back cover]
Van Gogh—*The Starry Night* [color plate 8]
Giotto—*The Lamentation* [26]

ACTUAL MOTION IN SEEING WORKS OF ART

3. Motion is growth, change, life itself. We experience motion by moving ourselves past or through forms. We perceive motion from forms that move past or around us. We make our own motion sequence when we look or move from object to object through space in time. And we understand or imagine a past, a present, and a future.

Looking at a picture may seem to be an instantaneous event, and what is seen may appear motionless. But a painting is a compression of action, and looking at a painting involves a sequential process of motion. The eye quickly absorbs the whole, but this is only a first, fleeting impression. A viewer who believes he has seen the totality of a work in a single viewing is deceived. The entirety of a picture and its parts do not enter the perception simultaneously.

It is only after the first "total" impression that you take note of what makes the greatest demand on the eye and mind. You begin to choose and sort out what lines the eye is compelled to move along, to follow the movement from shape to shape, color to color, around and through the field of action. The images in the painting are seen not as fixed and changeless, but rather as unfolding before the viewer in a different sequence each time the viewer "sees" into the work.

The pattern that the eyes follow over the field of action produces a sensation of sequence and motion. Seeing works of art in this manner requires time and active participation in the work.

The skillful artist controls the timing with which you sort out rhythms, patterns, and meanings, being fully aware that if everything is revealed at once, the viewer will leave the work with little desire to return to it. The mystery or intrigue in any work of art is the possibility of seeing new, fresh relationships within it.

Seeing a work of art is also a process that occurs *through* time. The eye and mind coordinate a first impression, sorting out what is compelling in line, tone, color, space, shape, and texture. This selection process not only produces a sensation of sequence and motion, it changes with each viewing. It is a process that is true for the artist as a work develops as well as for the viewer.

*Paul Klee, *Notebooks of Paul Klee: The Thinking Eye*, ed. by Jürg Spiller (New York: Wittenborn, 1961), p. 267.

> Seeing a work of art is a sequential process requiring time and repeated viewing.

Example

An introduction to a work of art is much like an introduction to a new person. When first meeting a person, you get a general impression regarding appearance, interests, and values, but you don't really know this person. On further meetings you get to know the person better, and your first impression often changes. You may see facets of the person's character that you hadn't seen before. Sometimes you begin to like the person and want to develop an enduring friendship; other times you may find you have nothing in common with the person and that further contact may be boring or even unpleasant.

Similarly, a work of art has an inner force with the power of changing your thinking. A novel, a play, a song, as well as a painting, can take on additional meaning with a second, third, or fourth experience with it.

Exercises

(a) Name a song that you disliked on first hearing and that you later discovered you liked.
(b) Name a poem that you disliked on first reading and that you later discovered had meaning for you.
(c) Name a color that you disliked as a child but have since found "wears" well.
(d) Name a person whom you disliked on first meeting but who later proved to be friendly and interesting.
(e) Name a food that you disliked until, on repeated trying, it became one of your favorites.

— — — — — — — — — — — — — — — — — — —

There are no right or wrong answers. The intent is to recall that in all parts of our lives we change our minds and form second and third impressions.

Seeing a Work of Art Sequentially and Over Time

4. You have looked at Picasso's *Girl Before a Mirror* [color plate 5] before. Can you remember your first impression? It may have caused you to think: "That's not like any girl I've ever seen"; or "What a mixed-up confusion— how can anyone call *that* a work of art?" A second viewing in the search for line patterns may have reminded you of a brightly colored stained-glass window. On further looking you may have noticed more of what Picasso included: three faces for the girl, one primitive, masklike, bright yellow; a second flesh-colored with classic proportions; a third, the mirror face, not a reflection of either outer appearance, but shapes that look as if she has been

turned inside out. A truth we know, but don't readily admit, may come to you at this point: we all have many faces—not just one; our real self has more to do with inner feelings than outer appearance. Considering the forms and colors of the mirror image, do you think the girl is happy or satisfied with what she is seeing? The more often you look at this work, the more possible relationships may fall together for you. Can you identify so fully that you *become* the girl before the mirror? Your change of mood may be another variable in the many possible ways of responding to this work.

Application

Go through your set of reproductions and list the five you like most. Then list the five you react to most negatively. After making these two lists, look at each of the works again and indicate *why* you made your choice. Put the reason after the word *because* following the name of each work.

I LIKE

(a) because
(b) because
(c) because
(d) because
(e) because

I REACT NEGATIVELY TO

(a) because
(b) because
(c) because
(d) because
(e) because

————————————————

Did you have difficulty determining likes and dislikes? Were there any changes in the like-dislike columns after you considered your reasons for liking or disliking? This can be an interesting record to look back to and reconsider at the end of the course—or a year from now.

Looking at a work of art after a period of time has elapsed often provides new meanings and interpretations. To illustrate this for yourself, look at Matisse's *Decorative Figure on Ornamental Background* [46]. Record your first impressions and tuck them between the pages of the book here. Do nothing more at this point. Then continue with your reading.

IMPLIED MOTION THROUGH REPRESENTATIONAL IMAGERY

5. Traditionally, artists have tried to create the impression of motion actually occurring on the flat, static picture surface, and in some contemporary work actual motion is introduced with swinging forms extended ahead of the picture surface or with forms set in motion by electricity.

One way the artist can give the viewer the impression of motion is through the creation of shape and form relationships associated with motion in real experience. Such shapes and forms are called *representational* because they represent the reality. They may also be called *realistic* or *naturalistic.*

Realistic action may be implied by images such as a figure moving from one position to another, a turning head, a pointing hand, a twisting body, a blowing wind changing the shape of a tree, a flowing fabric suggesting movement of wind or body, rippling water, or a mirror holding a momentary reflected image.

The moment of time of the implied action and the resulting chain of reaction is always a critical choice for the artist.

> Motion may be implied—represented—through recognizable images as if in action. The moment of time of the implied action is important in seeing the implied motion.

Examples

There have always been artists who have wanted to represent the human action of ordinary daily life such as sharing food, conversation, work, or play. Motion themes with heightened drama include travel from place to place, combat in some form, or the struggle to sustain life.

Exercise

List three action themes that would be logical for an artist of the 1970's or 1980's to represent.

_ _ _ _ _ _ _ _ _ _ _ _ _ _ _ _

Again, there are no right or wrong answers. Some possible answers might include: transit on an impersonal freeway, motorcycle or car race, space travel, surfing, news traveling through the air from country to country.

Where is "the action at" for you? What would you like to represent?

Seeing Implied (Representational) Motion
and the Chosen Moment in Time

6. Look at *The Last Supper* as presented by Vinci [79], Bouts [6], and Tintoretto [74]. Observe the implied (representational) action and the moment of time chosen by each of the three artists.

Leonardo da Vinci has chosen a moment of heightened drama in the story of the last sharing of food between Christ and his apostles. With resigned acceptance, Christ has just told them that one of the group would betray him. His followers are represented in electric response with gestures of astonishment, self-questioning, or intense concern—except for Judas who leans back, listening.

Bouts has chosen the moment when Christ holds forth the bread by which he has asked to be remembered. His followers listen with expressions and gestures of pious attention. Can you find which is Judas?

Tintoretto has chosen a moment of dramatic action as Christ leans over one of his apostles as if to supply food, giving importance to the legacy of nourishment.

Each of these artists has selected a different significant moment in the story, composed a different chain of actions, and presented a different emphasis.

Application

Look at the three marriage portraits in your set of reproductions to determine the moment of time the artist has selected in each. Explain the implied (representational) motion expressed by the artist.

(a) Van Eyck—*Jean Arnolfini and His Wife* [color plate 7]
(b) Rubens—*Rubens and Isabella Brandt* [69]
(c) Rembrandt—*Rembrandt and Saskia* [66]

— — — — — — — — — — — — — — — —

(a) Van Eyck selects a moment when Arnolfini and his wife appear to be making a marriage pledge. Her hand is laid in his, and Arnolfini holds one hand up to solemnize the occasion. He looks toward her; she looks downward. Whether or not she is pregnant is a question, since her apparel and the appearance of pregnancy were fashionable at that time.

(b) Rubens has selected a moment similar to that often selected today for photographing a wedding picture. Rubens is seated, and Isabella appears to be kneeling with her hand over his. One finger of Rubens' hand, which holds the hilt of a sword, points to their overlapping hands. They both look directly out to us as if aware of our presence.

(c) Rembrandt, holding high a tall glass of beer, toasts an intimate moment. The drapery suggests the privacy of their home where Saskia is seated on Rembrandt's lap. As if suddenly aware of our presence, they turn, almost beckoning us to join in their celebration.

IMPLIED MOTION
THROUGH NONREPRESENTATIONAL IMAGERY

7. Another way in which implied motion appears is through your intuitive physical response to form. You may not *know*, but you instinctively *feel* how a work of art was constructed. The artist can appeal to this feeling by purposely revealing rather than concealing his manner of working.

As you become aware of the sequence, pressure, speed, energy, and body rhythms the artist used in doing the work, your own body replies in a response called *empathy*. This is an imaginative projection of your own organic vitality into the work to find personal correspondences with the energy and tension recorded by the artist. Your eye searches and sorts through the

abstract patterning of the work, with every mark communicating the force of its creation and demanding some measure of your attention.

The empathic response does not depend on representational subject or narrative, but is a felt reaction to the nonrepresentational forces in any work. According to Rudolf Arnheim, "a visual object is a stimulation, that is, an action upon the organism that results in action within the nervous system."* From among countless specific action stimuli, the artist may use:

— diagonals in opposition to other diagonals
— diagonals contrasted to stability of vertical or horizontal
— broken edges, nervous double edges, fluid or slashing lines
— gradation of value, color, size
— contrast of value or color
— volume appearing to project or recede indicating spatial interval
— texture

Our response to the implied motion of abstract form is the result of empathy with the seen surface. It is similar to the way we respond to the rhythm of a poem or the beat of music.

> **Motion may be implied through abstract, nonrepresentational forces such as diagonals, broken edges, double edges, fluid or slashing lines, gradation, contrast, volume appearing to project or recede, or texture.**

Examples

Nonrepresentational (abstract) motion may imply *energy released:* to explode, to splash, to split, to rip, to slide, to grow. Or it may imply *energy contained:* to clamp, to clutch, to shrink, to fade, to shrivel, to imprison.

Exercise

Following is a list of visual indications of action that has happened. What *actual* motion do these visual indicators imply? (The first one is completed for you as an example.)

Visual Indicator	*Implies*
(a) A black eye	Someone was hit
(b) A skid mark on a highway	
(c) A crack in a cement floor	
(d) Footprints on a path	
(e) A charred piece of wood	
(f) Erosion marks in rock	
(g) A ragged edge on a piece of paper	

*Rudolf Arnheim, *Art and Visual Perception* (Berkeley: Univ. of California Press, 1966), p. 361.

(h) A heap of sawdust
(i) A bent rear bumper
(j) Desert sand waves
(k) Radiating ripples in a pond

— — — — — — — — — — — — — —

(b) A speeding car stopped suddenly
(c) Split from uneven tension
(d) Someone walked that way
(e) A fire has burned
(f) Wind and water have pressured
 into rock

(g) Some force tore the edge
(h) Wood was cut with a saw
(i) Someone's car was rear-ended
(j) The blowing of wind
(k) A frog jumped in or someone
 tossed in a stone

Can you think of other visual indicators that imply actual motion?

Seeing Implied Nonrepresentational Motion

8. Just as we can respond to visible signs in terms of actual motion, we can
also look at a work of art and react to visual indicators that tell us about the
artist's "life on the canvas." For example, in Van Gogh's *The Starry Night*
[color plate 8], the sinuous rhythmic flow of short strokes following one
another in rapid outpouring allows us to sense the urgency and revelation of
the artist's own life force.

In Pollock's *Autumn Rhythm* [58], short diagonals deliberately placed
at angles to one another suggest the gesture of jerky brush strokes, which are
overlapped by skeins of paint flung from a stick without touching the canvas.
The tangled interlace is like an exposed nervous system, and, in Pollock's own
words, is ". . . energy and motion made visible"*

Application

Look at the following works to find the nonrepresentational visual indicators
that imply motion:

(a) de Kooning—*Woman, I* [15]
(b) Soulages—*Painting, 1953* [73]

— — — — — — — — — — — — — —

(a) It is not the figure of a woman, but the attack on the canvas that sug-
 gests motion. Paint strokes that slice and slash, scrape and smear with a
 frenzied energy mesh figure and ground with a "whiplash line traveling
 at $94\frac{1}{4}$ miles per hour."† We sense the throb of life in the reversals and
 continuations as well as the implied disintegration in the destructive
 canceling of strokes by wiping out or painting over.

*Bernice Rose, *Jackson Pollock: Works on Paper* (New York: Museum of Modern Art,
 1969), p. 10.
†Thomas Hess, *Willem de Kooning* (New York: Braziller, 1959), p. 26.

(b) These lines draw the eye down/up/down/across/up/down/across/up/
across/up/across/up in gigantic, broom-wide strokes placed on the sur-
face with the certainty of strong, sweeping, continuous motion and no
retracing. They reflect vigor, sureness, speed, and strength.

Look again at Matisse's *Decorative Figure on Ornamental Background*
[46]. What is your second impression?

PAINTING TECHNIQUES RELATED TO FILM

9. Knowing that "a moving mouse is more engrossing to the attention than
a roomful of precious things,"* artists have, throughout history, made many
attempts to represent the life of things in motion. This effort was intensified
to become the chief motivation of a group of early twentieth-century artists
who called themselves *Futurists.* At the same time the Futurists were aban-
doning painting things as recognizable objects in favor of complex, dynamic
rhythms and lines of force, related experiments of equal importance were
taking place in the development of movies and photography.

Various techniques evolved in tandem or preceded the development of
the moving picture. We have looked at representational and nonrepresenta-
tional ways artists have used to imply motion. Following are some devices
used to communicate motion and the sequence of a story which are related
to the evolution of the moving picture.

A series of frames may communicate motion and sequence, each with a
different episode which the spectator sees in order. It is the viewer who moves
to see the sequence. Sometimes the frames are side by side on an interior wall
or on the surface of a small, walk-around shrine. Sometimes the frames are
widely spaced; sometimes they cover the walls and ceiling of a room, creating
a panoramic environmental setting.

A shift from page to page in a book can illustrate the passing of hours,
days, months, years, decades, centuries. This method of communicating mo-
tion and sequence was used in the Medieval Book of Hours, with each page
providing prayers and pictorial reminders of passing hours, days, and months.

A narrative sequence in one frame can also create motion and sequence.
A series of separate events can lead the spectator's eye in the direction of the
action. Recall Watteau's *The Embarkation for Cythera* [85]. The Oriental
scroll is another example of a narrative sequence in one frame.

Overlapping stages of motion began in the nineteenth century when
artists experimented with compression of a series of events and stages of
motion. This can be seen in Duchamp's *Nude Descending a Staircase* [19],
which is closely related to the dynamic energies and force lines of Futurist
painting.

Blurred edges and elimination of detail suggest motion with the con-
stant, rapid shifting of moving forms, their boundaries always out of focus

*Olive Cook, *Movement in Two Dimensions,* quoted from D. S. McColl (London: Hutch-
inson, 1963), p. 121.

and details blurred or lost entirely. As speed and change became characteristic of life, artists began to see blurred edges and elimination of descriptive detail as expressive of rapid action and to use blurred and abstracted form to indicate this motion and change.

> Motion may be communicated through a series of frames, a narrative sequence in one frame, a shift from page to page, overlapping stages of motion, blurred edges, and elimination of detail.

Examples

Series of frames: Comic strip.
Shift from page to page: Flip-book.
Narrative sequence in one frame: A three-ring circus poster; a parade.
Overlapping stages of motion: Double or triple exposure of one film frame.
Blurred edges and elimination of detail: TV out of focus.

Exercise

List as many examples as you can of each of the techniques for communicating motion:

(a) Series of frames
(b) Shift from page to page
(c) Narrative sequence in one frame
(d) Overlapping stages of motion in one frame
(e) Blurred edges and elimination of detail in one frame

— — — — — — — — — — — — — — — —

You might have mentioned some of the following:

(a) Film strip or film loop, fold-out brochures, nickelodeon stereoscope.
(b) Newspaper, a story picture book.
(c) Sometimes a political cartoon (e.g., past, present, future effects of energy control), sometimes in one comic-strip frame (e.g., Superman in three places at once), sometimes in advertising (steps in proper floor waxing).
(d) Television—several cameras with three or more views projected onto the screen simultaneously.
(e) Out-of-focus photography, double exposure, time-lapse photography, squinting your eyes or taking off your glasses, cars in an auto race.

Seeing Progressive Stages in a Story Sequence

10. *Series of Frames:* Giotto has decorated the walls in the Arena Chapel, Padua, Italy, with twenty-eight scenes from the lives of Mary and Christ. The frames are arranged on three levels, and the narrative unfolds as the spectator

moves along the right wall to the left, following each register around toward the end of the story. *The Lamentation* [26] appears on the lowest level of the left wall, preceded by *The Crucifixion* and followed by a frame with *The Resurrection*. Within the frame of *The Lamentation* the eye is held by the grieving group around the body of Christ, and then the eye follows the diagonal earth form up the tree to the hysterically lamenting angels, who become like the action sequence of a single angel shifting from one gesture of despair to another. *The Lamentation* frame is followed by a frame with Magdalene reaching out to the risen Christ.

Shift from Page to Page: Look at one page from Pol de Limbourg's *Book of Hours: Duc du Berri—Month of April* [38]. A compressed illumination of April events in late fourteenth-century France is accompanied by the chariot of the sun and signs of the zodiac. The book contains sections for each of the twelve months. (A contemporary compression is the flip-book, with the pages held together at one side; as the pages are flipped fast, this is in effect a series of frames similar to the action frames of film.) The spectator sits still and moves the images at will.

Narrative Sequence in One Frame: Look at Paul Klee's *Around the Fish* [34]. It moves counterclockwise out from the platter and fish, the arrow pointing the way to go: to a flower-skull, to glass, to cucumber, to diamond and leaf, to flower and leaf, to glass, to flower and cross, to circle, and to crescent. You may interpret these abstracted forms as different objects, but the progressive sequence is undeniable and almost like a sentence of words (pictographs) shaping around the fish. Look, also, at the *Cursive Script Poem* of Sung K'o [84]. Oriental characters are pictographic or ideographic shorthand, or abstracted pictures of actions and processes in nature, with each character a part of a picture-story sequence.

Overlapping Stages of Motion: Look at Duchamp's *Nude Descending a Staircase* [19]. The stages of overlapping motion are like stroboscopic photography, which records each major shift of action-positioning with multiple-exposure, high-speed photographic equipment. It was about thirty years before this painting was done that E. J. Muybridge made his famous stop-action photographs of a galloping horse, and shortly after Etienne J. Marey invented a camera that would take a series of action exposures on one plate.

Blurred Edges and Elimination of Detail: Look at Manet's *At the Races* [41]. Observe the blurring of all images and loss of detail in horses, riders, and spectators. With rapid action the edges of forms appear distorted. When this was acknowledged by photographers and painters, it became a new way of seeing the world.

Application

Observe carefully the following works and identify the way in which the artist is telling a story sequence:

(a) Lichtenstein—*Whaam!* [37]
(b) (Celtic Manuscript)—*Lindisfarne Gospels: Initial Page* [87]
(c) Duccio—*Christ at Gethsemane* [16]

(d) Picasso—*The Three Dancers* [56]
(e) Turner—*Steamer in a Snow Storm* [75]

————————————————

(a) Series of frames. This is a two-frame set, similar to a comic strip that may contain as many frames as the artist chooses. The first frame indicates an airplane in flight with a balloon of words to clue the action. Forms in the second frame imply an explosion. The imagery is described through an enlarged Ben Day dot, the device by which newspaper imagery is transmitted.
(b) Shift from page to page. This is the first page of a series that will tell a story.
(c) Narrative sequence in one frame. Three separate episodes are contained in one frame: (1) at left, the sleeping apostles; (2) at center, Christ speaks to his followers; and (3) at right, Christ prays in isolation.
(d) Overlapping stages of motion. The figures and displaced anatomical details combine several views simultaneously and are overlapped to suggest shifting action.
(e) Blurred edges and loss of detail. The extreme lack of decisive precision allows several stages of action to be read into one image.

THE INFLUENCE OF PHOTOGRAPHY ON PAINTING

11. The moving picture has been a major twentieth-century innovation. Artists' efforts to communicate motion, along with the fertile experimentation of mid-nineteenth-century peep shows, panoramas, shadow plays of the Far East, and motion toys of many kinds, contributed to the development of the moving picture as we know it today.

Essentially the "movie" consists of a rapid sequence of still frames (about 24 frames per second). Every still frame implies a slight advance in the action. When seen in rapid succession, the illusion is one of "real" action taking place before the stationary spectator. With animation and dubbed-in sound, the result has been still photographs or drawings that can walk and talk.

The illusion of moving-picture reality is so effective that the movies have been related primarily to theater or literature. The mechanics of the camera involve many complexities and permit many effects not possible for the artist, who continues to paint on a single frame; however, an inescapable factor, often overlooked, is that film's visual compositional problems are closer to those of the painter than to any of the other arts.

The basic structural unit of film has been the single frame, the boundary of the camera viewfinder. Along with a growing realization (particularly by the viewer) that film is a two-dimensional simulation of the three-dimensional world, film has begun to be considered a serious art form by a broader public. (A recent revival of the circuit camera by Jerry Dantzic allows 360°+ of vision with a seamless image that circles the horizon with no vanishing point.)

The camera has given us the still photograph, the moving picture, and television. It has changed life in the world as well as our view of the world. Contemporary painting has been affected by film in many ways. Some of the devices used in photography which have been adapted in painting include the following:

— *Animation:* Projecting a sequence of photographs or filmed drawings at a rapid speed so the images appear to actually move.
— *Candid-camera shot:* An unposed shot with accidental effects left untouched (often associated with amateur photography).
— *Dissolve:* An image is superimposed briefly on another and the first image fades slowly. The transition between images is a blended gradation without a distinct separation.
— *Double exposure:* The same film is exposed twice, resulting in a composite of two images superimposed and seen simultaneously.
— *Flashback:* A break in normal sequence with a shift suggesting or recalling past events.
— *Pan:* The pivotal movement of the camera in a horizontal plane; for a flash, a swish, or a blur pan, the camera is moved rapidly.
— *Story-board grid:* A series of rectangular frames is arranged horizontally and vertically for a sequence of sketches planning action continuity. It resembles a cartoon strip.
— *Stroboscopic photography:* The film is shot with rapid flashes of light so the subject appears to move imperceptibly during each light flash.
— *Telephoto shot:* The use of a lens with magnification power capable of making distant objects appear nearer and larger.
— *Zoom:* Smoothly moving in for a near shot and back to distance from a subject (zoom in/zoom out).

> Photography and motion pictures have influenced painting in several ways, including animation, candid-camera shot, dissolve, double exposure, flashback, pan, story-board grid, stroboscopic effect, telephoto shot, and zoom in and out.

Examples

Animation: Lichtenstein—*Whaam!* [37]
Candid-camera shot: Toulouse-Lautrec—*La Divan Japonais* [76]
Dissolve: Turner—*Steamer in a Snow Storm* [75]
Double exposure: Magritte—*The False Mirror* [39]
Flashback: Chagall—*I and the Village* [12]
Pan: Rauschenberg—*Buffalo II* [62]
Story-board grid: Rauschenberg—*Buffalo II* [62]
Stroboscopic effect: Duchamp—*Nude Descending a Staircase* [19]
Telephoto shot: Magritte—*The False Mirror* [39]
Zoom in and out: Magritte—*The False Mirror* [39]

Application

Having looked at each technique in isolation, now examine the following works and identify as many photographic techniques used in each as you can:

(a) Duchamp—*Nude Descending a Staircase* [19]
(b) Toulouse-Lautrec—*La Divan Japonais* [76]
(c) Rauschenberg—*Buffalo II* [62]
(d) Indiana—*The American Dream, I* [28]
(e) Chagall—*I and the Village* [12]
(f) Lichtenstein—*Whaam!* [37]

— — — — — — — — — — — — — — —

(a) Stroboscopic photography and multiple exposure.
(b) Candid-camera shot.
(c) Story-board grid plan, panning, zooming, dissolve.
(d) Zoom close-up.
(e) Flashback, zooming in, telephoto shot.
(f) Animation, zooming.

APPLICATION

12. Compare Goya's *Execution of the Madrileños* [27] with Mathieu's *Painting, 1952* [44] to determine how each implies motion. Which is representational and which is nonrepresentational? Which do you prefer and why?

— — — — — — — — — — — — — — —

Execution of the Madrileños: The representational shapes are not refined in detail, but through Goya's generalized masses of form, we know the horrifying action taking place before us—sudden and sure death in the blinding focus of intense lantern light. It is shockingly rapid with the machinelike sureness of the soldiers at the right in contrast to the agonizingly slow pressure of the human mass being forced up the hill to the left. The chain of action/reaction is a highly selected sequence that informs us graphically of the command to kill: the rifles aimed for action, the dread of the captives, the bewildered victims, the grisly job of jailor and priest, and the chaos of the fallen in death.

Â Â Â Â Â Â *Painting, 1952:* We sense with immediacy the directness and sureness of the lines, which look as if they might have been shot into their positions. Overlapping and interweaving lines lead our eye with a swing, a snap, and a spring comparable to the working of some intricate machine that has been tampered with and has sprung apart from its delicate, ordered functioning. These forms seem not to match any real-life images, and yet, can you relate Mathieu's forms to a bolt of electricity flashing to rip open the sky? Or might you imagine Stella's tightly interlocked *Sinjerli Variation IV* [72] split asunder to fly off into splintered fragments?

The Goya is representational; the Mathieu is nonrepresentational. Your preferences will be your own. Be open and honest in your reactions to the choices of the artists, but withhold final judgments, remembering that your responses change with time, knowledge, maturity, and further contact with the work.

SEEING THE UNITY

13. Combine what you have learned about motion with what you already know about order, balance, line, light/dark, shape and proportion, space, and texture. Look carefully at Stella's *Sinjerli Variation IV* [72] and describe it as completely as you can in terms of the preceding factors.

_ _ _ _ _ _ _ _ _ _ _ _ _ _ _ _ _

Order: Rigid.

Balance: Symmetrical.

Line: Compass curve and ruler-straight lines of the narrow light bands are a contrast following and echoing the wider, darker bands that lead the eye along linear paths.

Light/Dark: Lightest areas are thin line edges following the wider bands that vary in tone. Stella has used flat tone with no modeling.

Space: The bands overlap and interweave. Only the thickness of the paint and the illusion of overlap suggest the very shallow space.

Shape and Proportion: The circular outer shape forms a close, tightly harmonious relationship with the arc curves within. The straight-line shapes become a contrast. The narrow light line (which is actually bare canvas) contrasts in tone and width to the wider bands, giving the effect of a grand-scale cloisonné—colored enamel bits fused with fine metal walls separating the many colors.

Texture: Smooth, with no apparent brush strokes.

Motion: The circular outer shape and the overlapping arcs give a rotating effect that is counteracted by the center forces, invisible vertical center, and the more visible center horizontal. The intersection of these forces forms a Greek cross with each arm of equal length. But the sliding, swinging arcs take over to give a back-and-forth rocking motion as the eye moves in and around the tightly locked interlace, which is like a gigantic Celtic knot such as in the *Lindisfarne Gospels: Initial Page* [87]. (Another interlace is the line pattern decorating the altar of Raphael's *The Dispute of the Sacrament* [59].)

You should now be able to look at a work of art and describe the actual and implied motion that occurs. You may want to review the questions at the beginning of this chapter before completing the following Self-Test.

SELF-TEST

This Self-Test will help you evaluate how much you have learned so far—how well you can answer the questions raised at the beginning of the chapter. Answer the questions as completely as you can (use a separate sheet of paper) and then check your answers against those that follow.

1. Describe visual rhythms (conforming, sequential, contrasting) in:

(a) Blake—*Book of Job: "When the Morning Stars Sang Together"* [3]
(b) Rauschenberg—*Buffalo II* [62]

2. Can you name a work of art and artist you disliked on first seeing that you have discovered now has more meaning for you? (Answer this question only if there honestly has been such a change.)

3. Describe the moment in time and the use of implied motion through representational imagery in the three paintings of *The Resurrection:*

(a) Francesca [57]
(b) Grunewald [29]
(c) El Greco [21]

4. Describe implied motion through nonrepresentational imagery in:

(a) Sung K'o—*Cursive Script Poem* [84]
(b) Mathieu—*Painting, 1952* [44]

5. Look at the following works and identify the way(s) in which the artist is depicting a story sequence:

(a) Klee—*Around the Fish* [34]
(b) Picasso—*The Three Dancers* [56]
(c) Manet—*At the Races* [41]

6. Look at the following works and determine what film devices might have influenced the artist:

(a) Renoir—*Le Moulin de la Galette* [64]
(b) Turner—*Steamer in a Snow Storm* [75]
(c) Magritte—*The False Mirror* [39]
(d) Rauschenberg—*Buffalo II* [62]

7. Look at Giorgione's *The Concert* [25] and discuss the artist's use of motion.

8. Look at Rubens' *The Rape of the Daughters of Leucippos* [68] and discuss the artist's use of order, balance, line, light/dark, space, shape and proportion, texture, and motion.

Answers to Self-Test

In parentheses following these answers are given the number of points each question is worth, if you want to total your overall score, and the frame references where the topic is discussed, if you wish to review.

1. (a) Similar kinds of line run through the entire work in the repeated scalloped line of the outer border shapes, in the edges of the cloud shapes, and in variation through the figures. The angels fit ovals for repeated patterns. Contrast rhythms are seen in the horizontal/vertical arrangement of the figures, in the difference in the standing/kneeling figure forms, and in the single centered figure. Sequence rhythms are built into the tonal light-to-dark gradations. (frames 1-2; 3 points)

 (b) Strong content and shape contrasts exist in the disparate subject matter. There is also contrast in line, texture, and tone throughout. There is a unifying harmony in the invisible, repeated vertical lines that divide the surface into thirds and in the invisible, repeated horizontal lines that divide the surface into fourths. (frames 1-2; 3 points)

2. Answers will vary considerably here. (frames 3-4; no points)

3. (a) A living Christ, triumphant over death, emerges from the tomb while the watchmen (ourselves?) sleep, unaware of the miracle happening. (frames 5-6; 2 points)

 (b) As the guards (ourselves?) sleep, Christ ascends, hovering in space between heaven and earth, showing to those who are awake the wounds in his hands and feet as his body and a luminous cosmic form become one. (frames 5-6; 2 points)

 (c) The armed but powerless guards (ourselves?) fall back as if stricken by the light and action of a revived Christ freed from the earth. He ascends in an enveloping cloud. (frames 5-6; 2 points)

4. (a) The darkest, thickest forms indicate a loaded brush and firm pressure. The ragged edges follow as the brush gets drier. The fine lines trail and disappear as the brush gradually lifts from the page and the touch lightens. (frames 7-8; 2 points)

 (b) The lines snap and spring with electric energy as if the paint had been shot onto the surface. (frames 7-8; 2 points)

5. (a) Narrative sequence in one frame. (frames 9-10; 1 point)

 (b) Overlapping stages of motion. (frames 9-10; 1 point)

 (c) Blurred edges and elimination of detail. (frames 9-10, 1 point)

6. (a) Candid-camera shot. (frame 11; 1 point)

 (b) Dissolve. (frame 11; 1 point)

 (c) Zoom in, telephoto shot, double exposure. (frame 11; 3 points)

 (d) Story-board grid, panning, zooming, dissolve. (frame 11; 4 points)

7. In this quiet painting, the foreground nude women, largest in scale, are the most active figures. The standing one draws water in a graceful, dancelike gesture. The other, seated and turned away from us, hesitates between notes on a flute. The seated, clothed men converse as one is

about to play a chord on his stringed instrument. In the distance a shepherd takes a step toward his sheep. Far beyond is a hazy, peaceful villa. Giorgione has captured a moment of echoing notes just before new notes sound forth into the gentle harmony of the warm, sunny day. (If it is a dream, as it is often considered to be, whose dream is it? That of the goddesses? The men? The shepherd? Yours?) (Chapter 7; 10 points)

8. *Order:* Seemingly random, but with a rigid understructure within a vertical rectangle. (Chapter 1; 2 points)

Balance: An asymmetric, radial system. (Chapter 1; 2 points)

Line: The axis of forms builds from the center and becomes an angular swastikalike action plan based mainly on the projecting arms and legs of the women and the plunging horse. Forms are distinguished chiefly through edge line. A few open, trailing, linear forms occur in the reins, neck piece, and hair strands. (Chapter 2; 5 points)

Light/dark: Figures are carefully modulated to give the illusion of volume and bulk. The foreground figures of the nude women and one horse are light in value; the men and the other horse are darker. The background alternates light and dark, adding to the suggestion of distance. (Chapter 3; 5 points)

Space: Overlapping planes make a shallow, up-front surface which is a solid volume interlace constructed within a large diamond shape placed on its point, a precarious balance system. The pivot of the diamond is at the bottom edge center where a light foot overlaps a dark foot. All the major forms fall generally within diagonals running from this point left and right, turning at the outer point of the left angel's knee and at the right horse's plunging hoof to meet at the pointed ear of the right horse. Behind this focused drama, space seems to roll back. The background is indicated as low on the picture plane by irregular horizontal bands and seems abruptly far away. With no transition between the large scale of the surface forms and the small distant forms, Rubens gives the impression that the action is set high on a hill with mainly sky as background. (Chapter 5; 5 points)

Shape and proportion: Shape preference is decidedly curvilinear and circular. Larger forms are made up of smaller curved shapes with softened edges giving the feeling of vibrating, palpitating flesh. Proportions are filled out and buxom. The women are largest in scale; the men are slightly smaller; and the horses are very small when compared with the human forms. (Chapter 6; 5 points)

Texture: The actual texture is oil paint built in layered glazes of paint mixed with thinner and light varnish. This and careful modeling and color choices give the convincing impression of living flesh, whether human or horse. Textural focus is on the women's bodies. (Chapter 7; 5 points)

Motion: The women are being captured and will be abducted by the two men, but the violence of the event is softened by the two winged cherubs, symbols of love, clinging to the horses. The entire action, which in general falls within a diamond shape, balances from the

precarious pivot point of overlapping feet at bottom center. The action is a complex thrust and counterthrust; the legs and arms of the women form a pinwheel relationship. When the work is viewed abstractly, it takes on a spinning motion. The background for the action is mainly sky, with low horizontal bands suggesting that the setting is high and the landscape spreading far below. (Chapter 8; 10 points)

Total possible points: 77. Your score: _____ . If you scored at least 61 points, you understood the main points of the chapter. If your score was lower than this, you may want to review the appropriate frames before you go on.

IMAGINATION STRETCHES

— Try to tap out the beat or imagine the sound and rhythm of boogie-woogie while looking at Mondrian's *Broadway Boogie Woogie* [back cover]. Mondrian has also done a *Victory Boogie Woogie.* Select a musical rhythm or beat you think would be fun to space out with color and blocks.
— Establish an arbitrary system of color and shape with specific music notes. "Rewrite" the musical notation of a melody of your choice with your own coding of color and shape.
— Build a one-minute television commercial unraveling an action series from one work of art in your reproductions and developing the sequence on story-board paper.
— Make a flip-book (pages held together at one end and designed to be flipped through rapidly) indicating the gradual action change of day to night and back to day again; or you might try indicating a change of season with color.
— Begin a search for poems that resulted from a poet really seeing a visual art form or of music that resulted from a musician really seeing a painting. A few starters:

> "Seven Studies on Themes of Paul Klee" by Gunther Schuller (musical compositions recorded by the Minneapolis Symphony Orchestra, 1958)
>
> "The Man with the Blue Guitar" by Wallace Stevens (poem based on Picasso's *The Old Guitarist*)
>
> "The Man with the Hoe" by Edwin Markham (poem based on Millet's *Man with the Hoe*)
>
> "Nude Descending a Staircase" by X. J. Kennedy (poem based on Duchamp's *Nude Descending a Staircase*)

CHAPTER NINE
Images and Symbolism

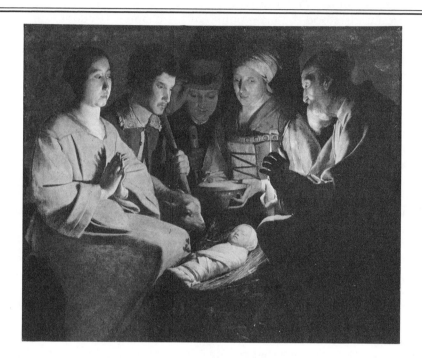

 In a work of art, can you:

- describe the images and explain those that have symbolic significance to you?
- explain the use of public and private symbolism?
- decide whether the symbols are used intentionally or unintentionally?
- describe how different images combine to communicate symbolic meaning?

Entire books have been written on symbolism; this chapter provides only the basic concepts you need to start exploring symbolism in a work of art. Your awareness, your imagination, and your efforts at seeing and interpreting can all combine to draw genuine meaning from visual imagery. You will need paper and a pencil for the exercises in this chapter.

Georges de la Tour. *The Adoration of the Shepherds.* 1643. Des Musees Nationaux, Paris. Collections du Musee du Louvre.

INTRODUCTION TO SYMBOLISM

1. When we say "What do you see?" we're talking about *image;* for example, when you look in the mirror, you see a reflection of your image. When we say "What does it *mean?*" we're talking about *symbolism;* for example, you may see a fire (actual image), but you may associate it with comfort or pain. The association is a symbolic meaning.

Everything appearing in a work of art can be considered in terms of *symbol*—that is, every visual property or representation of appearance can stand for some meaning beyond its visualization. Each mark within a work of art is part of a coding system invented by the artist to penetrate to a new vision involving feelings, thinking, and meaning.

Every aspect of visual art that we have considered thus far, each of the means that the artist seeks to control, can have symbolic significance. Recall the following:

- The interrelated controls of balance and order are associated with your own physical and mental needs.
- Diagonal lines are associated with action, vertical lines with strength and support, horizontal lines with stability and rest.
- Broken lines are associated with freedom, enclosing lines with captivity.
- Light and dark are associated with such polar opposites as day and night, lightheartedness or depression, and sometimes good and evil.
- Color is associated with warmness and coolness, with forcefulness or mood, and with every hue having a range of possible symbolic meaning.
- Spatial conventions are associated with nearness and farness.
- Texture is associated with your sensation of touch.
- Implied motion is associated with being alive.

As one of the requisites of visual thinking, Rudolf Arnheim has noted: "Every perceived property or object [can] be taken to be symbolic . . . the darkness of *Guernica* [50], for example, has to be interpreted symbolically."*

Symbolism permeates our everyday life; in fact, the very words you are reading are symbolic:

> A word is a symbol because it stands for its meaning. The sign + is a symbol, because it stands for the operation of addition. A lily, in religious art, is a symbol because it stands for purity. The creature which, in a terrifying dream, threatens to devour the dreamer is a symbol, because it stands for some situation in the environment or some conflict in the inner life which threatens to engulf the personality. The flag in battle is a symbol, because it stands for the ideals and the honor of the mother country. In theology, the Cross is a symbol, because it stands for a truth which words cannot completely express.†

*Rudolf Arnheim, *Picasso's Guernica, The Genesis of a Painting* (Berkeley: Univ. of California Press, 1962), pp. 10–11.
†Mary Anita Ewer, *A Survey of Mystical Symbolism* (London: Sheldon Press, 1933) p. 113.

Each of these images shares the common quality of representing a dimension beyond its actual existence.

Is every image in a painting symbolic to you? At this point, your answer will probably be "no." What the artist meant and what the work means to you are both tied to your response to this question. Sometimes the artist explains in words the intended meaning of images in a work; reading the artist's writings can help you shape your own interpretation. Or, you can read and compare the interpretations of scholars who have studied the work in depth. Important as it is, however, reading cannot take the place of *seeing* the work repeatedly (ideally, the original work). What a work means to you can change and grow with seeing it many times.

Whether the images in a painting are seen as symbolic depends on YOU. The meaning of a symbol is found most directly within yourself. Although every property, every object in a painting carries the *potential* for symbolic significance, any personal, honest, real meaning must be *discovered* by you—not memorized, but understood and believed by you.

We may search and seek to discover meaning in many ways. That search will always be a quest for cross-connections, hookups, keys that will spring open the doors of insight so we can "see" beyond what our eyes show us.

> An *image* is what we see: line, tone, color, or the representation of an object or person. A *symbol* is an image that stands for or suggests something in addition to its own existence: an idea, a quality, a meaning.

To determine symbolic meanings beyond the actual appearance of a concrete image, you can follow these steps:

— Observe, describe, and consider the concrete image in isolation. Describe a commonly accepted standard set of permanent characteristics, and record variations in size, shape, color, structure, and so on.
— Determine the function of the image in the actual world. What does it do? How is it used? Where does it exist?
— Investigate what else it relates to or is associated with. How does it compare to things similar to it?
— Finally, search for where the image has appeared: in visual art, advertisements, song lyrics, nursery rhymes, children's stories, poems, other literature.

An example may clarify the process of determining symbol meanings beyond actual appearances.

Example

— Observe water: Permanent characteristics—liquid, colorless, tasteless. Variations—clear, spring, running, stagnant, dead, fresh/salt, reflecting, purifying, deep/shallow, swirling/calm, stormy, murky, still/rippling, waves.

— Functions: Irrigates, purifies, reflects, dissolves, feeds, gives life, is a source of death and destruction, rejuvenates, gives birth. Is used in: washing the body, clothes, food; as a vital element for the human body; ritual baptism.
— Related to: Clouds, steam, vapor, rain, ice, snow, blood, wine, milk (any liquid); circulation, any force of renewal and regeneration. Associated with the source of life, personal unconscious, and psychic depths.
— Has appeared: In several of your reproductions such as Turner's *Steamer in a Snow Storm* [75]; Gericault's *The Raft of the Medusa* [24]; Monet's *The Poplars* [51]; and Botticelli's *The Birth of Venus* [4]. It has also appeared in: advertisements—"the land of sky-blue waters"; song lyrics—"over troubled waters," "deep river"; nursery rhymes—"to fetch a pail of water," "if all the seas were one sea"; literature—James F. Cooper's *Water Witch*, Charles Kingsley's *Water Babies*. You can probably think of many more and varied suggestions to add.

Exercise

Give as many symbolic meanings as you can for the following images. Then use the four-step plan for interpreting symbols given above for one of the images and see how many more symbolic meanings you can discover:

(a) Cross
(b) Lion
(c) Rose
(d) White cloth
(e) Black cape
(f) Dove
(g) Laurel wreath
(h) Star
(i) X

— — — — — — — — — — — — — — — —

Your answers may vary considerably from those that follow:

(a) Christianity, intersection, addition; (b) bravery, power, leadership, king, library; (c) love, life, Virgin Mary; (d) purity, chastity, surrender; (e) evil, mourning, magic; (f) peace, Holy Spirit, soaring aspiration; (g) victory, fame, distinction; (h) cosmic body, award, career success; (i) twenty-fourth letter in the alphabet, railroad crossing, multiplication, omit.

In searching for the range of symbolic significance and possible meaning differences of an image, any of the following references may be helpful:

Cirlot, J. E., *A Dictionary of Symbols* (New York: Philosophical Library, 1962).
Eliade, Mircea, *Images and Symbols* (New York: Sheed & Ward, 1961).
Ferguson, George, *Signs and Symbols of Christian Art* (New York: Oxford Univ. Press, 1955).
Gombrich, E. H., *Symbolic Images* (New York: Phaidon, 1972).

Hall, James, *Dictionary of Subjects and Symbols in Art* (New York: Harper & Row, 1974).

Jung, Carl, *Man and His Symbols* (Garden City, N.Y.: Doubleday, 1964).

Seeing Images and Discovering Symbolic Meaning

2. Look at Picasso's *Guernica* [50]. An inventory of images that might have symbolic meaning could include the following:

> Sun-eye-light bulb
> Figure holding forth a lamp
> Flower emerging from the hand holding the broken dagger
> Horse with lance thrust
> Figure falling through flames (at right)
> Fleeing figures
> Fallen warrior with shattered dagger
> Bull behind mother and dead child

The sun-eye-light bulb, the figure thrusting forth a kerosene lamp, and the barely visible flower emerging from the fallen warrior's hand that clutches the broken dagger are images suggesting light and a hope of renewal. The other images represent the agony of death, the panic of those caught in the holocaust, the despair of those fleeing, the death of innocent victims, the defeat of battle. The bull behind the mother and her dead child appears to be an impassive and enduring power symbol with ambiguous meanings.

The work's monochromatic lack of color is part of its joylessness; its emphasis on dark with sharp contrasts of light is part of its message of fear; the pointed, razor-edged lines and exaggerated, distorted shapes relate, in part, the idea of pain; the spatial compression of all this chaos in the shallow space is part of its despair.

Application

Look at Durer's *The Knight, Death, and the Devil* [20]. Make a list of the images that might have symbolic significance and find an interpretation that is meaningful to you.

— — — — — — — — — — — — —

Following are some possible meanings; you may find others:

> Young man—hero, everyman
> Boarlike "devil"—death or evil
> Skull-like "death"—death or danger
> Fine, strong horse—loyal friend and ally
> Old nag—age and passage of time
> Armor and helmet—protection
> Sword and lance—protection, weapons
> Snake-entwined crown of "death"—evil

Hourglass—passage of time
Dog—loyal friend and ally
Skull and gravestonelike slab—death and record of the past
Trees and roots (barren)—tie between earth and heaven
Hills—transition between earth and heaven
Distant castle—heaven, unattainable goal, place of refuge, place of power

One possible interpretation might be: The knight, a youthful hero who is Everyman, sets forth on the journey of life. Riding beside and behind are death and the devil—constant threats to Everyman. We do not know the knight's mission. The castle may be his goal (heaven), or it may be the place from which he has set forth, strong, assured, and grimly determined as he rides to meet his destiny, whatever it be.

PUBLIC/PRIVATE AND
INTENTIONAL/UNINTENTIONAL SYMBOLS

3. Symbols may be generally understood and *public*, or they may be individual, elite, and *private*. According to the psychologist Carl Jung, the effective living symbol that evokes a universal response must contain an understanding shared by large numbers of people. An example of public symbolism is the flag of a country, which its citizens recognize as representing the ideals and honor of the country.

People may also have private or individual symbols that are a part of their personal lives. For example, the creature in a terrifying dream, which threatens to devour the dreamer, may be a private symbol standing for some situation or some inner conflict that threatens to overwhelm the individual personality. An intentionally limiting elite can be established with private symbols that exclude those who do not belong to the group; they are a secret except to those who are "in" on the meanings. Private visual symbols such as a family shield or a mysterious club emblem can be a powerful means of maintaining the strength of a special group.

When a symbol is broadly public, you are likely to feel comfortable with some level of understanding without reliance on anyone else telling you how to interpret it. When a symbol is private, however, you tend to feel the frustration of being left out, or you may interpret freely and intuitively through personal associations. Sometimes the artist explains private symbols as Kandinsky does in his book *Concerning the Spiritual in Art* (New York: Wittenborn, 1947). Sometimes private symbols become public, as with the once secret symbols used in the catacombs by the early Christians.

Symbols may also be used *intentionally* or *unintentionally*, consciously or unconsciously. The symbolic meaning you discover in the images of a work may *not* have been intended by the artist. Sometimes an artist consciously seeks to create images with anticipated symbolic meaning, but at other times the artist does not intentionally do so. The images and marks made without specific intention often result from an artist projecting the content of his

subconscious into the materials with which he works, as in the paintings of Jackson Pollock, who marks out "the runes of his own mystery."

> Symbols may be *public* (generally understood) or *private* (individual). Symbols may be used *intentionally* or *unintentionally* (without specific awareness by the artist).

Examples

Public symbols include such things as birthstones, signs of the zodiac, rabbits' feet, horseshoes, national flags, national birds, state flowers.

Private symbols include such things as family crests or shields (private made public), dream images, and club mascots or insignia.

Intentional symbols are those involving deliberate choice—for example, the selection of a class ring.

Unintentional symbols are similar to marks you make when you doodle with a pencil.

Public symbols that are frequently found in works of art (and literature), and which may be used intentionally or unintentionally, are those associated with the universal experience with the life cycle:

Life Span	Time of Day	Season	Abstract Associations
Birth/youth	Dawn	Spring	Beginnings, blossomings
Adulthood	Noon	Summer	Peakings
Old age	Sunset/evening	Autumn	Fadings
Death	Night	Winter	Endings

Exercise

Which of the following do you believe have a public interpretation?

(a) Cross
(b) Boot tassels of a majorette
(c) Skull and crossbones
(d) Your class ring

(e) Heart
(f) Locket worn from a chain
(g) Crown
(h) Lapel pin

– – – – – – – – – – – – – – – –

You probably checked (a), (c), (e), and (g) as public. The cross is commonly representative of religion, the skull and crossbones of danger or death, a heart of love, and a crown of sovereignty or victory. The others often have private meaning.

<div align="center">

Seeing Images and Finding Public/Private, Intentional/Unintentional Symbolism

</div>

4. Look at Grunewald's *The Resurrection* [29]. The public symbols used are generally understood in the Western Christian world: the sleeping guards

associated with our own unawareness; the empty tomb, an emblem of death overcome; the boulder background, the externally solid and stable; the wounded hands held forth, suffering transcended; the ascending image of Christ together with a radiant sunburst, the source of hope and light.

Look at Van Eyck's *Jean Arnolfini and His Wife* [color plate 7]. Here you find symbols that were public when the work was done:*

> Burning candle—the all-seeing wisdom of God and special reference to weddings ("the marriage candle")
> Bedroom setting—the nuptial chamber
> Carved wooden figure of St. Margaret triumphing over the Dragon (armchair standing by the bed)—she was the saint invoked by pregnant women
> Griffin terrier—symbol of faith
> Clogs removed—sacredness of space, the removal of shoes in a holy place
> Joined hands—the union of marriage, related to the gesture of the traditional marriage pledge
> Arnolfini's raised arm—confirmation of the matrimonial oath

Finally, look at Pollock's *Autumn Rhythm* [58]. This is an example of private symbolism. Pollock's aim was an order that retained a maximum of the random, improvisational, and seemingly accidental that would emerge from his subconscious without deliberation. It is a linear puzzle that seems to entangle and coil itself infinitely. Thinking yourself within this work and trying to find a rational pattern is like finding yourself inside a labyrinth where the way out is unknown. The resulting confusion, frustration, and complexity is its meaning. Within the labyrinth one is tormented. Only outside or above it can one see a total and rational pattern.

Application

Look at these works and discuss briefly the artist's use of public and private, intentional and unintentional symbolism:

(a) Johns—*Target with Four Faces* [32]
(b) Mathieu—*Painting, 1952* [44]

— — — — — — — — — — — — — — —

(a) The images with public meaning are: newspaper—understood as something to be read, associated with words related to today's (NOW) events, related to technical, mechanical processing; target—a mark to shoot at, a goal, a bull's eye, an object in mind, target day, zero hour, H hour, D day; laughing stock, butt, figure of fun, victim (Johns' target is painted in encaustic, which you can see through, over the newspaper).

*From Erwin Panofsky, "Jan Van Eyck's Arnolfini Portrait," *Modern Perspectives in Western Art History*, ed. by W. E. Kleinbauer (New York: Holt, Rinehart and Winston, 1971), pp. 193-203.

More private symbols include the life-cast human masks cut off just under the eyes and the compartmental wooden frame into which the faces are set. This intentional juxtaposition of images forces the viewer to relate to these images. Does Johns intend: Indifference to newspaper and news? A carnival shooting gallery? Blindfolded men before a firing squad? Human sacrifice? Loss of personal identity? To frustrate the viewer? You may have other ways of interpreting this combination of images.

(b) In general the marks have a private symbolic meaning related to writing in a personal linear calligraphy—action of speed, spontaneity, and audacious sweep of the line give the feeling of a flare or an explosion. Mathieu projects the instant of a moment, a heightened NOW, when neither efforts of the past nor of the future seem important. The dark background with the snapping light line could relate to a bolt of electricity. This kind of work, in which the artist emphasizes the subconsciously made mark, is called "action painting." The viewer's empathy with the performance process is a compelling factor in interpreting meaning.

COMBINING IMAGES FOR SYMBOLIC MEANING

5. In looking at a work of art, many people do not see meaning in images beyond the fact that they look like or match with something or someone from the actual world. Perhaps this should not be surprising since it seems that most of life for vast numbers of us is experienced on this primary, practical level.

To find symbolic meaning you must consider images in a work beyond the artist's ability to match objects you can recognize from the real world. How the artist has combined an image with other images can give you different meanings.

Consider the image of a flower in combination with other images in a painting. In Botticelli's *The Birth of Venus* [4], the air blown by the winged winds at the left is filled with red roses, the flower of love and desire. Combined with rose, wind, and water is the beautiful figure of Venus standing on a shell (related to fertility), along with an attendant who wears a flower-patterned garment and holds forth a robe designed with primroses. Here the mysteries of beauty, fertility, and renewal tied with the love symbolized by the rose provide meaning deeper than the symbolism of any single image in the work.

In general, the more expected and visually realistic the imagery, the more able you are to interpret meaning. The more unexpected the image relationships and/or the more abstract the forms, the more you may find yourself unable to imagine meanings and associations that are significant to you. In fact, total abstraction may push your credulity to the point of complete frustration in trying to make any kind of meaningful connection with reality. (This may be true when seeing the works of Pollock, Soulages, or

Mathieu.) In such works, observe the marks and the artist's control of the means (line, tone, color) and relate these properties with the artist's energy and decision-making process. Empathy with feelings involved in producing such specific evidence of existence may result in meaning for you.

Since images may occur in an infinite number of combinations, an image never has one absolute symbolic meaning. Its meaning depends not only on how it is combined with other images, but also on your ideas and experiences, as well as new relationships you see on repeated viewing. If you are flexible and willing to accept new insights, a work of art can continue to grow in richness with unlimited levels of meaning.

If your interpretation does not agree with someone else's, this does not invalidate your idea. Your conclusions are important and right for you at your particular moment in life and looking. You can always put into "symbolic storage" ideas that do not have significance now but may later take on meaning.

> An image can have different meanings in different combinations and to different viewers. An image never has one absolute symbolic meaning.

Example

A practical, factual example is a United States one-dollar bill. Have you ever thought of the meaning of money—other than what it can purchase? Paper money symbolizes reserves in the U.S. Treasury, but a dollar earned is also a symbol of your stored energy ready to exchange for someone else's energy. Observe the combination of images printed on a one-dollar bill. Considered together, what symbolic meaning do they convey?

Front (black ink): Portrait of George Washington, circle seal of the Federal Reserve Bank and the U.S. Treasury, shield, scales, key, stars, a number, leaves.

Back (green ink): Circle seal with pyramid and eye in triangular apex of the pyramid, circle seal with eagle and shield, claws clutching arrow bundle and branch with leaves, ribbon with *e pluribus unum,* circle of stars.

Some possible meanings: Authority, strength, power, protection, stability, justice, security, trust. You can probably think of many others.

Exercise

Heraldry, in the forms of crests, banners, shields, and coats of arms, uses visual symbols for meanings such as identity, power, security, protection, and continuance. Because of their symbolic significance, monsters are a favorite motif in heraldry:*

*Drawings from Heinz Mode, *Fabulous Beasts and Demons* (New York: Phaidon, 1973), pp. 12-13.

The lion is a sun symbol of strength, victory, leadership; combined with wings, associated with power to soar to great heights; combined with a book, associated with wisdom, learning, and peace.

A beautiful woman with the tail of a fish, a mermaid, combines all the strengths of the sea and earth; the sword and shield may symbolize both protection and aggression.

The castle represents a stronghold and a place of refuge that stands firm in spite of the dragon's threats of darkness, death, and the forces of evil.

Use the following shields to draw images or write the words for images that might have symbolic meaning for an identity shield for yourself or your family:

Seeing Images in Different Combinations
and Finding Different Symbolic Meanings

6. Look at the center panel of Roger Campin's *The Merode Altarpiece* [8]. Observe, particularly, the flower and how it has been combined with other images. On the tilt-topped, centrally located table is a vase with a stem of Madonna lilies, the trumpetlike flower symbolic of the Christian annunciation as well as purity. The table also holds a smoking candle, symbolic of the moment God takes the form of the Child, and an open book, symbolic of wisdom. At the right, Mary reads from a book of Psalms protected by a white cloth, symbolic of purity and of her piety and reverence. At the left is an angel, a spiritual messenger, announcing to Mary that she has been chosen, while just over the angel's wing the image of the tiny Christ Child glides in on a cross along light rays from the nearest round window. On the back wall is a bronze laver for holding water and a hanging towel, both symbols for purity and cleanliness.

Application

Look carefully at the following works and observe the differences in the flower forms and how they have been combined with other images for differences in meaning:

(a) Ingres—*Madame Moitessier* [31]
(b) Manet—*Olympia* [40]
(c) Watteau—*The Embarkation for Cythera* [85]

— — — — — — — — — — — — — — —

Your answers may vary from those that follow:

(a) Roses form a contrasting light halo-wreath around Madame Moitessier's dark hair, accentuating the light of her face and shoulders. We see a three-fourths-length figure, an elegantly dressed lady, with pearl necklace, handsome brooch, rings, and bracelets. The roses are like a crown, symbolizing youth, alluring femininity, beauty, and future hope. The low-cut gown of rich fabrics, jewels, gloves, and fan are symbols of high fashion and social status. The background wainscoting and wall also suggest a setting of wealth. The wall pattern repeats the flower motif in a value reversal of darker flowers against a slightly lighter ground.

(b) A large, light flower is worn in the dark hair of the reclining female nude. A bouquet of flowers is presented to her by a black serving maid. The bold outward look of Olympia, the dark-curtained bedroom setting, and the cat at her feet are overt sex symbols. (According to Theodore Reff in his *Manet: Olympia* [New York: Viking Press, 1977], the rare tropical orchid, satin slippers, and Indian silk stole worn by Olympia are emblems of the wealthy courtesan. The orchid is also symbolic of primitive passions and evokes beliefs concerning its aphrodisiac powers. The center flower of the bouquet is either a gardenia or a white tea rose

surrounded by white and red rosebuds and unidentified blue flowers, but primarily roses, symbolic of love, beauty, and expensive taste.)

(c) Under an arbor formed by a tree at the far right is a sculpture entwined by roses. At the far left roses deck the cornucopia-shaped boat. The figures on the right are more defined and seem closer to us, but as they move over the crest of the hill, both colors and figure forms are blurred, blending into a hazy dream of romantic love. The cherubs related to Eros float above the waiting boat, and the vaporous distant water, misty mountains, and sky all contribute to an idyllic paradise. The roses, here, symbolize idealistic love, and the sculpture is probably a Venus, goddess of love and beauty.

APPLICATION

7. The dangers in symbol interpretation must be acknowledged. Not only can the same image have opposite meanings in different combinations, but meanings accepted publicly at one time in history or in one part of the world can be totally different in another time or place. For instance, the snake is a meaning-charged image with implications of evil and death in Western Christian art, whereas in ancient Greece the snake was related to the Pythian oracle of wisdom and prophecy.

There is always the possibility of appearing naive or provincial when symbols are interpreted or used without comprehension, as in some early American art where artists were using symbols from sophisticated European compositions without understanding.

Symbolism is often related to sex since almost any image can be assigned male or female significance. In fact, several entire language systems, such as Spanish, French, Italian, and German, have gender assigned to each word.

If we interpret visual images literally, systematically, or absolutely, we raise a deterrent to further learning. The stereotyping of symbol meaning can be heavy or just boring when obviousness and imposed meanings are conveyed with finality. It has much the same effect as explaining a joke. When others assign meanings where you see none or when interpretations are different from your own, symbol interpretation can be annoying, funny, or provoking.

On the other hand, a flexible symbolic framework can become a giant switchboard for new connections, hookups, and attitudes. It can become the basis of a great game, the game of finding our own selves reflected in the meanings we find. The study of symbols centers on our common need for self-awareness and our constant search for meaningful values.

The potential for extended meanings is in every work of art. Whether you find meanings depends on your involvement and your willingness to observe, to ponder relationships, and to make associations with imagination. Many people will offer views different from yours; whether or not you agree, it is always a valuable experience to compare, either with our interpretations or someone else's.

Observe Gericault's *The Raft of the Medusa* [24]. Give a factual account of what is happening—describe the images. Then give a possible symbolic interpretation of the work.

A factual interpretation would describe exactly what is depicted—survivors of a shipwreck adrift at sea on a raft. Some viewers stop "seeing" on realizing the images (subject) depict an actual tragedy of 1816 with involved political implications for the French Navy. The event occurred three years before Gericault's painting, which he began as an historical record. However, in the final, generalized choices that he made, specific descriptive and narrative features were eliminated. He emphasized not the factual incident in French naval history, but the elemental conflict of the men's struggle against the forces of nature. The emptiness of space, the vastness of the surrounding sea, and the threat of death are presented with such compelling force that it is possible for the imaginative viewer to see the raft as a symbol of the world adrift in churning space and to identify with the suffering survivors as representing all of humanity striving for rescue from the glimpse of a power beyond.

 SEEING THE UNITY

8. Now that you have looked at the major components of a work of art, let's see how all combine into a unified whole. Look at de la Tour's *The Adoration of the Shepherds* [color plate 1] and describe the artist's use of order, balance, line, light/dark, color, space, shape and proportion, texture, motion, and symbol.

Order: Rigid.

Balance: Symmetric.

Line: Lines to be seen in fabric folds, edges of shapes, and invisible axis of forms. A strong, zigzag line in the bodice lacing of the gift-bearing figure.

Light/Dark: It is a night scene filled with shadows. The background is dark, and forms emerge from a shadowy, unidentified space. The source of light is the candle on the right held in one hand by Joseph with the other hand held as a shade and backlighted. The centered Christ Child is the lightest except for the candle flame. Mary, at left, is the other figure most fully lighted. The shepherds between Mary and Joseph are darker and less defined.

Color: The single basic hue is red in a range of values, tints, and shades.

Space: The dark background suggests an indefinite, cavernous abyss or even infinity. The figures form a defined, curved wall by the shoulder-to-shoulder relationship from left to right. At far left and right the figures overlap inner figures who overlap a center figure set deeper into space, darker, and with

less definition. Placed in the negative space shaped by the bodies is a basket with the Christ Child, the focus of attention. The candle is held at the head of the Child, and the backlighted hand forms the plane closest to the spectator.

Shape: The shapes are firm and sculptural. The strong contrast modeling, the reduction of detail, and the abstraction of shapes to an almost geometric severity give them a solid, sculptural look.

Texture: Very smooth. Texture depends on the interplay of light and shadow to suggest the simple, plain fabrics worn by shepherds and lowly people. The wooliness of the sheep and the wattle-weave of the basket are the most specific textures. (The earthen jar, the wooden staff, and the wax of the candle are also convincingly communicated.)

Motion: Each figure holds a contemplative pose; each seems lost in deep thought with a hushed reverence caught and held for all time. This is a very silent painting, with no sound, no motion except for the burning of the candle. (Andre Malraux, in *Voices of Silence* [Garden City, N.Y.: Doubleday, 1953, p. 391], describes de la Tour as "the interpreter of the serenity that dwells in the heart of darkness.")

Symbol: The symbol of focused attention is the Child, a renewal symbol; the hands of Mary, a gesture of devotion; the staff of the shepherd, a symbol of protection; the shepherd deepest in space offers a broad smile, a soundless expression of joy; the gift held forth by another shepherd, a symbol of sustenance; the candle, a source of light and life as well as the passage of time. It is the adoration of humble shepherds gathered around a Child who promises a new source of light for the darkness of life. It also has to do with the moment of wonder over the beginning of every new life, with the hope and aspiration which the infant Child brings to all people in all walks of life.

You should now be able to look at a work of art and discuss the artist's use of imagery and symbolism and give at least one possible interpretation of the work. You may want to review the questions asked at the beginning of the chapter before completing the following Self-Test.

SELF-TEST

This Self-Test will help you evaluate how much you have learned so far—how well you can answer the questions raised at the beginning of the chapter. Answer the questions as completely as you can (use a separate sheet of paper) and then check your answers against those that follow.

1. Look at Lichtenstein's *Whaam!* [37] and list the images used, giving a possible symbolic meaning for each.
2. Look at Van Gogh's *The Yellow Chair* [77] and describe the artist's use of public and private symbols. Which images do you suspect were presented intentionally? Which unintentionally?

3. Look at Chardin's *The Boy with a Top* [11] and describe how the particular combinations of images enriches symbolic meaning.
4. Look at Leonardo da Vinci's *Mona Lisa* [82] and discuss as fully as possible the artist's use of images to convey symbolic meaning.
5. Look at Van Gogh's *The Starry Night* [color plate 8] and describe the artist's use of order, balance, line, light/dark, color, space, shape, texture, motion, and symbol.

Answers to Self-Test

In parentheses following these answers are given the number of points each question is worth, if you want to total your overall score, and the frame references where the topic is discussed, if you wish to review. (Your symbolic meanings and interpretations may vary from those that follow.)

1. Airplane—a twentieth-century transit image, a weapon of war.
 Irregular form in the second frame—an explosion (force lines from a center).
 Balloon words—narrative, giving a hint of what's happening, as though you walked into the middle of a soap opera.
 Word *Whaam*—suggests violence, force, or destruction.
 Exclamation point—emphasis, emotion.
 Two frames—comic-strip composition technique of frame series.
 (The Ben Day dot-painting technique is imitated in this painting. If you look through a magnifying glass at a newspaper, you can see the photomechanical process of printing which creates visually unreal forms that are taken for real.) (frames 1–2; 10 points)
2. The setting is the corner of a room. The chair is spatially askew in relation to the tilted floor. The corner contains a very ordinary chair, sturdy with rough wooden back, legs, and straw seat on which sit a pipe and tobacco. A door is against one wall and a bin follows the opposite wall. The bin contains onions and carries Van Gogh's first name, Vincent. A chair is an extension of the self; the sturdiness, roughness, and color (yellow was one of Van Gogh's favorite colors) reflect characteristics of the artist. That he wants us to associate it with himself is reinforced by his pipe and tobacco on the chair seat—both generally conceded to be male symbols. The spatial askewness also relates to Van Gogh's personal lack of orientation to his world. (You might compare *The Yellow Chair* with *Gauguin's Chair*, which Van Gogh also painted; the structure of the chair is different, as are the objects on the chair, the setting, the spatial relationship, and the colors.) (frames 3–4; 10 points)
3. A young boy of about twelve years—age in life, vigor, innocence.
 Courtly attire—status in life, wealth.
 Books—learning and wisdom.
 Ink jar and quill pen—the written word, authorship, learning.
 Scroll of paper—study, research, recording.

Spinning top—a phenomenon of balancing, an amusement involving
chance.
Possible interpretations can embrace the thoughts that, whatever the
social station and in spite of wisdom and learning, chance dominates an
impressionable young life; or that learning can be the directive force in
the game of chance that will influence the youthful boy. (frames 5–6;
10 points)

4. Leonardo's pursuit of ideal beauty is expressed in the full, rounded
forms of a young woman. She is a three-fourths figure seated very near
to us, with a regal composure, looking out to us with a slight smile. Her
only ornament is the knotlike interweave of gold thread along the bod-
ice of her gown. Youth—renewal; beauty—desirability; regality—com-
posure and command; interweave—knots and binding. The background
cuts abruptly to a barren, craggy rock wilderness with hints of surreal-
istic monsters rising from waterways that curve and wash through the
deserted earth forms. The only sign of habitation is the viaduct on the
right. The hostile area beyond the serenity and self-containment of the
foregound figure suggests the weird, the fearful, the uncontrollable and
dissolution in contrast to the assurance, the youth, and the fullness of
beauty. Can the look and the smile be communicating to us the secret
of acceptance and knowledge that everything is in motion and in the
process of being transformed? (Water, erosion of rock, light, fluidity,
the knot or interweave, facial expression, human caricature, and human
beauty are conscious themes of Leonardo's sketches and his verbal
observations.) (Chapter 9; 20 points)

5. *Order:* Rigid. Horizontal rectangle. (Chapter 1; 2 points)
 Balance: Asymmetrical. (Chapter 1; 2 points)
 Line: The entire work is constructed from a flowing but broken
line, a brush stroke that is consistent in width, length, and curvilinear
quality. The most "solid" of the forms—trees, buildings, hills, crescent
moon—are outlined, often in red. (Chapter 2; 5 points)
 Light/dark: Most of the painting is a dark value of blue with the
lightest areas small rectangles suggesting lighted house windows. Streak-
ing along the skyline is another area of light intermingled with darker
strokes as well as the light explosions from star forms. The darkest area
is the foreground cypress tree. (Chapter 3; 5 points)
 Color: Hues are blue, yellow, green, with accents of red. Most
intense is the yellow-orange of the crescent moon. (Chapter 4; 5 points)
 Space: Overlapping of planes and horizontal banding from side to
side. In scale the smaller forms of buildings seem very distant. Seeing
the nearness and the top of the cypress tree gives the feeling that we are
high and looking down into a valley and across to the sky. (Chapter 5;
5 points)
 Shape: A preference for curvilinear form, for circular shapes, and
for curved edges. (Chapter 6; 5 points)

Texture: The surface is rough with skeins or threads of paint. You feel the speed, the intensity, and the rhythm with which the hand and brush applied the paint. (Chapter 7; 5 points)

Motion: The cypress has an almost snakelike or flamelike form that flickers upward on a vertical axis. The interlocked cloud shapes roll across the sky with a horizontal momentum that drops to meet the diagonal sweep of the skyline. The circular stars spin and shimmer; the other foliage, the hills, and the little houses roll and toss like boats rocking on sea waves. The most stationary forms are the spired church and the building beside it, which are lighter and constructed from straighter, stronger lines. (Chapter 8; 5 points)

Symbolism:

Stars—cosmic forms leading our thoughts to the mysteries of the unknown.

Earth—painted almost like sea waves, representing an uncertain stability.

Cypress tree—a flamelike form reaching to a source of power, God; also a male symbol.

Hills—steps also forming a passage to that which is higher and more powerful.

Church spire—a source of stability pointing to the power on high; also a male symbol.

Interlocked clouds—related to the yin-yang, male-female, intertwining opposites.

Crescent moon—mystery of the unknown, also considered a female symbol.

The subject is a landscape, specifically a starry night, as indicated by the title. It depicts churning, natural life forces swirling around the upward-pointing cypress tree and the church spire. For some this painting expresses serenity and great encompassing peace. For others it represents the extreme of loneliness and anguish. In either case, it is the great energy of gesture that contributes to heightened feeling. (Chapter 9; 20 points)

Total possible points: 109. Your score: _____ . If you scored at least 87 points, you understood the main points of the chapter. If your score was lower than this, you may want to review the appropriate frames before you go on.

IMAGINATION STRETCHES

— Record and interpret a "symbol day" during which you reflect upon the symbolic meaning of every image that attracts your conscious attention. If you actually do this, it will be a memorable day.

— Dip into Marshall McLuhan's book *The Mechanical Bride* (Boston: Beacon Press, 1967), in which he examines the symbolism in contemporary advertising.

— Arrange a still life (a grouping of inanimate objects) with things that have symbolic significance to you. What objects do you cherish? Do they have a combined meaning? Look at still-life paintings with this in mind.
— Investigate the symbolic language of flowers. Arrange a bouquet with a meaning "spoken" by your flower choices. Look at flower paintings with this in mind.

CHAPTER TEN
Review and Application:
Art—As *You* See It

The following pages contain a summary of the most important concepts (indicated by •) presented in this book and imagination stretches (indicated by —) that you might ponder (or actually try) to solidify your understanding of the concepts.

ORDER

- *Order* ranges from geometrically rigid to haphazardly random.
- The size, shape, and proportion of the *field of action* are strong ordering forces.

Paul Cézanne, *Mont Sainte Victoire*. 1885-1887. The Phillips Collection, Washington, D.C.

Imagination Stretches

— How many measured squares and/or rectangles are a part of your daily life? Can you escape steps? Risers? Sidewalks? City blocks? Streets? Windows? Doors? Envelopes? Boxes? What else holds us captive?

— Carefully observe the order system of works of art in your reproductions and decide which artists might provide you with a field, counters, and rules for a board game. (You might enjoy reading Sid Sackson's *Beyond Tic Tac Toe* [New York: Pantheon, 1975], a book of games based on systems in Miro, Vasarely, Mondrian, Arp, Delaunay, and Klee.)

— In a book called *Provocative Parallels* (New York: Dutton, 1975), Jean Lipman has found order-system parallels between specific examples of early American folk art and contemporary studio art. Are there any "provocative parallels" within the set of reproductions in this book?

BALANCE

• *Vertical center* is a strong ordering force within the field of action.

• *Symmetric (formal) balance* is created when parts on either side of a center line or a center point correspond in size, shape, and relative position. The effect is static, restful, or tranquil, implying certainty, predictability, and stability.

• *Asymmetric (informal) balance* establishes equilibrium by placing a few large, heavy weights on one side of vertical center and more, equalizing, smaller, lighter weights on the opposite side. (Weights can involve size, amount, location, direction of line, light/dark, color, form, texture.) The effect is action, motion, or tension.

• The structure and the meaning of a work of art are inseparable.

Imagination Stretches

— Balancing games can be lighthearted fun or very serious business. Imagine yourself in each of the following paintings and how you would feel participating: Chardin's *The Boy with a Top* [11], MacIver's *Hopscotch*, Cadmus's *Playground*, Shahn's *Handball*, DeChirico's *Girl with Hoop*, Bellow's *Stag at Sharkeys*, and Toulouse-Lautrec's *In the Circus*.

— What balancing game would you choose as the subject for a painting?

LINE

• Lines are either *straight* or *curved*. Many variations of these two basic kinds of line are found in works of art.

• *Horizontal lines* are associated with relaxation, serenity, rest. *Vertical lines* are associated with still tension, readiness, strength, support. *Diagonal lines* are associated with action, vitality, imbalance.

- *Continuous line* around a form tends to clearly define, contain, and hold form captive. *Broken line* tends to allow open, free, and flexible form.
- A *contour line* suggests the three-dimensional substance of a form. An *edge line* delineates where one shape or color ends and another begins.
- *Volume* may be communicated by contour lines, hatching, cross-hatching, edge lines, and curved lines. Clear, sharp lines usually appear to project. Unfocused, blurred lines usually appear to recede.
- *Invisible lines* include the inner structure of form, points of eye appeal, and paths of look and gesture.
- *Calligraphic line* refers to alphabetic shapes or to lines that suggest the written word.

Imagination Stretches

- Select one work from the set of reproductions. Overlay tracing paper. Begin with an indication of the field of action. Using three different-colored marking pens, draw a different line system with each color. Include a key that tells the kind of line system each color has charted on your final set of linear patterns.
- Copy the lines from the palm of your hand. Make an ink print. Blow up the design using an opaque projector and use stipple or cross-hatch to build out the pattern.
- Draw the visual equivalent for sound with lines: traffic, different voices, a clock ticking, the difference in musical instruments.

LIGHT/DARK—TONE

- *Tone* refers to relative lightness or darkness. *Contrast*—distinct differences between light and dark—results in firmness, fixedness, clear definition, and clear focus. *Gradation*—gradual steps of change from light to dark—results in haziness, softness, indeterminacy, and out-of-focus forms.
- The illusion of solid form can be created either through contrast or gradation. Forms constructed with high-contrasting light/dark will appear firmly defined with the impact of surprise or shock. Those constructed with light/dark gradation will appear softly diffused with the easy grace of expected transition.
- Forms that are backlighted or presented in edge line and flat tone appear flat and two-dimensional.
- Intense light directed against an object can give the appearance of *disintegration of form*. The result is a flat, two-dimensional plane or a dazzling breakup of the surface.
- Distribution (amount and location) as well as degree of light and dark affect mood and the emotional response to a work of art. A low-key, dark work generally results in solemn, somber, even grim response; a high-key, light work generally results in a happy, contented, joyful response.

Imagination Stretches

— Sketch the same object or set of forms early in morning light, again at noon, and again at dusk. Notice how the changes in light change the appearance and shapes of the forms. How does this relate to a sundial?
— Lie beneath a tree and look up through the leaves or branches to see light filter through the leaves or see the branch pattern silhouetted against the blue of the sky.
— With the lights off in your home, look out to the patterns of night light shown when the moon or street light makes visible the forms outside your window. Or walk through the woods on a moonlit night. Notice how different things look than in daytime. It is harder to find signs to guide you.
— Experiment with the different patterns and effects produced by a flashlight (or several flashlights) shining onto a dark wall or onto textures such as tree bark.

COLOR

• Red, yellow, and blue are the most distinctly contrasting hues. Green, orange, and violet are less distinct in hue contrast. Red-orange, yellow-orange, yellow-green, blue-green, blue-violet, and red-violet are still less distinct in hue contrast.
• Every hue has a value sequence from its lightest tints to its darkest shades. Through light/dark contrast, color can be controlled to exaggerate form toward three-dimensional effect or to suppress form toward a flattened effect.
• Every hue has an intensity scale running from dull light to bright to dull dark.
• Warm colors (in general, yellow, yellow-orange, orange, red-orange, red, red-violet) appear to advance. Cool colors (in general, green, blue-green, blue, blue-violet, violet) appear to recede. White, gray, brown, and black lean toward warm or cool.
• Hues may predominate through amount or force. The inherent force of each hue, going from strongest to weakest, is: yellow, orange, red, green, blue, violet (Goethe).
• *Analogous colors* are those that are side by side on a color wheel. *Complements* are opposite each other: yellow/violet, blue/orange, red/green. When two colored surfaces are juxtaposed, each is altered by the other (simultaneous contrast).
• *Additive mixtures* of projected colored *light* increase in light toward white. Basic hues are magenta, green, and cyan. *Subtractive mixtures* of reflected color from *pigment* reduce light and get darker toward gray approaching black. Basic hues are red, yellow, and blue.

Imagination Stretches

— Look at colored light carried through strained-glass windows onto walls or floor and watch the shifting patterns as the source of light changes—the first man-made light show.
— Watch a grade-school playground at recess time for the changing blocks of color as children play. Color walks down the street as a group of children amble along.
— Make a list of all the colors of houses within four blocks of your house. Observe that some houses are similar in color, but are different in value and intensity.
— Mentally shift the color choices in a work of art to their opposites, their complements on the color wheel. (Some artists study the work of other artists by painting out this problem.)

SPACE

• Space can be conveyed as a flat pattern, as having the illusion of some degree of depth, from shallow to deep, or in terms of extension forward from a surface.

Conventions

• *Horizontal lines* provide a base related to earth and the horizon. *Diagonal lines* imply depth into space. *Clear lines* suggest nearness. *Blurred lines* suggest distance.
• When a form overlaps other forms, the completely seen form appears nearest. When images diminish in size, the smaller form appears farther away than the larger form (unless the smaller form overlaps the larger form).
• Images placed at the bottom of a picture plane usually appear near; those placed higher on the picture plane usually appear distant. Figure in relation to figure contributes to spatial construction. By forming connections through empty space, gestures such as signals from one person to another provide additional space clues.
• Usually light, warm, and bright colors appear to project (seem nearer). Usually dark, cold, and dull colors appear to recede (seem farther away).

Spatial Systems

• *Linear parallel perspective* uses a single vanishing point, foreshortening, horizontal and diagonal lines, size, overlapping, and tone to create a three-dimensional effect.
• *Linear angular perspective* uses two vanishing points, a horizon line, diagonal lines, size, overlapping, and light/dark to create a three-dimensional effect.

- *Horizontal banding* uses tiered horizontals, verticals, overlapping, and light/dark.
- *Planar space* uses flat-layered thickness of paint, some overlapping, edge line and flat tone with little or no modeling, and color to indicate space, creating the effect of two-dimensional or flat space.
- *Isometric perspective* produces a slanted or angular view into the picture plane; forms tend to stay in the same scale.
- *Plane and elevation on the same surface perspective* combines two views— one from above, one from the side—on the same surface.
- *Reverse perspective* uses depth diagonals that diverge with the widest span toward the top. The point of convergence is near the bottom or in front of the surface, producing the effect of movement toward the viewer.
- *Simultaneous perspective* presents fragmented views of a subject seen from many different locations at the same time.

Imagination Stretches

— Observe how groups of people can give you certain feelings. One person, even in a room full of other people, can suggest solitude or loneliness. Several people grouped closely in conversation or game playing can suggest communication or a mood of gaiety.
— Watch a work crew tear down a building. Notice that as each wall falls, the space formerly defined is lessened. When the whole building is gone, notice how the entire area is changed. Watch as another crew constructs a building. Watch as an undefined space becomes a defined space.
— Draw a chair from many points of view. Using tracing paper, place each consecutive drawing upon the previous one.
— See how many friends you can get into a Volkswagen or a phone booth. This is an example of compressed space.

SHAPE AND PROPORTION

- Shape expresses feelings to which we respond. *Geometric shape* is systematic and measured. It is related to the calculated and the intellectual. *Organic shape* is irregular and flowing, containing the dynamic tensions of growth. It is related to the spontaneous and the intuitive.
- Similarity of shape can help you recognize the work of specific artists.
- Every visual experience depends on both *figure* (positive, filled) shape and *ground* (negative, unfilled) shape. *Ambiguity* results when it is unclear which is figure and which is ground.
- *Proportion* (scale) is based on relationships of size, amount, and degree. Juxtaposition is used for comparison. Scale influences balance and our emotional response.
- *Idealized proportion* seeks mathematically perfect, flawless beauty. *Natural proportion*, based on life study, includes real, accidental flaws.

Hierarchic proportion expresses the most important as largest. *Distorted proportion* exaggerates to inform or to intensify expressiveness, often creating a grotesque effect.

Imagination Stretches

— Watch cloud shapes shift and change. Observe how the wind currents shape the clouds and how often they are birdlike in shape.
— Look at a drop of water or a leaf through a microscope to see how the shapes differ when magnified.
— Think about what proportion system you prefer in drawing the human figure.
— Make a list of different cars and describe differences in proportion. How does price vary in relation to proportion?
— Think of stories that involve changes in body proportion, such as Lewis Carroll's *Alice in Wonderland* and Jonathan Swift's *Gulliver's Travels.*

TEXTURE

- *Actual texture,* that which can be physically felt, results from the materials and tools used.
- *Implied texture,* the visual appearance of texture, may be imitative or stylized.
- *Textural variety* occurs in the contrast of a rough/smooth relationship, or through two different degrees of rough or smooth texture.
- *Textural focus* may give the illusion of space, may call attention to a point of interest, or may become the subject of the work.
- *Textural uniformity* may be achieved through some general quality of textural sameness: a technique, the medium, or repeated units of textural pattern.

Imagination Stretches

— Get a chest with small drawers or stack boxes (like cigar boxes) and find a texture surprise for each drawer or box.
— Arrange a bouquet of weeds or flowers in which you repeat at least four different textures.
— To get a stylized texture, ink the end of a stick or a wad of paper to use as a stamp and press the inked image side by side over a paper surface.
— Make a mosaic of bits of stone, tile, colored beads, buttons, or chunks of colored paper.

MOTION

- The basic principle of rhythm is motion. Rhythm can be conforming, sequential, contrasting, or a combination of these to form complex, multi-rhythm patterns.
- Seeing a work of art is a sequential-action process requiring time and repeated viewing.
- Motion may be implied—represented—through recognizable images as if in action. The moment of time of the implied action is important in seeing the implied motion.
- Motion may be implied through abstract, nonrepresentational forces such as diagonals, broken edges, double edges, fluid or slashing lines, gradation, contrast, volume appearing to project or recede, or texture.
- Motion may be communicated through a series of frames, a narrative sequence in one frame, a shift from page to page, overlapping stages of motion, blurred edges, and elimination of detail.
- Photography and motion pictures have influenced painting in several ways, including animation, candid-camera shot, dissolve, double exposure, flash-back, pan, story-board grid, stroboscopic effect, telephoto shot, and zoom in and out.

Imagination Stretches

- Plan step by step the action sequence in making a pilgrimage to see a work of art of your choice.
- Begin a visual notebook with data about yourself. Keep visual imagery you like and record your thoughts. Watch the juxtapositions emerge for a personal documentary.
- Imagine this happening in a group of people: Each person identifies with one creature in Picasso's *Guernica* [50] and decides mentally what sound the creature would be making in this circumstance. At a given signal, everyone makes such a sound in unison.
- Try a series of 35mm slides projected rapidly, or do a cameraless animation by scratching, inking, or painting directly on the film frames to create the illusion of motion when the frames are projected. (This can be done with old 35mm slides or film loop.)

IMAGES AND SYMBOLISM

- An *image* is what we see: line, tone, color, or the representation of an object or person. A *symbol* is an image that stands for or suggests something in addition to its own existence: an idea, a quality, a meaning.
- Symbols may be *public* (generally understood) or *private* (individual). Symbols may be used *intentionally* or *unintentionally* (without specific awareness by the artist).

- An image can have different meanings in different combinations and to different viewers. An image never has one absolute symbolic meaning.

Imagination Stretches

— Begin recording your own image meanings in a symbol dictionary.
— Begin a dream journal to record images and combinations in your dreams. Can you interpret the meanings in your dreams?
— Collect examples of symbol in commercial art: magazines, newspapers, billboards, television commercials. Try to discover how life is suffused with symbols whether or not we are consciously aware of them. Look for such images as sun, flowers, horse, eye, and so on.

ART: AS *YOU* SEE IT

Works of art will carry conviction for you when your thought processes conform to what you are seeing in a work of art. The work can become a theater for transferring your own experiences and energies through empathy, and in so doing you become a co-creator with the artist.

Insightful seeing occurs only for the prepared individual. You now have numerous starting points for *seeing* works of art. Where you begin and what you see are matters of personal choice. The result of meaningful seeing can be an additional frame of reference for looking at the world.

With this in mind, look at the following works and describe each artist's decisions about order, field of action, balance, line, light/dark, space, shape and proportion, texture, motion, symbol, and meaning:

(a) Kandinsky—*Improvisation 35* [33]
(b) Francesca—*The Resurrection* [57]
(c) Cezanne—*Mont Sainte-Victoire* [10]

— — — — — — — — — — — — — — — — —

(a) Kandinsky—*Improvisation 35* [33]

Order: Appears random. The field of action is a horizontal rectangle very close to a square with its rigid underlying structure.

Balance: Asymmetric.

Line: Lines vary from dotlike stipple marks to short, thin, wispy lines to long, wandering, wavering lines. They vary from dark lines to light lines which are thicker, irregular, jiggling, trailing lines and outlines. Linear shapes of solid color are like snippets from a sewing basket. Some edges are contained and defined; others are soft and shaded in blurred transitions.

Light/Dark: The major and central part of this work is light in value. The upper corners, lower-right corner, and an area that moves toward center from the upper-left corner are dark in value.

Space: There is no ground line. The forms appear to push beyond each of the four sides of the field of action. It can be like looking laterally upward into a sky of changing atmospheric forms or possibly from directly above eye level (airplane view) looking downward onto shifting cloud and earth forms beneath. There is no clear stratification, and any cleavage is tensile, fragile, and seemingly momentary.

Shape and Proportion: The background appears to be a soft, atmospheric, spatial infinity of soft-edge, nebulous shapes. Some areas are partially defined by hard edge and taper away with a soft, blended edge into the nearest form. A few hard-edge, more completely defined forms appear to drift in this amorphous space. There is no recognizable, nameable shape by which a relative proportion system can be determined. This could be compared with a microcosmic or macrocosmic view of space, or it could be related to layers of torn paper from a billboard segment.

Texture: Wavy lines, crossing lines, stipple, and some hard edges provide the most lively surface textural changes, contrasting gently with the soft, subtle, brushless color blends. The most abrupt changes are in the hard edge shapes which in the original are dark green, blue, and red-violet.

Motion: As one looks, the forms that are small and undefined lose hold on the eye. Other shapes attract, only to drift away in a similar manner, so the eye is beguiled through the space in which forms seem to emerge, melt away, and reemerge in the melodious manner of symphonic sound. The entire composition is structured within a near square, slightly wider than its height. A twisting line bending downward from dead center forms a central pointer; another wavy arc moving left and right becomes a centered pendulum. There are alignments along a centered diamond shape, but the diamond shape that becomes defined is off-center with a longer, lower point. It is so penetrated by overlapping and interrupting shapes that it is a major shape that disappears even as it becomes defined.

Symbol: Perhaps you can imagine shapes related to a naturalistic imagery, but the greatest enjoyment of this work can be derived from the psychological effect of its pure shapes and colors, which for Kandinsky produced "a correspondent spiritual vibration." He notes correlations between color and taste, color and the sense of touch. He speaks of "perfumed colors," and of the "sound of colors." He says, "Generally speaking, color directly influences the soul. Color is the keyboard, the eyes are the hammers, the soul is the piano with many strings. The artist is the hand that plays, touching one key or another purposely, to cause vibrations in the soul."* He continues, "Shades of color, like those of sound, are of a much finer texture and awaken in the soul emotions too fine to be expressed in prose."†

*Vasily Kandinsky, *Concerning the Spiritual in Art* (New York: Wittenborn, 1955), p. 44.
†*Ibid.*, p. 63.

(b) Francesca—*The Resurrection* [57]

Order: Rigid. Field of action is a vertical rectangle.

Balance: Symmetric.

Line: Axis of forms, verticals, and diagonals; edges of forms are firm with edge pattern of fabric folds, sword, lance, banner staff, cross, and clothing details clearly defined.

Light/Dark: The lightest forms are the edge of the tomb, the figure of Christ, the banner, and the barren trees at left. The hills, the sleeping guards, and the trees at right are darker. The sky is lighted, especially along the horizon, as if dawn's light is just beginning.

Space: Near forms, the sleeping guards, are lowest and overlap the tomb behind them. Christ steps from the tomb as if to come toward us. Behind him, higher and smaller in scale, are hills, trees, and a distant castle. The foreground forms are sharply clear-cut while background forms blend into atmospheric darks.

Shape and Proportion: The abstracted shapes have an impersonal geometric quality. Human forms are held into formal, tightly enclosed patterns. The human figure is constructed three-dimensionally and then brought into a visual plane of color that makes it appear decorative and flattened, in a synthesis of form and color. Piero sought a "key to harmony in the numbers from which proportion derives."* (Piero wrote a famous treatise, "De Quinque Corporibus," related to Plato's basis of world forms, which he felt to be the fundamental structure of the elements themselves.)

Texture: The actual texture results from the fresco technique, a water-base paint built into a plaster ground, which accounts for the mat tonality. Simulated texture of fabric and foliage are closely keyed.

Motion: Against the light of dawn, Christ looks over our heads to a remote beyond, into the centuries ahead, as he rises with impassive power and grandeur from the tomb of death. The unwavering strength of this upward movement is reinforced by the flagstaff and the repeated upward vertical thrust of the trees. Counter to this rigidity is the even more relentlessly strict horizontal of the tomb, a conflict of opposites held at peace. In contrast to this tension are the curves of the fluttering banner and the more relaxed bodies of the sleeping guards, whose legs, arms, and weapons form diagonals from a wheellike center. This is a moment of time, frozen for eternity, a silent moment with only the sounds of the wind-whipped flag and the totally relaxed sleeping guards. Christ, forever, is rising from the tomb while the guards, forever, sleep. It is as if some great symphonic crescendo were beginning.

*Rene Huyghe, *Art and the Spirit of Man* (New York: Abrams, 1962), p. 196.

Symbol: The guards (ourselves?) are deep in a symbolic sleep, lost in an unconscious unawareness (related to the sleep of Sleeping Beauty and all that is lost in sleep). In contrast, Christ is the personification of renewal (also the self), like the rising sun, a source of light and life after dark and death. The connection between the Resurrection and an actual sunrise on a spring morning is emphasized by the barren earth and trees at the left in contrast to the fertile landscape at the right.

(c) Cezanne—*Mont Sainte-Victoire* [10]

Order: Rigid. Field of action is a horizontal rectangle.

Balance: Asymmetric.

Line: Dark lines begin, fade away, and reappear without isolating or containing shapes. Trailing line and edge line are used to separate or to connect shapes and tones that are side by side.

Light/Dark: The darkest areas are the foreground tree and foliage, a patch of dark starting at center bottom and moving diagonally leftward to a group of sharply defined buildings, and a patch of dark that moves on a diagonal to the right. Most of the work—sky, mountains, fields—is light in value.

Space: Trees frame three sides of the picture plane and, because we see neither their top nor bottom, they seem near and establish our position as high—as if we are looking down and into the distance of a valley below with our eyes carried inward along diagonals similar to Oriental isometric perspective. With longer looking, relationships occur that make it difficult to enter this space, which becomes strangely flattened when, for instance, the foreground tree, dark of the mountain at left, foliage in the foreground, and clumps of dark at far right midground all seem to be on the same plane. Cezanne controls tone to dictate volume and depth. The mountain seems not to diminish in scale, as the valley distance implies it should, but moves forward with the reverse diagonal of the viaduct.

Shape and Proportion: Larger shapes are angular and can be reduced to triangle and parallelogram. Forms are not naturalistic, but are a reduction in the direction of geometrically ideal in relation to Cezanne's search for fundamental form. (Cezanne sought substructure and the foundations of form. He wrote, "Treat nature in terms of the cylinder, the sphere and the cone. . . .")

Texture: The material is oil paint. The actual brush-stroke texture takes precedence over the implied textures of earth and foliage.

Motion: Forms of earth, tree, and mountain suggest subjects of changeless, timeless permanence. Yet, with looking, the earth shifts back to the left and the mountain rolls forward to the right, locked in counter-tension. The foreground tree suggests graceful, slow dance gestures with the branches of a tree outside the picture plane providing answering

gestures. The surface rhythm is established by brush strokes generally consistent in width and length, patches of paint carefully related in direction to the edge of the picture plane. (It is important to see the brushwork in an original Cezanne.)

Symbol: The mountain may be connected with meditation, spiritual communion, the celestial center, the abode of the gods, the inaccessible, supreme strength. The vertical tree suggests the relationship between earth and heaven, a life force with ideas such as "tree of life," "tree of knowledge," "family tree." The earth and fields might be associated with a source of life, harvest, or the solidness underfoot. (In his effort to record that which is solid and durable, Cezanne selected as his subject for many paintings the most permanent objects he knew—his beloved Mont Sainte-Victoire, trees, and earth. The content becomes a reminder of the grandeur and dignity from the most basic earthly sources of our life and strength.)

You should be ready for this final test of your seeing ability. Look at Dierick Bouts' *The Last Supper* [6]. Describe, as you see it—and completely on your own—the artist's decisions about order, field of action, balance, line, light/dark, space, shape, proportion, texture, motion, symbol, and meaning.

EXPERIENCING A WORK OF ART

We noted at the beginning that works of art cannot be "packaged." Throughout this book we have examined various aspects of the artist's skill and considered specific concepts related to the construction of a work of art. Remember, however, that any time we look at a particular work, we are simultaneously seeing its labyrinth of interrelated visual maps. There is an all-at-onceness in our viewing as there is in our hearing an orchestra playing a symphony.

If you have assimilated ideas about segmented ways of seeing, it is logical to set these arbitrary separations aside. One way to do this is to look at a work of art and let yourself become a part of it. Imagine what you see and feel if you are inside the space created by the artist. The following poem, "Letter," by Leonard Nathan communicates this kind of *experience* to the reader:*

LETTER

I'm writing this to you
From two miles inside a Chinese painting
Called "Mountains After Rain."

For a long time I too dreamed of money
In the pockets of love dining nightly
On power and Peking Duck.

*Leonard Nathan, "Letter," © *New Yorker Magazine,* 1973, reprinted by permission.

I was called intimate first names
In silken rooms, and in public deferred to
as "The Master."

Exiled, I thought, This is the end
Of the world, and it was—a narrow trail
Westering into the fog.

The painter wanted that intense green
Of autumn just before the world
Renounces itself.

This, then, is not death or happiness
But a long, comfortable meditation
On the impossible.

So I write to prepare you for the next disappointment,
Its beauty, its loving art, and its need,
And for the disappointment after.

— Leonard Nathan

On the following pages are student examples of such "space letters" (reproduced by permission).

Space Letters

Kandinsky—*Improvisation 35* [33] (Donna Brody)

As I walked in I lost all sense of time, direction, and familiar space . . . floating with the swirling colors and sounds. I rested on a mushroom, slid down a slice of watermelon, rode on a butterfly's back, became the sole of a dancing shoe, caught fragments of color melodies and delicious odors— how do you leave a dream?

Picasso—*Guernica* [50] (Jeff Hays)

Deep within this panorama I am so deeply moved by the destruction, the sorrow . . . the pain . . . the grief . . . the torment . . . the death. This is not only war . . . but the depth of any painful experience. It is all of humanity and inhumanity . . . and I am a part of it.

Seurat—*A Sunday Afternoon on the Grande Jatte* [color plate 4] (Matthew Hoffman)

I'm on this soft green earth . . . relaxing . . . people and muffled sounds of their voices all around me . . . people each onto something different . . . but here tuned in together . . . everyone aware of everyone else . . . the sunlight . . . the trees . . . the water . . . perfect melodious rest . . . I'd like to stay . . . I wish I could.

Pollock—*Autumn Rhythm* [58] (Gary Loewenberg)

Where am I? Here . . . but where? I'm not sure . . . only hope there's a way out . . . paths in all directions . . . which to take? . . . I'm getting nowhere . . . maybe I should try this way . . . back where I started . . . Can't get out

. . . Where do I want to go? . . . Not sure . . . Can't get there from here. Nowhere to go . . . No place to start . . . No place to end . . . Can't run out . . . keep coming . . . It's a big void . . . may never find my way back . . . No choice . . . Getting nowhere . . . Must make a run for it . . . and just jump out.

From Within the Castle of Albrecht Durer's *Knight, Death, and the Devil* [20] (Joanne Koech)

I'm old and they call me a silly old lady, but I've lived long and know and see many things. Once I was proud, too proud . . . yes, and beautiful. But now I am old . . . and crippled. I like to sit at my window. Far up here on the hill and high up within the castle I see so much. My children are good to me, but they keep so busy. And they don't like to talk to a silly old lady. They say I scold them, but I have lived long and I know the dangers they ignore. I can sometimes see a shadow falling on my son as he rides off—a shadow following closely. How wonderful that he doesn't fear death and how terrible that he doesn't recognize the devil. They both crowd me so closely

Goya—*Execution of the Madrileños* [27] (Tim Halligan)

I am standing here in a crowd of people . . . I don't know why . . . I know what's going to happen . . . I have never witnessed an execution before . . . The only thing I can hear is the loading of guns and the groans and cries from the victims . . . The soldiers raise their guns . . . It's silent now . . . The guns go off . . . The crowd leaves . . . I am standing all alone, staring at the dead . . . I can't seem to move

Pollock—*Autumn Rhythm* [58] (Theresa Crosby)

i am
receptive to all that falls
from heaven to earth.
i am
dressed with atmospheric wonder,
winds that blow,
rains that fall,
snow that dances joyfully to earth.
i receive the dust
as well as the leaves of autumn
the branches, nests of birds
blown from their homes in the trees
cradled by the arms of the earth
i am
the barren earth of autumn
these rhythms are my raiment.
they garment me gladly.
we are One.

Monet—*Rouen Cathedral* [color plate 3] (Craig Groe)

It must be one hundred degrees in the shade today. The sun's glare is so bright I can hardly see. It's a beautiful blue day without a cloud in the sky. Nothing to shade my eyes from the constant brilliance of the sun. The details fade from view as the magnificence of Rouen Cathedral dissolves into one big glob of molten metal.

Friedrich—*Monk by the Seaside* [17] (Jim Duffey)

I reached out and You touched me—I recoiled in disbelief. I reached out again and once again You touched me—I want to believe.

Friedrich—*Monk by the Seaside* [17] (Chrys Heimerman)

All alone . . . in this vast space of emptiness . . . wondering . . . thinking how my life could have been . . . Clouds are descending upon me as I watch the past become dimmer and dimmer.

Ma Yuan—*Bare Willows and Distant Mountains* [45] (Pam Lees)

I am lost and alone in a faraway and distant land and in another time. The air, heavy with mist, is still and silent. Before me droop leafless willows . . . thin and frail against the giant mountains. They seem forlorn and strange, like myself.

Vasarely—*Vega-Nor* [front cover] (Juli Stephenson)

I'm sitting in a big bubble, and all around me are currents of air . . . warm and cool. I don't know where they are coming from . . . it must be from the colors that are so beautiful. There is no sound in here, only a muffled rumble from a great distance. It is from the combined energy of red, yellow, green, and blue! It takes on the sound of an undefinable song.

Kandinsky—*Improvisation 35* [33] (Kaye Schwab)

As I dive I break through the surface of the swirling water to a sea world. Descending, there are tendrils of color floating and moving. Seaweed and aquatic plants sway and bend, reaching out, then surge away. A fish with fluorescent scales flashes by me. I see fish eggs and colored rocks and pearlescent pastel shells. As I float back to the surface, there are bubbles and wisps of foam. Now on my back I look up and see a hint of clouds on a clear summer sky. I'm surrounded by a dream.

Rauschenberg—*Buffalo II* [62] (Jay Samuelson)

I feel invisible and alone . . . looking on . . . thoughts flash through my mind . . . doesn't anyone else see what is going on? I think: what's it all worth . . . what's it for? Where am I going? Are Americans dying for a symbol and chasing for a key to life? Suddenly the images merge and I see what is being pointed out. How could I ever have wondered . . . how could I ever

have been ungrateful? For a moment . . . for a fleeting moment my questions have been answered.

Try writing a "space letter" yourself. Select a work of art that you can "connect" with and describe what you see and feel on being *inside* it.

A FINAL WORD

This is just a beginning. As you look at and experience works of art, your ability to SEE into them will grow and your continued search for meaningful combinations will provide an enriched dimension to your life.

Glossary

Abstract—nonrepresentational; not concretely identifiable with familiar objects.

Action—motion, movement; may be implied or actual.

Actual motion—the act of moving the eye and head in viewing a work of art.

Actual texture—the physical surface; what can be felt; in painting, the real textural surface of the material (medium) the artist has used.

Additive color—when rays of colored light are projected "on top of" one another, the overlapping areas become lighter, increasing toward white light; this is the reverse of using a prism to break down a ray of light into rainbow spectrum colors; the basic additive hues—magenta (similar to red-violet), green, and cyan (similar to blue blue-green)—when overlapped in projected light rays, mix to white light.

Admixture—the product (the mixture) that results from mixing two or more colors.

After-image—the phenomenon that takes place when someone looks at a decisive hue, then looks onto a white surface and sees its complement (that is, the hue opposite the original hue on the color wheel).

Ambiguous—doubtful; uncertain because of obscurity or indistinctness; capable of being understood in two or more ways.

Ambiguous shape—shape that is unclear, difficult to determine, lacking clarity as to which is figure and which is ground shape.

Amount—how much; a number or expressed as a number.

Analogous colors—adjacent (side-by-side) colors on the color spectrum.

Angular perspective—spatial system in which objects are placed so their sides of extension into space are at an oblique angle to the picture plane; necessitates two vanishing points on the horizon line.

Assemblage—composition of assembled and pasted objects along with paint.

Asymmetry—equilibrium composed of dissimilar form or arrangement on either side of a center.

Atmospheric perspective—spatial system based on the phenomenon that objects become less defined in the distance due to atmospheric particles, thus differing from linear or other perspective systems; represented by gradations of blue, blue-green, or blue-violet, as well as by gradations of distinctness.

Axis of forms—center formed through any shape by an invisible horizontal, vertical, diagonal, or curve; an invisible, linear structure for the entire work and for shape within shape inside the work.

Backlighting—a lighting technique that places a form (subject) between a light source and the viewer, creating an outline or silhouette; an illusory device that makes solid forms appear flat.

Balance—the equilibrium of various elements—line, light/dark, color, shape, proportion, texture, motion, content—in a design or painting; a fundamental visual reference; may be symmetric or asymmetric.

Bisymmetry—having perfect mirror image on either side of a center line.

Broken line—series of visible lines that start and stop.

Calligraphic line—a series of continuous or broken lines that suggest letters of the alphabet or written words.

Calligraphy—handwriting or lettering that conforms to an organized and consistent pattern system.

Center point—the juncture of vertical and horizontal center.

Chiaroscuro—modeling or a gradual blending of tone to give the illusion of three-dimensional form; a word borrowed from Italian combining *chiaro*, meaning "light," and *oscuro*, meaning "shade or dark."

Chroma—saturation, intensity; brightness or dullness of a hue.

Collage—composition constructed with actual objects attached to and sometimes projecting from the field of action.

Color—a phenomenon of light or visual perception produced by the reflection of certain spectrum elements and the absorption of others; described in terms of its three dimensions: hue, tone, and intensity.

Complement—those hues opposite each other when the color spectrum is bent to form a circle; for example, yellow is across from violet, blue is across from orange, and red is across from green.

Content—the combination of images and their meaning.

Contour line—a broken or continuous line that describes changing planes of advancing or receding shapes.

Convention—a practice or form confirmed through general agreement, custom, or usage.

Cross-hatching—parallel lines that form a plane crossed over with another set of parallel lines (*see also* Hatching).

Curved line—a line that bends or turns without angle.

Deep space—type of space in which images appear to recede into the field of action, creating the illusion of near and contrasting great distance.

Degree—a step in a series; a division, space, or interval.

Diagonal line—a slanted line extending between two opposite corners of a figure or a field of action; oblique.

Directional—sign or mark indicating a specific direction.

Double meaning—having two meanings or possible interpretations.

Edge line—a line made by an edge that marks the outer limits of a plane or
where two planes meet; the termination of one shape or color and the
beginning of another.

Empathy—transference of one's own organic vitality into the seen object.

Expressive distortion—a proportion system that exaggerates shapes toward
the grotesque (often seen in primitive and folk art as well as in much
twentieth-century art).

Family of shapes—shape preferences, either organic or geometric, which are
carried or repeated through a single work or in many works of an artist
(also called *rhyming shapes*).

Field of action—bounds, perimeter, or enclosure of a work of art within
which the artist performs or creates.

Figure shape—positive, filled shapes.

Flat space—type of space in which images appear to be on the surface of the
field of action.

Flat tone—having no gradations of value; even tonality; uniform light against
dark or dark against light contained within an outer edge, as in a
silhouette.

Force of hue—related to a hue's visual attraction through brilliance or amount.

Foreshortening—in compliance with the rules of linear perspective, a calcu-
lated set of distortions through which forms appear diminished as the
eye sees into space.

Found object—(Duchamp's term: ready-made) an object found in a state or
condition that is within the selection range of a particular artist; may be
considered by the artist a work of art as it is or may be combined in a
collage with other objects.

Frame—a field of action (a term used by photographers and film makers).

Geometric shape—systematic, measured configurations; for example, a circle,
square, or triangle; related to the man-made, the intellectual, the con-
scious.

Ground shape—negative, unfilled shape; void; empty.

Hatching—broken lines that are parallel and close enough to form a plane.

Hierarchic—based on rank or order of importance.

Hierarchy of scale—a proportion system in which the most important figures
are larger and those of lesser importance are smaller.

High saturation—brightness of a hue.

Horizon line—a flat, level line running right and left parallel to the plane of
the horizon; where the straight line of vision meets the curvature of the
earth, always at eye level of the spectator; you are always at the center
of your visual universe.

Horizontal banding—tiered horizontals in which space is indicated by placing
levels of action one above another on the picture plane.

Horizontal center—a visible or invisible horizontal line dividing a field of
action into top and bottom halves.

Hue—the name given to various divisions of the visible color spectrum, such as red, orange, yellow, green, blue, and violet.

Idealized proportion—a proportion system that inclines toward geometric abstractions; attempts to achieve the "perfect proportion."

Image—can be a visual indicator or property as line, tone, color, or a visual counterpart of an actual person or object.

Imbalance—collapse; lack of balance (*see also* Balance).

Implied motion—action simulated by presenting real figures from the real world as if in motion; for example, a tree bending in the wind, a man running.

Implied texture—a simulated texture; the visual appearance of a real texture.

Intensity—chroma, saturation; the brightness or dullness of a hue.

Interval—range between steps on a scale; a progressive, graduated series.

Invisible line—paths created by the viewer's eye, may be points of eye appeal, lines formed by communication between figures within the work or between the viewer and figures within the work, or the axis of forms.

Isometric perspective—an illusory space device presenting a slanted or angular view into the picture plane and a diagonally upward inclined ground plane.

Juxtapose—to place side by side.

Lateral symmetry—parts on either side of center correspond in size, shape, and relative position, with some variation in weighting to left or right.

Line—a path that begins at a point and ends at a point.

Linear angular perspective—an illusory space device employing two or more vanishing points at unequal distances from vertical center.

Linear parallel perspective—an illusory space system that necessitates a horizon line and one vanishing point where diagonal depth lines appear to converge and disappear.

Low saturation—dullness of a hue.

Material—medium; the actual textural substances with which an artist may work.

Medium (plural: media)—*see* Material.

Modeling—the control of light/dark gradations to create the illusion of solid forms; shading, cross-hatching, and line variation that make objects appear three-dimensional; sometimes called *chiaroscuro*.

Motion—action, movement; may be implied or actual motion.

Multiple perspective—an illusion allowing a viewer to see the subject from two or more points of view on the same field of action.

Narrative sequence—story line; use of a single frame or a series of frames to communicate episodes of a story.

Negative shape—unfilled, ground shape; shapes of empty space.

Neorealism—literally "new realism"; a current trend in painting that com-
municates with camera accuracy what the eye sees.

Nonrepresentational art—employs the abstract arrangement of line, light/dark,
and color; forms are less likely to have easily recognizable matching
counterparts or referents in the real world.

Optical illusion—a false perception; the eyes are deceived.

Optical mixture—the optical effect of distributed bits of black and white or
color that are mixed in the eye of the viewer; the third color "mixed"
by the eye when two hues are intermingled in small particles—for in-
stance, when small bits of red and blue intermingle in an area, what
appears to the eye is some variant of a violet mixture; also called *visual
mixture*.

Order—the sequence or arrangement of elements; in rigid order—fixed, defi-
nite, systematically measured; in random order—unexpected, indefinite,
consistently inconsistent.

Organic shape—natural configurations; related to randomness, chance, growth,
and emotions.

Outline—line bounding a shape.

Parallel lines—lines which are equidistant from one another and which, in
reality, never converge or meet.

Pattern—an arrangement of parts that has a measure plan, consistent propor-
tion, or system of repeats.

Perspective—a view from a particular standpoint; objects are considered seen
in respect to their relative distance and position from the viewer.

Photographically real proportion—a proportion system emphasizing natural-
ism or realism, with all "accidents of nature" (flaws) included.

Physical mixture—a mix of white and black paint and/or color along with a
thinner or extender.

Picture plane—a field of action; the flat or two-dimensional surface on which
the artist works.

Pigment—coloring matter.

Planar space—an expanse described by two dimensions: length and width.

Plane—even, flat, level surface without elevations or depressions (adjective:
planar).

Points of eye appeal—invisible paths which the eye follows as it moves from
object to object or point to point of interest throughout the work.

Positive shape—filled, figure shape; solid.

Primary hue—sometimes used to describe the most distinctly contrasting
hues of red, yellow, and blue.

Private symbol—a symbol used by an individual or a small, closed group;
only they know the intended interpretation of the symbol, or its use
may be exclusively restricted to them.

Proportion—ratio; the relationship of one part to another or to the whole
with respect to quantity or size; scale.

Public symbol—images with meanings traditionally accepted or understood
by large numbers of people.

Radial symmetry—forms that spread out, balancing from a center point.

Random—an unpredictable, nonrigid arrangement of elements involving chance, intuition, emotions.

Relief—in sculpture, the projection of form from a flat background surface.

Representational art—employs recognizable figures and objects which have matching counterparts or referents in the real world.

Reverse perspective—sides of objects appear to diverge instead of converge.

Rhyming shapes—repeated shapes within a work (see also Family of shapes).

Rigid—a precision arrangement of elements; measured, calculated, deliberated.

Saturation—chroma, intensity; the brightness or dullness of a hue.

Scale—ratio between the dimensions of an object and its representation; proportion.

Secondary hue—used to describe less distinctly contrasted hues, such as green, orange, and violet.

Shade—a property of tone; a dark, a black-stained hue.

Shading—the blending of sliding gradations of tone; related in meaning to modeling and chiaroscuro.

Shallow space—subjects appear to recede into the field of action, creating the illusion of some depth into space.

Shape—spatial form, configuration; may be geometric or organic; may be figure/ground, filled/unfilled, positive/negative.

Silhouette—a two-dimensional representation of a solid form that is designated by an edge line filled in with a uniform color (flat tone).

Simulated texture—see Implied texture.

Simultaneity—many different viewpoints indicated simultaneously on the same surface.

Simultaneous contrast—when you see any given color, your eye simultaneously generates its complement spontaneously (after-image) if it is not present.

Size—physical dimension, bulk, extent, magnitude.

Skeletal structure—the invisible geometric framework of a field of action, its vertical center, horizontal center, and corner-to-corner diagonals.

Spatial ambiguity—having the characteristics of more than one type of space: flat, shallow, deep, extension ahead of the picture plane, or of more than one point of view.

Spectrum colors—hues resulting from the dispersion of a beam of visible light: red, orange, yellow, green, blue, and violet (see also Hue); refraction of sun's rays in drops of water also observed in a rainbow or when a ray of light is dispersed by a prism.

Stipple—repeated small touches making points or dots; controlled by size and spread.

Subject—topic or theme.

Subtractive color—color produced by mixing pigments; reflected color from pigment when mixed reduces light and darkens toward gray or black; the basic subtractive hues are red, yellow, and blue.

Symbol—something that stands for something else; in art, an object or figure not only existing within the work, but also representing an abstraction or an idea.

Symbol interpretation—deriving meaning from image indicators.

Symmetry—similarity of form or arrangement on either side of a dividing center.

Tertiary hue—used to describe the least distinctly contrasted hues, such as red-orange, yellow-orange, yellow-green, blue-green, blue-violet, and red-violet.

Texture (visual)—a pattern created by any sequence of repeated units that appeals to the sensation of touch; for example, smooth, rough, fine, coarse; a pattern with tactile (touch) attraction created from the organization of light/dark, color, line, and the material used as well as the tool the artist selects and the pressure applied; may be actual or implied texture.

Three-dimensional—having length, width, and depth.

Tint—a property of tone, a light value, a white-tinged hue.

Tonal scale—the gradation of gray from white to black; the range of relative lightness or darkness of a color; synonymous with value scale.

Trompe l'oeil—the illusion of real objects; when implied texture is so realistic that objects deceive the eye and appear to actually "be there"—for instance, a painted fruit can appear to be so real that you can taste and smell it.

Two-dimensional—having length and width.

Value—the relative lightness or darkness of a hue (*see also* Shade and Tint).

Value scale—*see* Tonal scale.

Vanishing point—the illusory point where two or more parallel lines into depth appear to converge, usually at a point on or beyond the horizon; for example, the point where the lines of parallel railroad tracks appear to meet and vanish over the horizon.

Vertical center—a visible or invisible vertical line dividing the field of action into left and right halves.

Vertical line—a line that runs straight up and down.

Visible line—a line the viewer can see.

Visual mixture—*see* Optical mixture.

Volume devices—variations of line that combine to create the illusion of solid volume; for example, parallel lines, cross-hatch lines, contour lines.

Artist Index

General Index

[Color plate 1] Georges de la Tour, *The Adoration of the Shepherds.* Oil on canvas. 1643. $41\frac{4}{5}''$ X $51\frac{3}{5}''$. Des Musees Nationaux, Paris. Collections du Musee du Louvre.

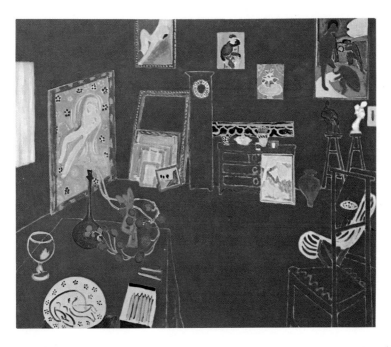

[Color plate 2] Henri Matisse, *The Red Studio.* Oil on canvas. 1911. $71\frac{1}{4}''$ X $84\frac{1}{4}''$. Collection, The Museum of Modern Art, New York. Mrs. Simon Guggenheim Fund.

[Color plate 3] Claude Monet, *Rouen Cathedral, West Facade*. Oil on canvas. 1713. $39\frac{1}{4}''$ X $25\frac{1}{8}''$. National Gallery of Art, Washington, D.C. Chester Dale Collection.

[Color plate 4] Georges Seurat, *A Sunday Afternoon on the Island of La Grande Jatte*. Oil on canvas. 1884-1886. $81''$ X $120\frac{3}{8}''$. Courtesy of The Art Institute of Chicago. Helen Birch Bartlett Memorial Collection.

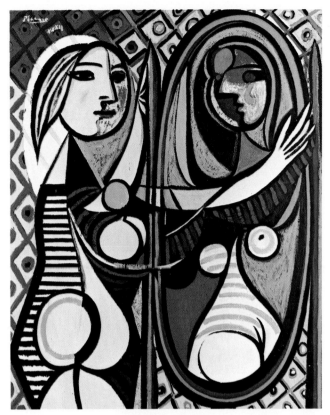

[Color plate 5] Pablo Picasso, *Girl Before a Mirror.* Oil on canvas. 1932. 64″ X 51¼″. Collection, The Museum of Modern Art, New York. Gift of Mrs. Simon Guggenheim.

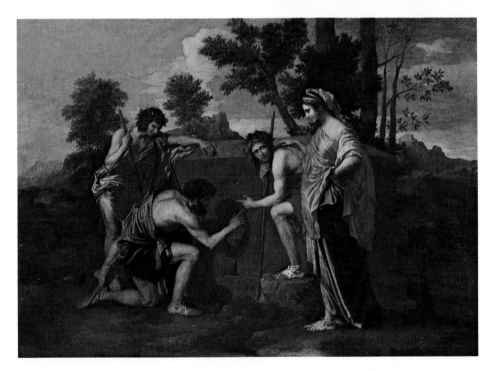

[Color plate 6] Nicolas Poussin, *Shepherds of Arcadia.* Oil on canvas. 1685. 34″ X 48″. Des Musees Nationaux, Paris. Collections du Musee du Louvre.

[Color plate 7] Jan Van Eyck, *The Marriage of Jean Arnolfini and His Wife.* Oil on wood. 1434. 33″ × 22½″. Reproduced by courtesy of the Trustees, The National Gallery, London.

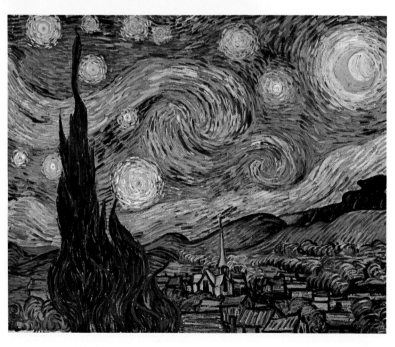

[Color plate 8] Vincent van Gogh, *The Starry Night.* Oil on canvas. 1889. 29″ × 36¼″. Collection, The Museum of Modern Art, New York. Acquired through the Lillie P. Bliss Bequest.

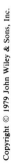

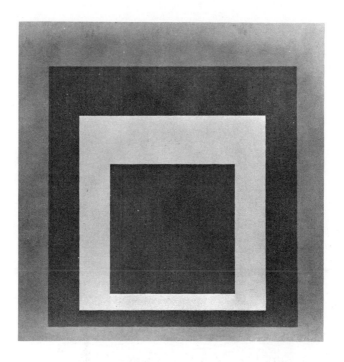

[1] Josef Albers, *Homage to the Square: "Ascending."* Oil on composition board. 1953. $43\frac{1}{2}''$ X $43\frac{1}{2}''$. Collection of Whitney Museum of American Art, New York. Photography, Geoffery Clements, New York.

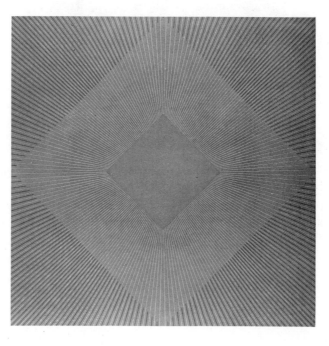

[2] Richard Anuszkiewicz, *Splendor of Red.* Liquitex on canvas. 1965. 72″ X 72″. Yale University Art Gallery. Gift of Seymour H. Knox, B.A.

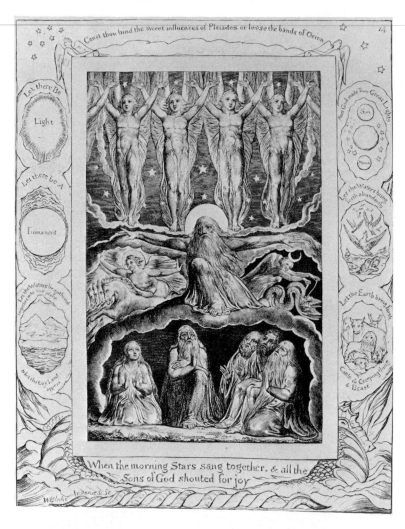

[3] William Blake, plate from the *Book of Job:* *"When the Morning Stars Sang Together."* Engraving. $7\frac{3}{4}'' \times 5\frac{7}{8}''$. The Metropolitan Museum of Art, New York. Gift of Edward Bement.

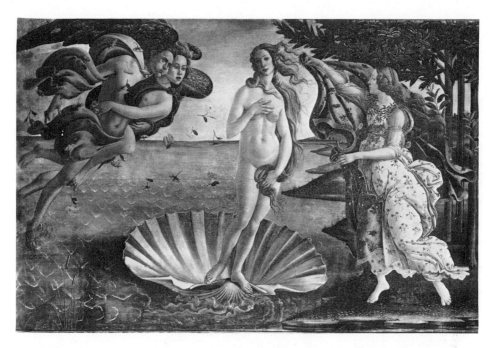

[4] Sandro Botticelli, *The Birth of Venus*. Tempera on canvas. C.1480. 79" X 110".
Alinari/Editorial Photocolor Archives.

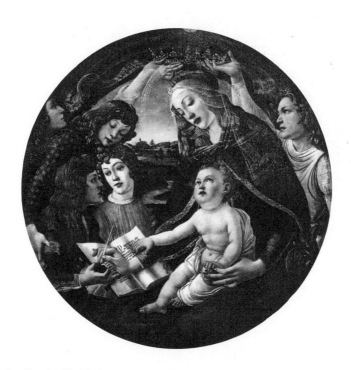

[5] Sandro Botticelli, *Madonna of the Magnificat*. Tempera on panel. C.1485. $46\frac{1}{2}$"
diam. Alinari/Editorial Photocolor Archives.

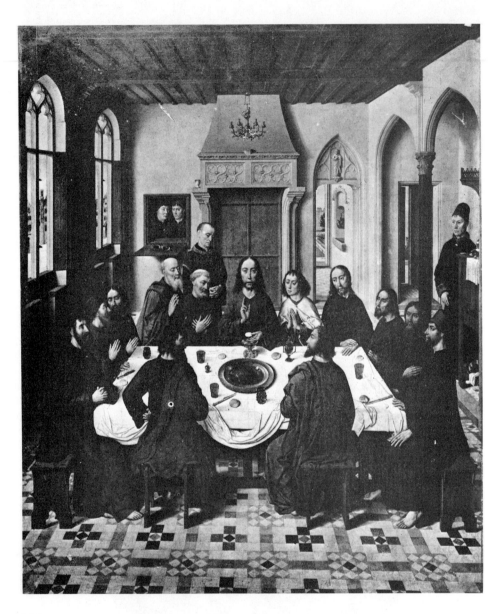

[6] Dirk Bouts, *The Last Supper.* Panel. 1464–1468. 71″ X 59″. Bildarchiv Foto
Marburg. Philipps Universitat, Marburg.

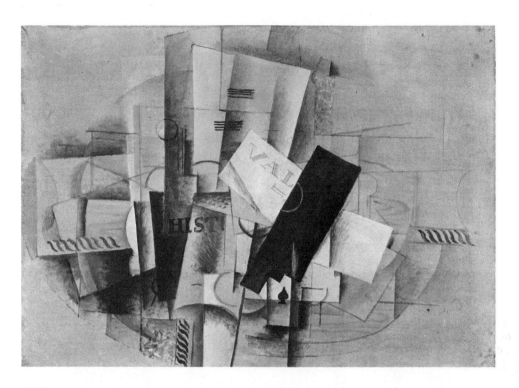

[7] Georges Braque, *The Musician's Table.* Oil on canvas. 1913. $25\frac{1}{2}''$ X $36''$. The Kunstmuseum, Basel. Gift of Dr. H. C. Raoul La Roche.

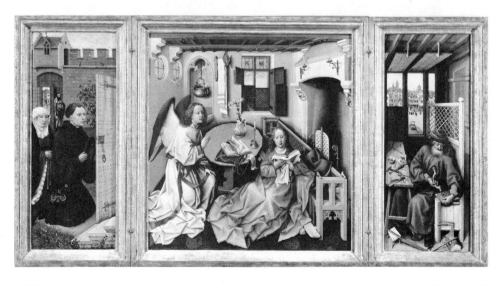

[8] Robert Campin, *The Merode Altarpiece.* Oil on wood. Center panel: $25\frac{3}{16}''$ h., $24\frac{7}{8}''$ w.; left panel: $25\frac{3}{8}''$ h., $10\frac{3}{4}''$ w.; right panel: $25\frac{3}{8}''$ h., $10\frac{15}{16}''$ w. Metropolitan Museum of Art, Cloisters Collection, Purchase.

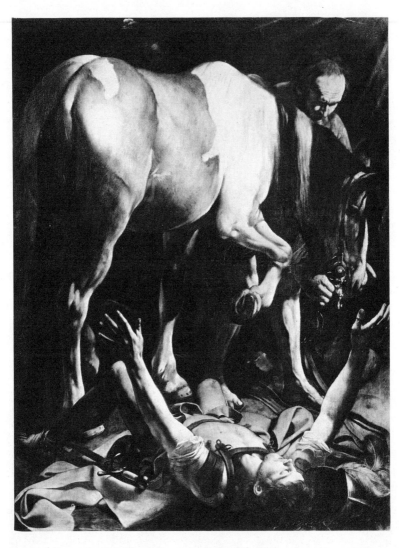

[9] Michelangelo da Caravaggio, *The Conversion of St. Paul.* Oil on canvas. 1601–1602. 90½″ × 28½″. Alinari/Editorial Photocolor Archives.

[10] Paul Cézanne, *Mont Sainte-Victoire*. Oil on canvas. 1885–1887. $23\frac{1}{2}''$ X $28\frac{1}{2}''$. The Phillips Collection, Washington, D.C.

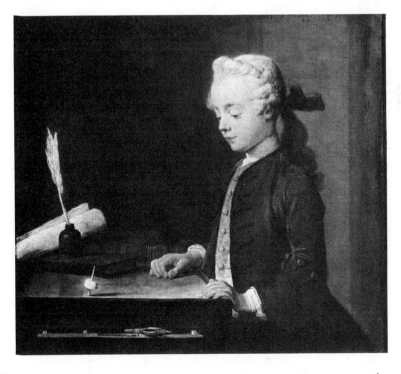

[11] Jean Baptiste Chardin, *The Boy with a Top*. Oil on canvas. 1741. $22\frac{3}{4}''$ X $29\frac{3}{4}''$. Des Musees Nationaux, Paris. Collections du Musee du Louvre.

[12]　Marc Chagall, *I and the Village*. Oil on canvas. 1911. 75⅝″ X 59⅝″. Collection, The Museum of Modern Art, New York. Mrs. Simon Guggenheim Fund.

[13] Gustave Courbet, *The Painter's Studio*. Oil on canvas. 1855. 142″ X 235″. Des Musees Nationaux, Paris. Collections du Musee du Louvre.

[14] Eugene Delacroix, *Liberty Leading the People (July 28, 1830)*. Oil on canvas. 128″ X 102″. Des Musees Nationaux, Paris. Collections du Musee du Louvre.

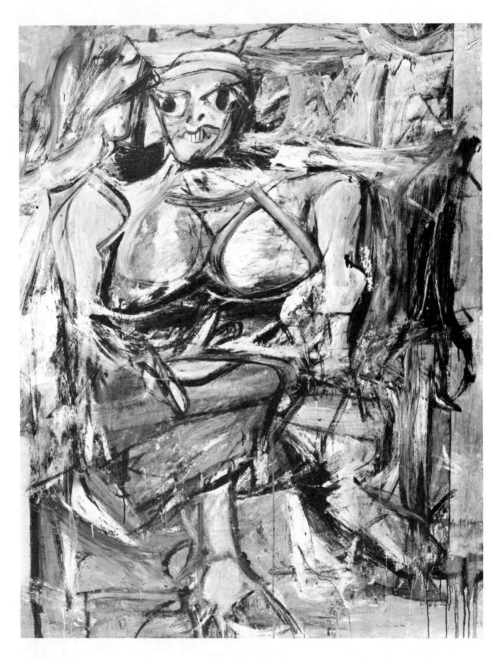

[15] Willem de Kooning, *Woman, I*. Oil on canvas. 1950–1952. $75\frac{7}{8}''$ X 58''. Collection, The Museum of Modern Art, New York. Purchase.

[16] Duccio di Buoninsegna, *Christ at Gethsemane* (panel from back of "Maesta"). Tempera. 1308–1311. 40″ X 30″. Alinari/Editorial Photocolor Archives. Cathedral Museum, Siena.

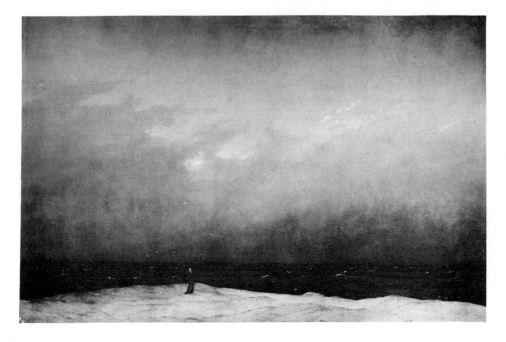

[17] Caspar David Friedrich, *Monk by the Seaside*. Oil on canvas. C.1806. $42\frac{7}{8}$″ X $66\frac{5}{8}$″. Nationalgalerie. Bildarchiv Preussischer Kulturbesitz, West Berlin.

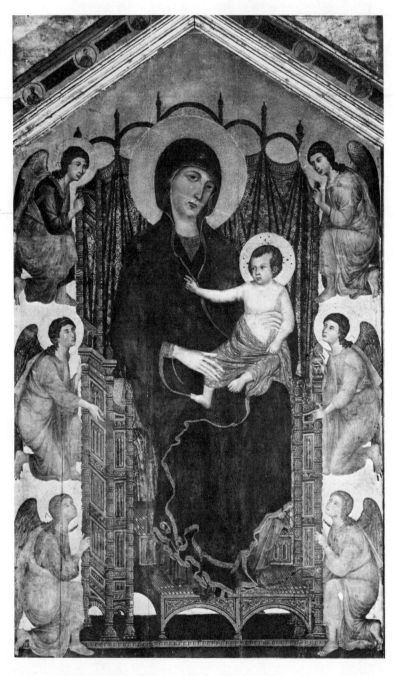

[18] Duccio di Buoninsegna, *Madonna Enthroned, with Angels*. Tempera and gold leaf on wood panel. C.1285. 177$\frac{1}{4}$" X 114$\frac{1}{2}$". Alinari/Editorial Photocolor Archives.

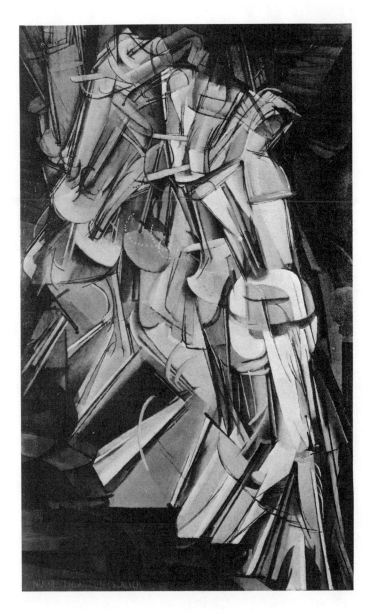

[19] Marcel Duchamp, *Nude Descending a Staircase.* Oil on canvas. 1912. 58″ X 35″.
Philadelphia Museum of Art. Louise and Walter Arensberg Collection.

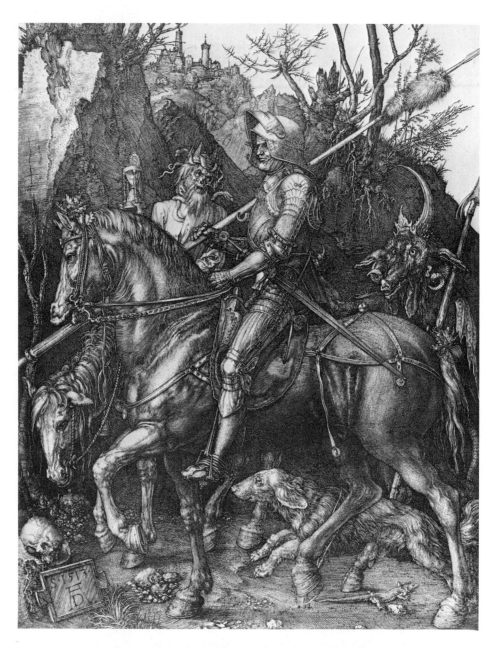

[20] Albrecht Dürer, *The Knight, Death, and the Devil.* Engraving. 1513. $9\frac{7}{8}''$ X $7\frac{1}{2}''$. Courtesy of the Museum of Fine Arts, Boston. Fund Bequest of Horatio G. Curtis.

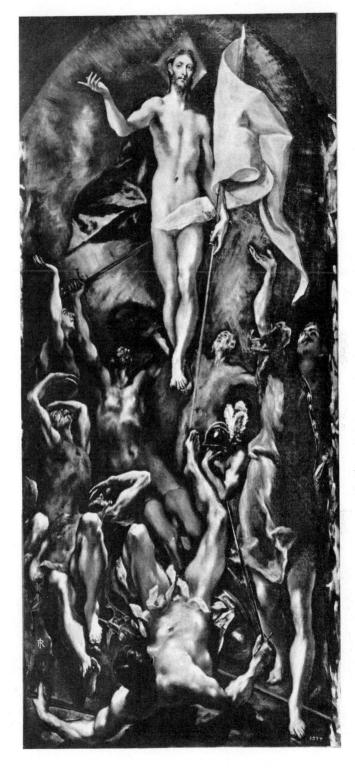

[21] El Greco (Domeniko Theotokopoulos), *The Resurrection*. Oil on canvas. 1595–1600. 108″ X 50″. Alinari/Editorial Photocolor Archives. Museo del Prado, Madrid.

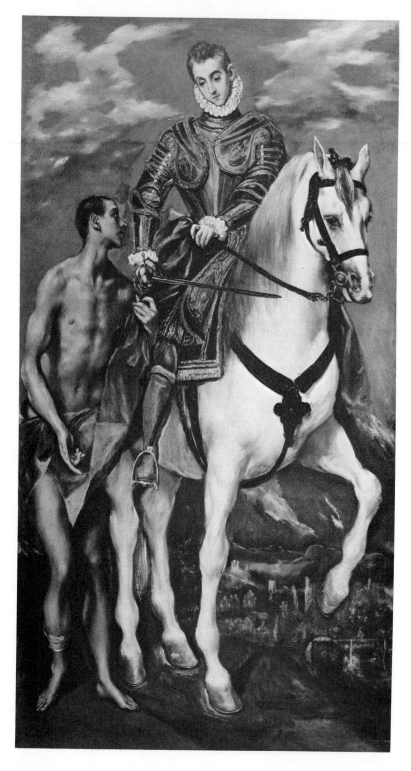

[22] El Greco (Domeniko Theotokopoulos), *St. Martin and the Beggar*. Oil on canvas.
1597–1599. 76⅛″ × 40½″. Courtesy of the National Gallery of Art, Washington, D.C.
Widener Collection.

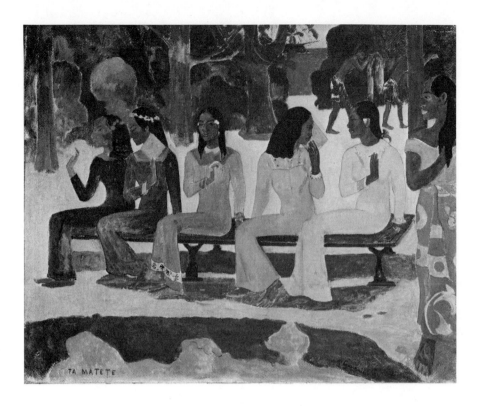

[23] Paul Gauguin, *The Market.* Oil on canvas. 1892. 399¾″ X 305″. The Kunst-museum, Basel.

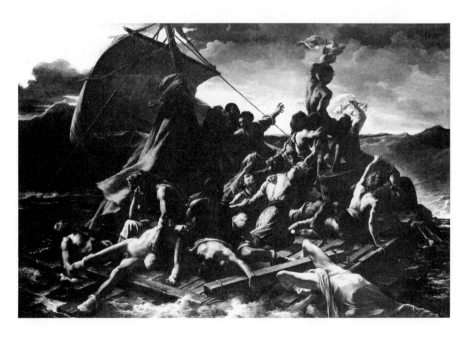

[24] Theodore Gericault, *The Raft of the Medusa.* Oil on canvas. 1819. 193″ X 282″. Des Musees Nationaux, Paris. Collections du Musee du Louvre.

[25] Giorgione da Castelfranco, *The Concert*. Oil on canvas. C.1510. $43\frac{1}{3}''$ × $54\frac{1}{3}''$. Des Musees Nationaux, Paris. Collections du Musee du Louvre.

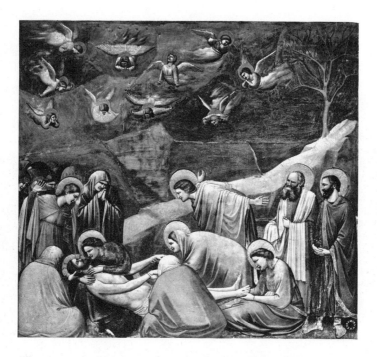

[26] Giotto di Bondone, *The Lamentation*. Fresco. 1305–1306. $72\frac{3}{4}''$ × $72\frac{3}{4}''$. Alinari/Editorial Photocolor Archives. Chapel of the Arena, Padua.

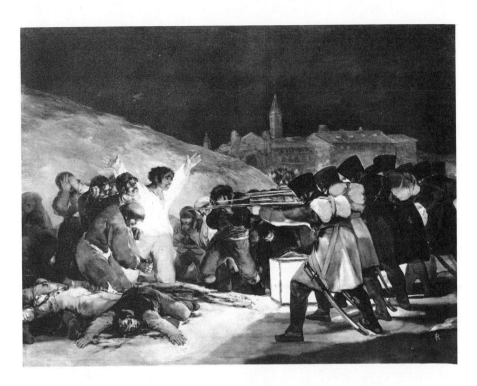

[27] Francisco Goya, *Execution of the Madrilenos of May 3, 1808 at Murat's Command.* Oil on canvas. 1814–1815. 104¾″ × 135⅘″. Alinari/Editorial Photocolor Archives. Museo del Prado, Madrid.

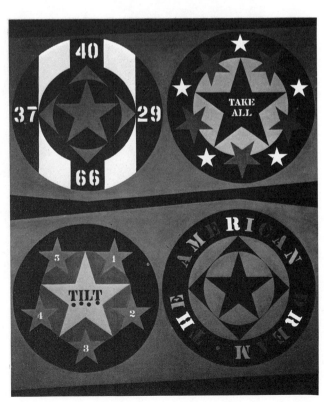

[28] Robert Indiana, *The American Dream, I.* Oil on canvas. 1961. 72″ × 60⅛″. Collection, The Museum of Modern Art, New York. Larry Aldrich Foundation Fund. Photo Credit: Eric Pollitzer, New York.

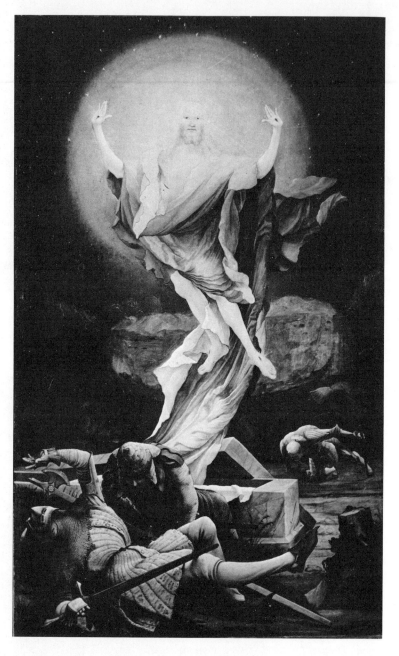

[29] Matthias Grunewald, *The Resurrection* (panel of Isenheim altarpiece). Oil on wood panel. 1515. 106″ X 56″. Musee d'Unterlinden, Colmar, France.

[30] William M. Harnett, *Old Models*. Oil on canvas. 1885. $54\frac{1}{2}''$ X $28\frac{1}{4}''$. Courtesy Museum of Fine Arts, Boston. Charles Henry Hayden Fund.

[31] Jean-Auguste-Dominique Ingres, *Madame Moitessier*. Oil on canvas. 1851. 58¼″ X 40″. Courtesy of the National Gallery of Art, Washington, D.C. Samuel H. Kress Collection.

[32] Jasper Johns, *Target with Four Faces*. Encaustic on newspaper over canvas. 1955. 26″ X 26″, surmounted by four tinted plaster faces in wood box with hinged front. Overall dimensions with box open, $33\frac{5}{8}″$ X 26″ X 3″. Collection, The Museum of Modern Art, New York. Gift of Mr. & Mrs. Robert C. Scull.

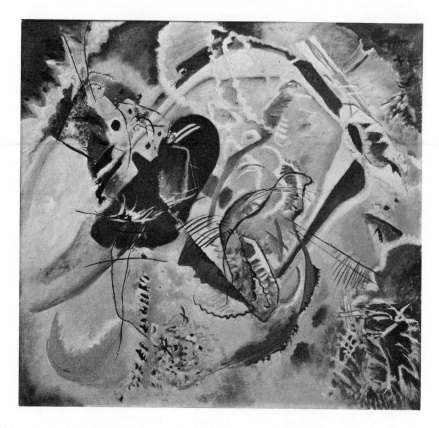

[33] Wassily Kandinsky, *Improvisation 35*. Oil on canvas. 1914. $43\frac{1}{2}''$ X $47\frac{1}{4}''$. The Kunstmuseum, Basel.

[34] Paul Klee, *Around the Fish*. Oil on canvas. 1926. $18\frac{3}{8}''$ X $25\frac{1}{8}''$. Collection, The Museum of Modern Art, New York. Abby Aldrich Rockefeller Fund.

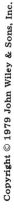

[35] Paul Klee, *Park Near Lucerne*. Oil and newspaper on jute. 1938. 39½″ X 99″.
Kunstmuseum, Berne. Paul Klee Foundation. © by Cosmopress, Geneve and S.P.A.D.E.M.,
Paris.

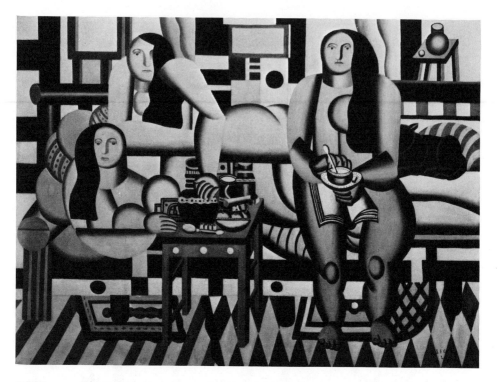

[36] Fernand Leger, *Three Women (Le Grand Déjeuner)*. Oil on canvas. 1921. 72¼" X 99". Collection, The Museum of Modern Art, New York. Mrs. Simon Guggenheim Fund.

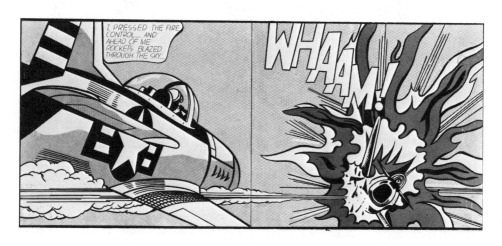

[37] Roy Lichtenstein, *Whaam!* Magna on canvas (two panels). 1963. 68" X 160". Tate Gallery, London.

[38] Pol de Limbourg and brothers, *Book of Hours: Duc du Berri—Month of April.*
Tempera and gold on vellum. C.1416. $8\frac{1}{2}''$ X $5\frac{1}{2}''$. Musee Condé/Giraudon.

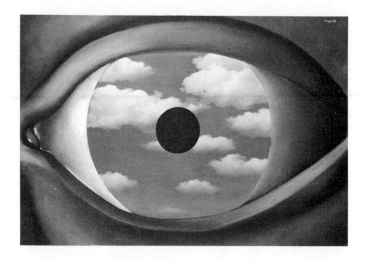

[39] Rene Magritte, *The False Mirror.* Oil on canvas. 1928. 21¼″ × 31⅞″. Collection, The Museum of Modern Art, New York. Purchase.

[40] Edouard Manet, *Olympia.* Oil on canvas. 1863. 51¼″ × 74¾″. Des Musees Nationaux, Paris. Collections du Musee du Louvre.

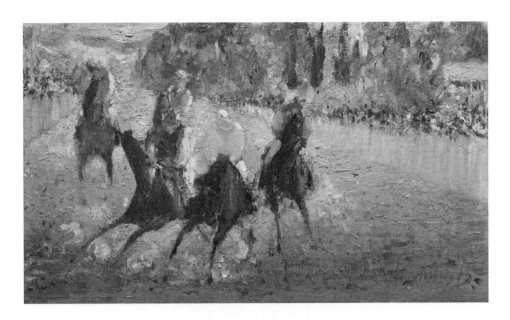

[41]　Edouard Manet, *At the Races*. Wood. 1872. 5″ × 8½″. Courtesy of the National Gallery of Art, Washington, D.C. Widener Collection.

[42]　Andrea Mantegna, *The Dead Christ*. Oil on canvas. After 1466. 27″ × 32″. Alinari/Editorial Photocolor Archives.

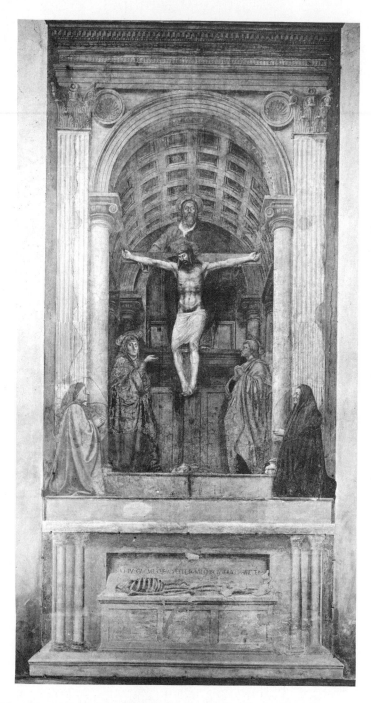

[43] Masaccio, *Holy Trinity, with the Virgin, St. John, and Donors*. Fresco. 1427.
$192\frac{2}{3}''$ X $124\frac{4}{5}''$. Alinari/Editorial Photocolor Archives.

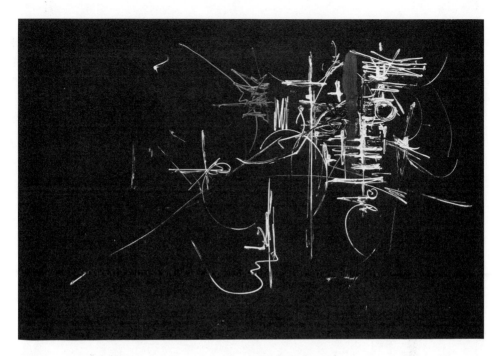

[44] Georges Mathieu, *Painting, 1952*. Oil on canvas. $78\frac{3}{4}''$ X 118''. The Solomon R. Guggenheim Museum, New York. Photo Credit: Robert E. Mates.

[45] Ma Yuan, *Bare Willows and Distant Mountains*. Painting on paper. 1190–1225. $9\frac{1}{2}''$ X $9\frac{1}{2}''$. Museum of Fine Arts, Boston. Chinese & Japanese Special Fund.

[46] Henri Matisse, *Decorative Figure on Ornamental Background*. Oil on canvas.
1927. 51½″ X 38⅜″. Musee National d'Art Moderne, Paris. Centre Georges Pompidou.

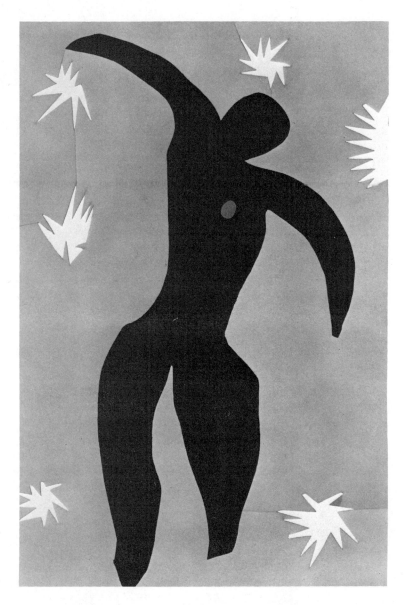

[47] Henri Matisse, *Icarus, from Jazz.* Color stencil after collage and cut paper original. 1947. Courtesy of the Fogg Art Museum, Harvard University.

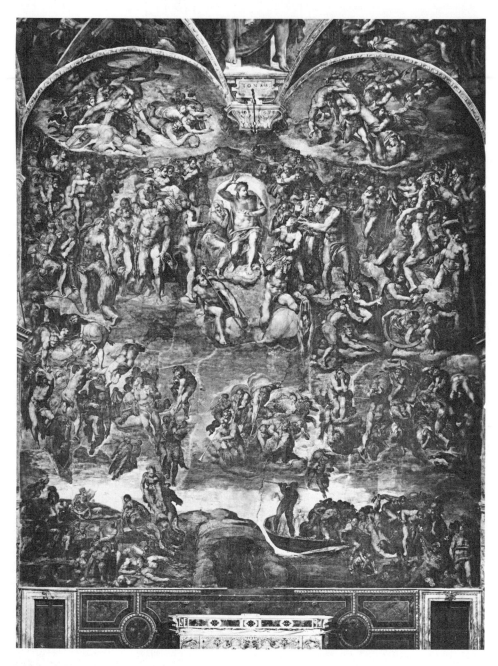

[48] Michelangelo Buonarroti, *The Last Judgment* (East Wall, Sistine Chapel). Fresco. 1534–1541. $542\frac{1}{2}''$ X $483\frac{3}{25}''$. Alinari/Editorial Photocolor Archives. Courtesy of The Vatican Museums.

[49] Piet Mondrian, *Composition No. 10, Plus and Minus.* Oil on canvas. 1915. $33\frac{1}{2}''$ X $42\frac{1}{2}''$. National Museum Kröller-Müller, Otterlo. Copyright Holland.

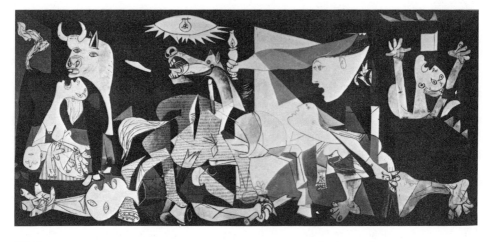

[50] Pablo Picasso, *Guernica.* Oil on canvas. 1937. $137\frac{1}{2}''$ X $300\frac{3}{4}''$. On extended loan to The Museum of Modern Art, New York, from the artist's estate.

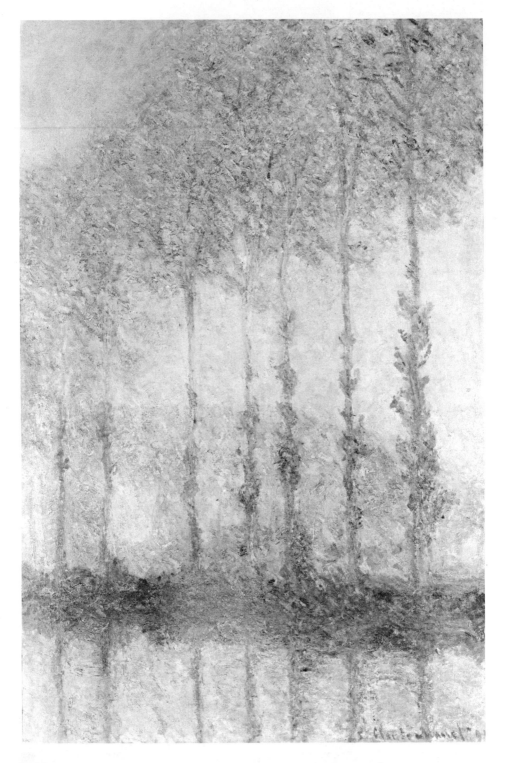

[51] Claude Monet, *The Poplars*. Oil on canvas. 1891. $39\frac{1}{2}''$ X $25\frac{3}{4}''$. Philadelphia Museum of Art: Bequest of Anne Thomson as a Memorial to her father, Frank Thomson, and her mother, Mary Elizabeth Clarke Thomson.

[52] Edvard Munch, *The Cry*. Lithograph. 1895. Image: $139\frac{4}{5}''$ X $100\frac{2}{5}''$; sheet: $191\frac{3}{4}''$ X $150\frac{4}{5}''$. Courtesy of the National Gallery of Art, Washington, D.C. Rosenwald Collection.

[53] Emil Nolde, *The Prophet*. Woodcut. 1912. 126″ × 88$\frac{1}{5}$″. Courtesy of the National Gallery of Art, Washington, D.C. Rosenwald Collection.

[54] Pablo Picasso, *Les Demoiselles d'Avignon.* Oil on canvas. 1907. 96″ X 92″. Collection, The Museum of Modern Art, New York. Acquired through the Lillie P. Bliss Bequest.

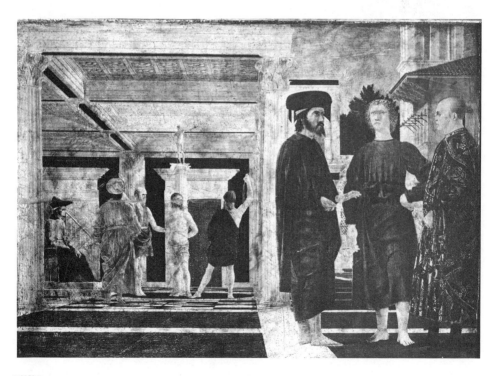

[55] Piero della Francesca, *The Flagellation.* Gesso ground on wood panel. 1458–1466. $23\frac{1}{4}$″ X 32″. Alinari/Editorial Photocolor Archives. Gallery Urbino, Spain.

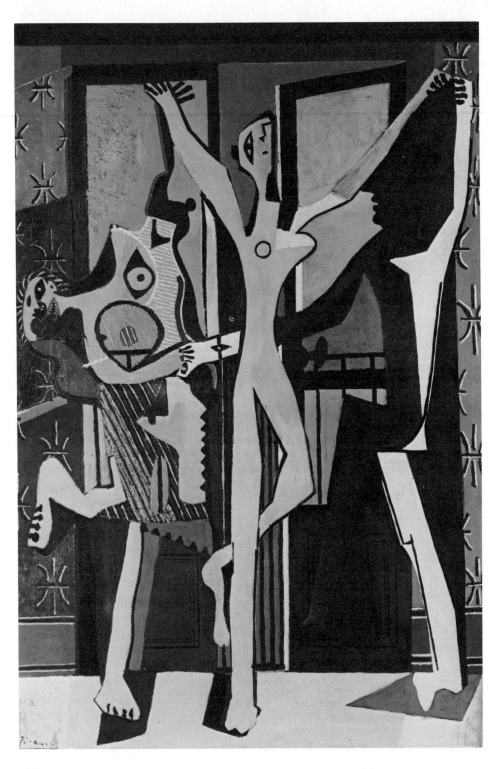

[56] Pablo Picasso, *The Three Dancers*. Oil on canvas. 1925. 84¾″ X 56″. Tate Gallery, London. ©, S.P.A.D.E.M., 1978.

[57] Piero della Francesca, *The Resurrection*. Fresco. C.1460. $88\frac{2}{3}''$ X $78\frac{1}{4}''$. Alinari/Editorial Photocolor Archives. Museum Palazzo Comunale, Borgo Sansepolcro.

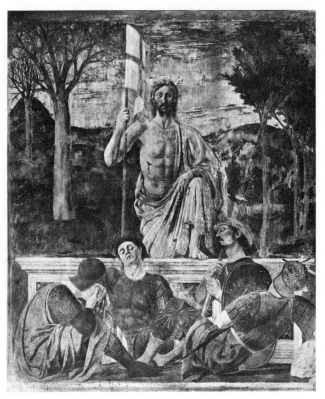

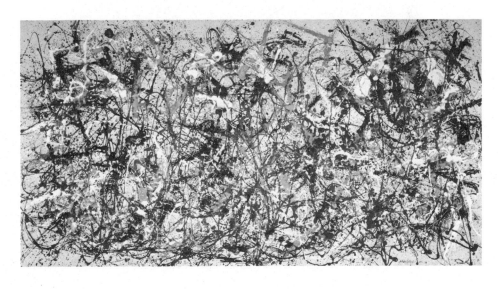

[58] Jackson Pollock, *Autumn Rhythm*. Oil on canvas. 1950. $105''$ X $207''$. The Metropolitan Museum of Art. George A. Hearn Fund, 1957.

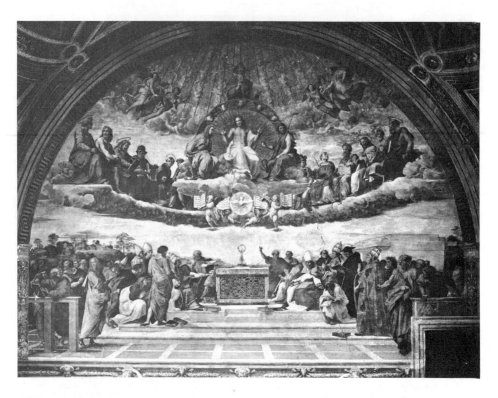

[59] Raphael Sanzio, *The Dispute of the Sacrament*. Fresco. 1510–1511. 324″ X 550½″. Alinari/Editorial Photocolor Archives. Courtesy of The Vatican Museums.

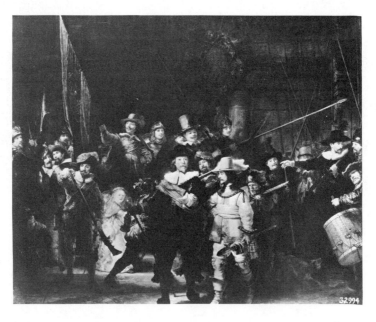

[60] Rembrandt van Rijn, *The Night Watch*. Oil on canvas. 1642. 24⅘″ X 17″. Editorial Photocolor Archives. Courtesy of the Rijksmuseum, Amsterdam.

[61] Raphael Sanzio, *Madonna del Cardellino (Goldfinch)*. Wood panel. 1505-1506. 42″ X 29½″. Alinari/Editorial Photocolor Archives. Galleria Uffizi.

[62] Robert Rauschenberg, *Buffalo II*. Oil on canvas. 1964. 96″ X 72″. Leo Castelli, New York. Collection: Mr. & Mrs. Robert Mayer. Photo Credit: Rudolph Burckhardi.

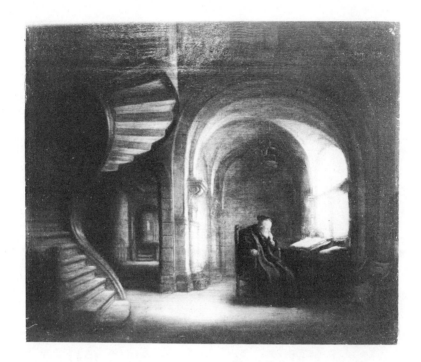

[63] Rembrandt van Rijn, *Philosopher in Meditation*. Des Musees Nationaux, Paris. Collections du Musee du Louvre.

[64] Auguste Renoir, *Le Moulin de la Galette*. Oil on canvas. 1876. $51\frac{1}{2}''$ X 69". Des Musees Nationaux, Paris. Collections du Musee du Louvre.

[65] Rembrandt van Rijn, *The Raising of Lazarus*. Etching B72. 1642. $4\frac{1}{2}'' \times 6''$.
Courtesy of the Trustees of The Pierpont Morgan Library.

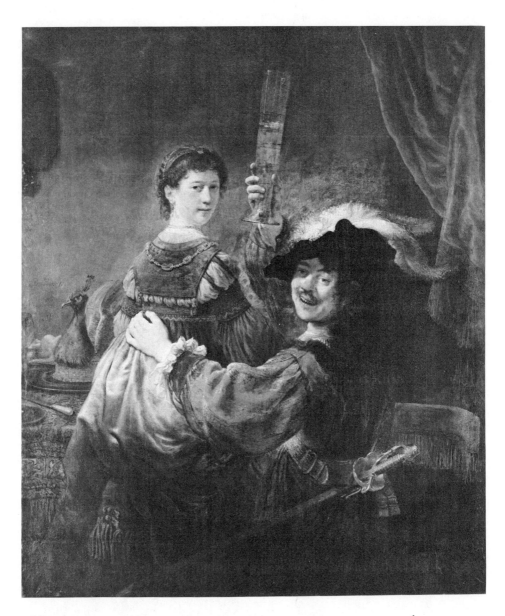

[66] Rembrandt van Rijn, *Rembrandt and Saskia.* Oil. C.1634. 7″ X 9½″. Staatliche Kunstsammlungen, Dresden—Gemäldegalerie Alte Meister.

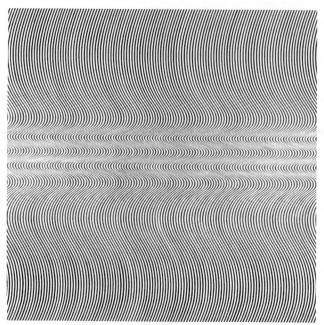

[67] Bridget Riley, *Current.* Synthetic polymer paint on composition board. 1964. $58\frac{3}{8}''$ X $58\frac{7}{8}''$. Collection of the Museum of Modern Art, New York. Philip Johnson Fund.

[68] Peter Paul Rubens, *The Rape of the Daughters of Leucippos.* Oil on canvas. C.1618. $87\frac{2}{5}''$ X $82\frac{3}{10}''$. Bayerischen Staatsgemaldesammlungen. Munchen, Alte Pinakothek.

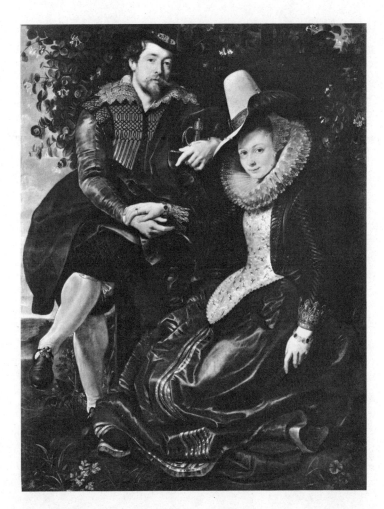

[69] Peter Paul Rubens, *Rubens and Isabella Brandt*. Oil on canvas. C.1609. $69\frac{1}{2}''$ X $53\frac{1}{2}''$. Bayerischen Staatsgemaldesammlungen. Munchen, Alte Pinakothek.

[70] Kurt Schwitters, *Revolving*. Relief construction of wood, metal, cord, cardboard, wool, wire, leather, and oil on canvas. 1919. $48\frac{3}{8}''$ X 35''. Collection, The Museum of Modern Art, New York. Advisory Committee Fund.

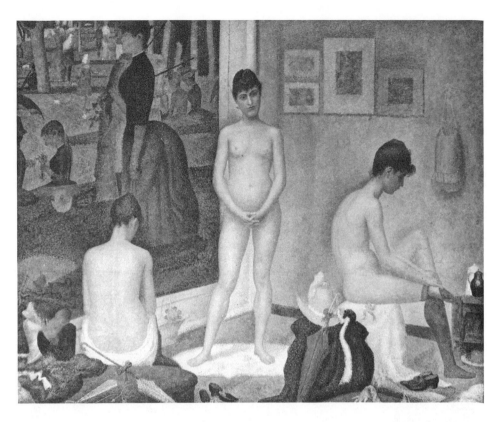

[71] Georges Seurat, *Models (Les Poseuses)*. Oil on canvas. 1888. 79″ × 98¾″. Photograph copyright © 1979 by the Barnes Foundation. Reproduced with permission.

[72] Frank Stella, *Sinjerli Variation IV*. Fluorescent acrylic on canvas. 1968. 120″ circle. From the collection of Mr. & Mrs. Burton Tremaine, Meriden, Connecticut.

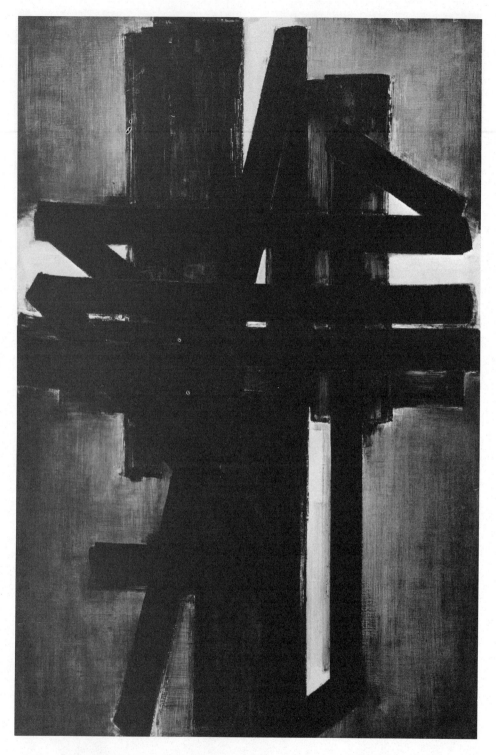

[73] Pierre Soulages, *Painting, May 1953*. Oil on canvas. $77\frac{3}{8}''$ X $51\frac{1}{4}''$. Younger
European Painters, Museum exhibition opening, Dec. 2, 1953. The Solomon R. Guggen-
heim Museum, New York. Photo Credit: Robert E. Mates.

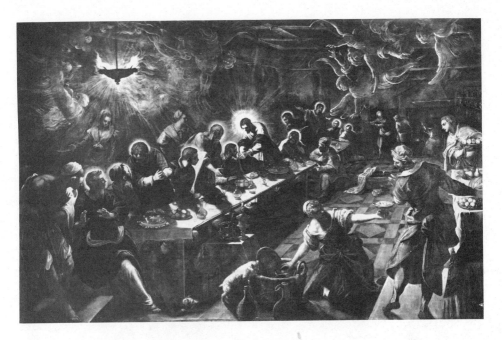

[74] Jacopo Robusti Tintoretto, *The Last Supper.* Oil on canvas. 1592–1594. 144″ X 224″. Alinari/Editorial Photocolor Archives. San Giorgio Maggiore, Venice.

[75] J. M. W. Turner, *Steamer in a Snow Storm.* Oil on canvas. 1842. 36″ X 48″. The Tate Gallery, London.

[76] Henri de Toulouse-Lautrec, *La Divan Japonais*. Color lithograph. 1892. $31\frac{4}{5}''$ X $23\frac{4}{5}''$. Courtesy of the Fogg Art Museum, Harvard University.

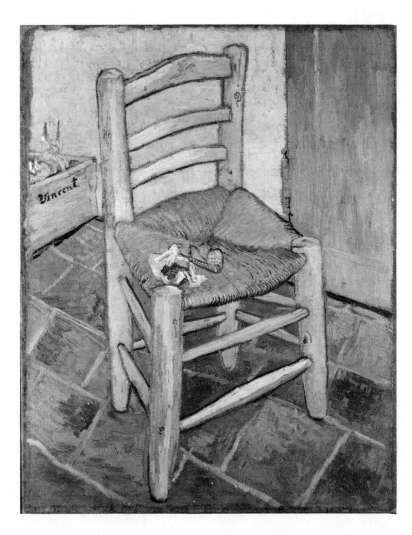

[77] Vincent van Gogh, *The Yellow Chair.* Oil on canvas. 1888. $36\frac{1}{2}''$ X 29''. The Tate Gallery, London.

[78] Victor Vasarely, *Eridan II*. Oil on canvas. 1956. 51″ × 76¾″. By permission of The Detroit Institute of Arts, Founders Society Purchase, the W. Hawkins Ferry Fund.

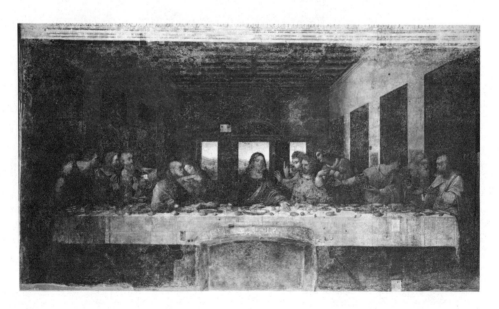

[79] Leonardo da Vinci, *The Last Supper*. Fresco. 1495–1498. 165⅓″ × 358¼″. Scala/Editorial Photocolor Archives.

[80] Diego Velasquez, *The Ladies-in-Waiting (Las Meniñas)*. Oil on canvas. 1656. 125″ X 108″. Alinari/Editorial Photocolor Archives. Museo Del Prado, Madrid.

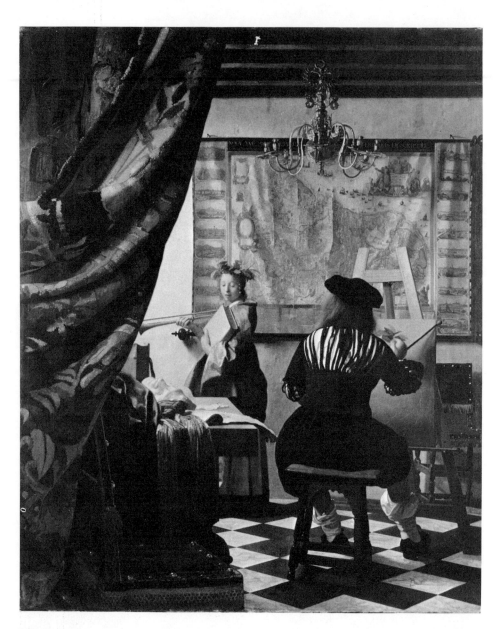

[81] Jan Vermeer, *The Artist in His Studio*. Oil on canvas. 1665–1670. 51″ X 43⅓″.
Kunsthistorisches Museum, Vienna.

[82] Leonardo da Vinci, *Mona Lisa*. Oil paint on wood panel. 1503–1505. $30\frac{1}{4}''$ X 21''. Des Musees Nationaux, Paris. Collections du Musee du Louvre.

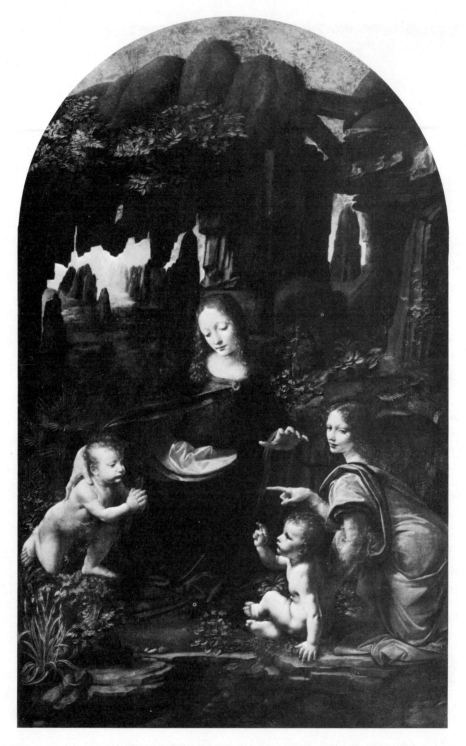

[83] Leonardo da Vinci, *The Virgin of the Rocks*. Canvas transferred from panel.
1483–1490. 75″ X 43½″. Des Musees Nationaux, Paris. Collections du Musee du Louvre.

[84] Sung K'o, *Cursive Script Poem from the Ming Dynasty*. Handscroll, ink on gold-flecked paper. $10\frac{1}{2}''$ X $27\frac{1}{2}''$. From the collection of John M. Crawford, Jr., New York, with permission.

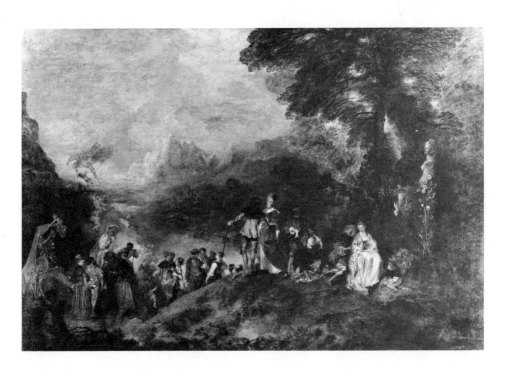

[85] Antoine Watteau, *The Embarkation for Cythera*. Oil on canvas. 1717. $51''$ X $76\frac{1}{2}''$. Des Musees Nationaux, Paris. Collections du Musee du Louvre.

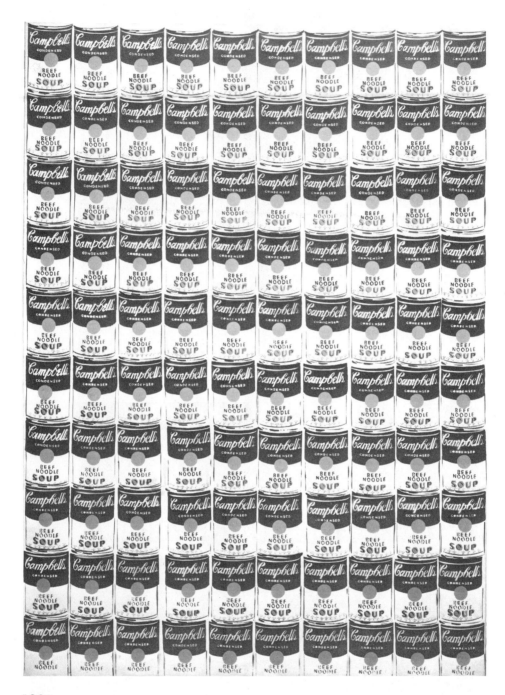

[86] Andy Warhol, *100 Cans*. Oil on canvas. 1962. 72″ X 52″. Albright-Knox Art
Gallery, Buffalo, New York. Gift of Seymour H. Knox.

[87] Page from the Celtic *Lindisfarne Gospels* (from folio 29). C.700. $13\frac{1}{2}''$ X $9\frac{3}{4}''$.
Reproduced by permission of The British Library.

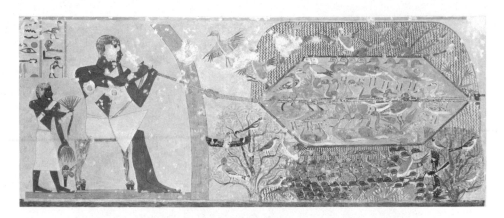

[88] Dynasty XII. Antiquities—Egyptian. Painting-wall painting-painted copies.
Wall painting: Fowling Scene copy in tempera. $40\frac{2}{5}'' \times 10\frac{2}{5}''$. From the tomb of Khnum-
hotpe, Beni Hasan. The Metropolitan Museum of Art.

[89] XII Century Sung Dynasty. *Wen-Chi's Captivity in Mongolia and Her Return to
China.* Courtesy Museum of Fine Arts, Boston. Ross Collection.